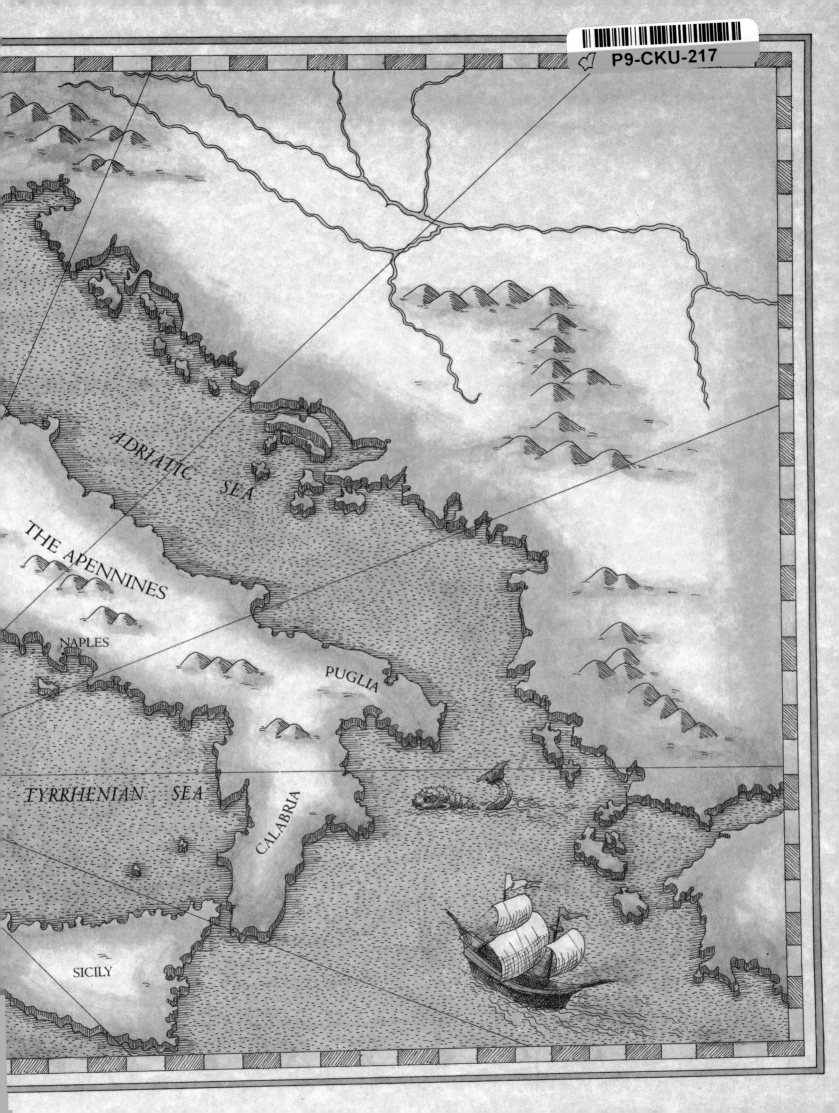

THE APENNINES

ADRIATIC SEA

NAPLES

PUGLIA

TYRRHENIAN SEA

CALABRIA

SICILY

A SEASON
OF GIANTS

A SEASON

GIA

MICHELANGELO

LEONARDO

RAPHAEL

VINCENZO LABELLA

Special photography by John McWilliams

OF

N T S

1492-1508

 Little, Brown and Company

BOSTON TORONTO LONDON

Published by Little, Brown and Company

Copyright © 1990 by Turner Publishing, Inc.

First edition

Library of Congress Cataloging-in-Publication Data
Labella, Vincenzo.
 A season of giants: Michelangelo, Leonardo,
Raphael, 1492–1508/by Vincenzo Labella. — 1st ed.
 p. cm.
 ISBN 0-316-85646-0
 1. Art, Italian. 2. Art, Renaissance — Italy.
3. Art patronage — Italy. 4. Michelangelo Buonarroti,
1475–1564. 5. Leonardo da Vinci, 1452–1519.
6. Raphael, 1483–1520. I. Title.
N6915.L25 1990
709'.45'09024 — dc20 90-6252

10 9 8 7 6 5 4 3 2 1

Published simultaneously in Canada by Little, Brown and Company (Canada) Limited

Produced by:
Welcome Enterprises, Inc.
164 East 95 Street
New York, NY 10128

Project Director: Lena Tabori
Designer: Nai Chang
Production Manager: Hiro Clark
Editorial: Linda Sunshine
Map: Sophie Kittredge

Composition by U. S. Lithograph, typographers

ACKNOWLEDGMENTS

My cordial thanks go to Lena Tabori, and to Irv Goodman, Hiro Clark, Nai Chang, Ira Miskin and Michael Reagan for their intelligent and generous contribution to this book, which would not exist without their labor of love.

It is fitting that I pay my debt of gratitude to Sue, my wife and first editor, for having helped me throughout this journey through the glorious season, and for just being in my life.

CREDITS

John McWilliams: jacket, pages 20–21, 22, 53 (left and right), 58, 59, 78, 79, 80, 142, 144, 145, 151, 152, 153, 155, 156, 157, 158, 159, 168, 220, 221; Scala/Art Resource, NY: pages 8, 11, 12, 13, 14, 15, 16, 17, 18–19, 19 (right), 24, 26, 27, 29, 30, 31, 32 (left), 32–33, 34, 35, 36, 39 (left), 41 (top and bottom), 42, 45, 46 (bottom), 47, 49, 50, 56, 64, 65, 66, 68, 75, 81, 85, 87, 93, 94, 97, 99, 104, 111, 112, 114, 116 (top and bottom), 118, 122, 123, 124–125, 126, 128, 134, 136, 160, 161, 163, 170, 172, 174, 175, 176 (left and right), 180 (bottom), 182, 183, 187, 188, 190, 191, 192, 195, 196 (left and right), 196–197 (bottom left, center, right), 198, 201, 203, 204, 205, 206, 209, 210, 211, 214, 223, 227, 236 (top and bottom left, center, right), 238 (top and lower right), 239 (left and right), 240 (top and bottom); Alinari/Art Resource, NY: pages 25, 37, 39 (right), 48, 72, 106, 133, 135, 146, 147, 171, 179, 180 (top), 181, 212, 232, 234; Giraudon/Art Resource, NY: pages 150, 165, 224; Marburg/Art Resource, NY: pages 46 (top), 197 (top), 217; Nimatallah/ Art Resource, NY: pages 33 (right), 178, 207, 208; Snark/Art Resource, NY: page 10; Bridgeman/Art Resource, NY: pages 173, 218, 238 (lower left); Isabella Stewart Gardner Museum/Art Resource, NY: page 169; Art Resource, NY: pages 117, 131; E. Bulgarelli: p. 148 (left and right).

This book is a companion to the TNT mini-series *Season of Giants*. Turner Publishing would like to thank all of the people at TNT who helped make this book possible: Gerry Hogan, Scott Sassa, Neil Baseman, Linda Berman, Betty Cohen, Jerry Letofsky, Terry Segal, Roxanne Captor, Jerry Clark and Nick Lombardo.

PRINTED AND BOUND IN ITALY BY AMILCARE PIZZI, S.P.A.

"Never,
You will never know
How it enlightens me
The shadow that comes timidly
To my side,
When every hope has left me."

GIUSEPPE UNGARETTI

TO

ROSSELLA,

IN THE LIGHT

READ THIS
WHEN YOU ARE WELL
DISPOSED

"The twenty-eighth day of July, 1500

"I wish to give you news of my coming back from the part of India by way of
the ocean and the grace of God, reaching safe landing in this city of Seville:
and since I trust that your Magnificence will like to hear the whole story of
our fortunate journey and of the most wonderful things that were presented
to me, I fear that my tale may prove to be too long and tiring; therefore let me
advise you that you begin reading this letter of mine when you are well disposed
to do so: perhaps instead of eating fruit before you leave your dinner table. . . ."

AMERICUS VESPUCIUS FLORENTINUS

TABLE OF CONTENTS

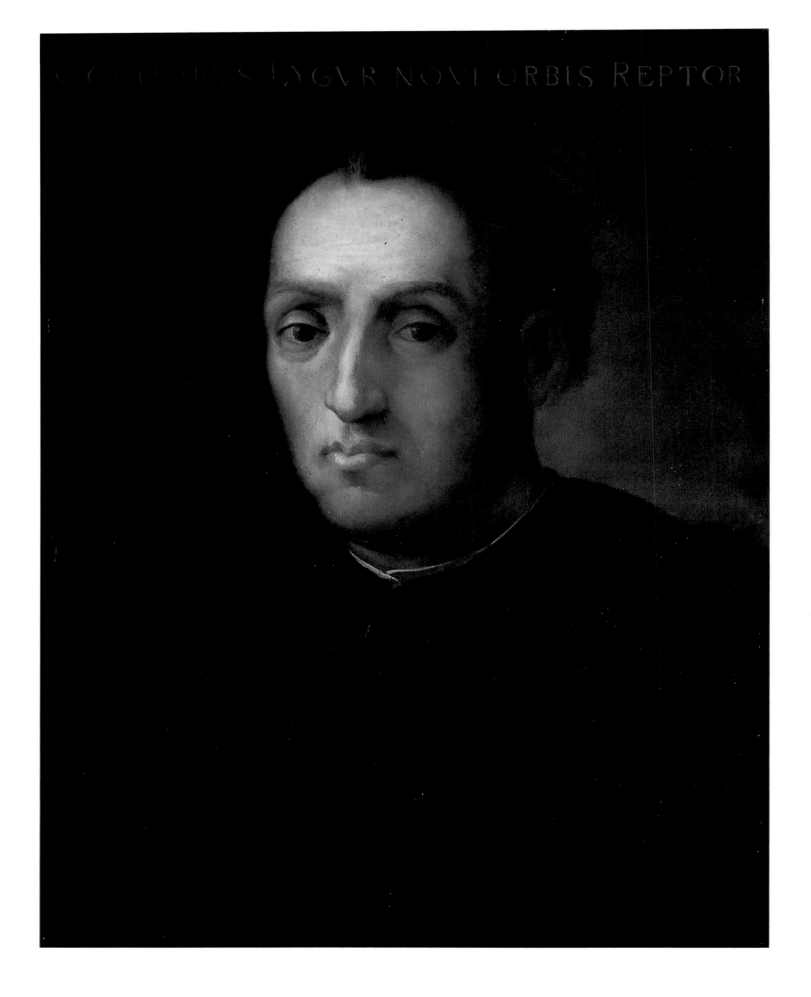

FOREWORD

"The hour in time and the gentle season."
DANTE

There happened a time in the history of humankind when the ravages of wars, plagues and social conflicts were overshadowed by artistic achievements of such excellence and power as to find but rare parallel.

This was the season that saw the sudden blossoming of painters, sculptors, architects, poets, scientists and musicians, in a manner and quantity so amazing that it was reasonably considered the rebirth or "renaissance" of the human creative energy.

This flowering of genius found its natural humus in the central part of Italy formed by four regions: Tuscany, Umbria, the Marches and Lazio. Florence was its ideal center, a city-state governed by the Medici, a genial dynasty of merchants and art patrons who had risen from their druggist shops to become the first and most successful bankers in Europe. They were represented in every major city, and even as far as Turkey.

Just when the Genovese Christopher Columbus was about to land in the New World, soon to be followed by the Florentine Amerigo Vespucci, whose name would be given to the discovered continent, Florence was under the gentle rule of His Magnificence Lorenzo de' Medici, who had gathered at his court some of the highest intellects of his time. He hosted

OPPOSITE:
Anonymous (sixteenth century). Portrait of Christopher Columbus. Madrid, Museum of America.

A CANDLE IN THE NIGHT

"Thursday, the eleventh day of October, 1492

"About ten o'clock at night, as Admiral Christopher Columbus kept watch on the sterncastle, he thought he beheld a light glimmering at a great distance to the west. It had the appearance of a small wax candle (*candelilla de cera*) that went up and down as if with the bobbing of the boat. It looked like a light in the hand of a person on shore who lifted or lowered it, as he was moving from house to house.

"Fearing his eyes might deceive him, in his eagerness to find land, he called to Pedro Gutierrez, gentleman of the king's court, and inquired whether he saw such light. After only a few moments he saw it. Then he called Rodrigo Sanchez of Segovia, the inspector-general of the fleet, and made the same inquiry. Rodrigo saw no light, nor did any other member of the crew. The light reappeared once or twice afterward, in sud-

den and passing gleams; so transient and uncertain were these, that few attached any importance to them as a proof of land. . . . He believed that the light was a signal from God.

"Friday, the twelfth day of October, 1492

"At dawn they saw perfectly naked people, the ship's boat was armed, and the Admiral went ashore. Martin Alonzo Pinzon, the captain of the *Pinta* and his brother, Vicente Yanez Pinzon, the captain of the *Niña*, followed him. The Admiral held the royal standard; he planted it on the newfound land which he knelt to kiss.

"A new world had been discovered for the new man."

FREY BARTOLOMÉ DE LAS CASES,
on the landing of the *Pinta* at
Samana City, San Salvador

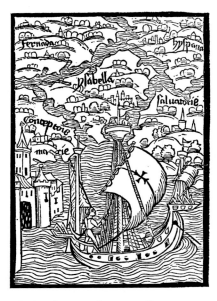

Columbus on the caravelle near the islands of the Saviour and the Conception.

a school for young sculptors, painters and architects, including his young "adopted son" Michelangelo Buonarroti, who stood out as the harbinger of the glory that Lorenzo's champions would garner for Florence.

The "city of the flower," as Florence was known because of the red lily (or iris) that shone in its blazon, earned the title of "new Athens." The *fiorino*, or florin, its gold currency, held financial credit all over Europe.

In the efflorescence of this season, three names rose above all others: Leonardo, Michelangelo, Raphael. For a brief, magical span in the course of time, they worked side by side in Florence, divided by rivalry, yet united by the common denominator of genius. And humankind is still being uplifted by them.

This book is about that season and its protagonists. They were not supermen; to the contrary, even as they climbed to the highest peaks of excellence and fame, they retained their natural vulnerability. Far from being unassailable, they were hurt, and in turn, hurt others by envy, jealousy and pride. They were arrogant in the self-assurance of their talent, humble in the knowledge that beyond any finishing line there was another, and yet another, to be crossed. The threads of their lives were spun from different origins, yet were interwoven, and often entangled, in that unique loom of the Renaissance tapestry that was Florence.

They were all attracted to this city by the same magnet of love and common spirit, like desert farers looking for the oasis to quench their thirst. One thing they had in common was the premature death of their mothers while they were still infants. Each of them bore the mark of this loss in his conscience, and each drew from it a cathartic inspiration that was translated into his works.

Otherwise, they differed greatly. Leonardo was the prober of all that was human, or pertained to the condition of humankind on planet Earth, and the mysteries beyond. In the opening words of his Madrid Codex, he proclaimed, "Come, men, to see the wonders which may be discovered in nature by my studies." His multifarious interests so stimulated his intelligence that he found it hard to complete all that he commenced. His continual search for innovation and invention led him to extraordinary accomplishment, and to dismal failure. He was handsome and possessed a natural elegance that won him the esteem of lords and artisans, of masters and apprentices alike. He was the champion of a nobility derived from his constant celebration of aesthetic values and the harmony of nature and its wonders.

Whether designing an equestrian monument or experimenting with a new painting technique in his fresco *The Last Supper*, Leonardo never ceased to surprise and amaze. He was called to paint a simple portrait, and he turned it into an invitation to enter a world of magic and mystery. The *Mona Lisa*, exhibited at the Louvre in Paris, was a window he left open for generations to pass from mere portraiture to a dimension of wider horizons. The property of genius is just this: to stimulate, to provoke *intelligence*, the quality of *intus legere* (to read inside), to decipher what life proposes in all its aspects.

"I have never had one day that I could call my own," wrote Michel-

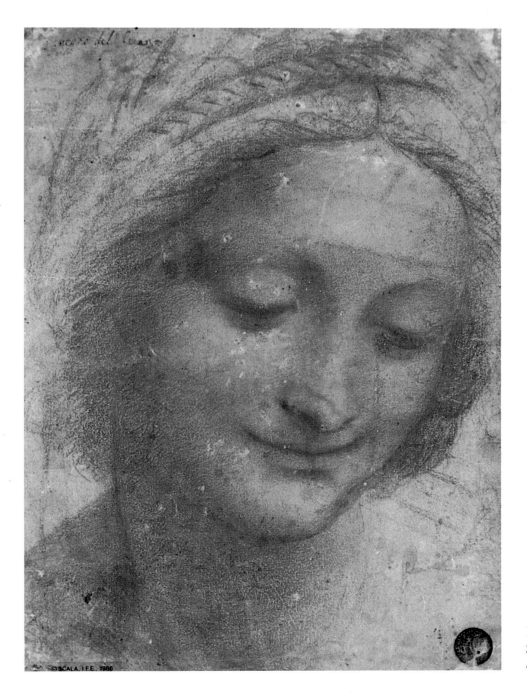

Leonardo da Vinci. Sketch of Saint Anne. Venice, Academy of Fine Arts.

angelo from the stronghold of his solitude, where very few friends were admitted, and where he defended his will to concentrate on the driving force of his vocation. Impervious as the stony mountains that he loved, he did not impress by his stocky and ungraceful appearance. Misunderstood by his family, opposed by a father who disapproved of what he considered the demeaning craft of stonecutting, Michelangelo found solace only in his work. When he lost his great patron, the man that all of Florence hailed as the Magnificent Lorenzo de' Medici, and his beloved city was shaken by the stormy drama of Friar Girolamo Savonarola, he was left alone to defend his visions, and battle frequent humiliations such as a commission to shape a statue in snow, an exercise as vain as it was painful. But on his path to glory he unearthed giants who proclaimed his greatness: the *Pietà*, the *David*, the *Moses*.

He rose in fame so as to stand face to face with another giant, Pope Julius II, daring to challenge him. From the excruciating adventure of the Sistine Chapel he emerged victorious, and his triumph, unlike those of the Caesars, was for all seasons, as proved by the recent stunning restorations of his work.

Raphael, the youngest in this triad of geniuses, was not a Florentine. He came from a town in the Marches region where another enlightened ruler held a court that shored up the energy of the Renaissance. Raphael, the son of an honest painter, was soon introduced into the practice of the art, and so precocious that, at age seventeen in an official contract, he was called "master."

Michelangelo. Male nude kneeling. Florence, Uffizi Gallery, Cabinet of Drawings.

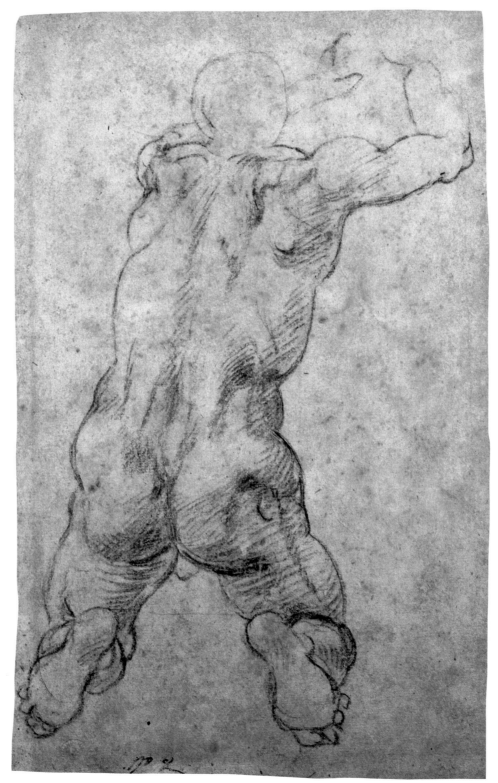

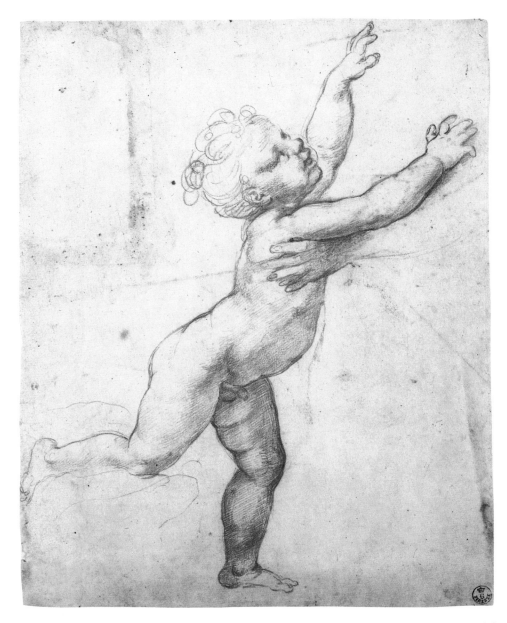

Raphael. Nude putto with arms opened. Florence, Uffizi Gallery, Cabinet of Drawings.

Enamored of life and almost prescient of the brief span it would allow him, he produced a wealth of images that partake of humanity while tending to a superior sphere in which the spirit moves freely and powerfully. His Madonnas are portraits of real women, captured tales of motherly love, transfigured by the artist and steeped in the inimitable ambient light that flooded his work.

Raphael, too, had an appointment with destiny in the *Stanze* — the rooms that Pope Julius II commissioned him to decorate in order to endow the Vatican palace with art treasures worthy of the new era he had inaugurated. In his *School of Athens*, the triad of champions of the Renaissance found consecration, as Raphael portrayed himself and his great traveling companions, Leonardo and Michelangelo.

A Season of Giants reconstructs the voyage that brought these champions through converging paths to common challenges and collisions, to experience the bitterness of hatred, the warmth of solidarity, the torture of defeat and the marvel of triumph. Their works are an invaluable celebration of human greatness, our heritage from that marvelous season.

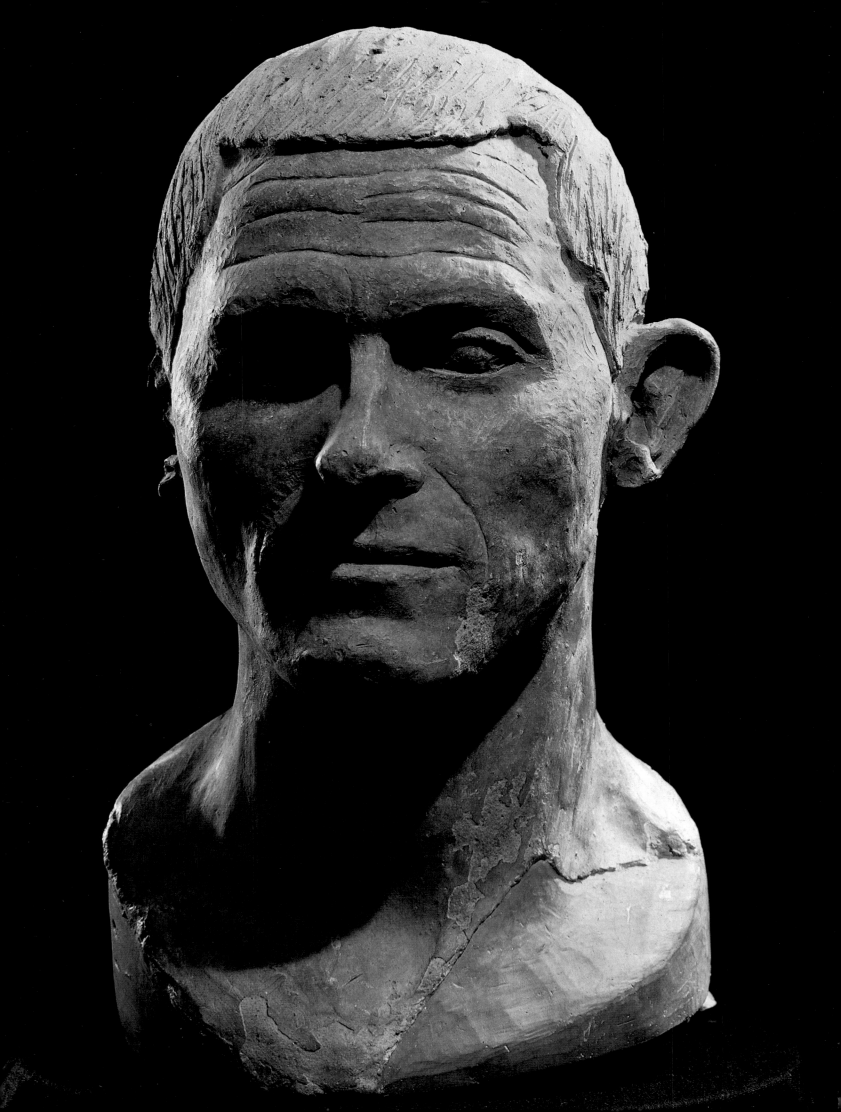

I.
SETTING
THE STAGE

ANCIENT ETRURIA, CRADLE OF CIVILIZATION

The central part of Italy, once inhabited by the Etruscans, was the perfect setting for the miracle known as the Renaissance.

A providential wind filled the sails of the "free seafarers" who landed on the coast of the Tyrrhenian sea when Rome was only a name (*rumon*) the Etruscans had given to the Tiber river. These seafarers called themselves *rese*, meaning "rays," possibly to remember their diaspora, the sea journeys their sails made from coast to coast in the Mediterranean.

Part of the Pelasgian tribe, the Etruscans, "the people of the sea," came from Illyria (the "free" land), then expanded their domain from Asia Minor to Palestine, from the Danube to the Tiber. They rapidly moved throughout the central part of the Italian peninsula, all over Tuscany and

"Italy today is far more Etruscan in its pulse than Roman: and will always be so."

D.H. LAWRENCE

OPPOSITE:
Etruscan. Head of a man called the "Manganello." Rome, Villa Giulia Museum.

Sixth century A.D. Sarcophagus of the Spouses (from Cerveteri). Rome, Villa Giulia Museum.

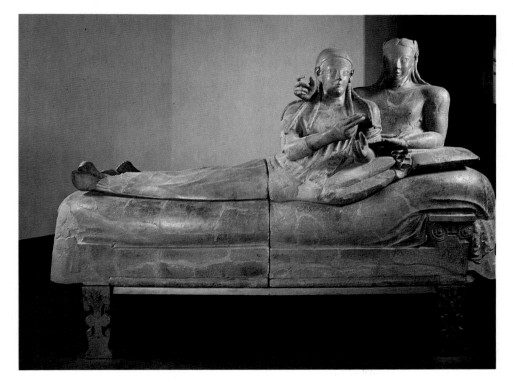

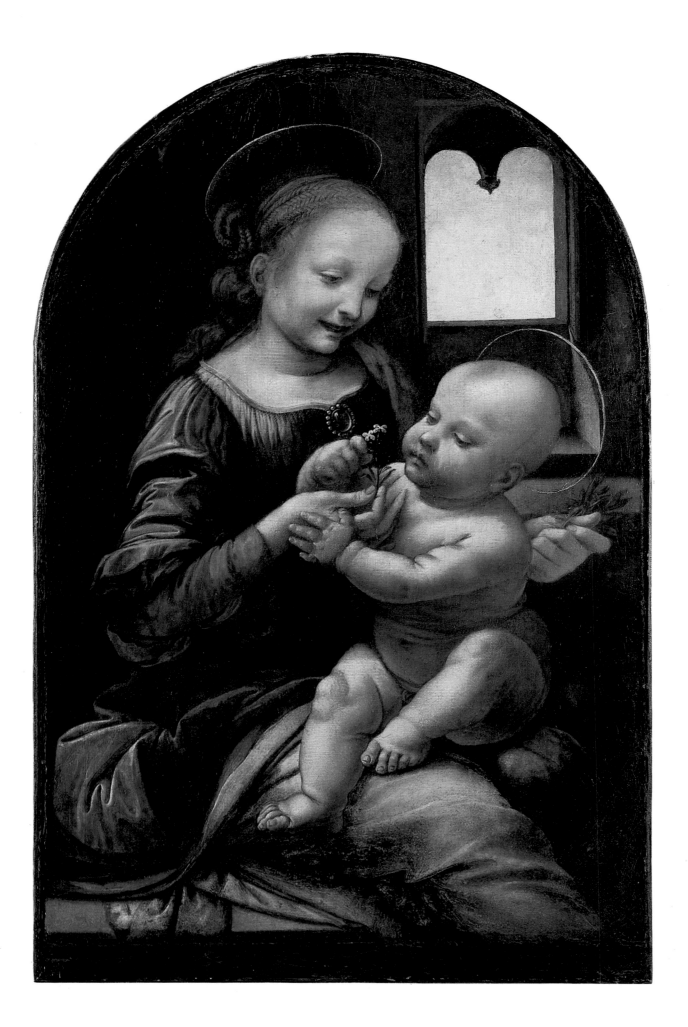

Umbria. They built walled cities for the living and underground abodes where the dead could rest through the "one long night to be spent without awakening." The tombs mirrored the houses where they had been born, grown up, worked, made love, sung, laughed, and where they had died amid music and weeping. Decorated with brightly colored frescoes, the tombs house coffins with portraits shaped in terra-cotta and depictions of children with their favorite pets and toys, husbands reclining next to their wives, blissfully prepared for an eternal banquet. These stone figures have a shadow of a smile on their lips that suggests a quiet, even humble knowledge of the finiteness of life, a calm acceptance of death and the absence of any fear for the afterlife.

Rome absorbed Etruscan wisdom and political intelligence and then grew wary of a culture that refused to be obliterated and continued to flourish within the walled cities. Inexorably, by the year 273 B.C. the Etruscans were overwhelmed by the belligerent descendants of Romulus, denied the honor of having been the first to civilize Italy. As their towns fell under the ravaging attacks of the Romans, their names were Romanized, their language submerged by Latin. Their literary texts survived only in a few privileged libraries.

The Etruscans' lost voices speak to us only through their funerary inscriptions. This is why, although their language has been deciphered, our knowledge of that language is very limited.

There were Romans, mostly young politicians, who were interested in studying the Etruscan language and in completing their education in Etruscan schools. A few others tried to reconstruct their history. Verrius Flaccus, a historian of the Augustan time, wrote *Rerum Etruscarum Libris*, a collection of historical events, as well as legends, that shed light on their lost records and provided valuable information about their origins. The emperor Claudius, whose first wife, Plautia Urgulanilla, was the daughter of a royal Etruscan family from Caeres (Cerveteri), compiled a twenty-volume *History of the Etruscans*. All that remains of these works are a few scattered quotations. Today, archaeologists dream of these texts as they keep alive the hope of discovering them in some still undefiled tomb or in one of the Roman villas still inviolate.

The smile of the Etruscans, their funerary inscriptions, and the remains of their walls, temples and burial places, are all that survive of these people. One cannot help but feel moved in reading the inscription found in the tomb of a young Etruscan: *MIJA RISIA TA KESH* (My youth may you have), a vibrant message that documents the heritage of spiritual energy willed by the people of yore to those who were destined to follow.

These refined, earthy and strong-willed people are still alive today in the population of Tuscany, Umbria, the Marches and Latium. As described in the testimony of Curzio Malaparte, the author of *Those Cursed Tuscans*, an irreverent study of Tuscan characters and manners, they are "limber, thin-faced youths, with arrowy noses, oblique eyes, startlingly similar to those of their ancestors, the Volumnii, the Rafia, the Noforsina, the Afunin, the Velthina, the Tetinii, all of them with curly black hair, straight slabs of temples and thin lips." They can still be met in the streets of Volterra,

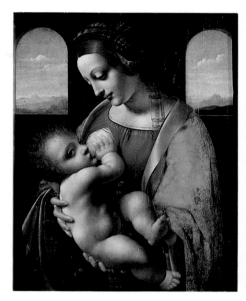

Leonardo da Vinci. The Litta *Madonna*. Leningrad, The Hermitage.

OPPOSITE:
Leonardo da Vinci. The Benois *Madonna*. Leningrad, The Hermitage.

17

Arezzo, Perugia, under Etruscan arches, and in the fields where the farmers' plows (or the spades of the *tombaroli*, tomb thieves) uncover ancient graves.

Azure hills frame these regions, once named Etruria (from the Etruscan *e* for "of" and *truria* meaning "mind, brain"; thus, "land of the brain"). The sky, the vines, the cypresses and the olive trees echo the distant smiles, preserved through the ages. This is the same smile that Leonardo floated on the lips of his *Mona Lisa*, and it appears in his other celebrated paintings: *The Virgin and Saint Anne, The Adoration of the Wise Men*, the Benois *Madonna*, the Litta *Madonna, Saint John the Baptist*.

The generations living the legacy of the "land of the brain" had their epiphany in the flowering of the Renaissance, through the works of its great protagonists. A heritage of millennia lives on in the Tuscan and Umbrian countryside, in this veritable corner of Dante's *Paradiso*, where every landscape seems to mirror a painting by one of its masters.

THE SPIRIT OF FLORENCE

Falling in love with Florence is as easy as walking its narrow streets and crossing the bridges spanning the Arno, a river as tame as it is capable of creating havoc and carrying death by water. A theater of the arts, a museum

Buonsignori. A map of Florence known as "Carta della Catena." Florence, Museo di Firenze Com' Era.

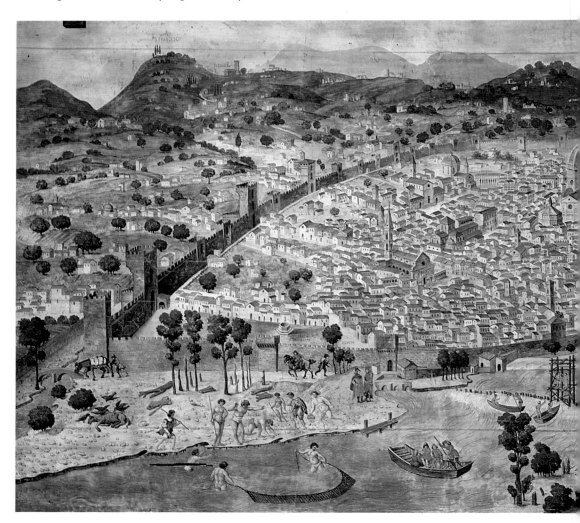

of urban buildings, graced with sculptures and paintings, the voices of its poets, as well as the outcries of popular riots and internecine fights, Florence aims straight at the heart and mind of its visitors, a beauty ready and willing to reveal its secret graces.

One hardly needs to take a photograph of the Dome by Brunelleschi ("the eighth wonder of the world") to make of it a *souvenir*; it is so deeply and immediately imprinted in one's memory, through dazzled eyes, that it will stay alive forever. For indeed it is proper to apply to Florence what Longfellow wrote about Rome in *Michael Angelo*: "it becomes to all a second native land by predilection and not by accident of birth alone."

It is quite impossible to sift through the few and often unconnected documents that are at our disposal, in order to re-create the story of the genius of Florence through twelve centuries, as it rose to the power and dignity of a free commune. When it finally emerged as a lighthouse of European civilization (a role it played for over four centuries), Florence appeared as one of the typical Italian towns of the Middle Ages. An urban center founded on both banks of the Arno, its stone houses and labyrinthine streets were contained within the embrace of solid walls, and these, in turn, were protected by a circle of blue-green hills blessed with olive groves and cypresses, hosts to the "people of the trees," the shrill singing cicadas.

Its people were mostly artisans and merchants, laborious, quick to

"And God created heaven and earth while sitting, with his palette in his hands, over the hills of Fiesole: the first day he painted Florence with one brush; during the six following days, all the rest of the world with another brush."

ANATOLE FRANCE

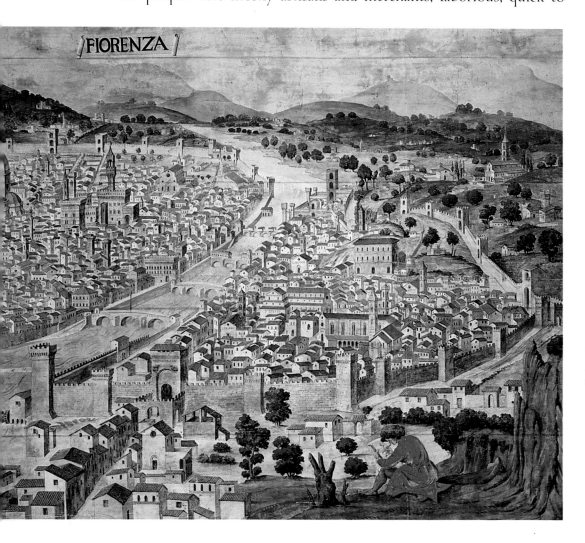

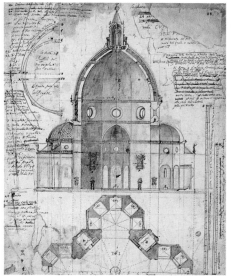

Cigoli. Drawing of Brunelleschi's design for the cupola of Santa Maria del Fiore. Florence, Uffizi Gallery, Cabinet of Drawings.

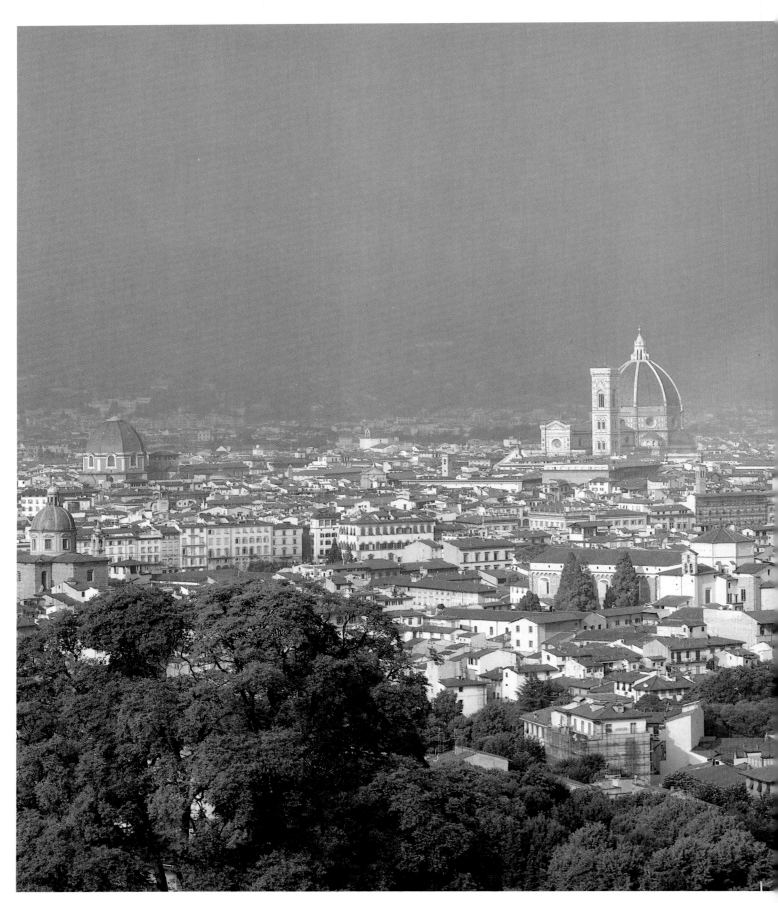

View of Florence with the Duomo of Santa Maria del Fiore by Brunelleschi.

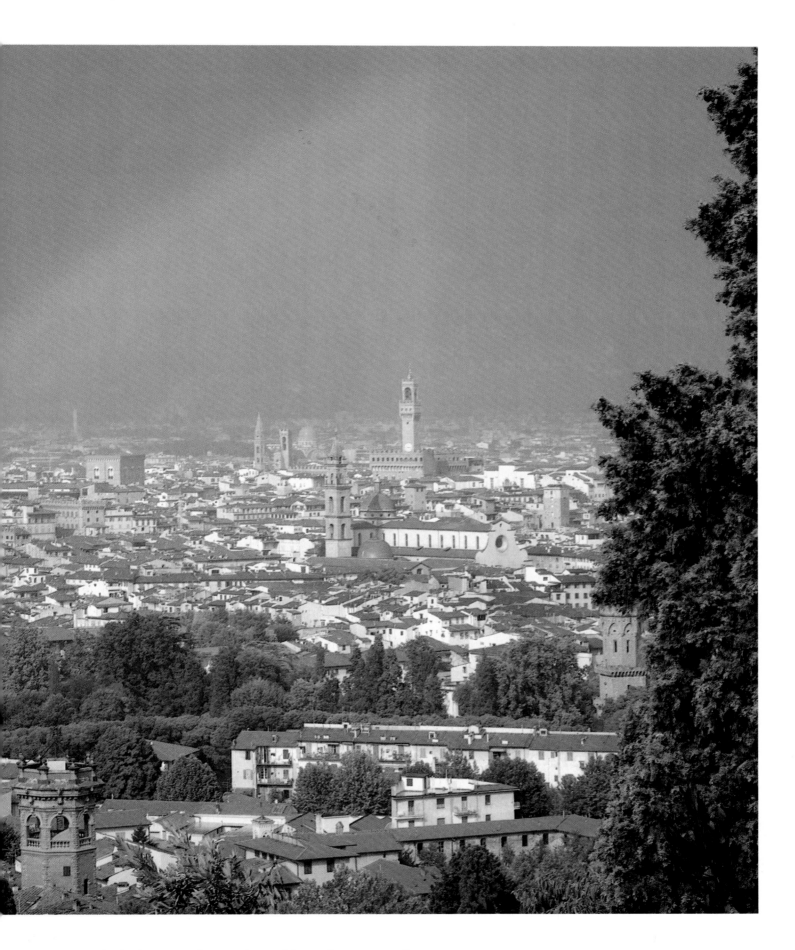

"I think Florence is the most beautiful city I have yet seen." PERCY BYSSHE SHELLEY

lose their tempers, yet rather inclined to consider trials and tribulations as the natural chattel human beings inherit at birth. Hard workers, industrious craftsmen and traders, they established banks and a network of commerce that spanned Europe. They practiced law and imposed a certain order above their inborn love of freedom, their reluctance to accept impositions. The wealth that the Florentines were able to build for their Commune, increased by their talent for commerce, led them to turn their culture and its visible urban manifestation, the figurative arts, into tools by which to embellish their city. At the end of the thirteenth century, the long painstaking weaving of the spiritual fabric and the efforts needed to secure the funding needed to support their ambitions were completed.

Florence had not yet competed with the other great Italian cities in architectural and courtly splendors. But, by the end of the thirteenth century, the city broke its patient silence with the music of its stonecutters, masons, architects, sculptors, poets and musicians; a veritable choir of people at work not for bread alone but for the glory of their Commune.

The youthful energy of Florence blazed in its flowering valley, and beyond. Lapo Gianni, one of its thirteenth-century poets, had dreamed of his beloved city in an ideal vision.

Through the fifteenth and sixteenth centuries, the vision grew from a misty dream to the sun-drenched reality of palaces, churches, squares and gardens.

Yet the gifted Florentines did not overbuild. They never fell for the gigantic, the titanic that Egypt, ancient Rome, and, in some instances,

O Love, I wish to possess my love,
The Arno like a precious balsam,
The silvery walls of Florence,
The streets paved with crystal . . .
LAPO GIANNI

Santa Maria del Fiore in Florence.

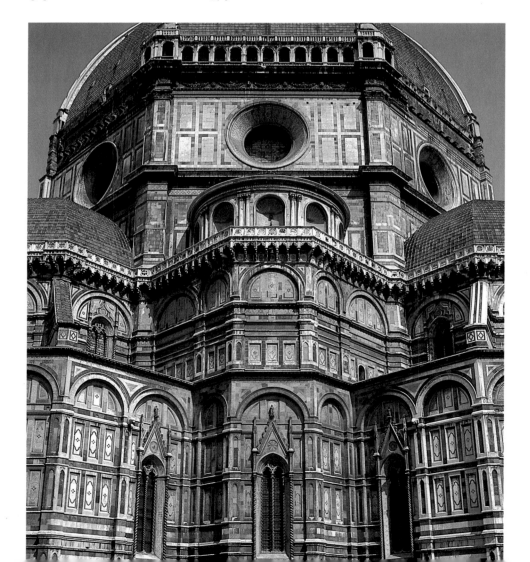

even the great master of civilization, Greece, had favored. Florentine edifices were designed according to "the measure of man." Windows were made large enough to frame a person and allow a vision of the outside world, but small enough to prevent cold wind from rushing inside and robbing the house of its warmth.

This quality of Florence to embrace and be embraceable at the same time has always granted visitors the gift of feeling at home within its walls. The city has affected many writers, over many centuries but, perhaps, none have been quite as eloquent in their praise as Stendhal (Henri Marie Beyle) when he described his first visit to Florence:

> The day before yesterday, as I approached Florence, my heart was beating wildly.... At last, in the misty distance, I could distinguish the dark mass of Santa Maria del Fiore, with its famous Dome, the masterpiece by Filippo Brunelleschi.
>
> "Behold the home of Dante, of Michelangelo, of Leonardo da Vinci," I told myself. "Behold this noble city, the Queen of ancient Europe." Here, within these walls, the civilization of mankind was born anew; here Lorenzo de' Medici so splendidly ruled and established a court at which, for the first time since the reign of Emperor Augustus, military skill was reduced to a lesser role.
>
> As time passed, so these memories rose crowding my soul, and soon I found myself incapable of rational thought, but rather led to yield to the sweet turbulence of fantasy, as in the presence of some beloved object. As I entered the city, through the gate of San Gallo, I felt ready to embrace the first Florentines I might encounter....
>
> In Santa Croce I saw the tomb of Michelangelo, ... and that of Machiavelli. Opposite Michelangelo lies Galileo. What a race of men! The tide of emotion was as intense as a religious feeling. My soul ... was in a state of trance.
>
> Absorbed in the contemplation of sublime beauty, I could perceive its very essence close at hand.... I had reached that most high degree of sensitivity in which the divine intimations of art merge with the sensuality of emotion. As I emerged from the portal of Santa Croce, I was seized by a fierce palpitation of the heart. I walked on, constantly fearing that I might fall to the ground.

It is not difficult — once the ear is attuned to it and the heart is in unison with it — to perceive the uniqueness of Florence in the language spoken by the Tuscans: sharp, witty, acerbic, a language that translates thoughts and emotions not through the filter of conformism, but frankly, directly, confrontationally. This language, like Florence, is, by nature, erudite and precious as it recovers classical roots, but is never out of tune with the present as it says, "bread to bread and wine to wine."

What is it about Florence that inspires respect and indeed passion? In the words of Giovanni Papini, a great Florentine writer of our century: "Simplicity, moderation and harmony, linked with the sense of reality: these are the qualities that distinguish the genius of Florence."

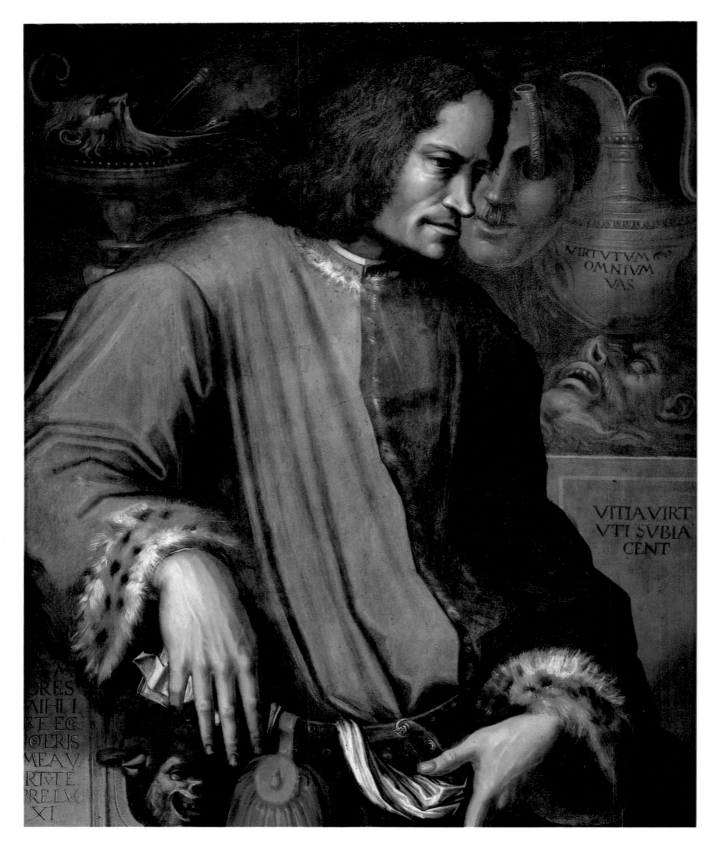

Giorgio Vasari. *Lorenzo the Magnificent*. Florence, Uffizi Gallery.

2. KINGS
WITHOUT A CROWN

"I bequeath you glory."

from the will of
GIOVANNI DI BICCI DÉ MEDICI

THE RISE OF THE MEDICI DYNASTY

No claim to aristocratic origins was ever made by the members of the powerful family whose name came to dominate the greatest and most dramatic pages of Tuscan history. Of good country stock, the early Medici were farmers in the fertile area of Mugello. Perhaps their original, or acquired, family name was due to one of their ancestors who practiced the trade of pharmacy. (According to many, the spheres or balls that are heralded in their coat of arms are nothing but pills.)

Yet the man whom the family regarded as the founder of its fortune was a banker and merchant. Giovanni, the son of Averardo di Bicci, emerged as a leader at the beginning of the fifteenth century. He was an able manager with a keen political sense, quick to understand the changes taking place in the old medieval structures of the Commune. The medieval democratic system of ruling was collapsing, undermined by the conflicts between the parties vying for leadership. Florence was still nominally a republic, founded on the consensus of its people, as its government was entrusted to worthy citizens freely elected by the people; but the ascending "nobility of wealth" was getting hold of the reins of the government. The influence of the rich families grew alongside the intensification of popular dissent. The stage was being readied for the advent of strong leaders, capable of putting both their economic means and the network of their clients and supporters at work to seize control of the palace, the city's power center.

In 1421, Giovanni di Bicci was elected Gonfalonier of Justice (bearer of the Gonfalone, the city standard, hence its chief magistrate). Giovanni di Bicci amassed wealth not only through the commercial enterprises of his bank and shops, but also by the securing for his family of the management of the Communal taxes. He did not hesitate to risk his family riches in order to counteract the fierce and wily opposition mounted against the Medici by the rival family of the Albizzi. He overcame a number of crises,

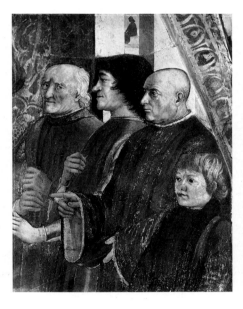

Domenico Ghirlandaio. *Confirmation of the Franciscan Rule*, detail showing Lorenzo the Magnificent and three members of the Sassetti family. Florence, Church of Santa Trinita.

lost much but recovered most of it, and even increased his reserves. Unswerving and inclined to treat the affairs of state like those of his own family, Giovanni was prodigal with his money in helping public causes, be it funds needed to combat a plague epidemic, to succor a poor convent of nuns, or to complete the works for a new building. He originated what would become a distinctive Medici tradition: the sponsorship of schools and artists. He commissioned the architect Filippo Brunelleschi to study and plan for the new basilica of San Lorenzo, very much against the advice of the chapter that presided over the placement of public works. He helped the young Tommaso Guidi, better known as Masaccio, a painter who eventually established himself (though he lived to be only twenty-seven) as one of the truly great masters of the Renaissance.

Giovanni was naturally generous, a quality that the Florentines, always wary of hypocrisy, learned to appreciate. He died, in the sixty-ninth year of his life, blessed with the title "Father of the poor." Without any trace of self-aggrandizement Giovanni confided to his heirs that, throughout his busy and often conflict-ridden existence, he had "never brought offense to anyone, but rather helped as many as possible." His sons, Lorenzo and Cosimo, became the leaders of the two branches of the family tree.

His true heir was Cosimo, called the Elder, the genius of the family, born with the intuition of the skilled politician, acquainted with the instability of human fortunes and the mutability of human character. After his father died, Cosimo realized that he had to move fast and consolidate his

The Medici coat of arms, detail of the floor from the Chapel of the Princes, Florence.

THE LILIES OF FRANCE FOR THE MEDICI COAT OF ARMS

When the Medici began to entrust the family name to a coat of arms, they chose as an emblem eleven red balls on a field of gold. Giovanni di Bicci reduced the number to eight; Cosimo to seven. In 1465, as a token of royal appreciation for an embassy to the court of France, well conducted by Piero the Gouty, King Louis XI granted the Medici the right to insert the three golden lilies of France in their blazon. As a consequence of this grand concession by the powerful sovereign, the ball atop the Medici shield became blue with the fleur-de-lis inscribed in it.

The Magnificent Lorenzo made one more change in the family's coat of arms, bringing the number of balls down to six. In accordance with the heraldic tradition that gave members of the great families the right to have a personal motto, Lorenzo adopted one word, emblematic of his faith in the fortune of his family and his determination to defend and increase it: *Semper*, always.

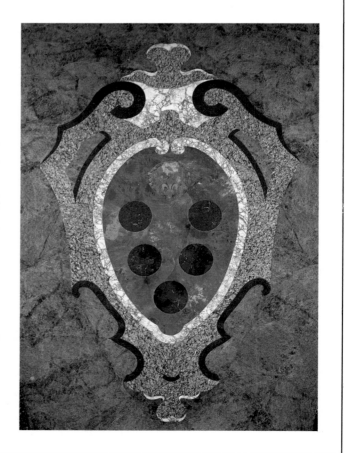

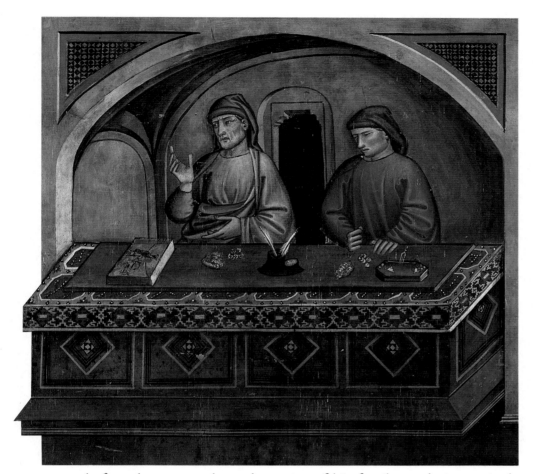

Niccolò di Pietro Gerini. *Story of the Life of Saint Matthew*, detail of bankers. Prato, Church of San Francesco.

power before the ever-restless adversaries of his family, made increasingly jealous by the Medicis' continuing rise, could organize more threatening counteractions.

Indeed, his rivals were not idle. Sensing that Cosimo, whose very countenance, with deep-set eyes and a profile worthy of a Roman emperor, suggested a will of iron, was closer and closer to seizing the absolute lordship of Florence, they moved to the attack, guided by the Albizzi. In 1433, with the connivance of Gonfalonier Guadagni, Cosimo was charged with conspiring against the free institutions of the Commune and sent to jail. He quickly assessed his precarious situation; he would either be sentenced to death or poisoned while being detained in the damp darkness of a palace cell.

Cosimo resorted to the least fallible of the weapons at his disposal. He ordered his administrator to release one thousand gold florins into the Gonfalonier's hands. A similar, discreet distribution of princely gifts induced his many enemies to better reasoning.

The Albizzi and their anti-Medici coalition had to contend with Cosimo's being condemned merely to exile, which he spent in Venetian and Paduan comfort. Barely one year elapsed before the Medici leader was back in Florence. His revenge proved pitiless and fast. His rivals were imprisoned or exiled. Whoever among them occupied a public office was excluded from it. Rinaldo degli Albizzi, his arch-enemy, left Florence in disgrace. From his exile he sent an insolent message to Cosimo: "Beware.

OPPOSITE:
Pontormo. Portrait of Cosimo
the Elder. Florence, Uffizi Gallery.

We are not sleeping." The Medici retaliated: "I am well aware of it since I am the one who deprived you of sleep."

Cosimo proceeded with intelligent caution, apparently respectful of the Communal institutions. Slowly but firmly, he began moving his pawns on the chessboard of Florentine politics: little by little his supporters were appointed to the main positions of power.

He did not care to claim any official title for his de facto rule. With his dedicated ability and experience, he widened the sphere of influence of his bank by setting up branches in Bruges, Geneva, Avignon, London, Pisa, Rome, Venice and Milan. His Florentine wool shops thrived. He lent huge amounts of money to influential people, including the king of England. When a humble monk approached him to solicit financial help for his order, Cosimo, a "reader of men," granted the request immediately. Years later this gesture would prove providential when the monk, Tommaso Parentucelli, was elected to the papal throne under the name of Nicholas V. One of his first pontifical decisions was to appoint the Medici family "bankers of the Holy See."

These were the years of conflict between the bishops of Rome and Constantinople; the Catholic Church was split in two: the Occidental and the Oriental. Cosimo succeeded in attracting to Florence the council that was being convened to resolve the controversy. Although the council did not achieve the results everyone expected, Florence enjoyed days of glorious recognition as one of Europe's capitals where history was being made. Splendid shows, parades and processions marked the event.

Cosimo enriched the city with churches and other monuments; the great architect Michelozzo was called to erect the majestic Medici palace on Via Larga (the Broadway of Florence). He sponsored writers, sculptors, painters and architects, among them Ghiberti, Donatello, Filippo Lippi, Leon Battista Alberti, Brunelleschi and Michelozzo. He did not neglect farmers; under his inspired rule, agriculture was favored and the navigation on the Arno was greatly increased to promote trading.

Ultimately, Cosimo raised the Medici insignia so high that it became one and the same with the symbol of Florence. Inside three centuries, the farmers turned merchants, bankers and politicians had come to rank with dukes, kings and emperors.

Praised for his tireless efforts to maintain peace in Italy, Cosimo died in 1464, survived by his legitimate sons, Piero the Gouty and Filippo, who would become archbishop of Pisa, and a natural son, Carlo, also destined for an ecclesiastical career. On Cosimo's tomb, in the church of San Lorenzo, by will of the Commune, the inscription "Father of the country" paid lasting tribute to his life and work.

Piero, who inherited his father's leadership, was plagued by the gout that afflicted his limbs. However, if he did not possess the indefatigability of his great father, he had learned enough from him to display a basic amount of political competence.

Opposition, hidden as well as patent, flared up again. Luca Pitti, the head of another influential family hostile to the Medici, instigated a plot to ambush Piero on his way back to his villa at Careggi, not far from

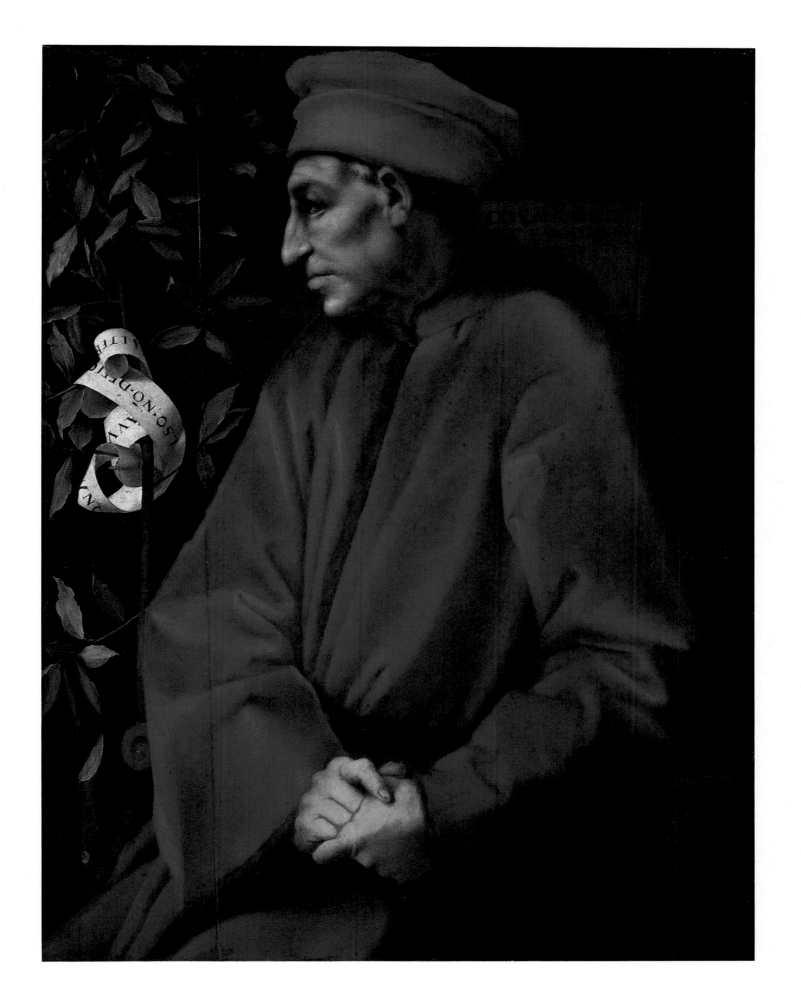

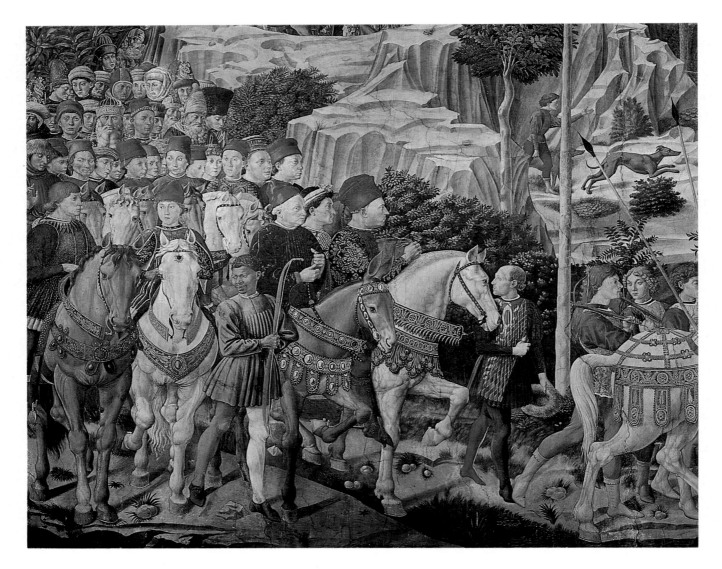

Benozzo Gozzoli. *Procession of the Three Magi*, detail showing Cosimo the Elder and Piero the Gouty (on the white horse). Florence, Palace of the Medici-Riccardi.

Florence. Only the promptness of his son Lorenzo saved him from being assassinated. Popular reaction was overwhelmingly favorable to Piero; a parliament was summoned and he was proclaimed ruler of Florence for a full decade. Piero died in 1469, amidst a general mourning. He left the dynasty fortunes and the ruling authority to his sons, Lorenzo and Giuliano.

LORENZO THE MAGNIFICENT

He came to life under a good star. When Lorenzo was born to Piero de' Medici and the refined Lucretia Tornabuoni, celebrations were held to mark the occasion. Artists were called upon to illustrate the historic event. Francesco Banchi dedicated a painting, aptly entitled *Triumph of Fame*, to the newborn.

As a child, Lorenzo was tutored by the best humanist teachers of the fifteenth century. He was instructed in the seven liberal arts: the *trivium* (grammar, logic and rhetoric) and the *quadrivium* (arithmetic, music, geometry and astrology). He was soon well versed in the languages of classical times, Greek and Latin, and in theology and geography. He learned from participating in erudite conversations with philosophers like Marsilio Ficino

and Pico della Mirandola, and poets like Girolamo Benivieni and Agnolo Poliziano.

Not handsome, he was of average stature, lean and dark-skinned, his strong beak of a nose overshadowing his other facial features and even affecting the tone of his voice. Yet Lorenzo easily won the attention of men and the admiration of women.

He practiced poetry, revealing a precocious talent in his well-cadenced verses, and dedicated amorous poems to the lovable Lucrezia Donati, a Florentine beauty, who sat on her throne as the queen of a tournament staged in the square of Santa Croce. The young Medici champion took part in the knightly contest, wearing an armor resplendent with jewels and riding a horse adorned with an array of pearls. As prescribed by the tournament ritual, Lorenzo carried a banner on which a verdant laurel branch sprang out from a dry trunk and a legend proclaimed *Le temps revient* (time returns). The world's spring was reborn with the leader of the new Medici generation; the laurel was a clear symbol of himself, the sapling of the Medici tree.

To a hasty observer, this Florence of chivalrous contests seemed immersed in the medieval mist that lingered even as the fifteenth century drew to an end. In reality, though, Lorenzo de' Medici heralded the dawn of an era in which new values were vigorously asserted and new vistas opened to the citizens of a new Europe. Lorenzo abandoned war and military menaces as necessary tools of power, in favor of negotiated agreements.

He had an extraordinary diplomatic talent, and an equally outstanding charisma in dealing with the potentates involved in Florentine foreign policy. With a masterful stroke of diplomacy, he sought the alliance of one of the most influential Roman families by marrying Clarice Orsini, a decision that cost him dearly. He had to sacrifice his love for erotic escapades and give up his relationship with the most fair Lucrezia Donati.

Clarice, his bride, was far from being beautiful. His mother had gone to Rome to cast a glance at her before the wedding and described her as being very "graceful," quickly adding, "but not as pretty as Bianca, Clarice and Lucrezia," the girls of the Medici family. But Clarice proved to be a good mother to their six children: Piero (called the Unfortunate), Lucrezia, Maddalena, Giovanni (the future Pope Leo X), Contessina (who eventually married Piero Ridolfi), and Giuliano II (who inherited the name of his paternal uncle).

Lorenzo altered the government. During the first part of the fifteenth century, Florence was governed by a political system still faithful to the model created in Communal times. Its components were a Council of the Commune made up of 250 members, a Council of the People with 300 members and an equally popular Assembly, whose role and function were considered of primary importance. With the century drawing further away from medieval times, the Commune evolved into a Signory. Ruling power was entrusted to eight members called Priors, who remained in power only two months. They were voted into office only by the citizens who paid their taxes regularly and belonged to the Corporations, or associations, of craftsmen and merchants. Upon consultation with the Corporations, the

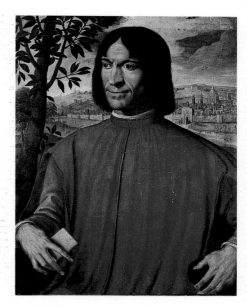

Florentine School (sixteenth century). Portrait of Lorenzo the Magnificent. Florence, Medici Palace.

"In Lorenzo's life you will not find a brave defense of a city, a notable taking by storm of a stronghold, nor a stratagem in a war and the vanquishing of hostile armies; his achievements do not shine with the blaze from battles; but you will find in him all the signs and hints of the virtues that can be considered and attributed to a civilized life."

FRANCESCO GUICCIARDINI

THE ONE WITHOUT EQUAL

Tournaments, very popular in the Middle Ages, were still held in great favor in Renaissance times. Lorenzo's brother, Giuliano, was the champion of a famous one, organized on January 28, 1475, in the square of Santa Croce, to commemorate the "holy alliance" with Venice to oppose the Turkish threat. The great sculptor Verrocchio designed Giuliano's bronze helmet, chis-eled in silver and gold, at a cost of 8,000 florins. On his banner, Athena embraced Eros, who leaned against an olive tree. The legend, mysterious to the foreign envoys who attended the tournament but eloquent to the Florentines, read in archaic French *La Sans Par*. Everybody in Florence knew that the "One Without Equal" was the beautiful Simonetta Vespucci, a niece of the

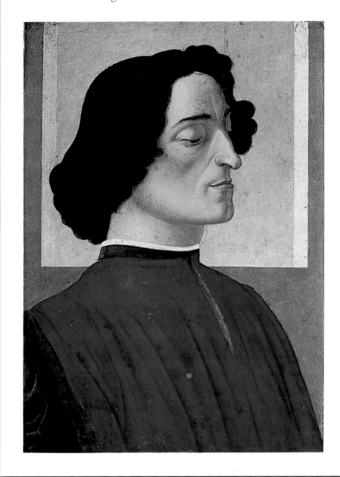

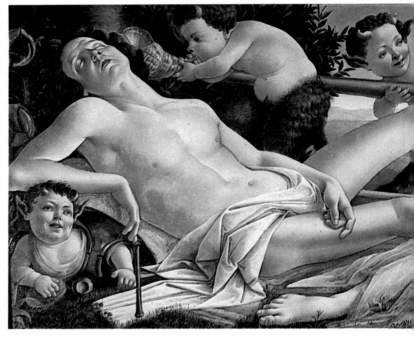

ABOVE:

Sandro Botticelli. *Venus and Mars*. London, National Gallery.

LEFT:

Sandro Botticelli. *Giuliano de' Medici*. Bergamo, Carrara Academy of Fine Arts.

Priors, in their turn, elected the chief magistrate, or Gonfalonier of Justice.

His political interests did not prevent Lorenzo from attending to the cultural development of the Florentine republic. He sponsored its most promising artists and collected books (still a luxury in his time) to endow the libraries of eminent teachers. Lorenzo spent time in the company of his *maestro di cappella*, Arrigo Isaac, and artists like Benozzo Gozzoli, Sandro Botticelli, Leon Battista Alberti, Andrea del Verrocchio, Giuliano da Sangallo (who built the splendid villa at Poggio a Caiano) and Domenico Ghirlandaio (who portrayed him, his family and courtiers).

With no less attention, Lorenzo concentrated on weaving a network of friends and allies, strengthening old ties, securing new ones. The ambassadors of Italian and other European states were favored guests under his roof. Though the Medici wealth certainly provided a solid foundation

merchant-navigator, married but desperately and platonically loved by Lorenzo's younger brother.

Botticelli used Giuliano and his beloved Simonetta Vespucci as ideal models for his mythological paintings.

Theirs was a story that moved the whole city to tears when Simonetta's death by consumption brought the relationship to a pathetic end. She was so fair, even after having succumbed to her sickness, that she was carried to her burial place with her face uncovered, to allow her fellow-citizens to cast a last glance at the young woman admired as a faithful wife and, at the same time, as the object of a supreme love.

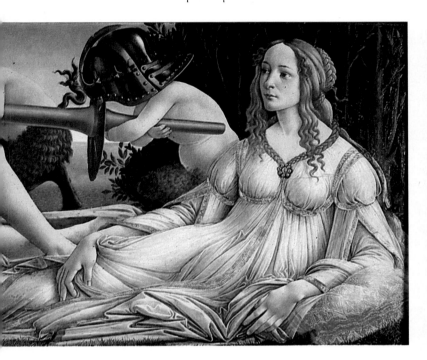

RIGHT:
Sandro Botticelli. *The Beautiful Simonetta*. Florence, Pitti Palace, Palatina Gallery.

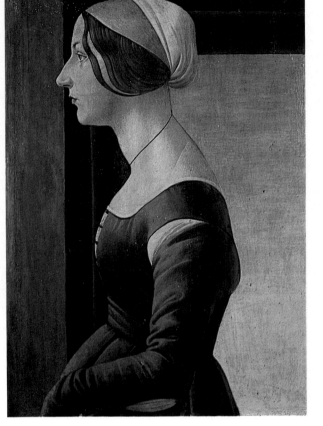

for his activities, intelligence was the currency that won the friendship of the rulers who were in daily contact with His Magnificence and the center of culture he was shaping in Florence. The innovative style that Lorenzo imposed on international relations was the secret of his success as the architect of progress, the ripples of which extended from Florence to distant shores, from Lorenzo's time even to today.

DAGGERS IN THE CATHEDRAL

In accordance with what seemed a traditional event in every Medici generation, in the ninth year of Lorenzo's rule the Pazzi family (bankers themselves) conspired with several antagonists of the Medici. They secured the secret blessing of the della Rovere Pope Sixtus IV (the builder of the

Leonardo da Vinci. The Hanging of Baroncelli, murderer of Giuliano de' Medici in the Pazzi conspiracy. Bayonne, Musée Bonnat.

Sistine Chapel), who revoked the appointment made by Nicholas V of the Medici as the Vatican bankers, and the help of his nephew Girolamo Riario, the Siena republic and the king of Naples, Ferrante of Aragon.

The Pazzi orchestrated a well-structured plot to have both Lorenzo and Giuliano killed and the members of the government, mostly Medici appointees, arrested and exiled. The secret plan was set for Sunday, April 26, 1478, when Lorenzo and Giuliano were expected to attend the solemn mass celebrated in the cathedral of Santa Maria del Fiore. At the elevation of the host, Lorenzo and Giuliano were assaulted by the plotters with daggers drawn. The fair Giuliano fell in a pool of blood. Lorenzo, his cloak wrapped around his arm, fended off the attackers' blows. He was only slightly wounded and managed to escape through the sacristy.

The sheer horror of the criminal action shocked the people and the conspirators' attempt to occupy the palace of the Signory failed miserably. Waves of enraged citizens ran through the city, excited by the cry of *"Palle! Palle!"* being shouted by the partisans of the Medici.

Escorted by bodyguards whenever he walked in the streets, Lorenzo reacted to the tragedy by calling for an equally bloody exercise of justice. The repression against the Pazzi was terrible. The leaders and participants in the conspiracy were seized and brutally executed, their corpses mutilated and denied Christian burial.

In a subsequent series of consummate diplomatic actions, Lorenzo induced the pope to come to terms and made peace with the Aragon king, whom he impressed by going alone to deal with him in his court at Naples. It was a daring act in which Lorenzo demonstrated both courage and a deep conviction that he had the ability to turn an enemy into a reliable friend. In fact, the aftermath of the conspiracy aided Lorenzo in his effort to reaffirm his right, sealed by popular approval, to rule his city.

But he was greatly grieved by the loss of Giuliano. As Thucydides wrote about Pericles' lamenting of the death of the Athenian youth, Florence felt that "spring seemed to leave the year."

Giuliano, unmarried, left a son, born from his love relationship with a middle-class woman, Antonia Gorini. The child, christened Giulio, was put by Lorenzo under his personal protection, to be raised in the Medici household with the Magnificent's own children.

Guiliano's death wrought a deep transformation in Lorenzo that, in turn, affected the cause of freedom and the political stability of the Republic. While still appearing as the defender of justice, Lorenzo made changes in the governmental machine that reflected his fear for the survival of the Medici rule and a growing perception of public dissatisfaction. In 1480, Lorenzo created a new ruling body, the Council of Seventy, to replace the ampler and more democratic Council of the People. The members of the Council of Seventy were mandated to elect the Eight of Practice, magistrates charged with the defense of the state, and the Eight Procurators, who presided over financial affairs.

Behind the semblance of a fair representation of the people, the Council of Seventy was, in practice, a private advisory board for the Prince (the new title for the Medici ruler, instead of the Communal *Signore*).

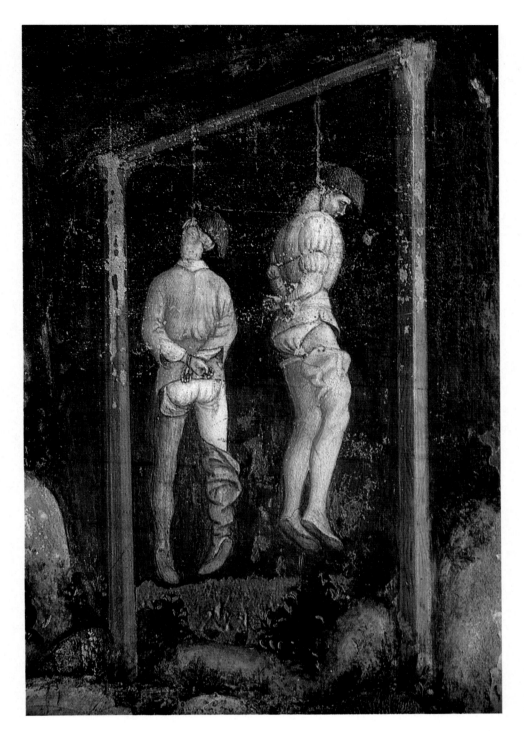

Pisanello. *Saint George and the Princess* (detail). Verona, Church of Sant' Anastasia.

Holding power for a period of five years, the Council elected the Signory, the group of eight Priors (called *Signori*, lords), a vestige of more democratic days but now limited to the mere function of carrying out the Prince's orders. With the Medici family, the ruling system shifted from absolute democracy to a more limited application of it.

And then a cold wind of reform was set in motion with the arrival in Florence of a Dominican friar named Girolamo Savonarola, who called himself the Hammer of God. The sounds of the serenades, the spring festivals with their dances and amorous contests, hardly hid the mounting roar of the storm that packed violence with every new sermon the inspired Savonarola delivered from his pulpit.

35

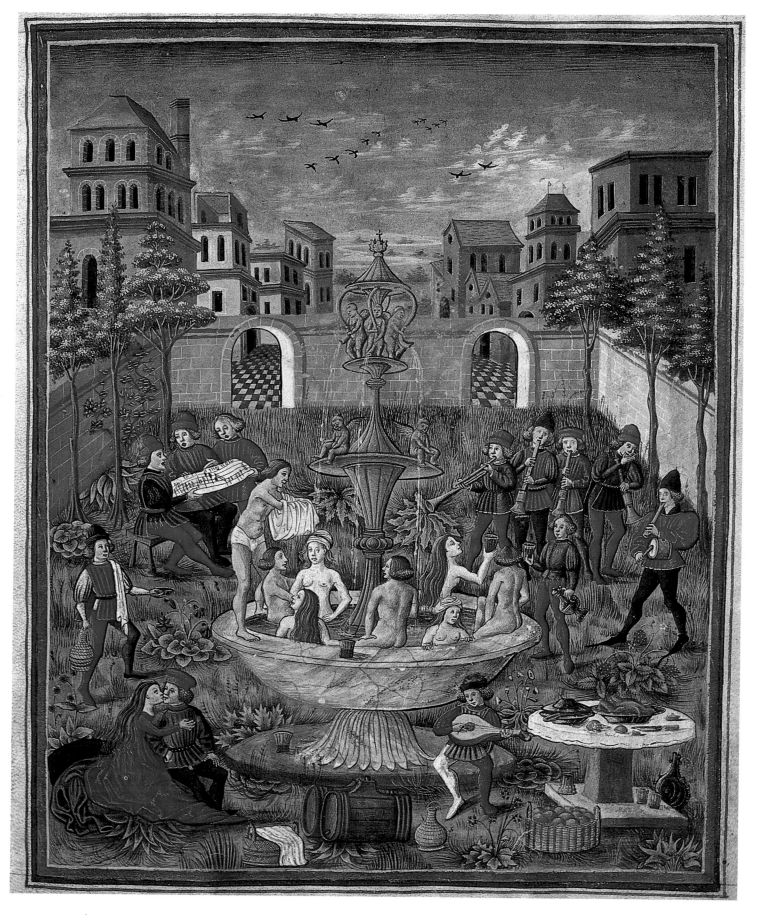

The Garden of Love. Modena, Estense Library.

3.
THE HAMMER
OF GOD

"I appeal to Him who chooses the weak of this world to confound the roaring lions of wickedness."

GIROLAMO SAVONAROLA

The Dominican friar Girolamo Savonarola (born in Ferrara in 1452) was transferred from his native city to the convent of San Marco in Florence in 1482, while the city basked in the glorious light, governed by the Magnificent Lorenzo's iron hand in a velvet glove. The nephew of a bishop who had converted to religious life after the sad conclusion of a love affair, Savonarola was preceded by the fame of his moving sermons. At first, Lorenzo the Magnificent, whose garden was near the convent, welcomed the new preacher to Florence. Surely, a great orator could only add to the prestige of his "new Athens."

Savonarola had olive-colored skin, burning eyes and a gaunt face with a profile that boasted a hooked nose. His eloquence was aided by a sonorous, seductive voice and his speeches were graced with a thorough knowledge of the Bible and its most charismatic pages. The courage with which he reproached the powerful was already bordering on the legendary. His oratorical blasting of the arrogance and corruption of the Bentivoglio, rulers

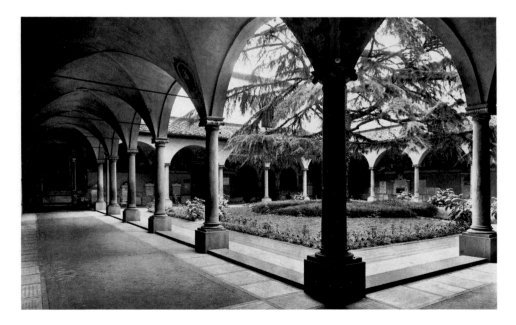

The cloister of the Church of San Marco, Florence.

SHADOWS ON THE THRONE OF PETER

Jesus Christ himself could not have put a heavier stress on the extent of the weakness of human nature and of his divine tolerance when he chose Peter, certainly not the bravest or the wisest among his apostles, as the leader of his community on earth. Undoubtedly, by the end of the fifteenth century, the Lord's patience was being severely tried as this particular time in the history of the papacy became known for the increased use of "temporal power" in the pursuit of political ambitions.

With perhaps an acute sense of timing, it was at this moment that Girolamo Savonarola arrived on the scene. The precursor of Martin Luther and as fanatical in his verbal excesses as he was sincere in his faith in the God-given mission of the Church, Savonarola lashed out at those like Giovanni Battista Cibo, who accused him of betraying his apostolic mandate and forecasting divine punishment.

Cibo succeeded Pope Sixtus IV on August 29, 1484, and became Pope Innocent VIII. He excommunicated and deposed Ferrante, king of Naples, for his refusal to pay the papal dues and gave his kingdom to Charles VIII of France. (Later, in 1492, Ferrante was restored to the pope's favor.) In 1486, Innocent declared Henry VII to be the lawful king of England by the "threefold right of inheritance, conquest, and popular choice," and gave his seal of approval to his marriage to Elizabeth, the daughter of Edward IV.

Innocent VIII developed a fiery hatred for heresy and was known for having, among other acts, condemned the reading of books by Pico della Mirandola, a member of the Medici court and friend of the Magnificent Lorenzo; invoked the intervention of all European Catholics to extirpate the Waldenses heresy; and appointed the infamous Torquemada to head the Inquisition in Spain, which led to the end of the Moslem presence in Spain when Ferdinand II of Aragon took Granada in January 1492.

Innocent's private life, however, did not command the respect of the Roman population. In particular, his nepotism — culminating in the pontifical gift of several towns in the Church territories to his son — brought about a high increase in courtly corruption. Nor could people easily overlook the fact that the pontiff, who had at least a son and a daughter before ascending to the papal throne, was certainly not a champion of chaste prudence. An epigram addressing this particular weakness in his nature circulated in Rome: *octo nocens pueros genuit, totidiemque puellas* (he guiltily generated eight boys, and as many girls).

In what appeared to be yet another in a series of fateful events in the year 1492, Innocent died, unmourned, on July 25. The story of the election of the man who succeeded him added more impetus to Savonarola's denunciation of the decadence that had come to afflict the Roman Curia.

Church historians are unanimous in judging this episode a scandal. Ascanio Sforza, one of the most influential cardinals at the time, decided to support Rodrigo Borgia, a Spaniard from Valencia who, after a disorderly youth, had obtained a degree in canon law at the University of Bologna and thereby moved quickly up the ladder of ecclesiastical honors. Sforza's intention was to block the accession to the papacy of Cardinal Giuliano della Rovere (who would achieve his place as Pope Julius II eleven years later).

In return, Borgia promised to compensate Sforza generously. At the same time, he orchestrated a campaign to buy votes: land and privileges were allocated without scruple. Even his direct rival, Cardinal della Rovere, was offered bribes that went from the promised assignment of the fortress of Ronciglione — a strategic stronghold situated between the northern regions and Rome — to the legation of Avignon in France.

Following only three votes — taken from August 6 to 11, 1492 — the shameless market for the papal crown ended with Rodrigo Borgia enthroned as Pope Alexander VI. Cardinal della Rovere, emerging from the conclave in the company of the young Cardinal Giovanni de' Medici, whispered to him: "We had better flee. The wolf has arrived who will devour all of us."

Once elected, Borgia kept his promise and appointed Sforza vice chancellor of the Church and bishop of Erlau, one of the richest properties of the Vatican. He also received as a gracious donation the Borgia palace in Rome and the feudal land of Nepi. Several other gifts, including many cardinal's hats, were dispensed to other participants in the conclave.

The Vatican palaces had seen manifestations of unholy behavior before, but never, at any time, had there been the effrontery, the absolute lack of all discretion with which the Borgia pope abandoned himself to the cultivation of his already well-known vices. Once again, nepotism was rampant. Borgia's four children — Juan, duke of Gandia, Cesare, the fair Lucrezia, and Joffré — ruled with their father over a dissolute court. To the implacable Savonarola, the Borgia pope was a threat to Christian faith. In his attempt to oppose the spread of the scandal caused by Borgia, he thought of summoning a council like the ones held between 1414 and 1431 at Costanza and Basel, from which a decision could result to depose the pontiff and restore spiritual dignity to the Church and order in Christendom.

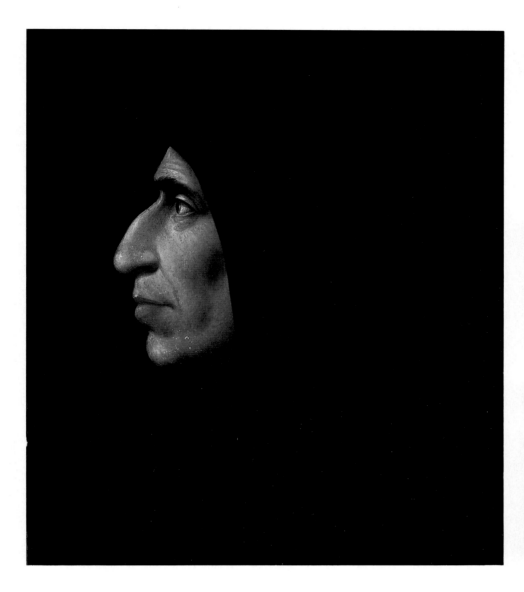

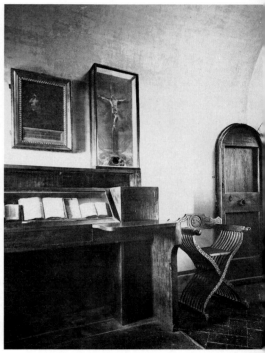

Fra Bartolommeo. Portrait of Girolamo Savonarola. Florence, Church of San Marco.

The cell of Brother Girolamo Savonarola. Florence, Museum of San Marco.

of Bologna, had echoed far beyond that city. Savonarola differed from the other popular preachers of his time (among them the much-admired Friar Mariano from Genazzano) for his erudite yet down-to-earth language and his disinclination to theatricality. He preferred *il parlar volgare* (the vernacular) to the Latin quotations with which most of his colleagues liked to impress their worldly audiences. "Tell me," he rhetorically asked his listeners, "are we to preach Jesus Christ or Horace?"

In the beginning, the congregations that filled first San Marco, then San Lorenzo and the cathedral of Florence, were mainly composed of pious old women from the lower class. Soon his followers grew to include representatives of the middle and higher classes; young people mingled in ever larger numbers. Members of Lorenzo's retinue of close friends appeared in the crowd that each sermon of the friar attracted.

Apparently, Savonarola found himself at home in the serene atmosphere of the convent which Brother Giovanni da Fiesole, the blessed Fra Angelico, had decorated with his beatific frescoes, visual delights and constant sources of deep spiritual inspiration. But Savonarola soon demonstrated his dislike for the "paganization" of the city as it was expressed by

*"Here they turn chalices into helmets
 and swords,
And they sell Christ's blood by the pint,
And patience falls even from Christ . . ."*

MICHELANGELO

39

the dominance of mythological themes in poetry, painting, drama and music sponsored by Lorenzo, and by the "moral decadence that artists reveal when they do not hesitate to use *courtesans* or lowlier prostitutes as models for their holy subjects in their works."

In the stern judgment of the friar, fashion reflected the decline in public morality: women's dresses revealed more than they were supposed to hide. The love for jewels, other ornaments and cosmetics indicated that attention to physical appearance was prevailing over concern for spiritual matters. Botticelli's suave *Birth of Venus*, where nudity celebrated a bold triumph, and *Spring*, where the bodies barely tolerated the airy veils that exalted their forms rather than covered them, were but mirrors of the sinful inclination of the Florentines, male and female alike. For, to his credit, Savonarola was clear on one thing: to him, men and women were one and the same, with equal rights and equal obligations in the eyes of their Creator. He chastised women for putting their fairness of limbs at the devil's service by using their natural gifts to lure men to sin. But with equal firmness, he threw his words, heavy as stones, against the men who defied the sanctity of their families to gratify their baser instincts, "indulging in violence, favoring prostitution, drunkenness," thus debasing their God-inspired impulse to love.

A great ideological chasm separated Savonarola and Lorenzo, now the two great protagonists of the public life of Florence. Lorenzo was the champion of the individualism of the Renaissance, of humankind restored to its role of predominance at the very center of creation. Lorenzo's "new man" sought a paradise, but not beyond the confines of human life, as Christ taught. The goods and pleasures of this world were his immediate goal, the here and now. Eternity was valued less than the fleeting moment. Religion was still alive, yet it bordered more on superstitious practice than on a fully accepted dependence on God's grace.

Savonarola had no doubts about the presence of the serpent in the Garden of Eden brought back by the Magnificent. He believed the cult of beauty had supplanted the cult of truth and moral virtue. The splendid ghosts of the Muses and pagan deities obfuscated the true light of the Holy Spirit. Discharging his lightnings, Savonarola spread veritable terror among his stunned listeners; they left his church with images of eternal fire and torments flashing in their minds. The friar, at odds with his fellow-clergymen and the pope himself, revealed that he had visions. "I saw a sword in the sky, and on its blade was written: The sword of God's wrath is about to descend on earth, swiftly and soon."

Yet his popularity among the people flourished. A medal was coined to commemorate his supernatural vision. His sermons were transcribed by faithful followers and rapidly circulated in the streets, the squares, the palaces and the humbler dwellings of the city. Women's fashions were soon affected; dresses and headgear became more chastened; jewels were discarded. A new party, avowedly opposed to the Medici faction, stepped into action. Its members were called *Piagnoni*, the weepers, and their name told of the mission entrusted to them by their leader: to "weep over the evils of the new pagan age." The Piagnoni were the result of the transformation

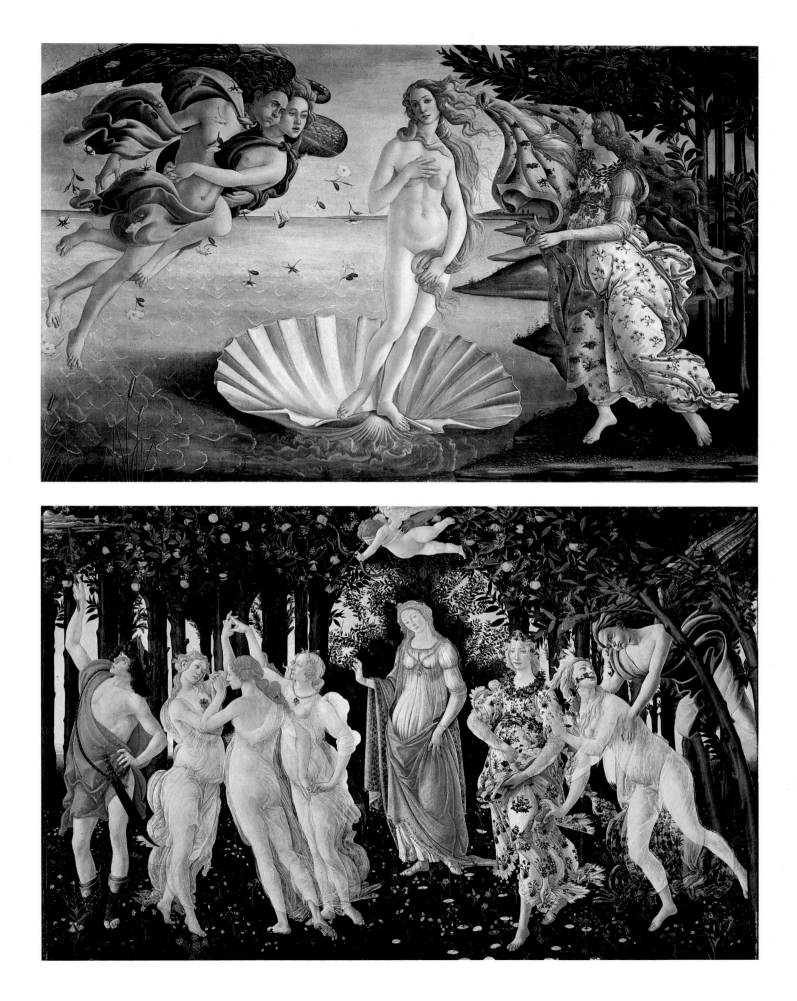

induced by the Dominican preacher in a large segment of the Florentine population: from citizens sharing the balmy atmosphere of a terrestrial paradise to fanatic supporters of a penitential tide that one day would ebb, carrying off the ashes of sin, the mirth of a season without parallel.

Lorenzo tried to come to terms with him, but Savonarola always refused to meet him, notwithstanding the proximity of his convent to the garden that the Medici prince normally frequented.

Only a short time passed before the first storm erupted. At Lent, Brother Girolamo Savonarola delivered a sermon in the church of Or San Michele, a cherished shrine for the people of Florence. His tone was angry, his words more biting than ever before, amounting to an open declaration of war. The opposite factions in the city clashed with unprecedented violence. The very texture of the democratic fabric was lacerated.

A year later, in 1484, as he preached in San Lorenzo, the parish church of the Medici family, he flared up anew, with unprecedented passion. He stressed his conviction that Lorenzo and his court of pleasure-seekers were responsible for the moral decadence of the city. He delivered a scathing attack against public permissiveness, the nefarious example given by the clergy, placing the blame for all the evil that had befallen Florence, and the inevitable divine retaliation, on the shoulders of the wealthy middle class that wallowed in the revelries promoted by the Magnificent Lorenzo. In 1487, another passionate and relentless volley of scalding accusations convinced Lorenzo that Florence had had enough of the turbulent friar. For two years in a row, he was sent to Siena to preach for Lent. Savonarola spent his exile, from 1488 through July 1490, in Lombardy. His Advent preaching in Brescia was hailed as a triumph of religious oratory.

Heeding the advice of his friend and Savonarola's admirer, Agnolo Poliziano, Lorenzo recalled the Dominican preacher to Florence, where he was soon elected prior of the San Marco convent. On August 1, Savonarola held his first sermon since his exile and the church of San Marco overflowed with the faithful. He talked about the threat of the plague's returning to the Tuscan region, the rumors of an impending invasion against Florence, and the crisis of the Medici banks. (A year later, Lorenzo would be compelled to devalue the florin.) All of these events gave credence to Savonarola's dire prophecies.

The Hammer of God found an ally in one of his Dominican brothers, a certain Silvestro Maruffi, who was a strange combination of simpleton and inspired fanatic. Savonarola allowed the somnambulant Maruffi to wake him in the middle of the night to tell him about his visions, to pummel him as a little child would do with a parent, in the excitement of delivering his revelations. Savonarola believed the younger friar was the bearer of divine messages, a naive proclaimer of powerful prophetic truths.

More and more Florentines flocked to fill the churches where the inflamed Savonarola spoke. Among them was the seventeen-year-old Michelangelo Buonarroti, a striking gem in Lorenzo's private collection of geniuses-in-the-making.

4.
MICHELANGELO
THE STONECUTTER

GENIUS IN THE MAKING

Born in the town of Caprese, in the Arezzo province, Michelangelo was the second son of Ludovico Buonarroti, citizen of Florence. The proud father duly annotated in his diary: "I remember that today March 6, 1475, a male child was born to me, at around four or five in the morning of this Monday, and I gave him the name of Michelangelo, and he was born as I was the mayor of Caprese...."

Ludovico's term in office expired one month after the birth of his son. In April, his wife, Francesca, bundled up her newborn child and followed her husband back to Florence. Her other son, Leonardo, held her hand. Not a strong woman, Francesca found it difficult to care for two infants. So Michelangelo, much to her regret, was entrusted to a wet nurse from Settignano, a village on the hills not far from Fiesole. The wet nurse was the daughter of a stonecutter and wife of a stonecutter.

The local light gray *pietra serena*, "serene stone," employed as prime material in the building of fireplaces, fountains, the facades of houses, in the making of lintels, window frames, thresholds and in paving streets, became familiar to Michelangelo. One day, much later in his life, he confided to his friend and biographer Giorgio Vasari: "If I have anything good in my talent, this has come to me from having been born in the purity of the air of your Arezzo countryside; and also from having received with the milk of my wet nurse, the chisel and hammer with which I make my figures."

But he never forgot his mother. Her image, gentle and frail, the warmth of her lost embrace, haunted the artist, hurting him like an open wound. A line from a poem he wrote gave thanks to the woman who had nourished him in her womb for his inborn artistic gift: "As I was born, for faithful vocation I was given beauty..."

He was only six years old when he was told that his mother, tired of being on earth, had gone to heaven. He could hardly recall her face or the sound of her voice; yet she was imprinted on his heart so deeply that when the time came to portray the mother of all mothers, Mary of Nazareth, he found the ideal model in the indelible filial love guarded in his memory.

Michelangelo was almost totally estranged from his family. He barely knew his stepmother, a soft-spoken, sweet-smiling woman named Lucretia

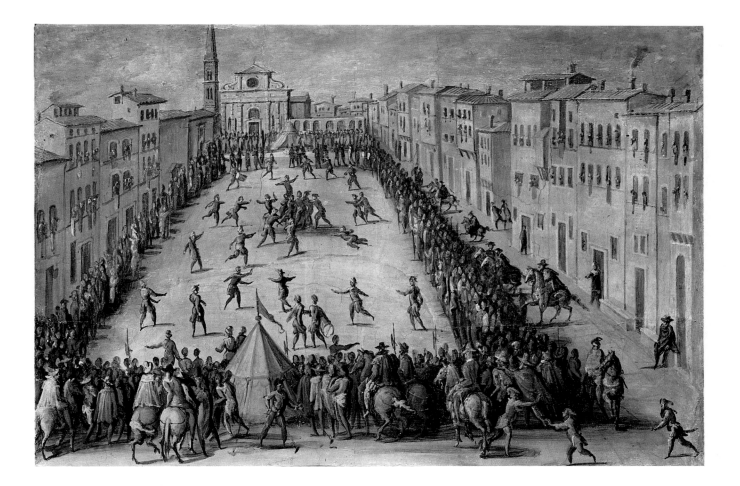

degli Ubaldini, whom his father married mainly to give his children a mother. Even his brothers were foreign to Michelangelo. Leonardo, and those who were born after him, Buonarroto, Giovan Simone and Sigismondo, were raised apart from Michelangelo.

The family was guided by a caring but limited father, incapable of rising above mediocrity and hence tormented by the inability to attain the honor and wealth to which his alleged noble origins seemingly entitled him. Frustrated by his unfulfilled ambition to resurrect the family fortunes, Ludovico hoped that one of his children would be the builder of a new, greater glory for the Buonarroti family. His first-born, Leonardo, disappointed him by choosing to join the Dominican order, as a monk in the convent of San Marco. As for Michelangelo, his fascination with drawing led him away from a career in public office that his proud father believed essential for the achievement of his goal.

Michelangelo's first grammar instructor was the Umbrian humanist Francesco from Urbino, who did little beyond teaching his pupil how to write. The asperities of Latin soon discouraged the boy, who felt an irresistible artistic vocation. His first great friend was Francesco Granacci, a painter and disciple of the celebrated Domenico Ghirlandaio.

Somehow Granacci succeeded in convincing Michelangelo's father to let his son join the workshop of his master. However reluctant, Ludovico signed a contract with Ghirlandaio. "Today the first of April 1488, I Ludovico son of Leonardo Buonarotti, place Michelangelo, my son, at work with

Michelangelo. Drawing of Saint Peter (copy after *Tribute Money* by Masaccio). Munich, Graphische Sammlung.

Domenico painter, for the next three years." Perhaps Ludovico thought that a test as tough as the one that the great painter — busy with a monumental cycle of frescoes for the church of Santa Maria Novella — would impose on Michelangelo was the way to end his thirteen-year-old son's stubborn pursuit of an activity that would certainly lead him to hard labor and final failure.

The work proved to be hard indeed and the pay meager. But Michelangelo held on. Ludovico saw his worst fears confirmed: his son, tired and exploited, his clothes dirtied with paint, was trudging along the wrong road toward the wrong destination.

In turn, his master felt frustrated, but for different reasons. As Michelangelo practiced his coveted craft on the scaffoldings erected in front of the walls of the chapel in Santa Maria Novella, Ghirlandaio was torn between admiration for the extraordinary ability of his pupil and the jealousy he felt for that very gift. One day, as Michelangelo quickly sketched a drawing of the master and all his assistants at work on the scaffoldings, Maestro Domenico exclaimed: "This boy knows more than I do!" Michelangelo dared even more: he corrected some of the preparatory drawings (called cartoons) that Ghirlandaio made to be transferred onto the wall.

Twenty-six months passed before Michelangelo started feeling he had had enough of this learning routine. He tried his hand at copying the works of other artists. He expanded his technique by going from the reproduction of painted originals to drawing from direct observation. He spent hours studying the models obtained from a friend at the market — rotting fish, the stench of which could only be overcome by his desire to learn their anatomy. Then the moment came for Michelangelo to say enough; enough with brushes and paint. He felt the urge to express himself through an art form that attracted him in a compelling, overwhelming way.

Domenico Ghirlandaio. *Apparition of the Angel to Saint Zaccaria in the Temple*, detail showing Marsilio Ficino, Cristoforo Landino, Agnolo Poliziano, Gentile de' Becchi (humanist friends of Lorenzo the Magnificent). Florence, Santa Maria Novella.

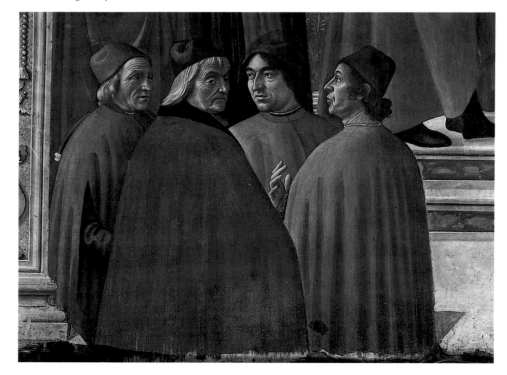

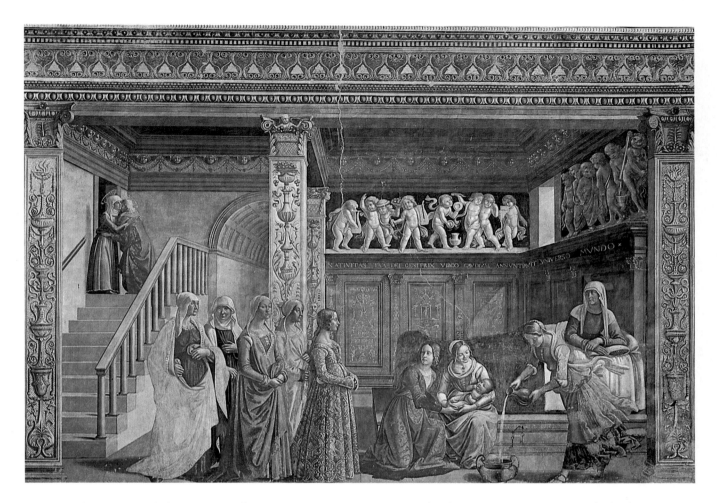

Domenico Ghirlandaio. *The Birth of the Virgin*. Florence, Santa Maria Novella.

As he traversed the streets of Florence, whenever he raised his eyes to the buildings, he saw statues. He was awed by the doors that Ghiberti had sculpted for the baptistry next to Santa Maria del Fiore. His fingers touched the reliefs, ran over the forms that the chisels of Ghiberti, Donatello, Verrocchio and the other champions of sculpture had shaped. They had made bronze lose the rigidity and heaviness of metal and achieve the docility and suppleness of wax, even of living flesh.

Michelangelo must have remembered his days at Settignano, where the *pietra serena* sang under the strokes of his first hammer, and the laughter, the comments of his wet nurse's husband the stonecutter, going from an amused reproach for his naive mistakes to cordial marvel for his learning ability. Shortly after he left the Ghirlandaio workshop, the "voice of stone" came to him from a garden near San Marco. He crossed the gate and stood gaping at the sight of many young people busy sculpting marble under the sharp eyes of a supervisor, a benevolent yet demanding teacher by the name of Bertoldo, son of Giovanni, a mediocre artist who had grown old without achieving any greater recognition than that of being a patient restorer of ancient sculptures.

He was told that Lorenzo de' Medici himself was funding that springtime school, allowing students to make use of precious antique statues as their models. It was the Magnificent's aim to find heirs to the dead masters: Rossellino, Desiderio da Settignano, Duccio, Mino da Fiesole, Luca della Robbia, and Donatello.

47

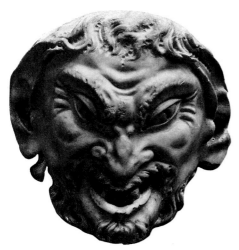

Michelangelo. Mask of a Faun. Florence, Bargello National Museum.

OPPOSITE:
Michelangelo. *Madonna of the Stairs*. Florence, Casa Buonarroti.

Michelangelo was instructed to copy the head of a satyr. The white Carrara marble yielded to his chisel. Under its curly hair, the face took shape, with its pointed ears, the sharp nose, the lips parted in a perfidious smile exposing two rows of perfect teeth. Later, someone told him that the Magnificent himself had remarked, in appraising the work, that the sculptor erred in giving the satyr a full set of teeth. Satyrs are old creatures, the Magnificent had observed, and old people lose their teeth.

Michelangelo took a second look at his sculpture and, with an exact blow of his hammer, knocked off a tooth. The satyr smiled back at him, suddenly made older.

One day, the Magnificent summoned him and his father to the Medici palace on Via Larga and announced his decision to take Michelangelo into his household as his adoptive son, with a monthly allowance to help him pursue his studies. The unexpected honor pleased Ludovico Buonarroti, but did not put to rest his hostility to sculpting. It was a craft that made Michelangelo, when he came home from work, look more like a miller covered with white dust than the son of a man invested with nobility.

But the Medici smile rewarded Michelangelo each time he exhibited his latest work. Pure delight danced in Lorenzo's eyes when he was shown the *Madonna of the Stairs*, where the rectangular marble, treated in bas-relief, acquired the translucence of ivory. The figure of Mary, the mother, turned to exalt her gentle profile, seemed to recede to a secondary position as her strong-limbed child turned toward her breast. Yet she enfolded him in her veil, holding him close with one hand, as if to keep him all to herself as long as the claim of her miraculous maternity lasted. Children were at play on the steps of the stair. The marble was small, yet the genius of the young sculptor magnified its proportions.

In 1491, on the eve of Michelangelo's sixteenth birthday, Agnolo Poliziano suggested the theme for his next work: a mythological subject, in tune with the classical climate of Lorenzo's new Athens. Michelangelo listened to the tale of the battle fought by the Lapithae against the centaurs, a fabulous race of beings half-human, half-equine. They dwelt in Greece, in the region of Thessaly. When their neighbors the Lapithae were holding a feast to celebrate the wedding of their king, Pirithous, to Hippodamia, the centaurs tried to abduct the bride and other young women. In the fierce battle that ensued, the centaurs were defeated and driven from their lairs on Mount Pelion.

The poet's voice quoted musical, yet to Michelangelo unintelligible, sentences from the Greek text of the story, as the young sculptor started to treat the marble slab, only ten inches thick, from which he was supposed to evoke the battle. There all the degrees of relief, from low to middle to high, were applied. Michelangelo juxtaposed the figures in a prodigious play and counterplay of volumes and shapes, with torsions that set the tangle of bodies in motion, once again turning the stiffness of marble into a wonder of pliability.

Those were the days of music and sonorous conversations, in the gardens of the many villas or by the fireplace in any of the innumerable rooms of the palace. Lorenzo's daughter Contessina, three years Michelan-

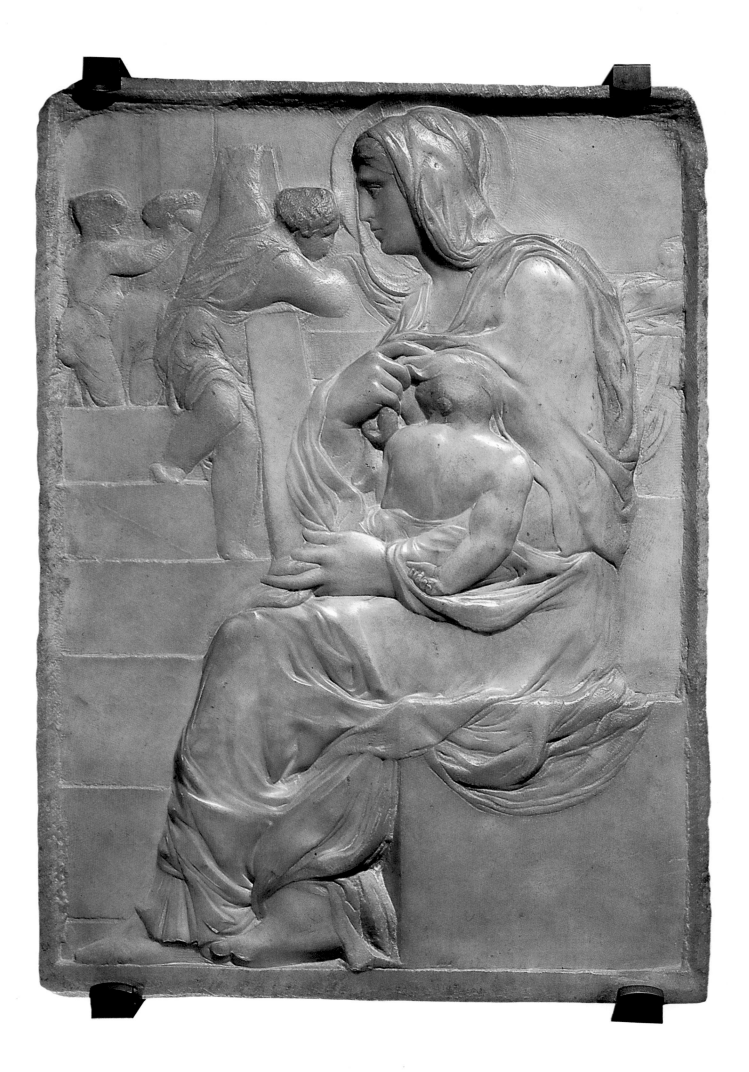

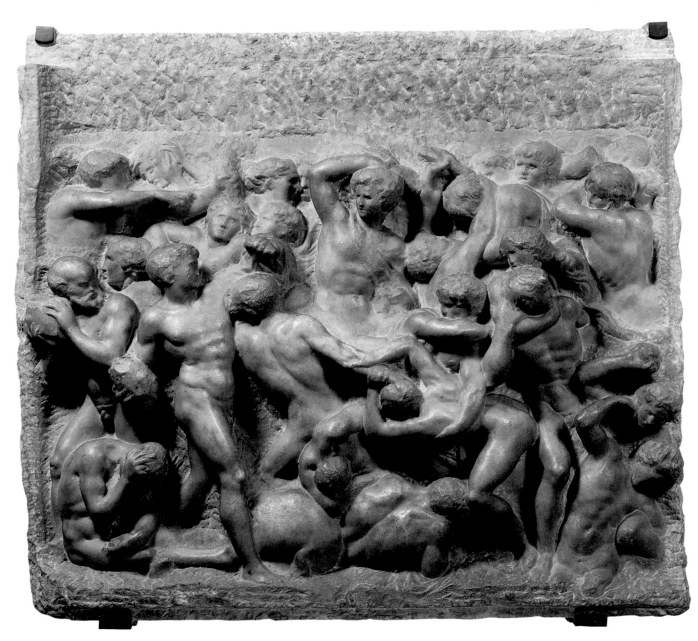

Michelangelo. *Battle of the Centaurs*. Florence, Casa Buonarroti.

gelo's junior, used to listen intently, or she let her vibrant impulses take over, to the merriment of her great father. Whatever she did made Michelangelo feel warm inside. Dante and his Beatrice came to his mind, and he could not help recalling the verse: "Love rapidly conquers a gentle heart." But his was a meek sentiment, an echo of the bliss that engulfed him, and the news that she had been promised in holy matrimony to the wealthy and influential Piero Ridolfi did not perturb the artist.

Like the majority of his fellow-citizens, Michelangelo was shaken in his heart of hearts by the vehement protests raised by the Hammer of God, whose fulminations against the new pagans did not spare anyone, from the pope to the Medici ruler. The passion that burned in Savonarola's sentences deeply penetrated Michelangelo's conscience, leaving an imprint, never erased, that later found sublimation in the sculptor's prodigious representation of the Calvary scene, with Mary the mother holding the dead Jesus in her lap as she had held the newborn child in the stable at Bethlehem.

THE GOOD STAR WANES

The late 1480s were not propitious for Michelangelo's patron, Lorenzo the Magnificent. He grieved over the death of his mother in 1482; the bond between mother and son had been strong, and her voice had been a constant source of solace and guidance. In the summer of 1488, Lorenzo was tormented by a recurrence of gout that afflicted his legs and feet, and tried to alleviate his pains by visiting the thermal baths at Filetta, one of the most renowned spas in Tuscany. While battling the disease of kings, he was informed that his wife of seventeen years, Clarice, had died suddenly.

His rapport with his Roman spouse had been sustained by a grateful tenderness for both the valuable political alliance her powerful Orsini family had brought to the Medici house and the children she had borne him. Clarice had been a respectful companion, if not a passionate lover. Indeed, Lorenzo had spent his most cherished hours with his literate friends rather than with his wife. But she had been resigned to that, and the only clouds over their domestic serenity were caused by Clarice's objection to Agnolo Poliziano as tutor of their children. Her strict religious orthodoxy clashed with the ideas "in odor of heresy" expounded by the poet-philosopher and his other friends in Lorenzo's entourage.

Suddenly a widower, the Magnificent found shelter in the willing embrace of a Florentine lady, Bartolomea Benci, more vivacious than beautiful. Yet she was even-tempered and discreet and did not claim any other privilege but that of waiting in the shadow of her great lover. He needed Bartolomea's consoling presence, albeit confined to the few moments, mostly nocturnal meetings, that he could steal from the pressing duties of his rule.

As the 1480s turned into the 1490s, the Medici finances entered a dangerous crisis. Lorenzo was compelled to borrow money from the Fund for the Orphan Girls of Florence, which he himself had instituted, in order to pay for some of his new buildings. The Medici star lost some of its radiance. The people of Florence saw it waning; and the wrathful Savonarola predicted that it would set before too long.

YEAR OF DESTINY: 1492

April in 1492 came with its usual display of glories. The fields around Florence were covered with flowers, the Arno flowed calmly under the bridges, and the people prepared to celebrate *Calendimaggio*, their favorite festival. Painters busily prepared sketches for triumphal arches, floats and public spectacles. The Florentines gathered in the squares of Santa Maria Novella and Santa Croce for the traditional football matches. It was a rough game, often violent to the point of causing wounds and fractures. Together with the *Palio*, the horse race staged on the day of the summer solstice in honor of Saint John, the patron saint of the city, it was the most popular sport in Florence.

Braving the decline of his health, Lorenzo focused his attention on the preservation of peace within and without his city. Florence was finally

secure in its relationship with the neighboring states. But the uncertain situation in the duchy of Milan was a source of great worry. Ludovico Sforza, called the Moor, had ruled it for the past twelve years on behalf of his young nephew Gian Galeazzo. But when the latter reached adulthood, Ludovico refused to relinquish the ruling power. Gian Galeazzo and his proud wife, Isabella of Aragon, grandchild of the king of Naples, protested against the usurper, invoking the protection of her grandfather. A war seemed imminent, its consequences disastrous for Lorenzo's carefully attained equilibrium.

Moreover, the rumble of the Italian conflict was raising far-reaching echoes. The French king, always alert to any pretext that could justify his descent into the peninsula, was levying soldiers for his army, while increasing the firing power of his artillery, the new staple of military might. The Italian states, Florence included, were still unable to modernize their battle forces, and depended heavily on the shifty cooperation of mercenary troops who were ever ready to change banners according to which side paid more.

Lorenzo was troubled by these impending events. After a last public appearance, at the beginning of March 1492, he retreated to his villa of Careggi, once again assailed by the relentless aggression of gout. Florence was in turmoil under the impetuous campaign that Savonarola was pushing to its peak, as he claimed he would transform the new Athens into a new Jerusalem.

The Medici ruler had failed to reach agreement with the friar. Lorenzo went so far as to offer generous donations to the convent of San Marco. Savonarola rejected the offers with such virulence as to burn any possible bridge between them. "Tell Lorenzo that when one throws a piece of meat to a watchdog, the dog may bite it and keep silent for a while, but soon he will let it fall to resume his barking against the oppression of freedom."

Diplomatic approaches conducted by people like Poliziano and Benivieni, friends and courtiers, also failed. As Savonarola heard their advice for moderation lest the Magnificent's patience be pushed to the limit and his reaction lead to the expulsion of the friar from Florence, he retorted: "Go back to him who has sent you, and tell him that I am a stranger in your city, but I will stay here long after he has gone from it." Once again, Savonarola's words carried the ominous weight of an oracle.

With his finances in disarray and his vital energy fading fast, Lorenzo was forced to think about an heir to his fortune and power. Giovanni, born in 1475 and secretly made a cardinal at fourteen, was clearly destined to follow the ecclesiastical career that, in Lorenzo's dream, might one day take him all the way to the throne of Peter. The period of three years of silence imposed by the pope before the papal appointment could be announced had elapsed, and the proud father made public the accession of Giovanni to the dignity and rank of Prince of the Holy Roman Church. Giuliano, at thirteen years of age, was still too young to be considered his heir. There remained his oldest son and would-be natural heir, Piero, but he had never won his great father's confidence. As Lorenzo himself said: "He was born unlucky," a defect that, bad for anyone, was disastrous for a political leader.

BOOKS AND LIBRARIES

An avid collector of manuscripts, Lorenzo de' Medici devoted efforts and money to the acquisition of rare and important texts for his own use as well as for the libraries of Marsilio Ficino, Pico della Mirandola, and Agnolo Poliziano. The last words he addressed to his scholarly friends were: "I regret not being given the time to complete your libraries."

Aside from the exchanges that set up a network of information and contacts among the main cultural centers in Italy, bibliophiles reached beyond national borders to establish international relationships all over Europe. Thus Pico della Mirandola in Florence could be informed by his letter friend Sir Thomas More of the wonderful work done by a printer from London by the name of William Caxton, who had published, in 1491, an *ars moriendi*, or *The Helthe of Mannes Sowle*.

Although printing had been introduced in Italy in 1465 (the first press had been installed by German Benedictine monks in the monastery at Subiaco), Lorenzo and his great rival in cultural achievement, Federigo Montefeltro, were rather disinclined to take advantage of it. Printed books were not considered worthy of being admitted to the shelves occupied by precious, often richly illuminated manuscripts. Where Florence failed, Venice flourished; 150 printers were active in the *serenissima* Republic between 1468 and 1500; 4,150 editions were published during those thirty-two years. The most famous among the Venetian printers was Aldo Manuzio, whose editions of the Greek classics still are superb examples of type design and typesetting.

By comparison with such wealth of printing activity, Florentine book production was rather scarce. Notable exceptions were represented by the presses that were set up in convents and other religious institutes. A truly rare and curious case was that of the Dominican nuns of St. Jacopo of Ripoli, near Florence. There, from 1476 to 1490, under the supervision of monks and laymen alike (the scholar Lorenzo Veneziano among them), the sisters learned to set the types, make them up, and work at the press.

A magnificent edition of Boccaccio's *Decameron*, of which only two copies are extant, attests to the quality of this convent press, where women belonging to a conservative religious order (cloistered or "regular tertiary" nuns) exercised intellectual freedom to typeset a text that included rather daringly erotic stories. The good nuns were said to have resorted to special prayers as they worked on the book.

In Leonardo's Atlantic Codex, several drawings show that he took a particular interest in the development of printing, and that he studied models of presses that include some remarkable automatic innovations. Leonardo, Michelangelo and Raphael were frequenters of libraries, be they at Urbino, Perugia, Florence or the Vatican. As to Michelangelo, he paid a worthy tribute to the Magnificent Lorenzo when, in 1524, he designed and began constructing the Medici Library in Florence, an architectural jewel. Aptly named the Laurentian, it bears witness to a cultural legacy still alive and operating.

The quiet of Careggi, where Poliziano was assiduously at his side, and the attention of his personal physician, Pier Leoni, were of little avail in quelling Lorenzo's spasms. In a cordial display of friendship, Ludovico Sforza sent a medical celebrity to Careggi to assist in finding a cure for the Magnificent. Lazzaro from Pavia had acquired vast fame thanks to some of his remedies, as extravagant as they were menacing. Much as Pier Leoni disagreed, Lazzaro insisted on giving Lorenzo potions of ground gems and pearls mixed in wine.

The condition of the Medici ruler worsened. The attack of gout was complicated by a severe stomach ailment. He called for his children and for those among his friends who were not yet at his bedside: Pico della Mirandola and Michelangelo Buonarroti.

Pico had been kept away by his own desire to attend yet another sermon by Savonarola. Michelangelo had suffered a brutal encounter in the church of Santa Maria del Carmine, where he and several students from the Medici garden had gone to exercise their painting skills by copying the famous frescoes by Masaccio. Michelangelo made bold to criticize the work of Pietro Torrigiani, a bullish, quick-tempered fellow four years his senior, which incited him to hit Michelangelo square in the face. The first blow smashed the cartilage of Michelangelo's nose, so disfiguring him that Michelangelo declared in one of his verses: "My face has the shape of fright."

Yet Michelangelo arrived in time to hear the last words of encouragement from his generous sponsor. Lorenzo, moved to tears, handed him one of his precious velvet cloaks to keep as a memento of his Medici patron. Michelangelo would treasure the cloak for the rest of his life.

Poliziano had interceded with Savonarola to hear Lorenzo's last confession. With some reluctance, yet faithful to his religious calling, the friar went to Careggi. Because of the secrecy of the sacrament, it is impossible to know what happened during that fateful encounter between the dying Medici and his undeterred accuser. Two sharply diverging tales circulated in Florence. According to one version, Savonarola firmly refused to absolve Lorenzo. The other tale had it that the friar had granted absolution upon condition that Lorenzo: (a) proclaim his total faith in God; (b) atone for the terrible vengeance he had taken against those involved in the Pazzi conspiracy; (c) volunteer to give back the money he had appropriated from the Orphan Girls' fund; and (d) leave proper instructions for the restoration of liberty.

Legend and history mingled in the chronicle of Lorenzo's last day. A heavy storm broke over Florence and its outskirts on April 9, 1492. One can imagine the scene as a teeming rain lashed the window in the chamber where Lorenzo was in agony, the black-coated friar standing at the foot of his bed.

Lightning flashed in the sky. Barely able to support himself on one elbow, Lorenzo the Magnificent raised himself from his pillow to ask in which direction the lightning had struck. When told it must have hit the Dome by Brunelleschi not far from the Medici palace, he exclaimed: "This is my end." He fell back onto his pillow, dead.

Contessina, his youngest daughter, placed a cross between his hands. Quietly, shaken by sobs, she knelt to pray at his bedside.

The imprint of Lorenzo's face, taken right after his death, portrayed the reflection of an inner calm so total that it is hard not to believe in an extreme act of mercy that Girolamo Savonarola possibly performed by raising his hand to bless his rival's passage to the great beyond.

AN ORPHAN AT HEART

The morning after the death of his protector, Michelangelo left the villa at Careggi. He did not want to return to the Medici palace on Via Larga, where he had lived under Lorenzo's patronage.

Walking in the pouring rain, the artist knocked at the door of his father's lodgings in Via Bentaccordi. Knowing his father objected to his life as an artist, he found it difficult to return to the family he had only briefly been allowed to consider his own. Many years later he sadly wrote: "My father and my father's brothers hit me often and hard, for they deemed it a shame that with me the craft of sculpture had entered our family. . . ."

The rain subsided, though thunder still rumbled, rolling in waves of sound that ebbed toward the hills. Michelangelo stepped up to his father's door. He held Lorenzo's purple velvet cape to his breast. A shield.

Entering Ludovico's house, where so much was expected of him and where he was bringing only his chattel of unfulfilled dreams, was equivalent to a defeat for the seventeen-year-old artist. On that tenth day of April, Michelangelo was an orphan at heart, compelled to leave behind the early spring of his life when the Medici roof was solid over his head.

As Michelangelo may have suspected on that fateful day, Piero de' Medici would prove an unworthy successor to his magnificent father.

PIERO DI LORENZO DI PIERO DE MEDICI

5·
PIERO
THE UNFORTUNATE

*"When together with the other sons of ambassadors
bear yourself politely, sedately, and kindly,
for they are your equals.
Be careful not to take precedence of those
who are your elders, for although you are my son,
you are but a citizen of Florence as they are."*

LORENZO THE MAGNIFICENT
to his son Piero in Rome

BORN UNDER AN EVIL STAR

Born in 1472, Piero was only six years old when the Pazzi conspirators murdered his uncle and attempted to kill his father. At twenty, on April 13, 1492, by the Republic's decree, he inherited a financial and political power that was above his natural ability. Having grown up during the years of the unstoppable ascent of his family, he was ill prepared for, and surely not very skilled in, the handling of political matters. Because of Lorenzo's widely known skepticism about Piero and his conviction that his eldest son was born under an evil star, Piero found it nearly impossible to get the support he so badly needed. And he had an unfortunate tendency to make enemies instead of friends.

Consequently, he was inclined to steer the Medici policy into a more autocratic course, stressing his role as a despot more than as a respecter of the democratic foundation of the Florentine Republic. It did not take long for Piero to alienate even the staunchest among his father's influential friends. His predilection for carousing and his almost childish passion for betting and horse racing fueled popular gossip in Florence.

In Piero, Girolamo Savonarola found an adversary much more vulnerable than Lorenzo the Magnificent. In a sermon delivered on Good Friday, April 20, 1492, Savonarola renewed his prophecy of terrible evils soon to befall Florence. To a mesmerized audience, he revealed another prophetic vision in which "a black cross rose from the city of Rome, and reaching up to the heavens, stretched its arms over the whole earth. Upon the cross was written: *Crux Irae Dei*, the cross of God's wrath. The sky was black, lightning flashed, thunder clapped, there came a storm of wind and hail. Suddenly, from the center of a walled city that appeared to be Jerusalem, rose a golden cross, its rays overflooding the world with light, and

OPPOSITE:
Bronzino. Portrait of Piero de' Medici, son of Lorenzo. Florence, Medici Museum.

upon it was written: *Crux Misericordia Dei*, the cross of God's mercy, and all the nations flocked to adore it."

Savonarola's message to the city and to his Piagnoni, the weepers, was clear: the Medici gilded season was over.

But Piero kept playing his evil-starred games.

A CRUCIFIX AND THE LOST HERCULES

"One cannot know how much blood it costs."
MICHELANGELO

Michelangelo did not neglect his vocation upon returning to his father's home. His keen interest in human anatomy, which he considered essential in the exercise of sculpture, led him to avail himself of the good offices of an Augustinian monk, Andrea from Alessandria, who was prior of the church of Santo Spirito, to which a hospital was annexed. There Michelangelo was allowed to conduct his anatomizations, which resulted in drawings of extraordinary value for physicians, artists and students of art desirous to know what preparation preceded Michelangelo's sculptural works.

Quite certainly, in his wish to repay the good Augustinians for their help, the eighteen-year-old made a wooden Christ on the Cross for their convent. (Wood was not Michelangelo's material of choice; he preferred Alpine hard marble.) Many art critics dispute the authenticity of the sculpture that was for centuries given a place of honor in the choir of the church, only to be moved in recent years to the Buonarroti house in Florence. Damaged by woodworms, the crucifix shows traits that attest quite strongly to its paternity. Michelangelo sculpted the figure of the tortured Jesus with the same pathos that he was to express so masterfully in the dead Christ held by his mother after having been taken down from the cross, in the Vatican *Pietà*. Yet even if the crucifix for the church of Santo Spirito is not Michelangelo's greatest work, it still commands admiration for the intense emotion it conveys, a feeling of resigned acceptance of martyrdom, and of a youthful grace that torture has not been able to eradicate.

In the summer following the death of his Medici sponsor, possibly by investing some of the money he had saved while under his roof (the rest having surely gone to appease his father), Michelangelo bought a "big piece of marble that had been left for years lying in the wind and rain." The size of the block, notwithstanding some faults, stirred Michelangelo to that *far grande*, doing big, which would be his proclivity throughout his long life.

At the time, he was sickly, of small stature, emaciated; in sharp contrast, this born maker of giants saw a Hercules inside the marble. He had seen examples of sculptures inspired by the mythical hero. His teacher Bertoldo had made one of them, now in the Berlin museum. In the Medici garden, Michelangelo had been given small marbles to carve; now he could extract from the block a statue at least seven feet high.

He brought his Hercules to life. Unfortunately, together with the

Michelangelo. Detail of the Santo Spirito Crucifix. Florence, Casa Buonarroti.

OPPOSITE:
Michelangelo. Santo Spirito Crucifix. Florence, Casa Buonarroti.

Satyr (or *Faun*), his first sculpture, it is lost. It is recorded that, before running away from Florence in 1494, he sold it to Alfonso Strozzi, the leader of an anti-Medici family and one of the new patrons of art in the post-Lorenzo Florence. In 1509, Strozzi's younger brother sold the statue to Giovanni Battista della Palla, the buyer of artworks for King Francis I of France. Michelangelo's *Hercules* was carried to Fontainebleau and placed in the center of the Jardin d'Estaing, where it stood until the year 1713. An etching by Israel Silvestre (who died in 1691) shows it in its full size, dominating the garden. For reasons that no one has been able to document, the statue ceased to be included in the inventory of artworks at Fontainebleau after 1713. Although several people claimed to have found fragments of it, none of these has been supported by any valid authentication.

THE SNOW STATUE

"If you will follow my precepts, dictated by my love for you, you will adorn your soul much more than your face; and you will honor those men who inhabit the sacred forest of the holy Muses...." Perhaps rereading the letter that Lorenzo had written (in Latin to familiarize his son with the language), Piero thought of the young sculptor who had lived for two years in the Medici palace. Since his ascent to power, Piero had not seen Michelangelo or paid much attention to his whereabouts. Two years later, in 1494, a rather exceptional event in Florence gave him an inspiration, a playful one at that, quite in accordance with his character.

As annotated in the precious diary of the Florentine druggist Luca Landucci (1436–1516): "On the twentieth day of January 1494, the day of Saint Sebastian, it snowed in Florence the greatest snow that anybody could remember.... And the fallen flakes made heaps so high that they remained for days on end in the streets and in the courtyards of palaces...."

Engaged in one of his famous parties in the warm comfort of the Medici palace on Via Larga, Piero looked out at the snow heaped near the palace entrance as Michelangelo happened to be passing by in the street below. This gave Piero the idea to commission the sculptor once dear to his father to make a statue from all that white, shimmering substance strangely similar to marble.

Was it just a joke? The object of a bet between Piero and his companions in revelry? Or did he merely seek to humiliate the artist his father had honored?

"If you knew what a heavy mask Fortune has put on you, you would leave no stone unturned to study how you can gain honor and glory...," Lorenzo had written to his son. But his words went unheeded.

Possibly Michelangelo objected to the idea at first. The freezing cold and the absurdity of the commission were enough to discourage even a former Medici protégé who was still grateful to the memory of his great, lost sponsor. Whatever his feelings, Michelangelo made a statue with the snow; and it was so beautiful that Piero rejoiced at the sight of it, as a child with a new, splendid toy.

The work was to last only the space of one day. The sun that rose over Florence melted her white cloak and destroyed the ephemeral masterpiece. All that remained of Michelangelo's statue was a puddle of water and a few frostbites on his fingers, but the episode survived as a clear symbol of the intellectual limitations of Piero, a weakling incapable of maintaining the great Medici dream. Piero tried to win back the friendship of the artist he had offended by offering him hospitality in the palace and treating him with a cordiality only distantly reminiscent of the warm affection that Lorenzo had bestowed on his adoptive son. But Michelangelo could find no more in the Medici house the home he had known when the Magnificent was alive.

AN IMPOSSIBLE DUEL

Piero lost whatever popular backing he could count on as support for Savonarola continued to grow, endorsed even by those Florentine citizens who, at heart, remained loyal to the Medici dynasty. He contrived to cause the banishment of the prior of San Marco from the city, but the exile did not last long enough to hinder either Savonarola's actions as a preacher or his political influence. He continued to let his voice be heard from wherever he happened to be, Venice or Bologna, and Brother Mariano, the monk summoned from Rome to replace Savonarola on the pulpit, did not match his charisma and his inimitable ability to impress the audiences.

Furthermore, when the friar returned to Florence, he became even more ingrained in the political life of the city. In order to free his convent from the unwanted patronage of a despised ruler, Savonarola insisted that his brethren work for their bread and wear only coarse robes. He stripped their cells of all superfluities, forbidding them to have illuminated books, gold or silver crucifixes, and similar "vanities."

He opened schools for the study of whatever craft could be learned by the friars and applied to the advantage of the convent. He hired teachers to train them in painting, sculpture, architecture, and in the traditional *ars illuminandi*, the art of illuminating manuscripts. Theology, philosophy and moral science were taught, together with Greek, Hebrew and other Eastern languages. The man who had been accused by many as a negator of cultural progress was answering with deeds that refuted their assertions; at the same time he was restoring the religious life in his convent to its original severity and purity, and setting a hard model for all those ecclesiastics whose conduct was far from being a source of inspiration to the faithful.

In a spirit akin to that of Francis of Assisi, Savonarola encouraged a renovation that proved to his listeners just how adamant he was in applying to himself and his brethren the principles he promoted in his relentless sermons. "You ask what we are doing," he told an abbess from Ferrara who had expressed doubts about the changes Savonarola had introduced in the rules governing convent life. "What are we doing? Only casting away superfluities, and returning to the simplicity and poverty enjoined by the original rules of our order. The real, bad change was when mendicant friars

began to build sumptuous palaces. . . . I wish I could make you understand that the world is darkened, depraved, and that it is time to regenerate God's people. The Lord is weary. . . . We must be ready to face the persecutions inevitably directed against any good work. And we are ready."

The enthusiasm kindled by Savonarola's sincere accent on a return to spirituality as a first condition for curbing corruption and recovering honesty and civility in public life spread throughout the whole population. Many nobles, as well as members of the lower classes, tried to join the friar's brotherhood. Even Poliziano and Pico della Mirandola were said to be ready to do so. The number of friars increased so prodigiously that, before long, the convent itself proved too small; and the tide of enthusiasm flowed across all of Tuscany.

Piero's ruin was inexorably forecast as the years passed since the death of his father — not that the memory of Lorenzo was extinguished. To the contrary, it had turned into an even deeper sense of nostalgia for the Magnificent's glorious season, which, by comparison, made his heir's embattled time seem even sadder. Savonarola compared Florence under the unworthy Medici to the biblical Babylon: "The city of the foolish and impious, the city that will be destroyed by the Lord."

On September 21, 1494, the cathedral of Florence could scarcely hold the huge crowd that had waited since early morning for Savonarola's sermon. When the preacher finally mounted the pulpit, the vast church fell silent. Savonarola broke the stilled hush by crying out the news of the Deluge: "*Ecce ego adducam aquas super terram!*" (Here I bring the waters over the earth!) His words resounded throughout the cathedral like a thunderclap. Pico della Mirandola reported that he felt a cold shiver run through him, and that his hair stood on end.

The echo of the friar's prediction of a catastrophe as tremendous for all of Italy as the universal flood, of his frantic call to enter the Lord's Ark to find therein the only possible safety, had not yet subsided when news arrived that a flood of foreign soldiers was streaming across the Alps, marching to the invasion of Italy. Rumors mounted like devastating waves, exaggerating and distorting reality, but finding acceptance with a population ready to receive them at their worst face value.

No Italian state, with the possible exception of the kingdom of Naples, was prepared to oppose a military invasion. An army as mighty as the one led by Charles VIII, king of France, would sweep through the peninsula with the force of a natural tempest. The Florentines rushed to the cathedral to implore God's mercy and Savonarola's help. His dire predictions appeared as the utterances of a prophet. The city yielded to his exhortations. Florence was ready to place itself in the hands of Girolamo Savonarola. Only God, they believed, could save them from the foreign invaders and from the ineptitude of Piero de' Medici. And to reach the good Lord, no intermediary looked mightier than the friar who one day proclaimed himself to be God's Hammer and who had demonstrated he was also God's harbinger.

6.
SHIP
WITHOUT PILOT

THE FRENCH INVASION OF ITALY

Ever since the fall of the Roman empire, foreign powers had greedily eyed the Italian peninsula. Lured by its ports open to the Mediterranean, the temperate climate of its central and southern regions, the products of its artists and artisans, and the splendors of Florence, Venice, Rome, Padua, Arezzo, Pisa, Urbino, Ferrara and Naples, troops led by captains of fortune dreamed of rich booties to be secured by sacking Italian cities, villages, palaces and churches.

By 1494, Italy was particularly vulnerable to foreign attack. This was due, in large measure, to problems created by Ludovico Sforza, who refused to reinstate his nephew Gian Galeazzo as the rightful ruler of the duchy of Milan. Gian Galeazzo's wife, Isabella of Aragon, appealed to her father, Alfonso, and her grandfather, the king of Naples. They threatened to deprive Ludovico of his unlawful power and restore it to Gian Galeazzo, now kept a prisoner in Pavia, where Isabella suspected he was being slowly poisoned by order of his cruel uncle.

To maintain his power and to secure the new pope's alliance, Ludovico called for the ambassadors of Milan, Florence and Naples to go to Rome together and present themselves as faithful friends to Alexander VI. Piero de' Medici refused. He aspired to the honor of leading a special embassy from Florence, independent from any other. Piero advised the king of Naples to second him in rejecting Ludovico's proposal.

At the same time, international problems threatened Italy. Spain had become a super power: the kingdoms of Aragon and Castile were unified under Ferdinand II, Christopher Columbus had planted the banner of the "most Catholic King" on a new continent, and the Spanish army vanquished the Moors. The Turks posed a constant threat to the Italian states, with their attacks at sea and on land. Germany, although ruled by the irresolute Maximilian I, was building its military potential. Swiss mercenaries, in stronger demand than ever before, were crossing the Alps, willing to be hired by anyone planning or fearing a war.

The greatest threat came from the king of France, Charles VIII, who inherited the duchy of Anjou from the Angevines, and their alleged right to the throne of Naples. Reassured by Ludovico Sforza of the pope's acquiescence, Charles rejected all conciliatory offers made by Ferrante, king of Naples, and decided to test the position of the other Italian states.

"Ah, Italy enslaved, hostel of grief,
Ship without pilot in a mighty storm
Mistress not of states but of a brothel."

DANTE

Leonardo da Vinci. Drawing of the mounting of a cannon in the courtyard of a foundry (facsimile). Florence, Uffizi Gallery, Cabinet of Drawings.

OPPOSITE:
Filippino Lippi. *Virgin and Child with Saints*, detail showing gate of Saint Frediano in Florence. Florence, Church of Santo Spirito.

Venice manifested its firm allegiance to neutrality and Piero de' Medici asserted his unbreakable link with the House of Aragon.

But then, on January 25, 1494, Ferrante, king of Naples, died. His son Alfonso, while strengthening his army, turned the Borgia pontiff into an ally by paying 30,000 ducats into his personal coffers and lavishing sums on his sons.

Entranced by his own vision of a God-sent avenger of a new morality, Savonarola called Charles "a new Cyrus." The Florentines agonized over Piero's devotion to the Aragons of Naples and looked to the French king to bring peace to Italy and to Florence.

Aware of the swelling anti-Medici sentiment and suspicious of being betrayed within his own family, Piero had his cousins Lorenzo and Giovanni arrested and banished from the city after learning that they had publicly opposed his policy.

As soon as he had collected enough money to fund his campaign (Ludovico Sforza had promised 200,000 ducats), Charles VIII marched to cross the Alps. At twenty-four years of age, the French king had a passion for adventure. Although he was plagued by frail health and a body on the verge of deformity, Charles proudly led a formidable army against the armored Italian cavalry, whose horses were so burdened with steel that if they fell, they could not get up. Twenty-five thousand horses and 23,000 footmen formed Charles's army, which was supposed to be joined by the troops of Ludovico Sforza as soon as the French contingent was on Milanese soil.

Meanwhile, Alfonso of Naples mobilized his soldiers. He sent his brother, Prince Federico, to Genoa, where Charles's fleet was anchored, in order to check the movements of the French. Another army, led by the duke of Calabria, the count of Pitigliano and the able captain Gian Giacomo Trivulzio, was dispatched toward the Romagna region to make a front that would keep the war away from the Neapolitan territory.

On August 22, 1494, Charles descended the slopes of Monginevro, stopping at Asti, where he was met by Ludovico the Moor. Shortly after this meeting, Gian Galeazzo Sforza died in his castle-prison at Pavia. Learning the news, the whole peninsula was shaken by indignation, and Charles's men began to worry whether the duke of Milan, who was to be their ally during the arduous campaign and whose cruel and treacherous nature had been exposed, could be trusted.

The French detachment under the command of General d'Aubigny victoriously repulsed the Neapolitan army in Romagna, while in Genoa

Leonardo da Vinci. *Cavalry Battle*. Venice, Academy of Fine Arts.

the duke of Orléans, commander of the fleet, fought back the attack of Prince Federico's militia. Success in Romagna resolved Charles's last hesitation to choose the route for his invasion toward Naples; he decided to proceed through the Lunigiana region along the Tyrrhenian coast, heading for Florence. The king received further assurance from Piero's exiled cousins Lorenzo and Giovanni that the Florentine population regarded him as a redeemer of freedom.

As the French army advanced, news of its violent pillaging, looting and raping plunged Florence into dread and confusion. The people, who had not hesitated to welcome the expedition, were now learning that because of Piero's alliance with Naples, Charles had entered their region as an enemy.

The French marched on, taking the first Florentine stronghold by storm; soon they became aware that the itinerary chosen by Charles was full of risks. Pressed between the forbidding flanks of the Apuanian Alps and the sea, where Pisan ships maneuvered at leisure, they were confronted by the well-manned fortresses of Sarzana, Pietrasanta and Sarzanello, a defense line that worked to the advantage of the Florentines.

Fate offered Piero a favorable moment; but he did not respond. He was still the ruler of Florence, yet he lacked support, financial means, and above all, the perspicacity needed to realize that the French were vulnerable when engaged in crossing the swampy expanses of the Tuscan Maremma. Without much conviction, he sent his brother-in-law, Paolo Orsini, with a small cavalry unit to reinforce the Sarzana garrison. He could have attacked with strength enough to show Florence's ability to defend itself, but instead he opted to imitate his father's action when, many years before, Lorenzo had gone to Naples, alone and unarmed, to parlay with King Ferrante.

Piero was not Lorenzo. As he reached the battlefront, he learned that the French had launched vain assaults for three days against the garrison of Sarzanello. Instead of taking advantage of the momentary failure of the French, Piero fell victim to his own terror. Without even consulting his counselors, he promptly surrendered the three Florentine strongholds. Furthermore, he volunteered to let the French army occupy the fortresses of Pisa and Leghorn for the duration of the war. To complete his disastrous mission, Piero engaged the Signory to pay Charles the truly royal sum of 200,000 florins.

A report recounting his visit to the French king found its way to Florence. Suddenly, the menace of a French invasion of the city spread fear like wildfire through the city. Popular reaction, akin to a rebellion, led to a series of events that sealed the fate of the Medici ruler and inaugurated another phase in the story of Girolamo Savonarola.

To the people, the only fountain of hope was to be found at San Marco. There, Savonarola kept preaching, carefully avoiding a shift from the spiritual to the temporal. He did not want to interfere in the changes now patently inevitable in the political life of Florence. Piero's days as a ruler were numbered; but the friar was conscious that the transition could involve a bloody purge.

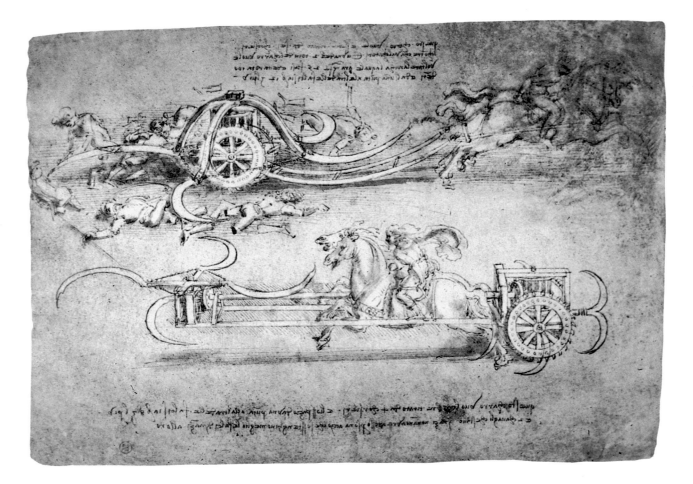

Leonardo da Vinci. Study of instruments of war. Turin, Royal Library.

THE END OF THE CHILDISH GOVERNMENT

Savonarola understood that the arrival of Charles VIII was not in accordance with his previously hopeful expectations that the king would bring moral and political order to Florence. Political realism tempered his religious ebullience, as evidenced in the sermon he delivered to alert his fellow citizens of the danger represented by the French monarch. "Behold! The sword has descended upon you, the prophecies are fulfilled, the scourge begun. O Florence! The time of singing and dancing is at an end; now it is the time to shed floods of tears for thy sins. Thy sins, O Florence; thy sins, O Rome; thy sins, O Italy! They have brought these chastisements upon thee. Repent! Be united! What desire has ever been mine but to see you saved, to see you united?"

On November 4, 1494, the Council of Seventy convened: a decision had to be reached as to the best course of action.

Without preamble Pier Capponi, son of Gino, took the stand and said: "Piero de' Medici is no longer fit to rule the state. The Republic must see to its own salvation. The time has come to get rid of this childish government. Let us send ambassadors to King Charles, having them take special care to avoid even saluting Piero, should they meet him along the way. Let us choose honorable men to deal with the French, and at the same time, let us prepare ourselves for whatever may happen. All our men at

arms should be ready to fight; let us find hiding places for them in cloisters, convents and other safe places. If Charles behaves honestly, we should be willing to appease his greed with money; but if he pushes us to the limit, we will show what stuff Florence is made of."

In the silence that followed, Pier Capponi added: "And let us appoint Brother Girolamo Savonarola as one of the ambassadors. He has won the love of everyone in our city."

His proposal met with unanimous applause. The next day, an embassy was formed: Pier Capponi, Tanai de' Nerli, Pandolfo Rucellai, Giovanni Cavalcanti and Savonarola.

Before leaving to meet the king, the preacher admonished the people: "Be steadfast in peace. If you want the Lord steadfast in mercy, be yourselves merciful toward your brethren, your friends, and your enemies; otherwise you too shall be smitten by the scourge prepared for the rest of Italy."

Arriving at the French camp, Piero quickly assessed the disregard the Florentine envoys had showed toward him and, in another rash move, ordered Paolo Orsini to rally as many soldiers as he could from the population of the region, and have them ready to escort him back to Florence. Again he approached Charles, offering to pay the 200,000 ducats without delay, in exchange for the king's protection.

On the evening of November 9, Piero arrived at the Signory palace demanding that a popular parliament be summoned to restore his ruling power. The Signory adjured him to disband his troops and avoid plunging the city into a civil war.

Piero left the palace only to command Paolo Orsini to take control of the San Gallo gate; then, armed and escorted by a cavalry squadron, he returned to the Signory. The palace guards barred him from entering. A scuffle ensued and a crowd of bystanders, whose number quickly increased, began to riot, shouting insults at Piero and his followers. The outcry "Down with the balls! Down with the Medici!" soon echoed throughout the city. Shops were promptly closed and citizens filled the streets, many armed with makeshift weapons.

Piero's desperate attempt was stifled only by the arrival of an old partisan of the Medici, Francesco Valori, who entered the Signory square riding a mule and covered with dust. Returning from an encounter with the vanguard of the French army, he recounted the humiliation inflicted by Piero's unwise and cowardly behavior in his meeting with King Charles, and stirred the people to attack the Medici palace and chase Piero and his followers out of Florence.

Piero ran to the San Gallo gate, as the mob ransacked and looted his residence, destroying precious objects. He abandoned Florence and went to Bologna; there an unfriendly reception forced him to repair to Venice. His brother Cardinal Giovanni, disguised as a monk, succeeded in saving a number of ancient manuscripts by summoning all his courage to rush to the convent of San Marco, where he asked Savonarola for shelter.

The Signory declared the Medici family outlawed and banished from Florence. A ransom of 2,000 florins was set on the head of Piero, and of

DEATH BY WATER

The most visible and sad result of the fall of the Medici dynasty was the dispersion and wanton destruction of the art collection that Cosimo, Piero the Gouty and Lorenzo the Magnificent had gathered in the palace on Via Larga. Priceless manuscripts were burned, with the exception of the few that Cardinal Giovanni succeeded in saving by entrusting them to Friar Savonarola; paintings and statues were plundered; gems, cameos, vases and other equally precious ornamental works were stolen and scattered all over Italy.

Eight years later, in 1502, Isabella d'Este, marchioness of Mantua, was informed that some of the Medici precious vases were being offered for sale. She asked Leonardo da Vinci to appraise them for her; they included a vase carved from one solid block of crystal, a jasper vase encrusted with pearls and rubies, an agate cup and a second jasper vase on a silver stand. Each bore Lorenzo's name engraved in Roman letters. The price proved to be too steep even for Italy's first lady, and they did not leave Florence. In 1540, Cosimo I de' Medici succeeded in buying them back and restored them to the family collection. The vases, unfortunately deprived of the many jewels and of their gold and silver stands, are exhibited at the Uffizi Gallery in Florence.

One of the most valued and cherished works of art in the Medici palace, the bronze group *Judith and Holofernes*, which Donatello had sculpted for Cosimo the "father of the country," was appropriated by the Signory to be installed in front of the Palazzo Vecchio. An inscription was placed on its base to warn anyone who "should think to impose tyranny on Florence." It was to remain there until it was decided to transfer it to the loggia on the Piazza della Signoria to make room for Michelangelo's *David*.

With his palace ransacked and his life threatened by the eruption of popular violence, Piero was not able to carry much with him as he left Florence on his way to exile. The twenty-two-year-old head of the disgraced Medici family traveled with his wife, Alfonsina Orsini, their two children, Lorenzo and Clarice, his brothers Giovanni, eighteen, and Giuliano, fifteen, and his cousin Giulio, sixteen. Giovanni, Giuliano and Giulio found hospitality in various courts over a period of five years, before deciding, in 1499, to leave Italy and seek shelter first in Germany, then in Flanders and France. They tried to visit England but the adverse weather conditions on the channel prevented them from sailing. They ended up in Rome, after a brief stay in Genoa, where Pope Alexander VI treated them generously.

For nine years Piero rode the tide of encouragements, humiliations, offers of help and rejections in his repeated and failed attempts to regain his position in Florence. He kept hoping until his last day that the French would help resurrect the Medici glory. For this he did not hesitate to enter the services of King Louis XII when the latter campaigned against the Spaniards for the conquest of the kingdom of Naples. On December 27, 1503, the French army, forced to retreat, engaged in a fierce battle to cross the Garigliano river. Piero tried to cross the river aboard a vessel carrying heavy artillery pieces; the swift current in the river engorged by the winter rainfall caused the boat to capsize. Piero was drowned.

His death proved that his great father had had an unerring premonition when he had called him "unlucky." With Piero, the Medici star sank to the depth of a turbulent river. History would not fulfill Lorenzo's dream until ten years later, when his son Cardinal Giovanni would ascend the papal throne to bring the Medici fortune to a new and higher magnificence.

1,000 on his brothers Giuliano and Cardinal Giovanni, should they ever dare to reenter the city.

Many who had been exiled by Piero now returned, among them his cousins Lorenzo and Giovanni. Their first act was to take the Medici coat of arms down from their houses and issue the emblem of Florence in its place. They also made public their decision to change their family name from Medici to *Popolano* ("of the people").

Savonarola had his first encounter with the French king. The preacher's charisma worked on Charles, who promised that his troops, once given a friendly reception and hospitality, would respond with similar respect for the Florentine populace.

On November 17, 1494, as recorded in a contemporary chronicle, Charles VIII entered Florence wearing a black velvet dress under a cloak of

gold brocade, mounted on a tall, splendid charger, his lance leveled:

All this rendered the meanness of his figure grotesquely conspicuous. By his side rode the Cardinal of San Pietro in Vincoli, the Cardinal of San Malo, and several marshals. After him came the one hundred bowmen that formed his bodyguard, then two hundred French knights marching on foot, wearing shining armors, and precious swords. These were followed by the vanguard of bare-chested Swiss mercenaries, with halberds of burnished steel, under command of officers with richly plumed helmets. The center consisted of Gascon infantry, agile men whose number seemed to grow as the military procession filed on. The flower of the army was the cavalry made up of the young aristocrats of France, with golden mantles, banners embroidered with gold, gold neck-chains, and resplendent shields. The cuirassiers had a horrific aspect, with their horses looking like strange monsters with their cropped tail and ears. The well-disciplined parade was closed by the Scottish archers, men of extraordinary height, armed with very long wooden bows, and by the German lansquenets, famous for their brutal warring efficiency.

The army marched over Ponte Vecchio, which had been decorated for the occasion, went through the Signory square, and stopped in front of the cathedral. As Charles VIII went into the church, he was met by members of the Signory, with Francesco Valori and Pier Capponi among them. The latter, thanks to experience gained on the occasion of his embassies to France, was best suited to deal with the situation. He was reported to have said: "Once our Italians have smelled the French, they will cease to fear them."

Charles, however, took on the manner of a conqueror rather than that of a welcomed guest. Soon clashes took place all over Florence between the citizens and the French troops. Homes were broken into, goods stolen, women molested. To the vehement protest of the Signory, Charles was haughtily indifferent. Irritated by the reports that some of his soldiers had been forced to back away from the enraged reaction of the population, he threatened: "We shall blow our trumpets," meaning that Florence's walls would incur the same fate as Jericho's. Capponi did not hesitate in retaliating: "And we shall ring our bells," to indicate that the Florentines were ready to stage an insurrection against the occupants of their city.

Savonarola intervened again with Charles. His prophecies of divine requital frightened the king. On November 28, at ten o'clock at night, the French army filed out of Florence. Many artworks left with them; Charles himself carried off a very precious gem with a unicorn chiseled on it, valued at 7,000 ducats in the estimate of a French historian.

The French occupation of Florence had lasted only eleven days; yet it left ugly scars. The Medici supporters vanished into thin air. Savonarola became the repository of the city's last remnants of pride and hope. His day was dawning. It would be a time of intense passions and tragic developments.

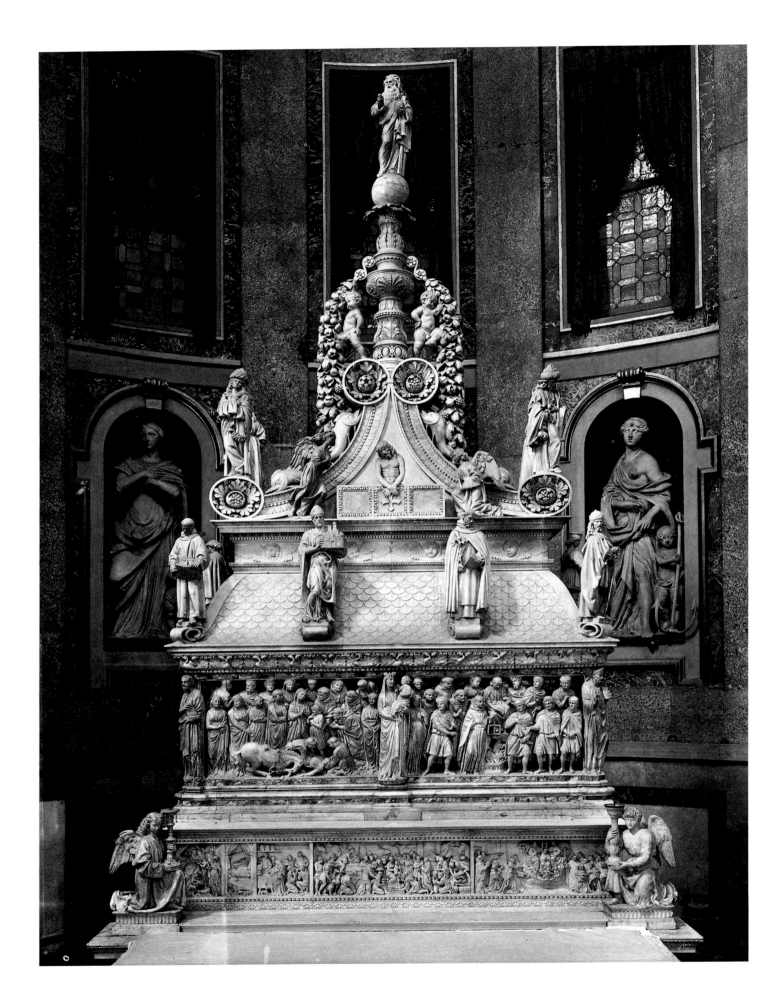

7.
MICHELANGELO
IN BOLOGNA

"He who arms himself with love wins every fortune."

MICHELANGELO

A PASSPORT ON A THUMB

Like his fellow Florentines during this chaotic time, Michelangelo suffered grave apprehensions. Dark portents were everywhere. From one of his friends, Andrea Cardiere, who had been Lorenzo's favorite lute player, he learned of a frightening dream the musician had had: the Magnificent had appeared to him wearing black, torn robes on his naked body. In a cavernous voice he had begged Cardiere to warn his son Piero that he was going to be thrown out of Florence, "never to return." Michelangelo encouraged Cardiere to tell Piero of the impending doom announced by his dead father.

The Medici gave the lute player a cold, derisive reception. When Michelangelo learned this, he decided to flee Florence and, two days later, was on his way to Venice with two other young men, probably Cardiere and Francesco Granacci.

The artist's flight from Florence did not go unnoticed. In a letter dated October 13, 1494, Ser Amadio, a merchant, wrote to his brother Adriano: "Know that Michelangelo, a sculptor of the garden, has fled to Venice."

As Michelangelo left Florence, perhaps he thought about his beloved countryman-poet Dante Alighieri, also forced into exile from his native city.

He and his two companions expected to find quiet in Venice, in contrast to the turmoils of Florence, but serenity eluded them, for the *serenissima* city was vexed by its own urgent need to levy an army to oppose the threat of an attack by Charles VIII.

Poor as churchmice, Michelangelo and his two friends quickly looked elsewhere for a peaceful place to live. Bologna appeared to be the next best destination. On they trudged toward the famous university town, with their pockets empty and their hearts full of hope. In their haste, they neglected to seek advice as to the rules governing access to Bologna. Consequently, they were unaware that a stranger was not allowed to enter the town gate without a red mark imprinted on his or her right thumb.

OPPOSITE:
The Ark of San Domenico. Bologna, Church of San Domenico. The three sculptures created by Michelangelo for the Ark are the *Angel* (lower right corner), *Saint Petronius* (second from left of the four figures at mid-level), and *Saint Proculus* (not visible in photograph).

How salty is the taste of foreign bread
And how hard a path it is to climb
And then descend the foreign stairs.

DANTE

BOLOGNA

Throughout its history, Bologna, known as *La dotta*, the learned city, had been a veritable beacon of culture in Italy. Liberty was sacred to Bologna, as proclaimed in the town's motto: *Libertas*. Its lofty past was documented by monuments and works of art, such as the church of San Petronio, built in 1390 in the Gothic style, with a portal embellished by the sculptures of Jacopo della Quercia, and the church of San Domenico, erected in 1235 in honor of the Spanish saint who had died in Bologna. The church contained one of the most admired treasures of Italian art, the Ark (or tomb) of San Domenico, with bas-reliefs begun by Niccolò Pisano and Brother Guglielmo and continued, in 1469, by Niccolò dell' Arca, but never completed. This was a work that was to be important to Michelangelo.

When the three Florentines first tried to enter Bologna, they were met with the inflexibility of the guards. Their protest that they were honorable citizens of the great Republic of Florence was to no avail. They were led to the tax office and sentenced to pay a penalty for their negligence. Only a fortuitous encounter with a Bolognese gentleman, Giovan Francesco Aldrovandi, who happened to be in the office at that moment, saved them from rejection and possibly a prison term.

No information is available concerning the fate of Michelangelo's traveling companions. They either returned to Florence, disillusioned and frightened, or they entered one of the workshops of Bologna, trying to support their basic needs.

Michelangelo himself was more fortunate. He found, for the moment, a roof under the Bolognese sky, the warmth of a friendly fireplace, one of his first honorable commissions, and above all the solace of freedom. Such hospitality came from Messer Aldrovandi, himself a poet and writer of no small repute, as well as a Bolognese magistrate. Aldrovandi loved Florence and the Tuscans. He shared with Michelangelo a deep

THE LEARNED CITY

Bologna's university boasted a unique reputation throughout Europe as a school of jurisprudence under Pepo (1076), the famous teacher of Roman law, his immediate successor, Irnerius, and the *glossatori* who learned from them. From the twelfth to the fifteenth century, between three and five thousand students attended it. In the year 1262, the university population rose to nearly ten thousand, the poets Petrarch and Dante among them. Its anatomical theater attracted physicians and students of medicine from every European nation. The cultural life of the university, instituted as an autonomous corporation, spread all over the city, as teachers lectured in their own houses and in halls hired or rented by the civic authorities.

A note of gentle charm was added in the fifteenth century to the university's list of remarkable features. A beautiful female teacher, Novella d'Andrea, joined the staff. By itself, this was not a novelty, for there had been several women teachers in the history of the institution. What made Novella d'Andrea especially celebrated was her personal attractiveness; she was asked to lecture from behind a curtain so that the attention of the students might not be distracted by her charms.

Novella was not alone in enjoying a vast popularity and in contributing to the town's attraction to foreigners. Bologna was, and is, praised for the comeliness of its women, its savory cooking and its ribald humor, rooted in the glorious goliardic tradition established by the traveling students who visited the university.

TO AN UNKNOWN WOMAN
IN BOLOGNA

Come si gode lieta e ben contesta

How full of joy and glad and braided well
Garland of flowers is on hair of gold,
One pushing another forth so that it may be
The first to reach and kiss the lovely head.

The whole day long contented is the gown
That holds her breast and then seems to flow,
And what is called a filigree that touches
Her neck and cheeks, and has not enough.

But happier still the ribbon seems to enjoy
Tipped with gold and placed in such a manner
To press and touch the breast that it restrains.

And the pure knotted belt seems to confess
To itself: here I'll hold forever.
Now what would they do, these arms of mine?

MICHELANGELO
(translated by V. L.)

Michelangelo. Drawing of a nude woman. Florence, Medici Chapel.

admiration for Dante and the *Divine Comedy*. And he was happy to have some company.

Like Alexander the Great, who could not fall asleep even in the midst of military campaigns without listening to tales that his faithful companions told him, Aldrovandi liked Michelangelo to read to him, in his lilting Florentine accent, lines from the *Inferno*, *Purgatorio* and *Paradiso*. Evening after evening, the Bolognese magistrate sat by a crackling fireplace listening to stories like the moving drama of Paolo and Francesca, the tale of an adultery dictated by that love "which does not absolve anyone who is loved from loving in return."

The old insomniac must have felt indebted to the young sculptor for the pleasure he derived from these fireplace readings. He arranged for the necessary meetings for Michelangelo to gain the coveted commission to sculpt three statues, planned but not so far executed, for the Ark of San Domenico.

Many Bolognese artists vied for the privilege of being chosen to complete a recognized masterpiece. One of these (perhaps Vincenzo Onofri) openly denounced the preference accorded to the foreigner Michelangelo and made no mystery of his intention to make him pay for what he deemed an insult to every artist active in Bologna. Michelangelo, however, faced the commission with a confidence that was characteristic of him when confronted by artistic challenges, though he must have worked with some trepidation as to his safety, aware of the hounds of jealousy barking at his heels.

The three statues, small in size by comparison with the others that form the gallery of his œuvre, are not masterpieces. Michelangelo was somewhat constrained by having to create works to be inserted in the harmonious context of an existing and consecrated magnum opus. Yet his *Angel with a Candle-holder* stands out, above all the other statues in the monument, for a gentle wistfulness that contrasts well with the fierceness of the head of his Saint Proculus, the Archbishop of Constantinople martyred in A.D. 303 at the door of Bologna.

Thirty ducats richer, Michelangelo decided to return to Florence. He had won a valuable friend, even a patron, in the learned town; he had been given a chance to study the splendid works of Jacopo della Quercia and Niccolò Pisano; and he had savored freedom. All this did not compensate for the bitterness of exile, for the forced neglect of his father, who loved and harassed him, for the loss of his brothers (beloved thorns in his side) and of his Florence, the generous and exacting lover he had left behind.

His "passport on the thumb" having been washed away by now, he went back home.

8.
RETURN
TO FLORENCE

"Within the circle of the ancient walls . . ."
DANTE

IN THE EMBRACE OF THE WALLS

To a Florentine returning home in November 1495, the ancient walls encircling the city must have looked as reassuring and comforting as a mother's embrace. Yet for Michelangelo this feeling was ephemeral. Once past the gates, he found Florence burning with the passions kindled by the unarmed prophet, Savonarola. His city had changed.

The treaty with Charles VIII signed the previous year upon his departure from Florence provided for a "good and loyal" friendship between the Republic and the king; reciprocal protection for its subjects; the titles of Restorer and Protector of the Liberty of Florence for the king, along with a payment of 120,000 florins to him; evacuation of the king's troops from Florentine fortresses within two years; pardon for the Pisans who had sided against Florence, as soon as they resumed their allegiance to Florence; revocation of the decree issued by the Signory that put a price on the heads of the Medici, except that the estates of Giuliano and Cardinal Giovanni continued to be forfeited until full payment of Piero's debt had been made. Piero himself remained banished at a distance of 200 miles, and his brothers 100 miles, from the Tuscan borders.

Piero, however, was plotting a comeback, desperately trying to summon the help of any powerful friends who would listen to him. All his attempts had so far failed; but they added to the unrest and disturbances that still plagued the public life of the Florentines.

In the past, the people were accustomed to changes of government through the calling of *Parlamenti* (parliaments). When the great Signory bell tolled, citizens gathered in the piazza, which was guarded by the Signory's armed escort. Then the Signory came out of the palace, stood at the *ringhiera*, or railing, and asked the people to grant the right of *Balía*, meaning full discretionary power for the Signory to decide as deemed fit. This was tantamount to giving the Signory license to act as a dictatorship and gave origin to the biting Florentine saying: "Who speaks of Parliament, speaks of detriment."

Savonarola rather easily convinced the citizens of Florence to change their form of government. He knew that the ruling structure of the Vene-

tian Republic had always been considered an ideal model by the people. And the need to install a political power capable of steering the Republic out of its current quagmire became more and more pressing because of the rebellion in Pisa. Traditionally fractious, the Pisans finally found unanimity. A new government was rapidly constituted, arms, money and men collected. Independence and freedom were the keynotes of the newly established Pisan spirit of concord.

Spurred by the example of Pisa and by monetary assistance from Siena, the towns of Arezzo and Montepulciano pledged allegiance to the rebellious movement, and several other towns were inclined to follow suit. The entire Florentine territory was shaken as if by a political quake. Hard pressed to meet the payment installments imposed by Charles VIII, Florence longed to be revitalized by a ruling body as firm as the one ruling Venice. After long debates, the palace councils approved the proposals put forth by Guidantonio Vespucci and Piero Soderini, two of the most eminent doctors of law in the city.

Soderini was thoroughly experienced in Venetian politics, having spent many years there as ambassador of Florence. He proposed replacing the two Councils of the People and the Commune with one General Council of the people, modeled on the Grand Council of Venice, with the task of electing magistrates and passing laws; and one Lesser Council composed of *ottimati*, men of wisdom, similar to the Venetian Council of the *Pregati*. The Lesser Council would examine the delicate affairs that were best settled quickly by a chosen few, in accordance with the Venetian proverb: "When too many people speak, dawn never rises."

Vehement debates followed this proposal, increasing public agitations. The only coherent appeals came from the pulpit of Savonarola, who, reneging on his decision not to become involved in political action, cried out:

A Florentine olive grove.

A terrace overlooking Florence.

In Italy, and above all in Florence, where men have keen wits and restless spirits, the government of one can only result in tyranny. The sole form of ruling suited to Florence is a civil and popular government. Woe to you, if you choose one head to dominate and oppress all the rest. . . . O my people! You know that I have always refrained from touching on the affairs of the State. I would not enter on them in this moment, if I did not deem it necessary for the salvation of souls. My words proceed from the Lord . . .

You have heard it said that states cannot be governed by Paternosters. Remember that this is the adage of tyrants, of men hostile to God and the common welfare. . . . If you wish to be ruled by a good government, you must submit it to God. Hence, when you shall have purified your hearts, rectified your aims, then set to work to frame your government, first proposing a draft of it, afterward proceeding to amendments and details. Make it so that *no man may receive any benefit* save by the will of the whole population who must have the sole right of creating magistrates and emanating laws. The best form of government for the city of Florence should be one modeled on the Grand Council of Venice. Therefore I would ask

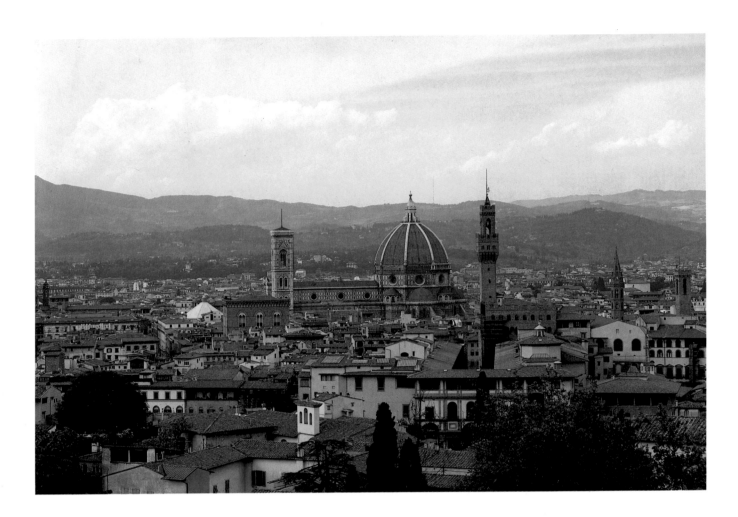

The Duomo of Santa Maria del Fiore, Florence.

OPPOSITE:
Santi di Tito. Portrait of Niccolò Machiavelli. Florence, Palazzo Vecchio.

you to assemble all the people under the sixteen Gonfalonieri and let each of the companies they represent make a proposal; from the sixteen forms thus obtained, let the Gonfalonier of the Signory select four and present them to the Signory, who, after having invoked the Lord's assistance, will choose the best one. I believe that the Venetian model will be the one chosen. We should not be ashamed to imitate the Venetians because they, too, were inspired by the Lord from whom all good things come. . . .

This sermon, delivered on a stormy December 12, 1495, marked Girolamo Savonarola's entrance into the political arena. The people were ready to bestow on him the title they had been forced to give to the king of France: Protector of Florentine Liberty.

In a series of bold moves, the friar supervised the organization of a new government composed of a Greater Council of one thousand members and a Council of Eighty. He enforced a new system of taxation based on the decima, or a tax of 10 percent on real property. He favored the institution of a Tribunal of Merchandising to set new commerce regulations, the abolition of the Parlamenti, and the formation of the *Monte di Pieta*, or Pawn Shop, to succor those in dire need of financial help.

His reforms, though criticized at the time by some Florentine politicians, were later praised. Machiavelli, who at first was unsympathetic to the

friar, later changed his opinion. "So great a man as Savonarola," he wrote, "should be mentioned with reverence."

In his *Remembrances*, Francesco Guicciardini asserted: "Florence benefitted from the Greater Council promoted by Girolamo Savonarola. The affections of the Florentines are so strongly set on the liberty given to them in 1494–95 that no devices, or caresses, or tricks of the Medici, will suffice to make it forgotten. It was easy to do so once, when only a few were robbed of their liberty; but now, after the Grand Council, too many would be robbed of it alike." And again, in his *Reggimento di Firenze*, he recognized: "You owe a great debt to this friar, who made the revolution at the right moment, and accomplished it without bloodshed.... For, but for him, you would have had first a restricted patrician government, and then an excessively democratic one; this would have led to riots and bloody clashes, and possibly ended in Piero's restoration by force. Savonarola alone had the wisdom to hold the reins loosely at first in order to pull them at the right moment."

As the city laboriously emerged from the post-Medici crisis, amid the open conflicts among the *Bianchi* (Whites) and the Piagnoni, who supported Savonarola's actions, and the *Bigi* (Grays), who still listened to the distant appeals from Piero, and the *Arrabbiati* (Enraged), who were opposed to the friar, Michelangelo sought to concentrate on his work, to resume normal activity.

The religious appeals of Savonarola were carried forth by his army of Angels, white-clad children and young men who raised red wooden crosses and roamed the city streets in search of the vanities, often ransacking artists' workshops wherever they found samples of the pagan art deplored by their preacher. It was difficult to retain the necessary calm of mind in such a volcanic situation. Torn in his own conscience, engaged in his never-to-end fight with the angel (the inner struggle between the spiritual drive and the weakness of human nature), Michelangelo relied on the power of his vocation, on a few old and steadfast friends, and on some of the new ones that his genius — shining through his youthful works — had attracted to him.

THE NEW LORENZO

Exiled from Florence by Piero, his cousin Lorenzo, son of Pierfrancesco de' Medici, was a grandson of Lorenzo the Elder, the head of the younger branch of the Medici dynasty who prospered in business but shied away from public life. Their position was always secondary to that of the main branch, and only much later in the history of their city (around 1537, with Cosimo I, the great-grandson of Pierfrancesco) would they take over as rulers of Florence.

Lorenzo returned to Florence in November 1494, after a rehabilitation strongly advocated by Savonarola. He cast off the name of Medici, and chose to be called *Popolano*, of the People. A month later, he was elected to the Council of the Reformers of the San Giovanni section.

He was a true lover of art, and clearly wished to share the title of

protector of humanists and artists with his Magnificent relative. He sponsored Sandro Botticelli by entrusting him to decorate his suburban villa at Castello and to illustrate Dante's *Divine Comedy.*

Himself a poet, Lorenzo of the People soon found a common denominator of cultural interest with Michelangelo in their love for Dante. To the young sculptor, recently returned from his exile in Bologna, the new Lorenzo was more than just another patron; he was a cord that tied Michelangelo to his adoptive Medici father. There was enough affinity between the new Lorenzo and his great namesake, barring their different political positions and the renunciation of the family name, for Michelangelo to feel that his relationship with the Medici was somehow continuing, despite changes and tragedies.

The first commission that Lorenzo obtained for Michelangelo was a marble statue of the patron saint of Florence, Saint John the Baptist. This work has been lost. The statues that are kept at the Staatliche Museen in Berlin, at the Victoria and Albert Museum in London (a plaster cast of which exists in Florence at the Galleria dell'Accademia), and at the Salvador Chapel in Ubeda go under labels that indicate a well-intentioned desire to recover this early work by the master, rather than any stylistic or historical certainty about their authenticity.

PENIEL AND FRAUD

The two sides of the Florentine coin, the sacred and the profane, had always attracted Michelangelo with equally suggestive power, as did the classical greatness of the Magnificent's new Athens and the religious revival of Savonarola. His first sculptures, the *Madonna of the Stairs* and the *Battle of the Centaurs and the Lapithae,* are perfect examples of this dichotomy; and the later *Bacchus* and his first *Pietà* executed in Rome would confirm it.

To Michelangelo, excellence in the profession of art could not be achieved without the exercise of a heroic life, bound to the thought of the Godhead, as Jacob was to the angel in the biblical episode set at the place he called Peniel.

Michelangelo had his Peniel early in his life, as the art historian Redig de Campos observed with deep intuition in his *Genius and the Angel:* "The Angel had two blessings: one was for men, the other for the company of heaven. And the Genius of man wrestled with the Angel of God, from the morning to the twilight of life's day. At noontime the Angel gave the Genius his first blessing: the one intended for men. But since the Genius wanted also the other blessing, he did not give up until the moment when — close to death — he wrested from the tired Angel also the last blessing: the one not meant for men, and the Genius was burned and overcome by his own victory."

Michelangelo gave himself to his art with a total dedication, allowing few distractions, and these he fought with painful abnegation to stifle whatever robbed him of his spiritual self and of his power of concentration. On one of his drawings he wrote: "O God, my God, how can it be that I am not mine anymore." His struggle with the angel continued, with

"And Jacob was left alone, and there wrestled a man with him until the break of dawn. And when he saw that he did not prevail against him, the man touched the hollow of Jacob's thigh, and the hollow was out of joint. And he said: Let me go for the day is breaking. And Jacob said: I will not let you go, unless you bless me. And the man asked: What is your name? And he answered Jacob. And the man said: Your name shall be called no more Jacob, but Israel: for as a prince you have power with God and with men, and you have won. And Jacob asked him: Tell me your name. And the man said, What need have you to ask me my name? And then he blessed him. And Jacob called the place Peniel: meaning I have seen God face to face."

GENESIS, 32:24-30

his ideals clashing one against the other, clasped in wonderful acts of love and hatred, until only what vitally mattered triumphed.

A few months after returning to Florence, Michelangelo could hardly recognize his city; Savonarola was succeeding in his drive to bring about a theocratic-republican regime. He began to notice how his fellow-citizens who had been the protagonists and the spectators of the Medici feasts were abandoning their rich attire in favor of more modest dress codes. He saw the churches fill up and the grammar schools lose their attendants, the Carnival turned into a religious festivity, and the erotic songs replaced by sacred hymns.

Shaken and defeated in his hope to arrive at an ideal coexistence between the two main impulses in his creative mind, he tried to react. He felt very much alone in a born-again Florence. He must have heard the faithful, pious echo of Savonarola's sermons from the mouth of his own brother, Leonardo, a friar himself at San Marco. Michelangelo saw that the most sensual painter of his adolescent years, the Botticelli of the *Birth of Venus* and *Spring*, had become a *Piagnone* and was ready to abjure his pagan past, along with many other colleagues.

Enamored of liberty, perhaps as a reaction to all this, Michelangelo tried to go against the current that was sweeping away almost all traces of the Laurentian golden age, by evoking, for his own pleasure, the Olympian dream being dispelled by the harsh penitential realism of Savonarola.

He fashioned in marble a *Sleeping Cupid* of exquisite Grecian perfection. Visiting him one day, Lorenzo thought it for a moment to be a real antique piece from one of the Roman sites in the Florentine region that sometimes released buried treasures. Maybe it was Lorenzo's desire to help the sculptor, at a time when funds for the arts were not as readily available as in olden days, that led him to trespass the confines of honesty. It is a verified fact that he caused Michelangelo to commit a fraud, with consequences that could have damaged the artist beyond remedy.

Lorenzo enthused about the classical quality of the statue, and he suggested that if Michelangelo aged it a little, he could fetch a considerable price for him. Did Lorenzo bolster his advice by hinting that a pagan god, even though an infant, would hardly survive the inflamed fanaticism of Savonarola's destructive followers? Better to sell the statue for a reasonable profit than have it smashed to pieces by the unpredictable results of iconoclastic violence. Michelangelo let himself be convinced by Lorenzo's insistence. The *Sleeping Cupid* found its way to a certain Baldassarre del Milanese, a merchant who bought and sold *anticaglie* (antique pieces) in Rome.

Michelangelo claimed that he received only thirty ducats from the dealer. It was a fraud within a fraud of which the twenty-year-old sculptor became aware only much later. He could hardly imagine that his fate, even all the way to a Roman prison, was in the hands of a powerful man, proud of being a connoisseur of antique art, whom Michelangelo, however reluctantly, had conspired to fool and humiliate.

9.
SECULAR AND HOLY WARS

The years from 1495 through 1498 were so taken up by political and military events in Italy, and Tuscany in particular, that a summary of the main events of that period is mandatory in order to have a panorama of the time.

The French occupied Naples after the Aragonese fled in 1495. Charles VIII's army alienated whatever sympathy they had initially found in the peninsula. Florence revolted against the king of France; Ludovico the Moor, duke of Milan, became aware of his mistake in having called for the invasion; and the Neapolitans, irked by the arrogance of the French, invoked a return of their Spanish kings.

On March 31, 1495, the pope, Ludovico, emperors Maximilian I and Ferdinand II of Spain and the Venetian Republic formed a Holy League for the alleged purpose of defending the Christian territories against Turkish invasion. The true aim of the league, hidden in the secret clauses of the pact, was to expel the French from Italy. In fact, the sultan of Turkey promised to help finance the army of over 20,000 infantrymen and 35,000 cavalry. Venice agreed to launch fleet attacks along the Adriatic coast. Ludovico the Moor was assigned the task of chasing the French out of the town of Asti and preventing any influx of reinforcements from France. Spain was to dispatch a fleet to Naples to restore Alfonso of Aragon to his throne, at the same time that Emperor Maximilian and the Spanish army were to attack the French borders by land.

Advised by Philippe de Commines, his shrewd ambassador to Venice, Charles VIII understood the real objective of the league. He ordered de Commines to visit the Italian states still loyal to France and summon their help. The ambassador visited Savonarola in Florence and reported that the friar displayed an awesome knowledge of international political affairs and, in particular, of the functioning of the Venetian Grand Council. "I have no desire," he wrote, "to pass judgment on his revelations, but he certainly predicted to me and to the king things that no one believed at the time, and that have been fulfilled since." Savonarola warned the French envoy that Charles would have to pay a high price for his errors and urged that the king mend his ways if he wanted to return to God's grace.

Leonardo da Vinci. Drawing of a giant cross-bow. Codex Atlanticus, fol. 53r. Milan, Ambrosiana Library.

Later, Savonarola was accused of revealing state secrets while talking to the French ambassador. De Commines was explicit in denying anything of the sort. "I believe him," he added in his report, "to be an honest man, and that any citizen of Florence could have told me the plain, public things I learned from him."

Charles VIII soon departed from Naples, with his army under the command of *condottiere* Gian Giacomo Trivulzio, and prepared to fight his way back to France. Upon his arrival in Rome, at the beginning of June 1495, he failed to gain an audience with the pope. Alexander VI, wary of the king's reaction to the sudden change in the papal political position, had left for Orvieto.

Later in June, Charles's army reached Siena. Great apprehension seized the Florentines, who were well acquainted with the treacherous nature of the king. Adding to their apprehension, the conflict with Pisa had escalated to such a level that the best of Florence's youth were serving in the field under the leadership of the brave Pier Capponi; the Republic had engaged Ercole Bentivoglio, a famous *condottiere*, and other captains to match the continuous supply of reinforcements that the Pisans were receiving from Milan, Siena and Genoa. Florentine ambassadors learned, with some surprise, that Charles VIII himself had provided 700 Gascon and Swiss infantrymen to fight for Pisa. To make things worse, the flames of rebellion were spreading all across the territory of the Republic. A week before the arrival of the French king, Montepulciano surrendered to the Sienese. And Charles drew closer to Florence, with Piero de' Medici in his retinue, always waiting for the right moment to attempt a comeback. Savonarola faced renewed unrest and called for solidarity among the factions.

Charles VIII moved on to Pisa, where he was accorded a triumph. The women of the town, dressed in black, bare-footed, with their hair loosened and ropes around their necks, staged a procession for the king, professing their detestation of Florence as the oppressor of their liberty, and asking for support in their long struggle against the Republic of Savonarola.

Charles continued his march to Lucca and Pontremoli. At Tornavo, on the banks of the river Taro, his twelve hundred men were confronted by a contingent of the league. The July 6 battle, fiercely fought, ended without anyone claiming victory. However, the French managed to ford the river and resume their progress northward. Charles stopped at Asti before finally crossing the frontier back to France.

On July 7, Ferdinand II of Aragon entered Naples without encountering opposition from the French garrison. In the space of one year, the French army twice crossed the Italian peninsula, victoriously at first, then painfully humiliated. The memory of their invasion was fraught with episodes of treason and disloyalty.

Later, Charles issued orders from Paris for his troops to release the Florentine fortresses held in Tuscany; but his officers disobeyed them, selling the Pisa stronghold to the local citizens for 24,000 gold florins, including in the price their valuable artillery. The strongholds of Sarzana and Sarzanello were sold to the Genovese; the Lucchese bought the for-

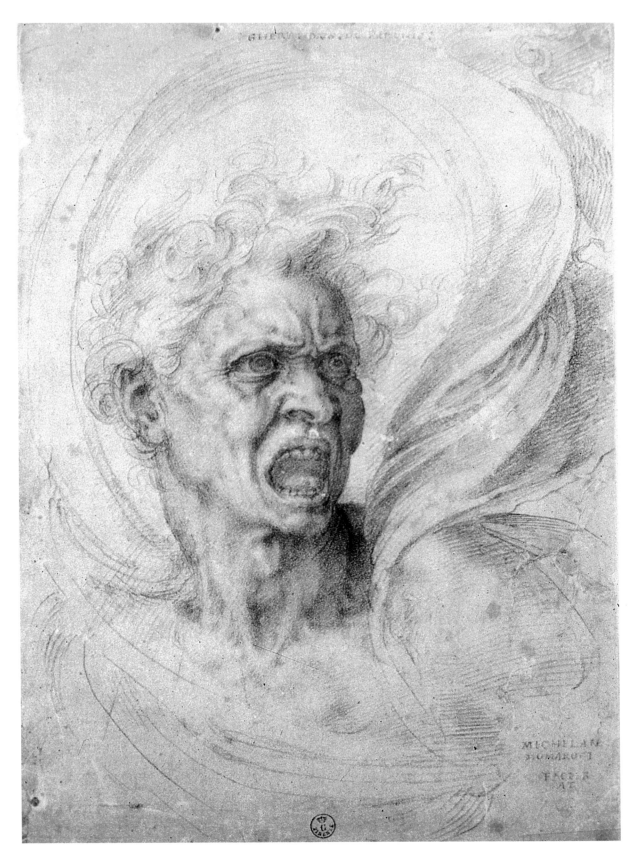

Michelangelo. *Fury.* Florence,
Uffizi Gallery.

tress of Pietrasanta. The only one returned to Florence was Leghorn.

With the French gone, the league was free to threaten the Florentine Republic. Under the protection of the pope and the doge of Venice, notwithstanding the animosity of Ludovico of Milan, Piero de' Medici was allowed to hire the services and the soldiers of Virginio Orsini, who had cowardly abandoned the French camp at the battle of Tornavo. The plan would have Piero and Orsini approach Florence, as Caterina Sforza, the ruler of Imola and Forlì, sent her troops from the side. Simultaneously, Giovanni Bentivoglio, at the head of the Milanese and the Venetians, was to advance across the Bolognese border. Perugia and Siena were supposed to aid the attack by contributing to the league infantry and cavalry contingents.

Piero and Orsini waited in vain for these reinforcements, wasting time and their already scarce financial resources. Upon Savonarola's incitement, the Florentines prepared their defense. The government of the Republic solemnly declared Piero de' Medici a rebel, thus stating that he might be killed with full impunity in order to protect the best interest of the state. Furthermore, it was stated: "Whoever kills the said Piero, who seeks to destroy our freedom, shall receive a reward of four thousand florins of gold."

Diverting attention from the war with Pisa, Florence dispatched twelve hundred men to guard the defense line at Cortona, while almost two thousand more manned the border of Siena to prevent the Sienese troops from aiding Piero.

Piero, penniless and hence unable to keep Orsini and his men under his banners, had no other choice but to disband his few followers; surrounded and humiliated, he chose to save his life by hastening back to Rome. His hope of finding support from the Arrabbiati, who had decidedly turned against him and his family, combined with the reluctance of Ludovico the Moor to aid a man he despised, had turned his attempt to total disaster. But his efforts directed against the friar did not subside. He persuaded the pope to send Savonarola a message asking him to go to Rome to be questioned about his alleged assertion that his prophecies came from God. The message was formally courteous, yet it ended in a harsh note as the Borgia pontiff enjoined the friar to wait on him without delay, by the vow of holy obedience.

Savonarola's friends, knowing well the character of Pope Alexander and aware that his enemies in Florence would not hesitate to conspire with Rome against him, urged him to beware lest he should end up in the dungeons of Castel Sant'Angelo. As an indirect reply to the papal order, Savonarola delivered one of his tremendous sermons. In front of the whole Signory and all the magistrates gathered in the cathedral for high mass on July 28, he reminded his listeners of the mortal danger twice avoided as the French army crossed Tuscany. He then directed his blows at the corruption and the scandals still marring Florentine private and public life: blasphemy, prostitution, unmentionable vices, gambling, graft. He referred to his reasons for staying in Florence: so much had to be done, and the need for vigilant prayer was so great that he had decided to stay away from the pulpit for a long while. He left his place to Brother Domenico da Pescia.

As for himself, the reward he expected for all he had done, and would do, was martyrdom. He was ready and willing to offer his life for the love of his city.

A few days later, he addressed a letter to the pope, claiming he would obey the summons, but at a later time.

In September a new papal brief arrived in Florence; this one addressed to the Franciscans of Santa Croce, the adversaries of the monks of San Marco. The language and the tone changed. In it, Savonarola was referred to as "a certain Friar Girolamo, a seeker after innovations, and a sower of false doctrines, who is seeking to make the people believe that he has a mission from God and holds discourse with God, although he is unable to offer any proof of this, either by miracles or the direct evidence of the Holy Scriptures.

"We have shown great patience toward him," the brief concluded, "in the hope that he would repent and retrieve his transgression by making submission."

Savonarola was quick to retort: "It is known to all the world that the charges made against me are false and will bring great infamy on those prelates and the whole of Rome. I well know that my accusers have no just cause for accusing me, but I do not fear either them or their power, because the grace of God and a clear conscience are my advocates. I know the roots of these plots and know them to be the work of evil people who would want to bring back tyranny to Florence, and they have other hidden powers behind them."

In a new letter to the pope he reasserted his innocence and declared his intention to submit himself and all his writings to judgment by the Holy Roman Church. The pope retaliated by ordering him to abstain from preaching and practice retreat.

Not everyone in Rome concurred with the pontiff in his relentless attack against the Florentine friar. A party led by the brave cardinal of San Pietro in Vincoli, Giuliano della Rovere, did not hesitate to back the accusations made by Savonarola. Moreover, the rumors of abominable iniquities committed by the pope's offsprings, who were openly accused of incestuous intrigues, murders by poison and dissolute practices of all kinds, stirred people to indignation.

Savonarola kept silent, devoting his time to study and meditation. On the death of his brother Borso, he wrote his mother a letter that was both moving and inspiring: "I would that your faith were as that of the holy Jewish women of the Old Testament, so that you might be able, without shedding a tear, to see your children martyred before your eyes. Beloved mother, I do not say this in order to comfort you; but to prepare you, lest I should have to die."

As the Carnival of 1496 approached, the Arrabbiati made plans to celebrate in the never forgotten Medicean fashion that the Savonarola-inspired ruling had forced to oblivion. The youth of Florence resumed the habit of stopping people in the streets to ask for money, barring the road with long poles and refusing to move until they acceded to their demands. They celebrated by wild feasting in the night, making bonfires in the

squares, dancing around them, singing and shouting obscenities, and crowned their carousal by engaging in the game of stones, a brutal contest in which one group pelted the other without concern for injuries, no matter how serious or even fatal. No penalty prescribed by law or other public ordinance seemed to prevail.

Once more, Savonarola succeeded where everybody and everything else failed. He had the prohibition of the game of stones firmly upheld; he turned the corners where the youth gangs convened into sacred places by having small altars erected there. He wrote songs to replace the bawdy ones, and bid the members of the gangs to collect money to be distributed among the *poveri vergognosi* (the timid poor). His absence from the pulpit was so widely lamented that the new Signory, elected on February 25, 1496, unanimously decreed that he was to preach during the coming Lent.

In Rome, a Dominican bishop, entrusted by the pope to examine the writings of his brother in the order, issued a response: he found nothing in Savonarola's many utterances that could be considered less than honest and orthodox. "Most Holy Father, this friar speaks against simony and the corruption of the clergy, which in truth is very widespread; wherefore I would rather seek to make him a friend, even if it were necessary, by offering him a cardinalship."

Alexander VI listened to the advice. The traditional purple hat, symbol of the cardinal's dignity, was sent to Savonarola at San Marco.

The friar received it with disbelief and anger. He did not spare his resentment to the bearer of the hat: "Come to hear my next sermon, and you shall hear my reply to Rome."

"A hat of blood I want!" he cried from his pulpit to an audience that overflowed the church, packing the square outside. "O Rome! Prepare for your punishment! I repeat the words of the Gospel: '*Audite verbum hoc, vaccae pingues*' — Listen to this, fat cows! How would you interpret these words: fat cows? For me they are the harlots of Italy and Rome. Are there none in Italy and Rome? One thousand, ten thousand are not enough for Rome, for there both men and women are made harlots.

"See how they go about seeking indulgences and pardons! Come here, go there, kiss Saint Peter, Saint Paul, this saint and that! Come, come, ring bells, dress altars, deck the churches, come. God mocks your actions, he does not need your ceremonies. Once Easter is over, you will be worse than before. All is vanity, all hypocrisy in our times; true religion is dead."

The dam of his ire was suddenly broken, his vehement oratory knew no restraint; Rome was branded as a source of all sins and corruption. And he resumed his preaching about the necessity to defend the Republic against the maneuvers of those who plotted in secrecy to restore tyranny.

On Palm Sunday, a huge procession led by scores of children carrying red crosses, waving palm branches and chanting, "Long live Christ, King of Florence!" went through the streets all the way to the Duomo. Alms were collected and given to the Pawn Shop to assist the poor.

Florence seemed to vibrate in unison with the voices of the innocent heralds of the friar. A red dawn opened Easter Sunday that year. Florence

wore it as a mantle of glory, the color of triumph, the color of blood and of martyrdom. The high tide that had helped Savonarola reign over the monarchy of Christ he had established in Florence by his fervor and faith was about to ebb. He would have to defend it with desperate courage, even unto his death. The hat of blood he requested instead of the cardinal's offered by the pope was being fashioned. Other challenges awaited him, other trials, before he could say with Christ on the Cross: "It is accomplished." Like Christ he would have to suffer abandonment, neglect, betrayal, and take on his shoulders the burden of human weakness.

At the end of April a conspiracy was discovered in Florence, its objective to tamper with the votes for the election of the new Signory (held every two months). Three of the people involved were sentenced to life imprisonment. Once again, Girolamo Savonarola proved to be a good prophet.

A GOD FROM OLYMPUS

The name of Cardinal Raffaele Riario was important in Roman society. Elevated to the rank of a Prince of the Church on his seventeenth birthday, Riario had been detained in a Florentine jail the following year, under suspicion of involvement in the Pazzi conspiracy. Once he was freed and was taken up by popes Sixtus IV and Alexander VI, his wealth vastly multiplied. His name became linked to acts of generous providence aiding artists and scholars, and to the Palazzo della Cancelleria, one of Rome's most elegant Renaissance buildings, which is said to include some work by Michelangelo.

"There Bacchus was not praised."

DANTE

In early June 1496, an envoy of the thirty-seven-year-old cardinal visited the Florentine sculptor and persuaded him to go to Rome in order to discuss his involvement with a certain pseudo-antique *Sleeping Cupid* that had disturbed His Eminence. Michelangelo reached Rome, "incensed at the idea of having been betrayed by a merchant, and attracted by the idea of visiting Rome, which the Cardinal's envoy had described as the widest field open to an artist who wished to display his talent."

His dreaded yet unavoidable meeting with Cardinal Riario ended in a cordial interrogation. Michelangelo admitted to having carved the *Cupid*, but denied any preconceived intention of using it for a fraudulent transaction. The sculptor lamented that he had been ensnared in such a dishonest plan, especially since it ultimately harmed a person of such special distinction as His Eminence Raffaele Riario.

The cardinal resolved the problem by forcing Baldassarre, the dealer, promptly to refund the two hundred ducats he had obtained for the sculpture. His Eminence was clearly more interested in the fact that the statue was stamped with the imprint of genius than in the matter of its authenticity as an antiquity. He offered the Florentine hospitality in his palace and promised him a commission. Michelangelo's biographers Condivi and Vasari assert that nothing came of this. But in a letter dated Saturday, July 2, 1496, Michelangelo wrote to Lorenzo of the People: "The cardinal seemed happy to see me.... Then he asked me if I had the heart to do something

beautiful. I replied that . . . he would see what I am able to do. We bought a piece of marble for a real life-size figure, and on Monday I shall begin to work."

In another letter, written to his father in Florence one year later (on Saturday, July 1, 1497), he related: "I have not been able to settle my business with the cardinal, and I do not want to leave before I am satisfied and remunerated for my labor."

Did Michelangelo refer to some work he had been doing for the cardinal's palace still under construction? In August 1497, he met with Piero de' Medici in Rome. Perhaps Piero wanted to be forgiven for the silly commission of the snow statue. Whatever the reason for the meeting, Piero and Michelangelo discussed the purchase of a block of marble for a project that the sculptor declared, in another letter to his father, he never started, "because Piero never did what he had promised."

Thus Piero the Unfortunate twice wasted his chance of an encounter with genius. He would not have another opportunity.

However, Michelangelo soon found a patron in Rome, a banker named Jacopo Galli, who was well placed with the Vatican and with the municipal administration of Rome. Good-natured and cultivated, Galli collected ancient works of art and kept his ear attuned to whatever signals of novel achievements the Roman breeze carried. We do not know how Galli first became acquainted with Michelangelo. Perhaps they were introduced by a man from Florence called Balducci, who worked in Galli's bank. Or perhaps it was the proximity of Galli's comfortable house to the palace of Cardinal Riario that provided the occasion of an encounter.

Whatever the circumstances of their meeting, it was an opportune time for both men. Michelangelo was impatient to get to work and disappointed by the lack of attention from his most eminent patron, all of which convinced him to move from the palace to the banker's house. And there he found *pane per i suoi denti*, bread for his teeth, as the Italians say, or more pointedly marble for his chisel.

Jacopo Galli asked him to sculpt a classical figure, and the elective subject was Bacchus, the god of wine and revelries, so often portrayed by the sculptors of antiquity. To Michelangelo, who now had had a taste of the pontifical city and its not exactly holy way of life, Bacchus offered a challenge. He certainly must have been surprised at the spectacle of the pope's cavalcade returning to the Vatican from a hunting party in the Roman countryside. His Holiness was dressed as a Spanish hidalgo and wore a plumed hat. He was followed by his fascinating daughter Lucrezia, and by his son Duke Cesare Borgia, about whom many unsavory stories were beginning to be told — ones that Michelangelo probably heard. Rumors were spread by the pope's own master of ceremonies, who told without too many qualms of the ancient Roman-style orgies that took place in the holy palaces of the Vatican in the august presence of the holy father himself.

When Michelangelo stood in front of the marble purchased for him by the banker, he must have paused to consider his first Roman experience. The *Bacchus* was there, enclosed in the block, with his bunches of grapes,

his pagan soul, his gifts and his curses. From the carved marble Michelangelo brought forth a young man, stultified by excessive drinking, tottering on the one foot that presses the ground in an effort to regain balance; his oblique, foggy stare fixed to the cup that a shaky hand strives to keep steady, while a child satyr bites a grape and derisively laughs behind his back.

The god Michelangelo summoned from Mount Olympus to the seven hills of Rome is not the usual joyous, carefree Dionysus of Greek ancestry. His *Bacchus* is a study in physical allure and depravity; the god is a young man with admirably constructed limbs, marred by a protruding belly, the mark of incipient decadence. The impression it gives is one of sensuous delight and repulsion at the same time. This bibulous reveler is a marvelous representation of two spiritual themes: the pagan, and the renascent spirit for which Girolamo Savonarola cried and wept and was ready to die. Yet the *Bacchus* shows a faithfulness to the sources of classical mythology, possibly advocated by Jacopo Galli himself in his enthusiasm for antique models.

In 1548, Francesco de Hollanda wrote: "I was shown in Rome, as an antique and wonderful work, a god *Bacchus* in marble, with a very young satyr who holds a basket of grapes...."

Somehow, the statue came to lose its right hand, as it appears in studies of it drawn by Girolamo da Carpi (at the Rosenbach Foundation in

Michelangelo. Detail of *Bacchus*. Florence, Bargello National Museum.

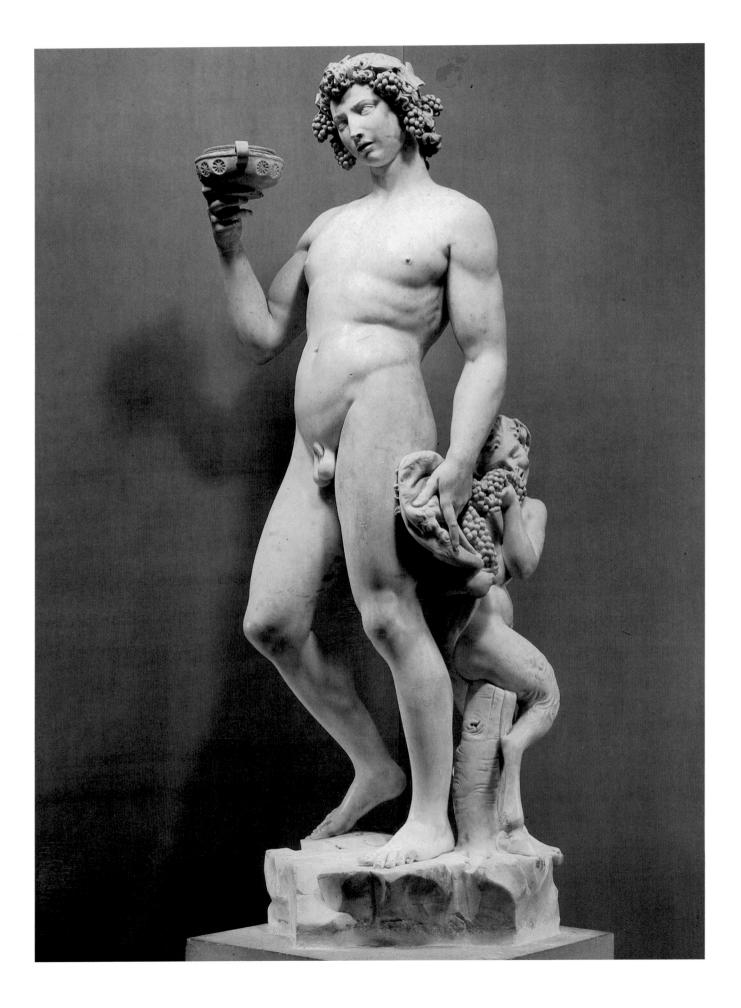

Philadelphia) and in those made by Maerten van Heemskerck and by the anonymous artist of the Cantabrigiensis Codex (at Trinity College in Cambridge). Did Michelangelo take the challenge of measuring his talent up to the excellence of his ancient predecessors to the point of breaking the hand off in order to accentuate its antique look? Or did the statue lose its hand because of some mere accident?

Thanks to Galli, Michelangelo was given the chance to pass quite swiftly from Olympus to Golgotha in his creative visions. The banker had learned of a commission requested by the French cardinal Jean de Villiers de la Groslaye, a Benedictine monk made bishop of Lombez and later abbot of Saint Denis. Dear to King Louis XI, who had reason to appreciate the intensity of his faith and his monastic rigor, de Villiers had been made cardinal in 1493. When Charles VIII invaded Italy, de Villiers followed him and took up residence in Rome. Galli became aware that the cardinal wanted to leave a memento of his Roman sojourn by commissioning a work of art worthy of the first basilica in Christendom.

For this reason, he introduced Michelangelo to the cardinal. As a Benedictine versed in the fervent writings of Saint Bernard, the cardinal wanted his statue to be a tribute to Mary, mother of God, whose cult was also close to the heart of Pope Alexander, notwithstanding the striking antithesis between the purity symbolized by the Virgin and the debauchery of the pontiff's behavior.

But the news that came from Florence just as his talent was being challenged by this commission saddened Michelangelo. After years of arm wrestling and many attempts to reduce the friar to reason, Alexander VI had lost his patience and excommunicated Savonarola. What added to the anguish of men like Michelangelo, who were torn between passions of diverging nature, was the change of heart evidenced in his Florentine citizens. Tired and vexed by the escalation of austerity measures advocated by Savonarola, who had not hesitated to order the destruction of works of art and other precious goods, the Florentines had deserted their former savior.

Far from his city, the echoes of the great tempest rumbling in his heart, Michelangelo faced the first capital challenge of his life as a sculptor. In the block of marble that awaited him, the conflicts of his times and the inner tempest of his soul were to find appeasement and sublimation.

OPPOSITE:
Michelangelo. *Bacchus*. Florence, Bargello National Museum.

10.
THE PROPHET'S VOICE IS SILENCED

"Can you thunder with a voice like his?"

JOB 40:9

In 1497, Francesco Valori became the new Gonfalonier of Justice for the January-February term in Florence. He was a man whose good faith and honorable intentions were not matched by political skills. He ignored the cautionary advice given him by Savonarola to keep the number of the Grand Council members as limited as possible, in order not to favor the infiltration of the Bigi and the Arrabbiati, the two parties opposed to the reforms enacted by the friar.

The second group was particularly aggressive; with another Carnival on the way, the young Arrabbiati organized themselves in bands named *Compagnacci* (bad companions), headed by a notorious troublemaker, Rodolfo Spini, better known as Doffo. Unfortunately, the new democratic rules allowed these rogues to become part of the Council, and to carry forth their disruptive activities from a position of power.

The new Gonfalonier took another false step by imposing a graduated, escalating tax called the Tenth Climb, which was supposed to lay equal burdens upon all. Supported by the lower classes and strenuously opposed by the wealthy, this controversial measure caused tempers to flare and bitter and violent confrontations to erupt, and finally led to the exacerbation of popular feelings against Savonarola. Although rigorously observing his voluntary isolation, Savonarola was still blamed for the daily sermons that his substitute preacher, Brother Domenico da Pescia, zealously inflicted upon the less and less pious audiences.

The somber veil of penance enveloping Florence was made thicker by the children's crusade that Savonarola had set in motion, now in full flood all over Florence. Another friar of San Marco, Brother Maruffi, Savonarola's favorite companion and adviser, was promoting what he called the "Bonfires of the Vanities." The children went about knocking at doors, sometimes breaking down those of artists' workshops, to demand the surrender of any objects — from game boards to cosmetics, from books to works of art, from ornaments to Carnival costumes and masks — that might be considered vanities, emblems of the pagan spirit condemned by the friars. The rise of the Compagnacci was countered by the Piagnoni, who were turning into a less submissive group, that of the *Frateschi*, or

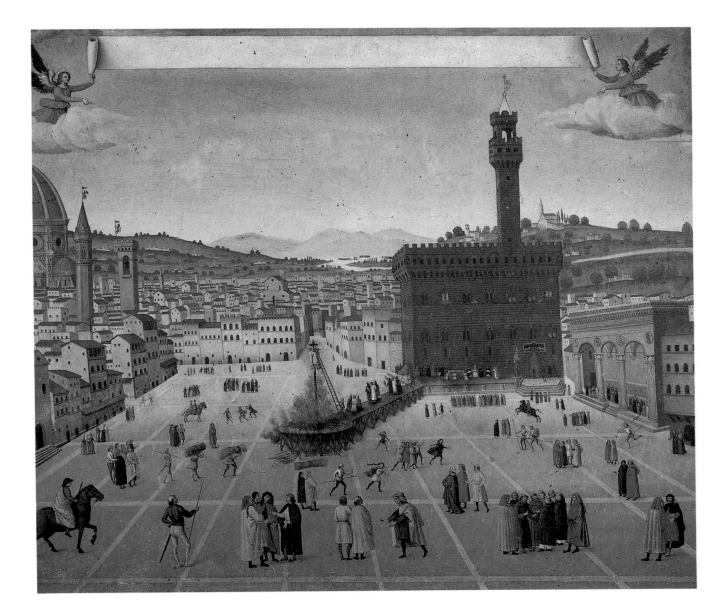

partisans of the friars, who seemed not too prone to heed the evangelical bid of "turn the other cheek."

On the seventh day of February, a procession of children and Frateschi marched through the streets singing religious hymns and collecting alms for the poor. In the piazza of the Signory, a huge pyramid was erected. Two hundred and forty feet wide at the base, the pyramid soared sixty feet high. It was composed of all the objects obtained or forcibly seized during the search for vanities. As the procession flowed into the piazza, the pyramid was set aflame. The palace bells, soon joined by every other bell in Florence, pealed in triumphal concert.

As described by the eyewitness Girolamo Benivieni, a poet and former friend of Lorenzo the Magnificent: "The flames consumed many lewd, vain, and loathsome objects, gambling cards, chess boards, and several paintings, beautiful but indecent, and some sculptures of remarkable value...." Benivieni added, as if eager to seek an alibi for future history accounts: "Should anyone deem these bonfires as childish games, let this person know that — if bound by a true Christian faith — it would be

Anonymous (fifteenth century). *The Martyrdom of Savonarola.* Florence, Church of San Marco.

better to cast off the spectacles of satanic pride and put on those of Christ's humility, before being tempted into passing judgment."

The reaction of the populace adverse to the rigors prescribed by Savonarola, and more specially that of the youths compelled to observe yet another funeral of their traditional Carnival (with dances and feasts strictly prohibited), mounted from a vociferous protest to a crazed and brutal avowal of violence.

The adversaries of Savonarola found it easy and convenient to fan the smoldering ashes of the bonfire, in order to spread the flames of public disapproval. When the friar resumed his preaching, his scourging of Rome took on more a vitriolic tone. He denounced the great harm that came to the Church from owning temporal possessions and directly addressed the moral decadence of the clergy: "The earth is replete with bloodshed, and the priests take little heed, and with their bad example they spread spiritual decay among the faithful." Once more, he proclaimed his preparedness for martyrdom: "I seek only your cross, O Lord. Let me not die in my bed. Let me be persecuted. Let me give my blood for you, even as you gave yours for me."

Alexander VI resorted to an extreme proposal in order to avoid a religious scandal. He sent word to the Signory, declaring his intention of mediating with Pisa to obtain her surrender in exchange for the adherence of the Florentines to the Holy League, and the submission of Savonarola to papal authority. The Signory instructed its special envoy Alessandro Bracci to reject the pope's offer, by stressing the fact that the Republic had always honored its pacts and alliances. Alexander burst into a fit of rage: "We are aware that your decision derives from your belief in the prophetic virtues of that friar of yours; you allow him to wound us, threaten us, and trample upon us who, although unworthy, are sitting on the throne of Peter."

Conditions in the city worsened. The Bigi incited the people to revolt, aided by a recent outbreak of the plague and a famine that caused a steep rise in the cost of bread. The Frateschi, coherent with the faith they professed, opened their houses to the sick and starving. According to Jacopo Nardi's *History of Florence*: "Many thousands of people die of hunger, and fall down exhausted by the roadside or on the doorsteps of the houses to which they have dragged themselves seeking refuge."

Over the dark storm rang the shrill voice of Brother Mariano from Genazzano hurling insults and accusations against Savonarola, the man "responsible for attracting the Lord's punishment over Florence."

In Rome, Piero de' Medici continued to lead his lazy life, lulled by comforts of all kinds, enjoying good food and amusing company. But he was still scheming to recover his place in Florence and did not let anything, including his mounting debts which he had to repay at a high interest rate, discourage him from plotting. He felt encouraged by the successful maneuver staged by the Bigi to have one from their ranks elected as Gonfalonier for March and April: Bernardo del Nero had always been a partisan of the Medici and a stern supporter of any initiative aimed at bringing them back.

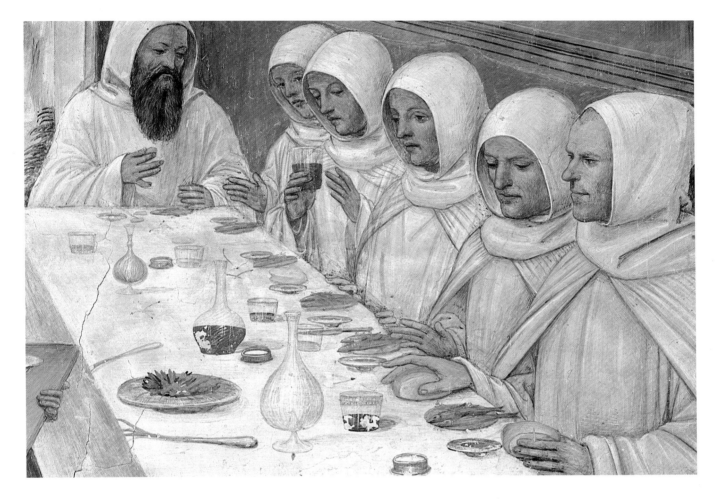

The news of the election spurred Piero to take action. He solicited, and received, funds to hire Bartolomeo da Alviano, a *condottiere* of rising fame, putting him in command of over thirteen hundred men. Piero was advised by Bernardo del Nero, whose term was about to expire, to be cautious, but Piero did not listen. At the end of April, he set off for Siena, knowing that he would be welcomed by its friendly ruler, Pandolfo Petrucci. On the twenty-seventh, he ordered Bartolomeo da Alviano to proceed toward Florence. The march was accomplished almost with the speed of lightning. The Medici troops were a few miles away from the Gattolini Gate, confident that, aided by the surprise factor, they would be admitted into the city without much resistance.

A rainstorm broke out during the night, forcing them to camp. A Florentine farmer who spotted the movement of soldiers and equipment rushed to Florence and gave the alarm. Defense measures were immediately taken. Savonarola, being asked for his counsel, urged every citizen to remain calm. He predicted that Piero would fail.

His words echoed throughout the city with the resonance of a prophecy. A few hours later, as the Medici rode with his men, he found the gate to the city bolted. Then, from the crenellated walls, an avalanche of Greek pitch, stones, cannonballs and harquebus fire fell on him and on Bartolomeo's troops, who were forced to retreat in total disarray.

Following this defeat, Piero could not summon either the courage or the determination to launch another assault. He abandoned any surviving

Sodoma. *Stories from the Life of Saint Benedict*, detail showing the Monteoliveto brothers dining. Abbey of Monteoliveto Maggiore.

hope of resuming his rule in Florence. In the evening of that same day, a new Gonfalonier, Piero degli Alberti, was elected to replace Bernardo del Nero, and the Signory entrusted Tommaso Tosinghi and Francesco Valori to monitor constantly the whereabouts and moves of the unfortunate Piero. Degli Alberti belonged to the party of the Arrabbiati, now decidedly against both the Medici and Savonarola.

The raging pestilence in the city was heightened by the increasing heat, giving the Signory a reason for ruling out all preaching, in order to prevent crowds in the churches. Savonarola was reduced to silence. The Piagnoni protested that the friar should not be impeded from speaking. Their foes, particularly the Compagnacci, swore that he would be silenced. The Signory relented, issuing orders that Savonarola not be disturbed while in the sanctuary of his church.

But Doffo and his band had no intention of abiding by this order. On Ascension Day they stormed the church, covered the pulpit with dirt, and draped a donkey's hide over it. On the ledge where Savonarola customarily banged his fist when he got carried away by his torrential eloquence, they nailed sharp iron spikes.

Some Frateschi tried to dissuade the friar from facing the provocation, but he rejected their warning. No action of man would scare him away from performing his duty as a spiritual shepherd to his good people. So the pulpit was diligently cleaned by the Piagnoni and the Frateschi, and the sermon was delivered with the usual energy: "I am accused of sowing discord; but Jesus himself said, 'I am not bringing peace, but a sword.'"

During the sermon, and in accordance with a secret plan, the Compagnacci struck their blow. One of them hurled an alms box across the nave, a signal to start a riot that would possibly lead to the assassination of the friar. His followers rushed to protect him; shouts of "Long live Christ!" rose over the screams of the Compagnacci. Savonarola tried to make his voice heard: "Wait! Have patience!" he cried. But he was escorted to his convent and guards were posted to prevent further attacks.

At last, the long-expected papal bull of excommunication fulminated from Rome:

> We have heard from many persons who deserve to be believed that a certain Friar Girolamo Savonarola has been spreading dangerous doctrines, to the scandal and consternation of simple souls. We had already ordered him to abide by his vows of obedience, and desist from preaching, and come to our feet to seek forgiveness for his errors; but he refused to obey and put forth various excuses, which we too tolerantly accepted, hoping to bring him to conversion by our clemency. Instead he persisted in his obstinacy; with a second brief we commanded him again. . . . But he remained obdurate in his stubbornness, thus ipso facto incurring censure. We are therefore commanding that, on all coming religious festivities, and in front of your congregations, you declare said Friar Girolamo excommunicate, and to be held as such by everyone, for his failure to obey our Apostolic admonition and orders.

Under pain of the same excommunication, all faithful are forbidden to assist him, have contact with him, or express approval of him either by word or deed, inasmuch as he is an excommunicated person, and under suspicion of heresy. Given in Rome this thirteenth day of May, 1497.

In a public ceremony celebrated by the light of innumerable torches and amid the tolling of funeral bells, the bull of excommunication was read in all the major churches of Florence: Santa Croce, Santa Maria Novella, Santo Spirito, the Annunziata. Dumbfounded crowds listened to the papal decree and, as the reading ended, in accordance with the ancient ritual, all the torches were turned upside down and extinguished by pressing them to the ground.

After the first moments of perplexity, the Signory stood up to defend its indomitable friar, asking the Florentine envoys at the Vatican to intercede for Savonarola and have the excommunication lifted. For a while, there seemed to be a flicker of hope. On June 14, the duke of Gandia, the pope's son, was killed. His brother Cesare, Cardinal of Valencia, was suspected of fratricide. The pope appeared to be overcome by grief and many believed that he might be moved to opt for mercy. But Alexander VI remained firm in his condemnation of the friar. Not even a letter from Savonarola, written in tones of the utmost sincerity and humility, received any acknowledgment other than contemptuous silence.

Personal struggle did not distract Savonarola from the pastoral and practical care of his people who were still besieged by the plague. He wrote an "Epistle to all the Chosen," which bore this subtitle: "A Medicinal Treatise against the Plague." It listed seven rules for protecting body and mind by temperance and tranquillity. It prescribed moderate eating, cheerfulness of spirit and charity to the sick. "Aid the sick," he recommended, "serve them, assist them and cure them in all ways, even if they are your enemies."

In August, the pestilence began to subside, the hospitals gradually emptied and those who had taken refuge in the countryside returned to the city. Peace seemed to descend on Florence and its crown of hills, as

THE PROPHET'S VOICE

"Our earth is full of blood, and the priests do not care. Instead, with their bad example, they kill everyone in the soul. They have drawn away from God and their cult consists in spending the nights with prostitutes, and the days gossiping in the choir stalls, and turning the altars into market stands. Beware, ribald Church! The Lord says: I had given you fair robes and you have made idols of them. You have used the sacred vases for your simony. . . . You are an abominable monster. Once you were ashamed of your sins; now you do not show any shame at all! You have exhibited your ugliness to the world, and your stench has risen to the heavens."

GIROLAMO SAVONAROLA
sermon at Lent, in the year of our Lord 1497

gentle as the September rain. Everyone trusted that the turbulent year would finally wind down to a quiet end.

Yet the wind of a new tempest was already on its way.

ORDEAL BY FIRE

An investigation, conscientiously conducted by Valori and Tosinghi to untangle Piero's treacherous plots, came to an unexpected turning point. They discovered a letter written by Lamberto dell'Antella, a man who had been banished from Florence. A former supporter of the Medici, Lamberto was so disgusted with Piero that he wanted to expose him and all those who had helped him. "He kept us continually on the move," wrote dell'Antella, "in order to fulfill his mad desire to return to Florence, and ended up treating us worse than dogs." Promised a pardon, Lamberto delivered a thorough account of Piero's schemes and named his accomplices in Florence, including the former Gonfalonier Bernardo del Nero.

Francesco Valori immediately demanded that all the traitors be sentenced to death. Others tried desperately to save as many heads as possible. Once again, the city was torn asunder by various factions clashing against one other. A revolt was feared. At last, it was decided that five of the conspirators should be executed.

Throughout this episode, Savonarola distanced himself from the civic passions. The Signory continued to send embassies to Rome to resolve the question of the friar in a way that would be satisfactory to all parties, and to induce the pontiff to use his influence in reducing Pisa to reason, thus reintegrating it in the Florentine Republic.

Little or no ground was gained at the Vatican. On Christmas Day, 1497, Savonarola celebrated mass at the altar in San Marco. He denounced the injustice of the papal excommunication, invoking the Gospel as his best witness. He swore he had committed no heretical action in lamenting the indignities of the papacy. "In the times when priests were inspired by a true Christian spirit, Paul could reprove Peter in front of everyone for being deplorable," he stated. "This is the reason that has prevented me from admitting to Rome that I have erred."

Strong, undeterred, the friar's voice thundered on: "To say that the pope, as pope, can do nothing wrong, is to affirm that a Christian, inasmuch as he is a Christian, a priest as a priest, can do no wrong. As individuals, the pope, the Christian, the priest, all are liable to err. When the pope errs as the leader of the Church, he is no pope; and if he issues a wrongful command, it cannot be held to proceed from the pope . . . as the Vicar of Christ. . . . When the pope orders you to do some deed opposed to charity, if you obey, then you will grant more to the pope than to God."

Lent in 1498 began with a second bonfire of the vanities. Another huge pyramid of precious objects and works of art was erected in the square of the Signory, surmounted by the figure of Satan surrounded by the seven deadly sins. Everything was burned to ashes.

A short time later, Savonarola proposed that a council of the Church

be summoned to restore order and morality and to enforce the necessary changes. "A council," he explained, "is a general meeting of the Church, that is, of all the abbots, priests, prelates and laymen who belong to the militant Church. . . . In a council, wicked priests are chastised, and a bishop guilty of simony or schism is deposed."

Pope Alexander viewed this proposal as an attempt by the friar from Florence to instigate an all-out attack against him and his court. New papal warnings were conveyed to the Signory. The Florentines were advised that, by continuing to defend an excommunicated member of the clergy, they were going against God's utterance: "render to Caesar what is Caesar's, to the Lord what is the Lord's."

The traffic of letters and embassies to and from the Vatican intensified. The pope grew more and more angry as he renewed his admonition to Florence not to meddle in ecclesiastical matters. Alexander insisted that Savonarola submit to the summons he had received and repelled. He must appear in Rome and be questioned. As soon as he obeyed, all disputations would end, and Florence would be restored to the pope's grace.

The governing body of Florence was divided between closing the rift with the Vatican in the interests of the Republic, and resisting papal intimations in order to save the friar from the dire fate reserved for him in Rome. After lengthy discussions, it was decided to adopt a temporary measure to avoid giving the Borgia pontiff further reasons for feeling vexed. On the evening of March 17, 1498, after delivering a sermon to a small crowd of women at the morning mass in San Marco, Girolamo Savonarola received the Signory's injunction to desist from preaching.

With a heavy heart, he released his "Letters to the Princes," epistles written to the kings of France, England, Hungary and Spain and the German emperor. The text, virtually the same for each, began on a harsh note: "The moment of vindication has come. I am commanded by the Lord to reveal new secrets, and declare to the whole world the danger that is threatening the boat of Saint Peter. . . . I hereby bear witness, in the name of the Lord, that Alexander is no pope, nor can he be held as one; and this because, even without counting the mortal sin of simony which he committed in buying his election to the papal throne, he sells benefices of the Church every day to the highest bidders, and — again leaving aside his known vices — I avow that he is no Christian, and believes in no God."

Savonarola asked his loyal secretary, Niccolò from Milano, to show drafts of the letters to a number of trusted friends meant to convey them to the various courts. The people involved hesitated long enough to allow the friar time to meditate on the enormity of his step. However, a draft of the letter addressed to Charles of France fell into the hands of some Milanese knaves who were only too glad to forward it to Ludovico the Moor. From the latter the document traveled to Cardinal Ascanio Sforza in Rome, and from him it reached the pope.

Thus began the penultimate act in Savonarola's tragedy.

A bizarre event took place in Florence on April 7, 1498. A Franciscan monk from Santa Croce, Brother Francesco from Apulia, who had been accusing Savonarola of heresy and false prophecies in his Lenten sermons,

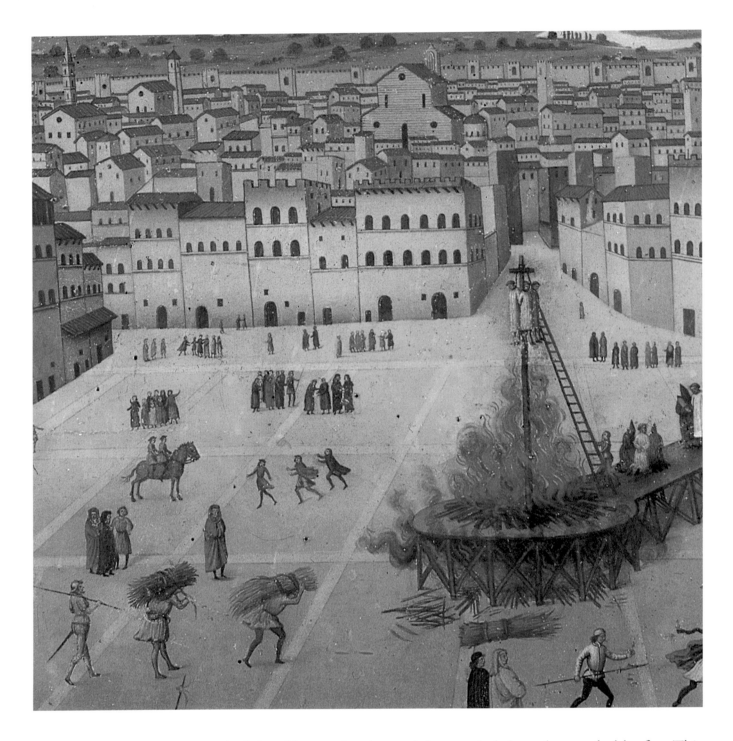

Anonymous (fifteenth century). Detail of *The Martyrdom of Savonarola*. Florence, Church of San Marco.

had dared him to let the truth be revealed through an ordeal by fire. This was a medieval means of establishing guilt or innocence by having people face a dangerous or painful test (by battle, fire or water), in order to let God be the sole judge. Overcoming the ordeal was believed to be a supreme witness of God's grace, and a proof of innocence.

Brother Francesco had no doubt: he was ready to step in the flames and he challenged Savonarola to do the same. Brother Domenico da Pescia, alleging that the holy man was to be spared for higher matters, offered to take on the challenge himself in his stead. The whole episode would have ended up in nothing more than an exchange of aspersions, except that the Compagnacci, eager to seize any opportunity to cause the demise of their

foe, appealed to the Signory to take over in order to "prevent possible tumults in the city."

Quite incredibly, their plea was taken seriously and the cruel, absurd contest was planned. The Franciscan (who had insisted that he wanted Savonarola, and only Savonarola, to face the ordeal with him) suddenly appeared almost relieved by the friar's decision not to pick up his challenge. However, not to lose face, he proposed that a brother from his order, Giuliano Rondinelli, take his place in the challenge with Brother Domenico. On March 30, the accord for the ordeal was signed. All of Florence followed the transaction, and many offered themselves to face the test on behalf of the two contenders.

The date chosen for the event was April 6; but on the evening of the fifth, the Signory announced that the contest would be postponed to April 7. The reasons for the delay were not disclosed, but there was a rumor that an order was awaited from Rome that would cancel the ordeal.

Silvestro Maruffi, Savonarola's inspired sleepwalker, claimed that his visions had revealed to him that their own Brother Domenico would survive the ordeal unscathed. The day before the contest, the Signory issued a decree stating that "if Brother Domenico should die as a consequence of the ordeal, Friar Girolamo Savonarola would have to leave the Florentine territory within the space of three hours."

On the morning of the seventh everything was ready. Special supervisors were appointed to oversee the preparations. Only three entrances were to be left open to the square of the Signory where the pyre and a wooden pathway for the two contestants were erected. The city gates were to be kept closed for the duration of the ordeal, and the troops were not to abandon their posts under pain of death.

Savonarola celebrated a mass to invoke the assistance of the Lord. Florence held her breath as a procession of the friars of San Marco marched toward the square. Two hundred followers of Savonarola walked solemnly in pairs behind a huge crucifix held high in their midst, escorting Brother Domenico, who wore a mantle of bright red velvet, his hands joined to hold a cross. He appeared calm, almost unaware of the excitement that surrounded him.

Savonarola, carrying the monstrance with the holy host, intoned a chant soon echoed by the huge crowd: *Exurgat Deus* (May the Lord rise and dispel his enemy).

It was almost nine at night when the procession reached the square. People perched on every balcony, roof, terrace. Many climbed poles or statues to be able to witness the challenge.

As the crowd grew more and more impatient, new arguments were raised by the Franciscans, evidently in an attempt to delay the ordeal. Although Brother Domenico was ready, his opponent was yet to be seen. The Franciscans objected that it was not permissible to enter the fire holding a crucifix because the destruction of the sacred object constituted a sacrilege. Brother Domenico announced that he would carry the host onto the fire with him. More, and louder protests were voiced at this by the Franciscans.

As evening fell, the sky over the square flooded with dark clouds, and thunder and lightning foretold an incoming storm. Spurred by the Compagnacci, and tired by the long wait, the throng turned wildly against Savonarola, whom they blamed for the failed spectacle. The enemies of the friar claimed victory; Savonarola had certainly worked some diabolical enchantment to provoke the storm and be spared the trial by fire.

The crowd was enraged. The teeming rain that began falling on the square, the pyre and the crowd was the ultimate signal that the morbid spectacle would not take place. The disappointed spectators did not know that a powerful hand, far away, had already given the signal for the building of a new pyre. And this time, an unconquerable fire would provide for a successful show.

"TORTURE QUESTIONS, PAIN ANSWERS"

The bell called the "Piagnona" of the Church of San Marco. Florence, Museum of San Marco.

By now, Florence was almost unanimously turned against Savonarola and his brothers. People were disappointed because they had believed their prophet possessed superhuman powers; many felt like betrayed lovers, angry at being unrequited.

On Palm Sunday, April 8, as the friar was about to celebrate mass in San Marco, his first prayer became the signal for the Compagnacci to vent the popular rage. The mob accused him of attempting to defy the Signory's prohibition to preach. This was a lie, for he had no intention of delivering a sermon; his was only a ritual prayer, but it was seized as a pretext to attack him.

On the square of the Duomo, Brother Mariano Ughi, a companion of Savonarola, was about to begin his homily when a band of Compagnacci prevented him from addressing the large crowd. Scuffles erupted all over the place, Ughi and his friars were chased from the square, hunted along the streets as they raced toward their convent under a shower of hurled stones. People were hurt, a young boy fell down in a pool of blood, many were trampled by waves of wild assailants. The mob reached San Marco. The frightened faithful were barricaded inside the church. Some Compagnacci tried to force the door open; a poor man who barred the entrance was pierced by a dagger and died on the threshold of the church.

Panic ensued. The famous bell of San Marco, the Weeper, rang out for help, but the Signory seemed not to hear it. Before sunset, an order came to the besieged convent from the palace: Savonarola must leave Florence before noon the next day.

The friar agreed, but his people begged him not to go; they armed themselves and were ready to defend him and his convent. Savonarola stopped them, biding them to lay down their weapons. He returned to the church to pray.

Francesco Valori, who was among the defenders of the convent, wanted to break the siege and go for help. But the mob turned against him, forcing him to run to his house, where he hoped to hide safely in an attic. A terrible surprise awaited him as he climbed the stairs leading to his shelter. His foes had preceded him: his wife lay dead, his house ransacked.

He himself was beaten to death as a group of Compagnacci were dragging him to the Signory palace.

Savonarola, in his truly superhuman serenity, ordered the doors of his church thrust open. "Let us listen to their complaints," he said.

A few friars reached the door, armed only with torches. The mob fell back at the sight of them. Soon, however, the assault was renewed. The church was flooded. Shots were exchanged, as one of the friars, having snatched a harquebus from the hands of a mobster, began firing at the Compagnacci with infallible precision. The church resounded with prayers, moaning from the wounded, cursing and invocations for help.

Savonarola grabbed the holy sacrament from the tabernacle and rushed to the convent, taking shelter in the library, where the guards of the Signory, who came to summon him to the palace, found him. Brother Domenico objected that they must have a written document to confirm the summons and the guards departed.

Urged to flee to safety, Savonarola refused to move. He would face his accusers. Brother Domenico insisted on accompanying him. As soon as the guards returned, the two friars surrendered to them. Other friars wanted to join but Savonarola stopped them: "In the name of our holy obedience," he told them, "do not come. Brother Domenico and I are going to die for the love of Christ."

On Holy Monday, 1498, a trial began, with sessions of pitiless torture. The accused were tied to the wheel and stretched violently till their bones were dislocated and their muscles torn. The tribunal was presided over by Francesco di Messer Barone, a notorious criminal recently returned from exile, who tried to extract a false confession. But the only result he was able to achieve was to compel Savonarola to admit that he was not a prophet, that he had no divine mission to prophesy. The torture so severely weakened the friar that he could not feed himself. Some of his brethren were summoned to countersign the final text of his confession and he asked them to pray for him. "God has taken away my spirit," he claimed. His Garden of Gethsemane had come, and like Jesus he had to shed his tears of blood. Brother Domenico displayed no lesser courage in asserting his faith beyond the torments of the torture.

Shortly after, Brother Maruffi was found in a refuge where he had been hiding. He was arrested and taken to join his superior in the prison.

The pope rejoiced over the capture of Savonarola. He sent a pontifical letter of commendation to the Florentines, relieving them from his threat of excommunication and granting them a plenary indulgence according to which all their sins were forgiven. Alexander VI would still have liked Savonarola sent to Rome, but he seemed to accept the fact that the Signory was not willing to renounce its right to judge the friar.

A second trial, which began on April 22, did not add much to the meager results of the first. The newly elected Signory decided to inform the Borgia pope that the refusal to surrender Savonarola to Rome was justified by the strong desire of the Florentines to see him meet his punishment in their city. Alexander was invited to send his ecclesiastical judges to Florence, where they could try him at their convenience.

Quite promptly, on May 19, the papal commissioners Gioacchino Turriano, Superior General of the Domenicans, and Francesco Remolines (or Romolino), fierce doctor of law, arrived in Florence "to examine into the crimes and iniquities of those three children of perdition."

Locked in his narrow cell in the tower of Arnolfo, Savonarola had been nursing the terrible lacerations caused by the torture. His limbs were one sole bundle of pain; only his left hand had been spared the torments to allow him to sign the depositions. He occupied his time praying and writing. His first work was a comment on the fifty-first Psalm: *Miserere mei Deus*, Lord, have mercy on me; the second was an equally moving and fervent exposition of the thirty-first Psalm: *In te Domine speravi*, In you, O Lord, have I hoped. In it Savonarola told of the struggle between hope and despair contending for his spirit. "Despair has pitched his camp around me. . . . He has filled my heart and wages war against me without cease, with violence and clamor, day after day, night after night. My friends are arrayed under his banner, and become my foes."

The apostolic commissioners were not inclined to waste any time. The third trial began on May 20 and the examiners tortured the friar without pity. He reiterated his innocence of crimes against the Church or the faithful. He denied having revealed secrets learned in the sacrament of confession. But he was firm in admitting that the papal excommunication had not terrorized him.

On the twenty-first, the transcripts of his previous interrogations were read to him. Savonarola was subject to a number of questions, some of them naive and utterly ridiculous: "Have you ever asserted that Jesus was only a man?" The reply was curt and immediate: "Only a fool could ask that." "Do you believe in charms?" "I have always mocked them," he retorted. Once again, only torture seemed to succeed where all other methods failed: "Torture questions, pain answers," whispered Savonarola as he wearily signed the depositions prepared for him.

The interrogation proved fruitless. Rumors circulated throughout Florence that the three friars would soon be released, having been found innocent. But contrary to these expectations, on May 22, a death sentence was read to the three prisoners.

Brother Maruffi listened with tears flowing down his face. Brother Domenico accepted the verdict almost enthusiastically, a radiant smile on his lips. Savonarola nodded to his brethren, mumbling prayers. He asked what kind of death was being ordered and learned that they were sentenced to be hanged and then burned. He asked that he be burned alive, so as "to endure harder martyrdom for the cross of Christ." Then, he sobbed, imploring God's pardon for having yielded to torture.

He then asked for pen and paper to write a letter to his brothers of the convent of San Domenico at Fiesole, of which he was the prior. "My beloved and dear brethren in the heart of Jesus Christ. As it is God's will that we die for him, pray for us, you who are left, bearing in mind my summons that you remain humble, united in charity, and intent in your religious practices. . . . Let my remains be buried in some lowly spot, not in the church, but outside, in a corner near the door."

Broken by torture, he was so overcome by drowsiness and fatigue that he dragged himself on the cell floor to the feet of Brother Niccolini, the so-called Black Friar entrusted with assisting those sentenced to death during the night before the execution. "Brother," he asked, "may I rest my head on your lap just for a few moments?"

Dawn came. His last morning in Florence began under a cloudy sky. In the piazza of the Signory three platforms were built on the steps of the palace for the most eminent Church and civic dignitaries: the bishop of Vasona, the apostolic commissioners, and the Gonfalonier and the Eight of Balía.

A long, raised wooden platform stretched from the railing of the palace across one quarter of the piazza "in the direction of the roof of the Pisans." A straight beam stood upright at the end of the platform, with a bar nailed across it. The gibbet that was to serve for the hanging was thus shaped like a cross. "Three halters and three chains hang from its arms, the first to hang the friars, the second to keep their corpses suspended over the fire which has to consume them. Combustibles are heaped at the foot of the stake."

A huge crowd, plunged into sad silence, assembled in the square. Some Arrabbiati and Compagnacci were unable to restrain their satisfaction and shouted obscenities and insults at the friars, who were pushed onto the long platform and made to proceed toward the stake. The bishop of Vasona took Savonarola by the arm to pronounce in his face the ritual formula: "I separate thee from the *militant* — " and nervous tension made him add " — and the *triumphant* Church."

With gentle calm Savonarola corrected him: "From the militant only, for the triumphant is without your power."

After this, Romolino imparted absolution from their sins to the three brethren. Then the official sentence was read aloud: "The Signory, having carefully considered the depositions of the friars, and the abominable errors committed by them, and having examined the sentence pronounced by the papal commissioners, who are now handing them over to the secular arm to be punished, hereby decree: that each of the three be hung from the gibbet, and then burned, so that their souls be entirely separated from their bodies."

The victims advanced along the platform, displaying a brave tranquillity. A spectator cried out words of comfort and Savonarola answered: "At the last hour only God can give his creatures solace."

A priest by the name of Nerotto approached, asking: "In what spirit do you bear this martyrdom?" The friar's reply was heard, firm and serene: "The Lord has suffered so much more for me."

These were Savonarola's last words. He kissed the crucifix that he was holding in his hands and approached the hangman.

Brother Domenico intoned the *Te Deum laudamus*, "Thee we praise, our Lord," soon joined by his companions. He turned to those on the platform and said, "Keep this in mind: the prophecies of Friar Girolamo will be fulfilled. We die innocent."

Brother Silvestro was the first to climb the ladder; the halter was

quickly tightened around his neck, leaving him only a moment to cry: "To your hands, O Lord, I entrust my spirit."

Smiling, Brother Domenico followed in the footsteps of the insomniac visionary, the monk of childish enthusiasm.

Savonarola was the last to be hanged. As his body swayed from the gibbet, a loud voice broke the silence in the square: "O prophet, this is the time for a miracle!"

The pyre was lit, tall flames leaped toward the bodies, rapidly engulfing them. Suddenly, gusts of wind lashed at the square, blowing the flames away from the victims. A hundred voices screamed wildly: "Miracle! Miracle!" But the wind dropped, and the fire recovered its destructive energy.

Savonarola's left arm, freed of the incinerated rope, was blasted upward by the fire; for a moment it appeared to be raised in a gesture of blessing. Not a few among the bystanders found that their knees bent by an irresistible emotion. Women wept. Several people recovered fragments of the friar's robes to be kept as relics.

Savonarola died at ten in the morning of May 23, 1498. He was forty-five years of age. The ashes of the man who had been "the soul and voice" of Florence through sixteen years of splendor and darkness were scattered over the Arno with those of his two companions in martyrdom.

MERCY ON GOLGOTHA

"Virgin mother, daughter of your son."
DANTE

The tragic events that had taken place in Florence on the day before the feast of the Ascension shook Michelangelo in the depths of his conscience. Lorenzo de' Medici and Savonarola had been the beacons of his formative years, and although the friar of the bonfires had stirred conflicting sentiments in him, the news of his atrocious death came as a severe blow to the artist, the man of faith, the Florentine citizen now living in the very place where Savonarola's fate had been sealed.

A great sadness must have mingled with his satisfaction when, on August 28, 1498, he signed the contract for the *Pietà* (or *Deposition*), the work commissioned to him by the French cardinal Jean de Villiers de la Groslaye.

The work was meant to be a sculpture in the round of precious Carrara marble, and Jacopo Galli felt so responsible for the choice of the artist that he added a footnote to the contract: "And I, Jacopo Galli, promise the most reverend Monsignor that said Michelangelo will make this work in a year and that it will be the most beautiful marble sculpture in all of Rome today, and that no other master could do one better."

The twenty-three-year-old Michelangelo found his first spark of inspiration in the *Divine Comedy*, as he imagined the scene on the hill of Golgotha where the dead Jesus, taken down from the cross, was given back to his mother. "*Virgin mother, daughter of your son*" — thus did Dante portray

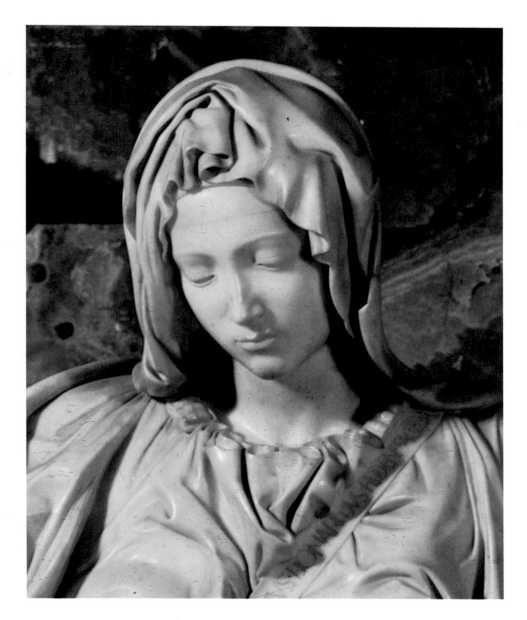

Michelangelo. *Pietà* (detail). Rome, Vatican, St. Peter's Basilica, Chapel of the Crucifix.

Mary and guide the hand that, two centuries later, would summon from stone the moving image of a young woman from Nazareth, torn from the quiet of everyday life and thrust into the mystery of a higher design.

The statue that Michelangelo carved in a pyramidal shape represents Mary holding her son in her lap. There is nothing here of the outburst of grief so often conveyed in poetry, paintings, music and previous sculptures inspired by the tragedy of the Golgotha. Mary is not the wailing mother of Jacopone's *Stabat Mater*. Her posture, her gesture, her face suffused with a sad yet calm resignation reflect what the ancient Greeks called *ataraxia*, the absence of violent emotions. Her head is slightly inclined toward the naked body of her child, abandoned across her lap; her left hand is out-stretched, palm upward, as if to beg for pity. Now her child is once more her own, as he was when she first lulled him to sleep in the stable at Bethlehem.

Mary is younger than her Jesus, yet her expression is deeply mater-nal; the young Jewish girl has conquered the mystery and accepted her role in one of the most awesome dramas in human history. When asked by his

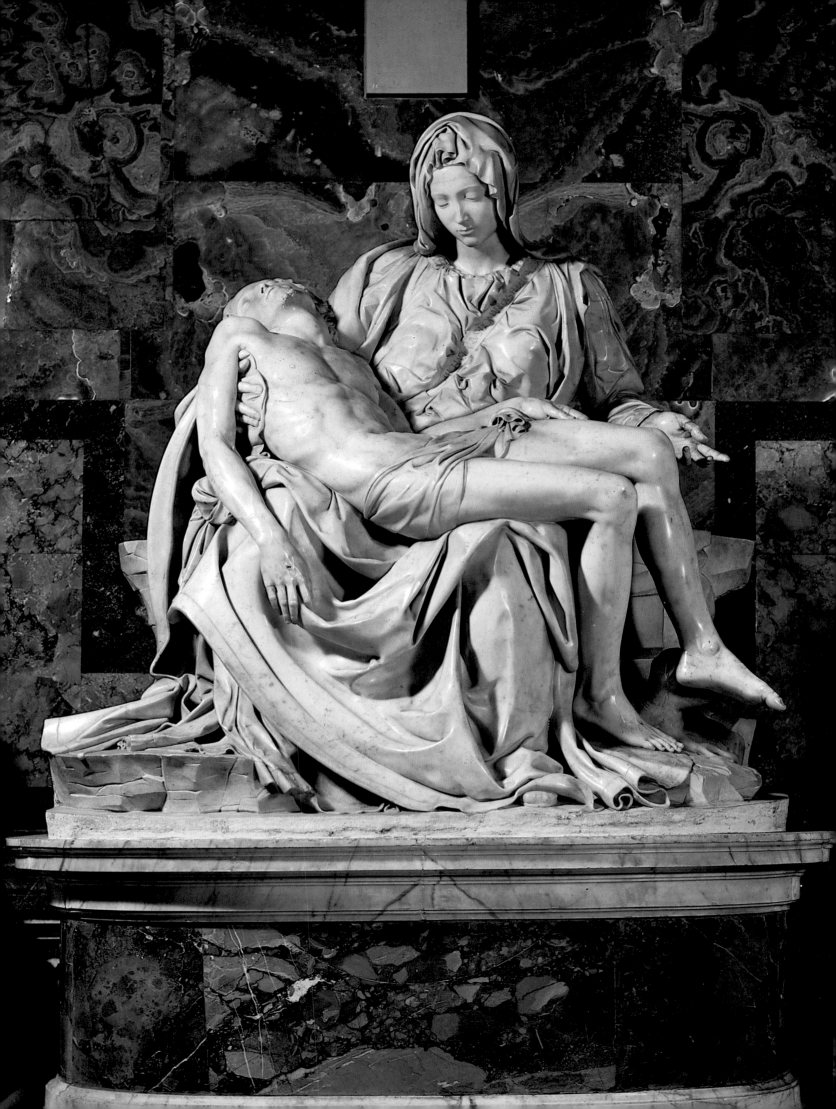

biographer Ascanio Condivi why he had chosen to make the mother younger than the son, Michelangelo replied that purity is evergreen.

In Michelangelo's vision, the body of Christ has the perfection of limbs, the weight of an adult and, at the same time, the levity of a child. The martyred, lacerated victim of the realists is here replaced with this sleeping son whom the mother is holding in a last, intimate conversation of the heart. He is the emblem of humanity incorruptible even in death, killed in vain by a power that could not find the equivalent in a pantheon of powerless gods. He is the emblem of humanity made perfect, incorruptible even in death.

In this work, medieval spirituality is merged with Greek classicism. Michelangelo had performed the miracle promised by Jacopo Galli and, at the same time, had inaugurated the great season of modern art.

The stake erected in Piazza della Signoria cast its long shadow over the young Florentine sculptor as he entered the merciful light of the passion on Golgotha. Sacrifice and cruelty were redeemed by the knowledge of the immortality of grace, the improbable logic of faith.

To Michelangelo, his Roman *Pietà* was a commentary on the tragedy of Savonarola, a celebration of the supremacy of love; the love that forgives without forgetting.

OPPOSITE:
Michelangelo. *Pietà*. Rome, Vatican, St. Peter's Basilica, Chapel of the Crucifix.

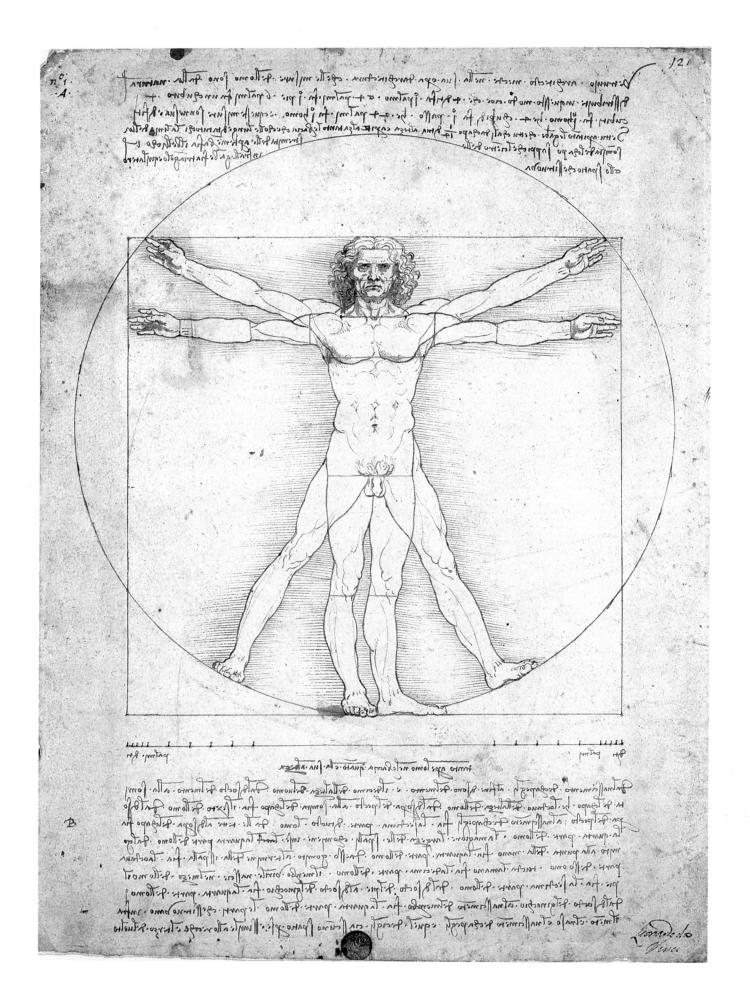

II. FROM THE VILLAGE OF VINCI

"He is the greatest among us born of woman.
A Dante with Plato's mind and Virgil's soul;
a Raphael with Michelangelo's and Galileo's stature."

NICCOLÒ TOMMASEO

A MAN OF THE FUTURE

Figlio dell'amore, son of love, is the Italian euphemism for a child born out of wedlock and is the best introductory description of Leonardo.

The 1457 registry of Vinci, a fortified village in the hills near Empoli, names a public notary called Antonio and as "members of his living family... his wife, Luisa, his sons Piero and Francesco, Albiera, wife of Piero, and the five-year-old Leonardo, the illegitimate son of Piero and a certain peasant woman by the name of Caterina, presently married to Cartabriga (or Attaccabriga) di Piero del Vacca."

The love relationship between Leonardo's mother and his married father must have ended after the birth of their son, their passion consumed in the span of a season from winter sowing to summer harvest, and burned out with the stubble of autumn. Yet Ser Piero loved his son, proud of the child's cherubic beauty and precocious intelligence. He convinced his childless wife, Albiera, that the infant's rightful place was under their roof.

Piero owned a house at Anchiano, an even smaller village in the area of Vinci. There, under the vigilance of his stepmother, who considered him a blessed gift from the god of love, Leonardo spent his childhood years: a quiet time in a quiet place, removed from the turbulence of the great city of Florence.

From a very early age, Leonardo was fascinated by the wonders of nature and, indeed, he learned a great deal by observing nature, the greatest book of all and his ideal teacher throughout his life. The inventions with which, in later years, he would amaze his contemporaries (and that continue to astound us today) had roots in that formative period. Biographer Giorgio Vasari reported that from earliest boyhood, Leonardo amused himself by drawing models of machines, and that he was moody and mercurial. "He would have made great profit in erudition... had he not been so inconstant and fickle. He applied himself to learn many things; and as soon as he began making them, he abandoned them."

Leonardo da Vinci. Drawing of a landscape dated August 5, 1473. Florence, Uffizi Gallery, Cabinet of Drawings.

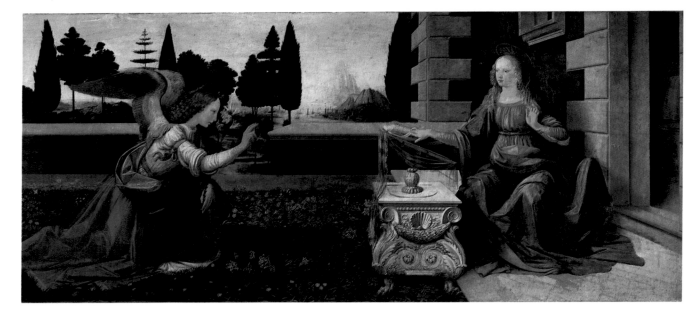

Leonardo da Vinci. *The Annunciation*. Florence, Uffizi Gallery.

The family moved to Florence, where Ser Piero sought to exercise more successfully his profession as notary for the Medici and other influential families. The city provided numerous channels for his son's talents. Leonardo had shown an inclination to draw and a keen interest in learning the skill of painting. In 1470, Leonardo entered the workshop of Andrea del Verrocchio, one of the most celebrated painters and sculptors in Florence and busy at that time constructing a bronze sphere meant to crown the Duomo.

Leonardo spent several years learning from the respected master. In the workshop, he enjoyed the company of Perugino (Piero Vannucci), Sandro Botticelli and the meek Lorenzo di Credi, painter of inspired nativities and other pious subjects. In 1472, Leonardo's name was officially enrolled in the *Red Book of the Debtors and Creditors of the Saint Luke Company of Florentine Painters*.

His first known drawing is dated August 5, 1473. A well-designed landscape, it bears his unique signature, an early example of his specular writing (letters that go from right to left and therefore are readable only in a mirror.)

Scant information exists about this period of his life. (In fact, biographical documents pertaining to Leonardo are very few.) A declaration made by Piero in 1480 reported that Leonardo was no longer living with his father. He left the Verrocchio workshop sometime around 1478 to undertake the painting of an altarpiece for the chapel of San Bernardo in the Signory palace, previously commissioned to Pietro del Pollaiuolo. Like many of Leonardo's commissioned works, this painting was either abandoned or never begun.

There are indications that he commenced two paintings of the Virgin Mary, which have been identified as the *Madonna of the Flower*, presently at the Hermitage Museum in Leningrad, and the *Madonna of the Cat*, of which only two drawings survive (at the British Museum). These paintings are supported by a wealth of preparatory sketches and studies that confirm his pictorial activity in this early Florentine period, an activity limited only to one other commission, namely the two predellas of the *Annunciation* now kept respectively at the Uffizi and at the Louvre.

Leonardo did not tire of drawing, observing natural phenomena and investigating the structure and inner workings of the human body. In his studies of flowers, plants, rocks, human heads, limbs and animals, he displayed his infinite curiosity and imagination, as well as a rigorous scientific discipline. He delighted in the often bizarre shapes and figures observed in the natural formations of stone and marble. He researched the laws of light and shade, as well as the rules of perspective involving the physiology of the eye. He studied anatomy, concentrating on muscular movement. He acquainted himself with hydraulics, the motions of the air, wind, rain, clouds, thunder, storms and snow. Pages and pages — dating to 1478 — with designs of gearings, winches, three-wheeled carriages for cannons, channels for the Arno between Florence and Pisa and much more have been found in his Atlantic Codex. These are extremely precious records of his initial technical and scientific probes.

Human faces fascinated him. In December 1479, he sketched Bernardo Baroncelli, the assassin of Giuliano de' Medici, hanging from the gibbet. The tragic image is as eloquent as any first-rate photograph of our time. In other drawings, attractive, repulsive, grotesque and monstrous human images alternate with painstaking observations of the growth of plants, their structures, and all the various other objects of his tireless curiosity. In these years Leonardo the painter, sculptor, architect, mechanician, military engineer, urbanist, musician, environmentalist, mathematician, biologist and philosopher was formed.

In 1481, the monks of San Donato at Scopeto commissioned from him an *Adoration of the Wise Men*, now in the Uffizi Gallery. Unfinished, or perhaps at the stage of a rough draft, the picture reveals the innovative force of the young artist. Instead of a traditional representation of the subject, Leonardo shows a crowd in great agitation. In the middle of the

Leonardo da Vinci. Codex Atlanticus, fol. 387r. Milan, Ambrosiana Library.

Leonardo da Vinci. *Adoration of the Magi*. Florence, Uffizi Gallery.

group appear a few heavenly messengers who convey a sense of mystery connected with the event. In deeper perspective, the cortege of the three kings projects their great anxiety to reach their destination. The still extant contract for this work stipulated that it had to be completed in one year and indicated the parsimonious reimbursements for the purchase of colors and other expenses.

Probably contemporary with the *Adoration*, and certainly indicative of a similar preparatory technique, is his *Saint Jerome*. Whoever commissioned this work remains unknown. The painting has a fascinating history. In 1789, the picture was mentioned in the will of the Swiss painter Angelica Kauffman, with an unequivocal attribution to Leonardo, as part of her collection, but without any indication of its provenance. After her death, the painting disappeared. Quite by chance, it was found in Rome in 1830 by Cardinal Joseph Fesch, Napoleon's uncle, in the shop of an antique dealer. A square portion of the board, corresponding to the head of the saint, had been cut out. This fragment was later located, by another stroke of good luck, in the shop of a shoemaker who had used it as the top of his workbench, fortunately with the painted side down.

Restored almost to its original state and exhibited in the Vatican Picture Gallery, the portrait shows the saintly hermit kneeling in front of a crucifix in the desert cave where he lived with his faithful lion. His ascetic face is intensely expressive, his right hand holds a stone with which he beats his chest. Although this, too, is only a rough draft (*non finito*, as were

many works by Michelangelo), the emotion conveyed by the painter does not fail to impress and move the viewer.

Fond of music, Leonardo constructed his own instruments: beautifully carved lyres with silver ornaments, slender flutes and lutes of harmonious resonance. In the spring of 1482, when he was thirty years old, he left Florence for Milan, sent by Lorenzo the Magnificent to the duke of Milan to present him with a lyre. (Other accounts asserted that the Laurentian gift was a "silver lute of wonderful making, shaped like a horse's head.")

He traveled with the musician Atalante Migliorotti, the only one able to play the instrument that Leonardo had made "mostly of silver to enhance its sonority," according to Vasari, and another companion, Tommaso Masino from Peretola, called Zoroaster. Florence barely noticed the departure of the young man from Vinci. Only the great Lorenzo and a few other perspicacious readers of men had perceived the genius the Tuscan city was exporting to Milan. As Leonardo's fame spread, his absence began to be regretted. Florence kept its doors wide open, waiting for her son to return.

Leonardo's first Milanese work began in 1483, when the city was under the regency of Ludovico the Moor and still shaken by the events that followed the death in 1466 of Francesco Sforza, the former brave *condottiere* who had become the first duke of the city. Through his marriage to Bianca Maria Visconti, the only heir of the powerful Milanese family, Francesco founded the Sforza dynasty. He was succeeded by his despotic and depraved son, Galeazzo Maria, who wanted a gilded bronze equestrian statue of his father to be erected in the family castle. The project was abandoned when he was killed in a conspiracy against him in 1476. His seven-year-old son, Gian Galeazzo, succeeded him, under the tutelage of his mother, Bona of Savoy. But his paternal uncle, the foxy and ambitious Ludovico the Moor, who had been exiled to Pisa, returned to Milan, put aside Duchess Bona and became his nephew's tutor. In reality the Moor was the ruler of Milan.

In April 1483, Ludovico welcomed Leonardo to his court, which was vying with that of the Medici in cultural enterprises and diplomatic exchanges. A contract with the Franciscan Brotherhood of the Immaculate Conception in Milan for an altarpiece devoted to the Holy Virgin was ready for him to sign. But, he learned, Ludovico had resurrected the project for the monument to the family founder. A letter in the Atlantic Codex, quite certainly in the hand of Leonardo, assured the duke that he would "make it possible to begin work on the bronze horse, which will be to the eternal glory and blessed memory of the great duke Francesco and the entire noble Sforza house."

Some scholars have assumed that Leonardo was away from Milan between 1484 and 1487. The grounds for this assumption are found in the drafts of a long letter addressed to a lieutenant of the sultan of Cairo. Leonardo, writing in the first person and illustrating his words with sketches, related his alleged adventures crossing Egypt, Cyprus, Constantinople, Armenia and the Cilician coast. He told of the advent and tribulations of a preacher and prophet who had risen in the region of the Taurus mountains

"The painter competes and debates with nature."

"Run from the precepts of those scholars whose reasonings are not confirmed by experience."

"Among the studies of natural effects, light is the one that elates the most those who contemplate it; among the great things of mathematics it is the certainty of its demonstrations that most elevates the intellect of the researchers. Perspective should therefore be placed before all human sciences and deductions, because by showing how linear shafts when bent give way to demonstrations, it attains the glory of physics even more than of mathematics."

"Ambitious people who are not content with the benefit of life or with the beauty of the world are given the penance of ruining their own existence, and never possessing the usefulness and beauty of the world."

"The innumerable images refracted from the countless waves of the sea by the solar rays where they strike them produce a continuous, immense splendor over the surface of the ocean."

and the apocalyptic disaster of a mountain that crumbled and buried a huge city, followed by a no less terrifying flood. In Leonardo's own words, he "was witness to these frightful events, all of which had been punctually forecast by the embattled prophet." He gave poetic descriptions of the splendid effects of light and shade as the sun set behind the peaks of the Taurus range (which he confused with the Caucasus.) Because of this mistake, and since no other documents confirm either Leonardo's travels in the Orient or these disasters, the general consensus is that he had let his imagination run far ahead of reality. His passion for travel tales and geographical ventures, for descriptions of buried cities and other archaeological wonders, possibly led him to invent this fable.

While at the Sforza court, where he was cherished as a prince of the arts, Leonardo designed pageants and banquet entertainments, working with poets, playwrights and musicians. He drew plans for urban sanitary developments, the strengthening of the ducal castle, other fortifications, military defensive and offensive devices, and he competed with Italian and German architects in developing projects for the completion of the Milan cathedral. For this work, he received payments throughout 1490.

When Gian Galeazzo married Isabella of Aragon in February 1489, Leonardo staged fabulous sets for the festivities; then he choreographed the allegorical dances for the feast of Paradise. His talent for airy decorations and scenic inventions was put to use on the occasion of other nuptials: the weddings of Ludovico and Beatrice d'Este; of Anna Sforza and Alfonso d'Este (where Leonardo directed the staging of the gallant tournament organized for the occasion); and of Bianca Maria Sforza and the Emperor Maximilian, a union prompted by Ludovico's dire need to secure solid political and financial support.

In his notes in the Atlantic Codex for the tournament Leonardo first mentioned the presence in his household of "Jacomo," a very young model-servant. Gian Giacomo Capriotti, surnamed Salvino or Salaì, was a spirited urchin, an incorrigible liar and a petty thief who continually got into trouble. But Leonardo had a special predilection for him, and he eventually became Leonardo's steady companion and attendant through the years.

Leonardo daily visited the duke and became acquainted with his intimate affairs. Ludovico commissioned paintings of his beloved Cecilia Gallerani, his mistress from her teens to his wedding night, of Beatrice d'Este and of Lucrezia Crivelli, who consoled the widower after the death of the duchess, his wife. Cecilia, in a letter to Isabella of Mantua, paid Leonardo a well-deserved compliment: "My portrait was painted by a master such as the equal cannot be found in our age."

Numerous preparatory drawings proved that his work for the equestrian monument went on amid the usual clash between his ambition and his perennial desire to research further. His indecision aroused the impatience of Ludovico, who had asked him to decorate two rooms in his castle, the Black Room and the Hall of the Tower. Leonardo resented the pressure imposed by the duke, who threatened to hire other painters if he delayed his work any further. Badly paid and vexed, he left Milan for a short visit to Florence. In a letter preserved in the Atlantic Codex, he

wrote: "I regret very much that I have to interrupt the work commissioned to me by your Lordship; but I hope I will be able to earn (elsewhere) enough to satisfy your Excellency with a relaxed spirit. And if your Excellency believes that I have money, you would be mistaken, because I have fed six mouths in my household for six months, and I have had fifty ducats in all."

In 1486, after a long struggle, he completed the painting of the Virgin (now known as *The Virgin of the Rocks*, two versions of which exist, one at the Louvre, the other at the National Gallery of London). The delay in executing the contract caused a bitter controversy with the Brotherhood of the Immaculate Conception.

Leonardo's slow progress in executing the monument to Francesco Sforza induced Ludovico the Moor to ask Lorenzo the Magnificent to suggest some other sculptor for the task. Leonardo knew that his Florentine patron would not accede to such a request. Oblivious to anything that was not pertinent to his obsession with perfection, Leonardo developed his preliminary sketches and shaped a clay model. In one of his copybooks he wrote: "Today April 1490 I begin this book and resume working on the horse." The model was completed three years later. Among his drawings, there is one of a wooden framework devised to transport the model to the foundry where it was to be cast in bronze.

But Ludovico's financial problems prevented the project from being completed. When the Austrian ambassadors came to Milan, toward the end of 1493, to escort Bianca Sforza, the betrothed bride of their Emperor Maximilian, on her nuptial journey, the gigantic model, four times greater than life-size, was still in full view in the courtyard of the castle.

In 1494, Gian Galeazzo died under a dark cloud of suspicion and Ludovico the Moor began scheming to induce Charles VIII of France to invade Italy. In September, a woman by the name of Caterina, who had been living in Leonardo's household for a year, died. The fact that she bore the same first name as the artist's mother and that Leonardo spent a considerable amount of money for her funeral has induced some to conjecture that she could have been more than just a servant.

Leonardo was amazingly active during this period. He drew plans for engineering works to improve the waterways of the Lomellina and its adjacent regions in the Lombard plain, vastly decreasing the danger of flooding. In the second part of 1494 he was in the refectory of the convent of Santa Maria della Grazie to execute a huge fresco commissioned jointly by Ludovico and the monks. Leonardo devoted all his concentration to the depiction of the subject aptly chosen for the place: *The Last Supper*. His sketches offered evidence of his extensive research and his quest for the best models. He was so intensely preoccupied that he never gave the smallest hint in his notes of having witnessed the fateful events of that year.

The work for *The Last Supper* went on through 1497, according to a document in the ducal archives in which the duke himself recommended that "Leonardo be urged to finish the fresco he has begun in the refectory, to begin painting another wall of the same."

The mathematician Luca Pacioli (the author of *Summa de arithmetica*),

ON FIGURES

"Figures have more grace when they are placed under the universal light of nature than when they are lit by small, individual lights, because large lights that are not overpowering bring out the relief of bodies, and the works made in such light appear graceful from afar. Those that are painted with small lights take on a great amount of shadow, and works made with many shadows, when viewed from a distance, never look like anything but blotches."

ON COLORS

"The color that is between the shadowy and the lighted parts of shadowed bodies is less beautiful than that which is fully illuminated, so that the prime beauty of colors is to be found in the principal lights."

who had been called to the Sforza court in 1497, supplied a precise date for the completion of *The Last Supper*. In a letter he wrote to Ludovico, Pacioli told of having seen the finished fresco: "the apostles are represented in their various reactions as they have just heard the Savior's words: 'One of you will betray me.' They all seem living creatures, so wonderful is the style with which Leonardo has painted them." The mathematician and the painter remained good friends, and Leonardo illustrated a new treatise by Pacioli, the *De Divina proportione* (of divine proportion), which became a cornerstone of Renaissance culture.

The mathematician's remarks about the realistic aspect of the characters in *The Last Supper* confirmed the stories that circulated about Leonardo's work, namely that he had been searching painstakingly for real life models in the Milanese population. Unfortunately, the tempera technique he employed in the fresco was responsible for the early decay and ruinous damages suffered by the world-famous painting. The tempera, possibly mixed with other experimental ingredients, did not bond to the fresco plaster, or the plaster to the wall. Spots of mildew appeared on the surface, making the paint scale and flake. Water infiltration caused by the weather added

Jacopo de' Barbari. Portrait of Luca Pacioli and an unknown person. Naples, Capodimonte Museum.

OPPOSITE:
Leonardo da Vinci. *The Virgin of the Rocks*. Paris, Louvre.

Leonardo da Vinci. *The Last Supper*. Milan, Santa Maria delle Grazie.

to the deterioration of the painting. As early as 1517, a visitor (Antonio de Beatis) described the condition of *The Last Supper* as "a most excellent work, although it begins to decay, I do not know whether because of the dampness that has infiltrated the wall or for other reasons." Decade after decade the deterioration continued. Another eyewitness reported a "rain

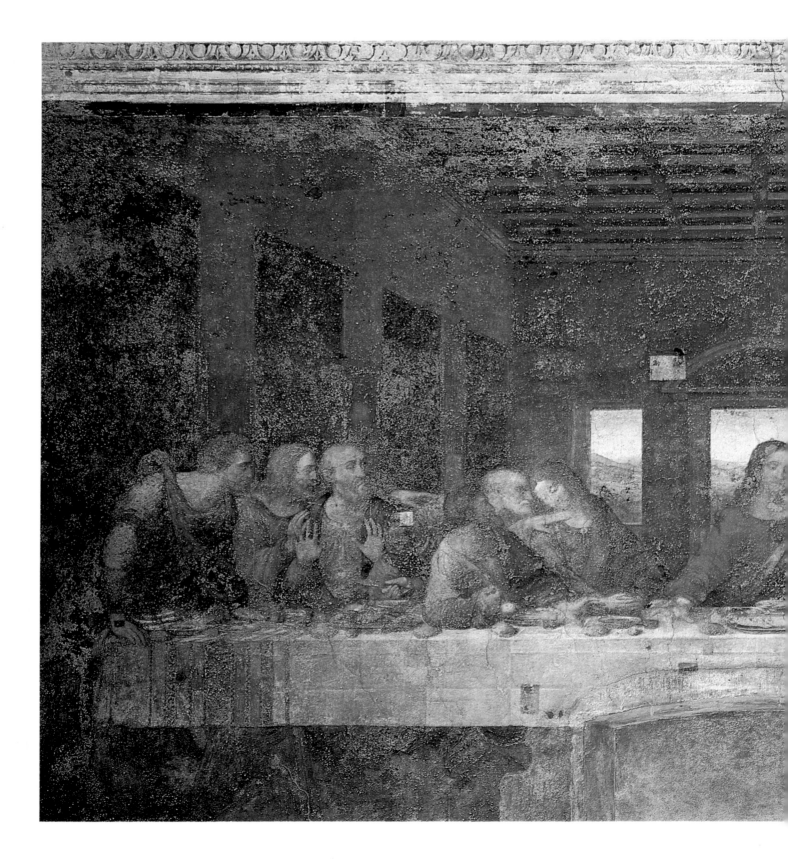

of minute scales and grains falling off the wall." Attempts to restore the ghostly fresco to its pristine glory have gone on for centuries, but what remains of Leonardo's masterpiece is but a faint shadow of what the artist must have first unveiled.

For all the irreparable damage, though, Leonardo's *Last Supper* still

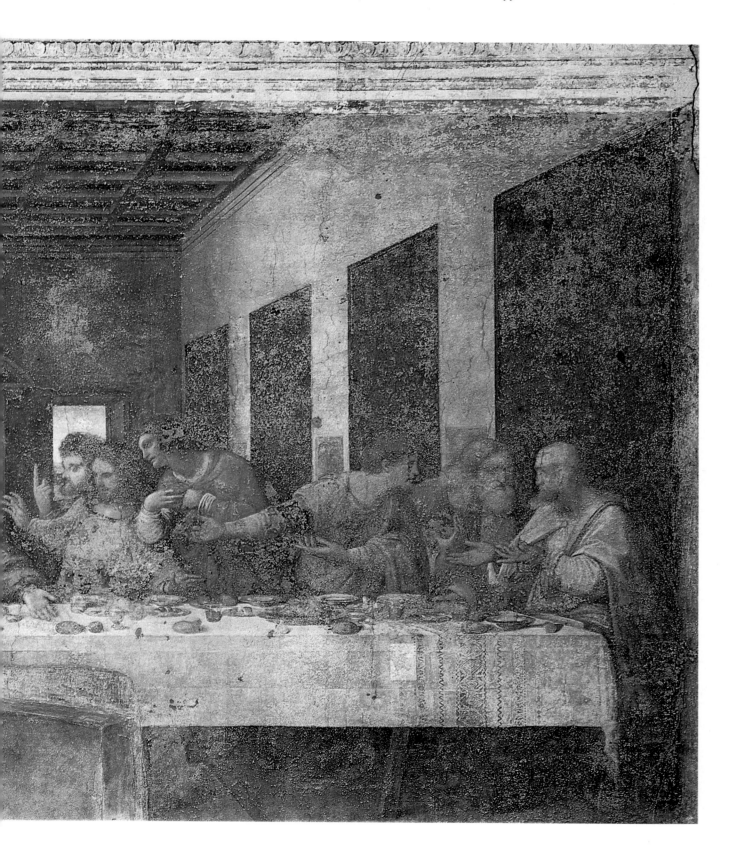

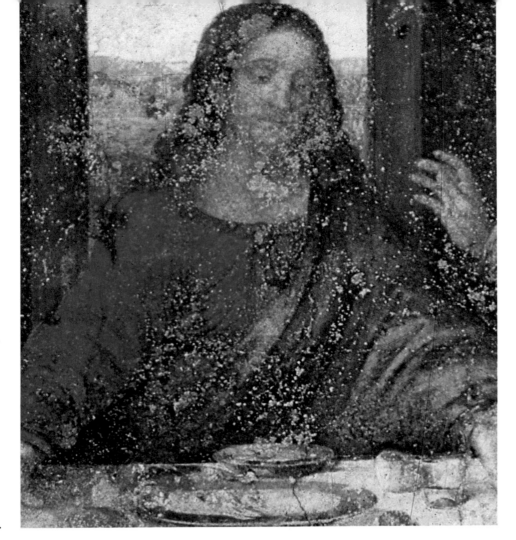

Leonardo da Vinci. *The Last Supper*, detail of Jesus Christ. Milan, Santa Maria delle Grazie.

provides a magical encounter with a work of art. He departed from any previous depiction by placing the disciples in equal numbers to the right and left of Jesus, and at the two ends of the narrow refectory table. They face the spectator, offering an open view of the scene. The shattering revelation made by the Master, "One of you will betray me," has exploded in the quiet room like sudden, unexpected thunder. It is as if a frosty wind has blown over the disciples, spurring them to a reaction: turning to each other, clustered along the table, some stand, some remain seated. A general symmetry governs the variety of gestures and postures; the groups of characters are balanced in a concert of rhythms, proportions and linear perspective arrangements that help bring to life the sublime and terrible moment, in that Passover supper celebrated by Jesus and his disciples, with an unprecedented spiritual intensity.

RETURN TO FLORENCE

"Of all studies of natural causes, light gives greatest joy to those who consider it."

LEONARDO

In his *Vita*, Paolo Giovio summed up the years Leonardo spent at the Sforza court in Milan: "He distinguished himself for his qualities of great gentlemanliness, and his refined and generous manners, accompanied by a most handsome appearance; and as he was a rare and masterful inventor of every elegance, especially of delightful theatrical entertainment, possessing also the art of music, which he practiced on the lyre and with the most suave singing voice, he became cherished to a very high degree, by all those who happened to know him."

Ironically, Ludovico had difficulty paying Leonardo and rewarded him for his work with a vineyard in the suburbs of Milan.

The Duke was compelled to invest large sums of money to strengthen his army. His political mistakes had made France a dangerous enemy; furthermore, his own patent weakness induced the pope and the doge of Venice to enter an alliance with the French king Louis XII to divide the duchy of Milan among themselves.

To confound their plans, Ludovico enticed the sultan of Turkey to challenge Venice, and Germany and Switzerland to fight France. He traveled to Innsbruck to solicit Austrian support. While he was away, the French invaded Lombardy, and the troops of Louis XII occupied Milan without encountering any resistance. Upon visiting the convent of Santa Maria delle Grazie, the king so admired *The Last Supper* that he wondered whether the fresco could be detached from the wall and transported to Paris.

Gian Giacomo Trivulzio, Louis's lieutenant and a fierce adversary of Ludovico, was now the virtual ruler of Milan. A commission was bestowed upon Leonardo to erect an equestrian monument for Trivulzio, but Leonardo felt that a hell-raising storm was about to descend on Milan as Ludovico prepared to restore his power. Leonardo refused the offer. In December 1499, he sent 600 ducats to Florence to be deposited at the bank of the hospital of Santa Maria Nuova, and then he abandoned Milan in the company of Luca Pacioli.

Several years passed before Leonardo came back to Florence. He and his mathematician friend first stopped for a while at Mantua, as guests of Gian Francesco Gonzaga and his wife, the generous Isabella d'Este, arbiter of elegance and queen of one of the most splendid courts in Italy. Her collection of works of art, precious gems, gold and silver objects fashioned by the best among the Italian goldsmiths attested to her culture and taste. Leonardo drew two sketches for a portrait of her, leaving one to the duchess and taking the other with him as a model for a painting he planned to execute.

In February 1500, Ludovico approached Milan at the head of a well-equipped army of Swiss mercenaries. The population, oppressed by the French, hailed the Sforza as a liberator. But his unresolved financial problems caused another defeat as his Swiss soldiery, in revolt because their salaries were overdue, refused to battle the French and a contingent of their countrymen. Taken prisoner, Ludovico was carried in chains to France. Milan was mercilessly sacked, and Leonardo's model for the great equestrian statue became a notorious casualty of this revenge. The king's Gascon bowmen amused themselves by using it as a target, reducing it to a heap of rubble.

In March 1500, Leonardo was in Venice. The *serenissima* Republic was being threatened by the Turks, who had invaded the neighboring region of Friuli and defeated the Venetian captain, Antonio Maria Grimani. Leonardo was engaged in designing daring plans for the defense of the Isonzo valley, which he believed could be flooded to impede the march of the Turkish invaders. He took advantage of his daily visits to the

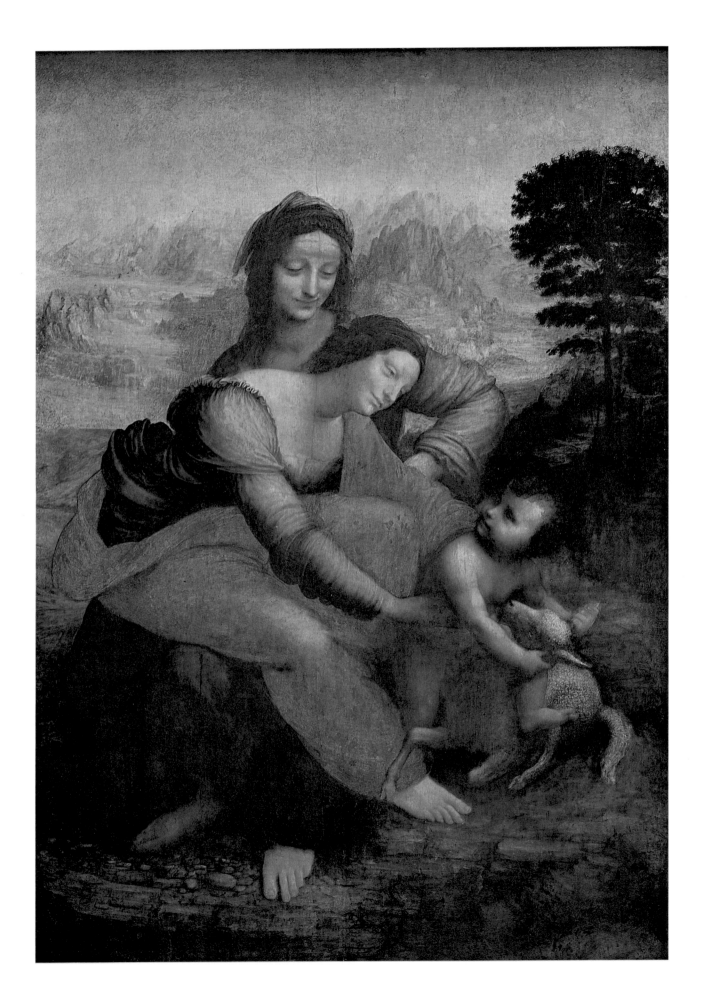

Adriatic Sea to observe the ebbing and flowing of the tides.

As soon as Leonardo heard the news of the second defeat of his Milanese patron, he decided to return to Florence. On April 24, 1500, he withdrew a sum from the bank of Santa Maria Nuova, proving his presence in the city of the flower. There Leonardo was reunited with his fellow painters di Credi and Botticelli, who had worked with him in Verrocchio's workshop, and with his friend Filippino Lippi, who, according to Vasari, passed on to him the commission he had received to paint an altarpiece for the church of the Annunziata.

Multiple interests distracted Leonardo from forging ahead with the work. He went from studying the tidal movements in the Adriatic Sea to advising the Art of the Merchants, one of Florence's corporations, about how to prevent a landslide on the hill of San Salvatore dell'Osservanza; he studied the canalization of the Arno and a system of sluices; he devoted himself to devising a scheme for transferring the baptistry of San Giovanni to another part of the city where it would be isolated and installed over a huge marble basement.

A year later, Leonardo finished the preparatory drawing, or cartoon, for the Annunziata. It became an object of irresistible attraction for every citizen of Florence, and soon its fame lured artists from all over Europe. The Servite monks of the Annunziata were anxiously waiting for the cartoon to be turned into their altarpiece. But as Brother Piero da Novellara reported: "This Holy Week I heard of the intention of Leonardo the painter through his disciple Salaì and some other close friends of his who, to give me more accurate advice, brought him to me on Holy Wednesday. His mathematical experiments have distracted him so much from painting that he cannot stand his brushes." The friar added that the artist was busy finishing a small picture for Florimond Robertet, Louis XII's secretary of state, who resided then in Milan. This is the well-documented *Madonna of the Spindles*, another lost work.

Isabella d'Este kept trying to induce Leonardo to come to Mantua, insistently asking for "at least a small painting of the Holy Virgin, devout and sweet as it is in his natural style." Brother Novellara, acting as her correspondent, gave her hope, although he pointed out that Leonardo was so occupied in studying geometry problems that he seemed to have little time for anything else. But the friar gave Isabella an accurate description of the cartoon for the Annunziata, which corresponded to the *Virgin and Child with Saint Anne*, now at the Louvre.

A cartoon with a similar subject is now exhibited at the National Gallery in London (a sketch of the same is preserved in the British Museum). Light and shade play on and around the figures in vibrating chiaroscuro effects that enhance the conquest made by Leonardo of chromatic values, which art historian Adolfo Venturi rightly defined as "color without color."

Leonardo became more and more immersed in researching mechanics and geometry; he spent day and night studying anatomy in the hospital of Santa Maria Nuova. There he witnessed the death of a very old man: "A few hours before his death he told me that he had lived more than a

hundred years, and he did not feel any pain, only a great weakness; and so as he was sitting up on his bed . . . without any other movement or any sign of illness, he passed from this life. And I anatomized him to see the cause of such gentle dying; I found it in a loss of circulation in the artery that fed the heart and his lower limbs, which I found arid, shriveled and dry."

In the spring of 1502, Leonardo abandoned plans to execute the Annunziata altarpiece; the commission was returned to Filippino Lippi. Many patrons sought out Leonardo. Piero Soderini, who was elected Gonfalonier for life in September, tried in vain to persuade him to take up the challenge of the "Giant," a huge block of marble that Agostino di Duccio had abandoned many years before in the workyard of the Opera del Duomo, and that Michelangelo later obtained. Isabella renewed her pleas for a picture she wanted, but all Leonardo would give her was advice about some precious vases, once the property of Lorenzo the Magnificent, that were being offered to her.

IN THE SERVICE OF THE VALENTINO

An invitation was addressed to Leonardo by the powerful Cesare Borgia, Duke Valentino, son of Pope Alexander VI. Having given up his ecclesiastical career, Cesare was directing his ambition toward the rule of Italy by exercising both his political guile and military skill. Initially, he had targeted Naples and Florence but quickly realized that his mighty father would not support such a reckless endeavor. By focusing on more immediate goals, Cesare Borgia waged his assault in the region of Romagna. Through a series of brilliantly planned and rapidly executed strategic moves, he conquered the town of Cesena and made it the capital of his small realm.

While at the court of the Sforza in Milan, Cesare had heard of Leonardo's military studies and of his many revolutionary inventions. The ruler of Romagna thought the genius from Vinci was a man of the future and wanted his help in building his own greater tomorrow. Leonardo showed sudden interest in Cesare; a new patron was offering him the chance to test his new devices. Between May 1502 and March 1503, Leonardo followed the terrible lord over a large part of central Italy as his chief military engineer.

In a small copybook, Leonardo recorded that on June 21 he was with Cesare as the latter entered Urbino, dispossessing its ruler, Guidobaldo da Montefeltro. One of his drawings illustrated the "wild stairways" invented by Francesco di Giorgio Martini for the ducal palace. There, in that center of Renaissance culture, the only truly worthy rival of Lorenzo's Florence, Leonardo met Niccolò Machiavelli, who was at the court of Cesare as the envoy of the Florentine Signory. It was a chance encounter between two minds with different interests, both in the shadow of a man whom Machiavelli believed destined to become the future leader of Italy, the restorer of its glory and the aggrandizer of its future.

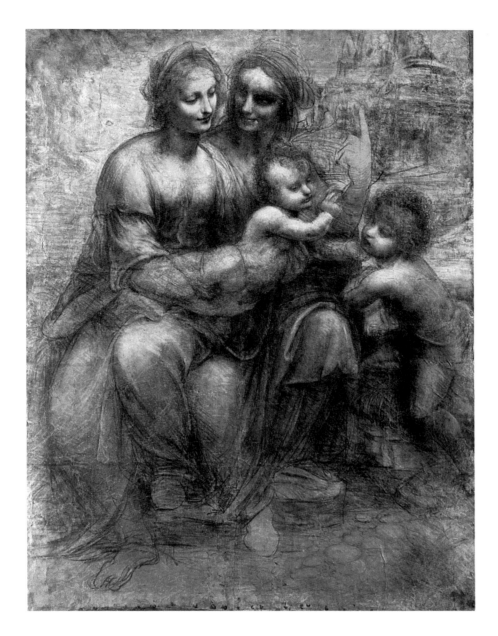

Leonardo da Vinci. Cartoon for *Virgin and Saint Anne*. London, National Gallery.

There Leonardo certainly entered the great Montefeltro library, with its rare manuscripts. He must have looked for the precious codex of Archimedes, which had been acquired by the lord of Urbino. On August 1, 1502, he was at Pesaro, interested in its no less celebrated library; on the eighth, he reached Rimini; then on to Santo Lorenzo, Cesena, and Cesenatico. According to tradition, the port-canal that connects Cesena with the sea was designed by him.

Cesare Borgia seemed to be unbeatable; but his *condottieri*, and the lords who had surrendered to his overpowering campaign, were tiring of his brutal despotism. They decided to join their forces and rise in revolt. Vitellozzo Vitelli, lord of Città di Castello; Gianpaolo Baglioni, ruler of Perugia; Oliverotto Oliverotti, lord of Fermo; Paolo Orsini, the lord of Palombara, and Francesco Orsini, duke of Gravina, met at Magione, near Perugia, and planned on attacking Cesare on two fronts with their troops, which totaled 10,000.

Cesare withdrew to Imola, where he was besieged. Leonardo stopped

recording his progress, but there is a possibility that both he and Machiavelli were still with Cesare. At this time Leonardo drew a map of Imola that was amazingly accurate, the first real *topographic* map of a city. (The original drawing is in the Royal Library at Windsor.)

Rousing Machiavelli's shocked admiration, Cesare Borgia plotted and carried out his own masterpiece of duplicity and cruelty. Still trapped inside the citadel of Imola, he inveigled the rebels to meet with him at Senigallia. A banquet was organized to celebrate the reconciliation and the pardon granted by Cesare to his former foes. But as his credulous guests convened, Cesare had them all massacred.

In January 1503 Cesare attacked Perugia, ousting the Baglioni. He proceeded to Acquapendente, where he stifled the revolt of the Roman barons who had risen against the papal authority.

Leonardo left Cesare Borgia in March, returning again to Florence. He had been treated with respect by the duke, if we believe the sincerity of Cesare's letter dated August 18, 1502, from Pavia, to serve as a safe conduct for the man from Vinci: "To all our Lieutenants, Castleholders, Captains, Condottieri, Officers, Soldiers, and Subjects, to whom news of this letter will be given, we commit and command that our noble and beloved member of our family, Architect and General Engineer Leonardo da Vinci who will exhibit it, and who has been commissioned by us to visit and study places and strongholds in our States, be given free passage wherever he happens to be, without any payment; and that himself and those who accompany him be welcomed with friendly reception, and be left free to take measures and examine them as much as he wants. And let no one act contrary to this command, if anyone cares not to incur our indignation."

Leonardo's newly acquired fame as a genius of military engineering preceded him. Florence was anguished by the ongoing war with Pisa. Three months after he arrived, on a terribly hot July day, Leonardo was sent by Gonfalonier Soderini to the battlefront to study a system of canals, sluices, locks, and dams for the purpose of deviating the course of the Arno river, so as to cut off Pisa from the sea. The staggering enterprise failed, due to some initial disasters and the incredibly high cost. Leonardo was still courting war, but he seemed to be wary of what he described as a *pazzia bestialissima*, a most bestial madness.

12. WINDS OF CHANGE

*"When a pope dies,
you make another."*

ITALIAN PROVERB

It happened on Saint Peter's Day, June 29, 1500. Pope Alexander was about to hold audience in the Vatican palace when a tempest hit Rome with the destructive force of a tornado. The ceiling of the audience hall crashed down, burying the pontiff and the small crowd gathered there to meet him. His guards searched the rubble and rescued Alexander VI, covered with blood and badly injured. The nearly tragic event seemed to portend a divine intervention. But the pope recovered. He celebrated the beginning of the ninth year of his pontificate by proclaiming that a wise oracle had predicted another nine-year term of his reign and that his son Cesare would soon be crowned king of Italy.

Cesare's victories throughout Romagna appeared to confirm the prophecy. His success was so awesome that the town of Cesena surrendered to him after a siege that lasted only a few days, and the adolescent Astorre Manfredi III, the last heir of the family that had ruled the city for over three centuries, left the fortress to meet the victor.

The Bentivoglio of Bologna was no less daunted by the new Hannibal. In order to appease Cesare, who now threatened his city, he offered him a stronghold and 3,000 men to be commanded by his own son. Only a last-minute order from the pope himself stopped Cesare from attacking Florence. But nothing could save the town of Piombino. In May 1501, Cesare was proclaimed duke of Romagna. His new state would be the first in Italy to have a regular army, controlled through an absolute discipline; it impressed Machiavelli as a "perfect cell in the organism of a national unity."

In the days immediately following the accident in which Alexander had almost lost his life, the name of Cardinal Giuliano della Rovere, nephew of Sixtus IV, the builder of the Sistine Chapel, circulated as possible successor to the papal crown. The della Rovere were a solid family from Albissola, near Savona, in the Liguria region. The oak tree (*rovere*) in their coat of arms suggested the strength of will and firmness of character that distinguished the members of this family who thrived on a coast often raided by Moslem pirates.

On December 5, 1443, Giuliano was born to Raffaello della Rovere and Teodora di Giovanni Manirola, a woman of Greek origin. At first intended for a career as a merchant, young Giuliano was sent by his uncle

Unknown. Portrait of Cesare Borgia. Bergamo, Carrara Academy of Fine Arts.

Sandro Botticelli. *The Temptation of Christ*. Rome, Vatican, Sistine Chapel.

Francesco, a Franciscan friar, to be educated among the brethren of his order. He demonstrated a bright intelligence and a remarkable facility to profit from his studies. When Francesco della Rovere was elected to the papacy in August 1471, taking the name of Sixtus IV, he showered his nephew with favors. He was made bishop of Carpentras, then bishop of Vercelli, moving to Avignon as its archbishop. Sixtus IV made him cardinal of the church of the Twelve Apostles and of San Pietro in Vincoli, then cardinal bishop of Sabina, Frascati, Ostia and Velletri.

In 1480, he was sent as a papal legate to France. In the span of two years, he displayed such extraordinary qualities that he acquired an influence over his colleagues in the College of Cardinals, which proved decisive later.

In 1494, Giuliano della Rovere returned to France to encourage Charles VIII to undertake the conquest of Naples. He was in the king's retinue during the campaign. There, he acquired the skill of an army leader and developed his profound resentment against foreign occupation of Italy by witnessing the result of the invasion he himself — among others — had prompted.

An excellent theologian, he was the author of important books on various thorny issues such as the one dividing the *sinelabisti*, the supporters of the immaculate conception of Mary, and the *labisti*, who denied it. Rough in his manners but a respecter of the intelligence of others, he loved active life and savored its gifts to the full. He found it impossible — before he acceded to the papacy — to keep his vows of chastity, but he never abandoned himself to the excesses that marred the life of Rodrigo Borgia.

He detested orotund eloquence and hypocrisy. He was parsimonious with his demonstrations of friendship or affection. He did not let the popular pleasures of the table affect his physical fitness; as he advanced in age, his appearance remained as vigorous, his limbs as agile as when he used to race across the fields of his native Albissola. Although he was himself the recipient of privileges granted by his father's brother, he was violently opposed to the shameless nepotism that polluted the papal court during the reign of Innocent VIII ("in whose pontificate the only innocent thing is his name"), and more particularly during that of Alexander VI, whose access to Peter's chair had been obtained by a hardly disguised practice of simony.

This was Giuliano della Rovere, at the time when the Borgias, father and son, were enjoying an unpredictable moment of triumph. Indeed, having escaped the crumbled ceiling in the Vatican hall, seemed to transmit a feeling of invincibility from the jocund, exuberant "bull of Valencia" to his ambitious offspring.

Melozzo da Forlì. *Pope Sixtus IV Installs Bartolomeo Platina as Director of the Vatican Library*. Rome, Vatican. Standing in front of the Pope is his nephew, Cardinal Giuliano della Rovere.

CESARE'S DECLINE

Political unrest involving Italy and the major European forces continued to escalate. On November 11, 1500, Spain and France signed a pact for the conquest and division of Naples. The following summer, the French army entered Rome, as the Spanish expedition landed in Basilicata to threaten Naples directly. A papal bull dated June 25 imparted apostolic blessing on the dual aggression by proclaiming the end of the Aragonese rule over Naples. Alexander VI assigned the city and other territories to the king of France, and the regions of Puglia and Calabria to the kingdom of Spain. The pretext that masked this arbitrary decision was the need to protect the peninsula from the Moslem attacks. In reality, the pope was paying his political debt to France for having seconded the climb to power of his son Cesare. The latter, having pocketed the rich pay he received from both the French and the Spanish kings, became the true dictator in Rome, surpassing even his pontifical father in the exercise of tyrannical powers.

A letter from the Florentine Agostino Vespucci to his friend Niccolò Machiavelli expressed the corruption, amorality and even criminal nature of practices of the papal court. "The pope," wrote Agostino on July 16, 1501, "goes on depriving one person of his possessions, another of his life, sending others into exile, inflicting jail sentences, stealing houses from

Sandro Botticelli. Detail of *The Temptation of Christ*, showing Cardinal Giuliano della Rovere (Pope Julius II) at the right. Rome, Vatican, Sistine Chapel.

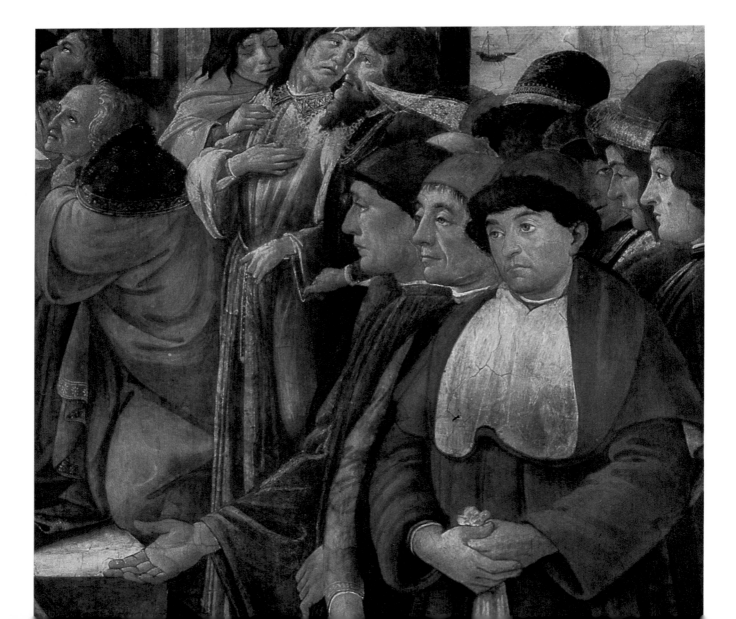

some to give them over to people from his Spanish land. Favors can be bought here with more ease than melons over there. Here justice resides in the might of arms, and one is led to hope in the Turks, because Christians seem reluctant to move to extirpate this cancer from mankind; here all those who think sanely, speak with one mouth. It remains for me to say that, beginning with the pope and his illicit herd, every evening, from sunset to past midnight, twenty-five or more women are taken to the palace, so that quite openly the palace itself is turned into a brothel of all filth."

The Roman chronicle for the year 1501 recorded the sumptuous wedding of Lucrezia Borgia, the pope's cherished daughter, to Alfonso, Duke of Bisceglie. In a typical display of Caesarian magnificence, the city was given an ample dose of bread and circuses, enough to cover up, at least for a drunken while, the wrongs caused by Cesare's iron-fisted rule.

The Romans who had not forgotten the legendary bullfight staged on June 24, 1500, during which the pope's son, wearing a simple leather vest, dismounted his royal steed and killed five bulls in succession, saw in him the ideal heir of Caracalla, the diabolical inventor and protagonist of incredible athletic performances in the circus. Down with Cesare the tyrant, long live Cesare the hero of the games.

Giuliano della Rovere's resentment grew into hatred when more reports arrived in Rome of Cesare's cruelty in the course of his victorious campaigns. His surprise attack of June 21, 1502, against Urbino aroused Giuliano's anger, as it involved his beloved nephew Francesco Maria della Rovere, who had barely escaped falling into the hands of Valentino. Now Cesare occupied the splendid residence of the Montefeltro, and ordered that the same people who conspired in his favor and facilitated his conquest be decapitated.

Cardinal Giuliano received the appeal for help from Guidobaldo da Montefeltro, who had taken shelter at the court of Mantua with his wife, the sister-in-law of Isabella d'Este. Giuliano rejoiced upon learning that the most famous *condottieri*, at the orders of the Borgia, had established an alliance against their master.

Suddenly, the fortune of Cesare seemed to decline. He ended up being trapped inside the Imola fortress, impotent to prevent a series of defeats that led to the loss of many of the territories he occupied, Urbino among them.

In his heart, Cesare retained some of his legendary self-confidence and much of his desire for revenge. "This year is under an evil planet for those who revolt," he confessed to Machiavelli. "My enemies will have to atone for their betrayal." Once more, he overcame the opposition. In a move meant to shift the blame for the excesses that provoked the rebellion in Cesena from his shoulders to those of his hated minister Ramiro de Lorca, he offered a horrifying Christmas show by exhibiting Ramiro's corpse, beheaded and torn to pieces, on a red damask carpet, in the town's square.

Now Valentino was ready to turn to his ultimate goal: the conquest of Umbria and Tuscany. In perfect unison with the politics of his father,

the pope, he planned to forsake France, a useful ally but a natural enemy, and drew closer to Spain and Venice to gain their support in the effort to chase the French king from Italy. Last but not least, his plan was to wipe out any residual resistance from his steadfast foes in Rome itself, the Orsini family.

Cesare in 1503 was twenty-eight years old, a veteran of three years of fighting that had taken him, through a series of blazing victories and bitter defeats quickly reversed by bloody revenges, to the peak of power. And he was still climbing. What he did not know was that the omen manifested by the terrible storm of June 29, 1500, was an exact parallel to the biblical writing on the wall. The abyss destined to swallow him and his ambitious dreams opened under his feet when Alexander VI, on the warm night of the eighteenth of August 1503, died in agony in his Vatican apartment. His decaying corpse was buried in haste, having been summarily wrapped in a carpet by caretakers unable to stand its vile stench; it was so swollen that they had to sit on the lid of his wooden coffin in order to press it down and finally close it.

A tide of jubilation rushed all through Italy. Simultaneously, Cesare was immobilized by an attack of malaria. Lying in his army cot, burning with fever, the would-be king of Italy was seized by delirium. In a moment of lucidity he dispatched his henchman, Michele da Colella, and a band of trusted men to ransack the papal apartment at the Vatican, to prevent the pillage that, by long tradition, the Roman populace carried out after the burial of a dead pope.

Michele returned with almost four hundred ducats and a load of precious objects that Valentino ordered be kept in the coffers of Castel Sant'Angelo. As soon as he recovered a little of his energy, Cesare promised the powerful Colonna family restitution of their properties in exchange for their alliance against an attack by the Orsini. He schemed to secure the assent of the College of Cardinals to confirm his title as Gonfalonier and Captain General of the Church. A meeting of the red hats was promptly summoned in the church of Santa Maria della Minerva to examine his appeal. The decision was unfavorable to him. In order to ensure the orderly ritual process of the conclave to choose a new pope, he received the injunction to leave Rome with his troops, and without delay.

He answered by posing the following conditions: first, the reconfirmation of his title; second, guarantees for the safety of himself and the Spanish cardinals who "depend on him"; third, an immediate action by the College of Cardinals with the doge of Venice to safeguard the territorial integrity of the state of Romagna.

These conditions were accepted, and Cesare signed a pact with Louis XII to serve the French king against all enemies, except the pope, in exchange for the royal protection over his person and possessions. On September 2, Cesare abandoned Rome, followed by his artillery. He was carried in a litter where he lay exhausted and still prey to raging fevers, hidden behind scarlet curtains. His favorite horse, caparisoned in black velvet, preceded him. The ambassadors of Spain, Germany and France escorted him. His battle drums dictated the pace for the slow march.

On September 3, the cardinals began to gather in Rome to choose the successor to Alexander VI. Thirteen days later the conclave began. The Spanish candidate was Bernardino Lopez de Carvajal, cardinal of the Holy Cross, a generous patron of the arts skilled in diplomatic exchanges and a product of the Borgia season. The French backed Georges of Amboise, highly respected and favored by his king, Louis XII. Cesare placed his bets on his countryman Lopez or on the Frenchman, while secretly thinking that he would be satisfied with the election of the Italian Ascanio Sforza, who owed him a large debt of gratitude for the support he had received from the Borgia. Cesare's only fear was that the choice would be Giuliano della Rovere, stern critic of his father's corrupt rule.

Thirty-seven cardinals convened in the Vatican palace; twenty-eight of them were Italian. They could surely influence the election if they were in unison. But they were not.

The tensions and divergences among the four main candidates ended up excluding each from the choice. The votes converged on what, in Vatican language, was termed *un Papa di transizione*, a transitional pope, possibly old and weak enough to forecast a short pontificate, and meek enough not to generate particular worry.

The conclave ended in the morning of September 22, with the election of the sickly sixty-four-year-old Francesco Todeschini Piccolomini, who took the name Pius III in memory of his maternal uncle Enea Silvio Piccolomini, Pope Pius II. This time the Vatican planners proved to be correct. The new pope hardly had the time to "warm the papal throne." Twenty-six days later, he died after a violent seizure of gout.

Cesare returned to Rome. Machiavelli reported, "The duke is in the castle, and he has a better hope to be able to perform great things, for he has confidence in the next pope's being elected according to the will of his friends."

PRISONERS OF THE HOLY SPIRIT

Locked in the Vatican apartments *cum clave* (with a key) that opened only from the outside, the members of the Sacred College of Cardinals gathered again to cast their votes. No communication was allowed between them and anyone who did not belong to the limited group of attendants who had taken a vow of secrecy.

The history of past elections had been indeed rich in episodes of strong political pressure by lay powers seeking influence over the head of the Church, and of venal corruption often lamented as *simony*, from Simon Magus, the sorcerer rebuked by Peter for having offered money to buy the secret power granted by Christ to his apostles. At the Lateran Council of 1179, Pope Alexander III had promulgated the constitution *Licet de vitanda discordia*, which, in order to avoid discord, made all the cardinals equally electors, and excluded the lower clergy or the faithful who used to confirm the election by acclamation.

Abuses and inconveniences had occurred throughout the centuries. In certain cases, the inner feuds kept the cardinals from reaching the

necessary majority for an inordinately long time. The conclave of 1268, held in the papal palace at Viterbo, set a record. The people of the town had to resort to the extreme remedy of secluding the candidates in the palace, removing the roof and allowing them only bread and water. Under those strict measures, the cardinals finally reached an accord to elect Gregory X, on September 1, 1271, exactly two years, nine months and two days after the death of the preceding pope, Clement IV.

The bitter experience provoked Pope Gregory X to issue a special constitution at the Council of Lyons of 1274, called *Ubi periculum*. It established that, at the death of a pope, the cardinals who were present at the Holy See were to wait at least ten days for their absent colleagues to join them; they were then to meet in one of the papal palaces in closed conclave; none of them was to be attended by more than one servant, or two in the case of grave illness; in the conclave they were supposed to lead a life in common, not even having separate cells (a rule now changed to allow individual sleeping quarters, yet always within the confines of the conclave); they were to have no contact with the outer world, under pain of excommunication for those who communicated with them; food was to be supplied through a revolving wheel kept under watch; after three days their meals were to consist of a single dish, and after five days, of bread and water, with a little wine.

As Cardinal Giuliano della Rovere was about to enter the conclave area, he was approached by Cesare Borgia. The latter recited a veritable act of contrition, begging for the cardinal's absolution. Giuliano listened intently, then disclosed his own proposals. He forgave all that Cesare had done in the past, and was ready to build a new relationship with the Borgia heir. But the cardinal wanted him to secure the support of the French for his candidacy. Once elected, he would confirm Cesare's title as Captain General of the Church, help him further his career, protect the Spanish cardinals as per his wish, and possibly, in the future, consolidate the alliance between the della Roveres and the Borgias through the marriage of his nephew Francesco Maria to Luisa, the three-year-old daughter of Cesare Borgia and Carlotta d'Albret, then being raised at the court of France.

Duke Valentino studied Giuliano's noble countenance, his clear steady eyes looking straight into his own. The cardinal had the face of a thoroughly loyal man. Cesare felt, in his cunning heart, that he could trust Giuliano.

The conclave door was locked shut behind the cardinals. The next morning, the first day of November 1503, in the solemn silence of the secluded hall, the votes were counted and declared aloud: Giuliano della Rovere triumphed. The Cardinal First Deacon approached him to ask the ritual questions: "*Acceptasne electionem de te canonice factam?*" ("Do you accept your election made according to canon law?") Giuliano nodded his assent. "*Quomodo vis vocari?*" ("How do you wish to be called?") The eyes of the cardinals converged on the man who had been voted their leader and master of wisdom. By the choice of his pontifical name, the newly elected

pope was to give an indication of the guiding lines that would govern his pontificate. "*Julius II*" was Giuliano's answer.

Those present readily understood the message. The only other Julius in the long series of popes, chosen as successor of Marcus in A.D. 337, was famous for his opposition to the Arian heresy, for his stand against the enemies of the faith, within and without the Church, and for the severity of his moral principles.

A while later, the election was announced to the huge crowd that gathered in the *platea Sancti Petri*, the square in front of the old basilica and the Vatican palace. The new pope appeared on the loggia to impart his first blessing *urbi et orbi*, to the city and the world. The bells of Saint Peter's joined those of all the churches in Rome. Julius II looked at his city. The Roman breeze, the balmy *ponentino*, brought him the breath of the sea; memories of his native Liguria flowed back. He looked at Rome, at her ancient stones, wounded by the invaders, offended by its citizens oblivious of the bygone glory. He envisioned a resurgent Church, a new sap flowing through the withering limbs of the ancient tree planted by Christ, a papal house visited by clean pure air; and this, and the whole city, rebuilt by tomorrow's men.

13.
THE GIANT
SET FREE

"Vivus ducent de marmore cultus."

"They will sculpt live human figures in marble."

VIRGIL. *Aeneid*, VI, 848

G iant: the word evokes images — exact, strong, absolute. It derives from the Greek *gigas*, meaning "son of the earth," a creature of superhuman stature yet sprung from the earth's soil.

In the second half of the fifteenth century, with war threats rumbling in from the north, the Opera del Duomo, the committee that presided over all work done on the cathedral of Florence, decided that the city was in need of divine help. Great artists were commissioned to erect twelve inspiring statues of the city's patron saints and other friendly heroes atop the Duomo.

One of the sculptors to receive a commission was Donatello, who carved a monumental terra-cotta statue of the prophet Isaiah, later smashed to pieces by lightning. Agostino di Duccio sculpted a Hercules, also destroyed by natural causes. In 1463, Agostino was commissioned to sculpt another prophet, his contract stipulating that the statue be composed of four pieces of marble.

Agostino left for Carrara to look for the marble. There he saw a huge block of pure white marble that had been cut from the steep mountain wall in a rich quarry. It was brought to Florence, where, believing he was the recipient of a special blessing, Agostino tried to match his ambition against the impervious power of the colossal block. But despite a hole he drilled through the lower portion of the block and a knot he roughly hewed in the upper part, he failed miserably. Beaten, he walked away from the untamed giant.

The huge block lay abandoned in the workyard of the cathedral of Florence for some forty years while sculptors, known and unknown, young and old, coveted it, hoping for a commission to challenge it. One, Antonio Rossellino, got a chance to deal with the block in 1475, but he too had to withdraw from it.

Michelangelo had not escaped the Giant's enticement. Since his greener days in the Medici Garden, the unconquered, secret block must have frequented his dreams. Never had such an enormous chunk of pure marble been seen in Florence.

FLESH OF THE MOUNTAIN:
The Apuanian Alps and Their Marble

All rocks derive from the melted materials that compose the surface of our planet. They are divided into three fundamental groups: igneous, sedimentary and metamorphic. Marble is defined as metamorphosed limestone. Chemically it is calcium carbonate, a hard, homogeneous, compact stone, with a crystalline structure. One of its foremost qualities is the solidity that allows it to survive any climate.

To Michelangelo, whom Walter Pater called "master of live stone," marble was a living matter, buried yet waiting to be recalled to life by the creative power of the sculptor. He had been acquainted with its almost magical quality since his early days. Not far from his home was marble's most renowned source: the chain of mountains that Boccaccio called "the Apuanian Alps" after the population who had first lived on its slopes. The Apuanian chain covers more than a thousand square kilometers, parallel to the Tyrrhenian coast, from the Appenines to the countryside of Lucca.

This formidable barrier rises like a colossal wave over land and sea, bearing cypress, pine and tamarisk trees on its lower slopes, while its peaks etch the sky above with splintered, rocky sharpness. Wherever humankind has opened deep furrows in its sides, since the time of Julius Caesar, the Apuanian Alps show their naked flesh shining white in the sun: an immense deposit of precious marble, the largest in the world, often running three thousand feet deep.

The Roman word for marble was *marmor*, from the Greek *marmairo*, which means "to shine," and the Carrara marble was named *marmor lunense* for its white translucence, resembling porcelain, and its proximity to the ancient town of Luni. As one stands today where Michelangelo stood over four centuries ago atop the precipitous quarries of Serravezza, Carrara or Massa, the massive rubble of marble can be mistaken for snow.

The Giant was found along these slopes, cut away from the side of the mountain by workers employing the primitive method of opening cracks into which wooden wedges were inserted and hammered in deeply. The wedges, when wet, would swell, causing the huge block to split from the wall. The block was then made to slide on soaped beams all the way down to the foot of the mountain where it was loaded onto a barge or a raft, and floated along the Arno to Pisa and finally to Florence. There, Michelangelo would see not a block of stone, but a cradle inside which the living creature of his imagination breathed, waiting for the genius who would set it free: a veritable Giant that would stir humankind to wonder, generation after generation.

In the spring of 1501, Michelangelo was in Rome, unhappy, tormented and nostalgic for Florence. The eternal city, where he had come bursting with desire to work and prove his talent, had both rewarded and troubled him. The scourging voice of Savonarola still reverberated in his conscience: the corruption and crimes he had witnessed in this very center of Christianity disheartened him, though in the city his *Bacchus* and his first *Pietà* were still celebrated as miracles.

His soul was in exile. He longed for the purity of the Florentine air, for the purple hills, the green ribbon of the Arno, even for his troublesome family.

When he heard that in the newly proclaimed Republic of Florence the chief magistrate, Gonfalonier Piero Soderini, was talking about commissioning the Giant, it seemed as if divine providence was stretching out its hand to him. Word soon reached him that Andrea Contucci, a sculptor

Michelangelo. *Saint Peter*. Siena, Cathedral, Piccolomini altar.

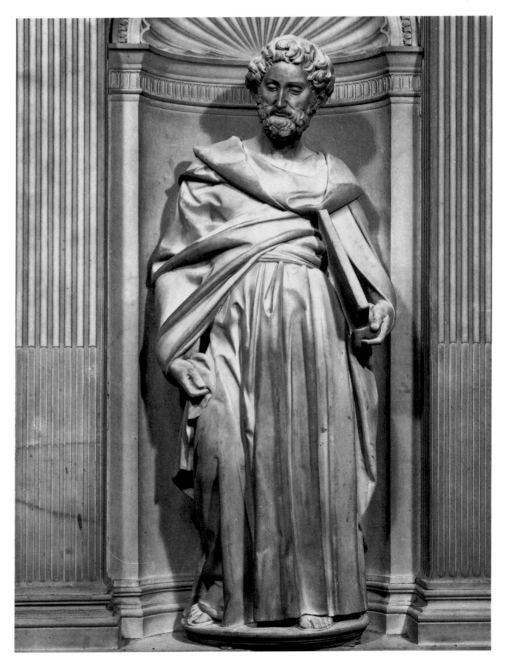

of some repute known as Sansovino, was to be considered, and that the great Leonardo da Vinci himself had been added to the list of contenders. Michelangelo did not waste any time. The recognition he had won in Rome made him intrepid and resolute. He wanted the Giant for himself.

Before leaving Rome in May 1501, he had entered a contract with Cardinal Francesco Todeschini Piccolomini to complete fifteen statues for the Piccolomini altar in the Duomo. Michelangelo had agreed to complete the statues in three years for 500 gold ducats. He guaranteed these would be "perfect works" and that he would not undertake any other commission during the three years.

Florence opened its arms wide to its returning son. His Roman fame had rebounded to the city of flowers, and more commissions were ready for him. It did not take him long to convince Piero Soderini and the cathedral's committee that no other sculptor could meet the challenge

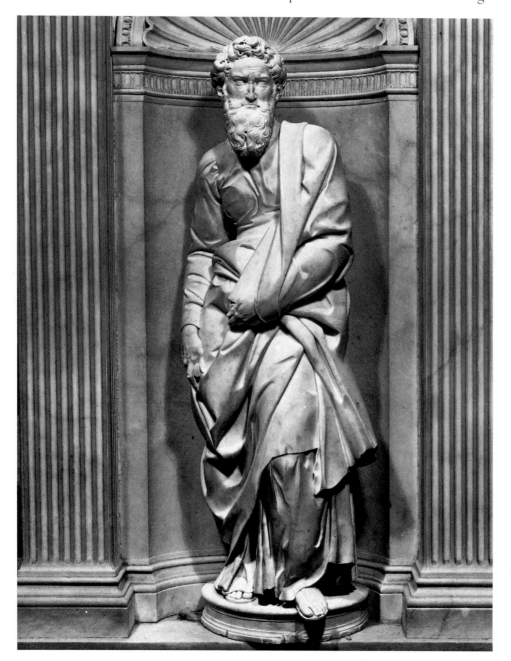

Michelangelo. *Saint Paul*. Siena, Cathedral, Piccolomini altar.

posed by the Giant. Michelangelo had a vision that the marble held closed in itself, a creature born in his imagination, yet mysteriously contained within the tremendous blocks: a David no one had ever evoked but that Michelangelo could see inside the stone. He would set that David free, unfettered from the very marble that imprisoned him. His creature would emerge alive in the splendor of its resurrection. Michelangelo knew that the clarity of his vision would guide his hand.

At last, on August 16, 1501, the members of the cathedral committee and the sponsoring consuls of the wool workers' guild called him to sign the contract "to execute and bring to completion a human figure from the block of marble called the Giant, fifteen feet high, existing in the Cathedral's workyard, once roughly hewn by master Agostino di Duccio...." Michelangelo was to finish his work in two years for a salary of six gold

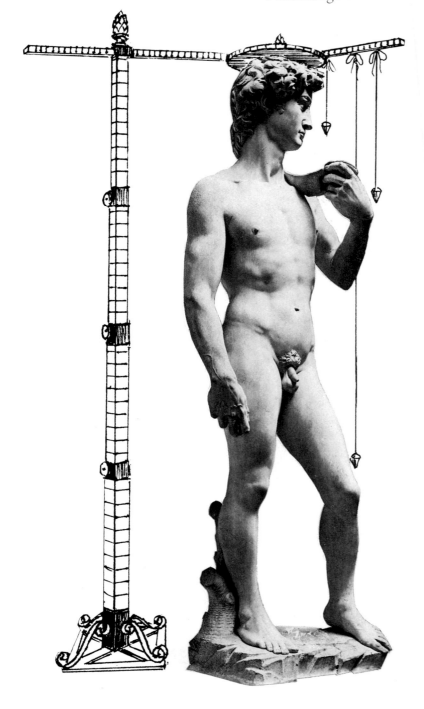

florins a month. Later, on February 28, 1502, his compensation was raised to a total of 400 gold florins, his monthly allowances to be deducted from that sum.

Possessed by a burning, creative fever, he forgot all other projects, including his commitment to complete the series of statues for the Siena altar. Between 1501 and 1504, he delivered only four (and these possibly executed by others). His inability to complete the commission haunted him in later years; he felt that he was betraying the trust of Cardinal Piccolomini, a man who had believed in him and helped build his reputation. But the David asleep in the block was calling to him in a voice louder than any appeal of his own conscience.

The Giant was lifted up from its horizontal position, turned upright and moved to a corner of the workyard, around which Michelangelo built a wooden shed to hide it from unwanted curiosity as he worked. On September 13, 1501, he stood for the first time alone and face to face with the indomitable block, which still held the secret of its inner structure, a delicate system of veins that, if wrongly hit, could cause the marble body to split in a tragically irreparable manner.

Deaf to the advice of many, including Soderini, that he should tackle the marble horizontally, so as to sculpt the boy shepherd with the mighty Goliath fallen at his feet, Michelangelo followed his own vision. With the help of his definer (the instrument used by sculptors to transfer the measurements from the initial drawings first onto the wax or clay model and then onto the marble), he prepared the block of marble for his attack. His creative genius sparked a formidable physical energy; an eyewitness who saw him working on a sculpture in his later years reported that Michelangelo could "carve the hardest marble in less time than three men working together. He could knock out chips as thick as four fingers, with such precise aim and calculated impact, that had he but hit any harder, all might have been ruined." Even he must have hesitated before striking the first blow, but once he had made up his mind, he removed the knot clumsily carved by Agostino on what would have been the chest of his aborted prophet.

Three days later, on September 16, he began sculpting his David. The boy shepherd, unlikely winner of an uneven duel, had inspired other great Florentine sculptors before Michelangelo; the bronze statues by Donatello and Verrocchio had been celebrated as examples of artistic excellence and depth of inspiration. These renditions had emphasized the boyish stature of David, his adolescent frailty. The creature Michelangelo was awakening transcended the traditional interpretation of the biblical story. Faithful to his belief that "all anger, all abjection, and every force, he who arms himself with love conquers," Michelangelo found his David to be mightier than Goliath. The youth, caught in the moment when his will is firmly set on meeting the terrible challenge, rises to become himself the true giant.

Giancarlo Marmori has expressed this concept beautifully in his *Adam, New Born and Perfect*: "Neither a warrior (Donatello, Verrocchio) nor a shepherd (Bernini), Michelangelo's giant has resolved the action into a

OPPOSITE, LEFT:
An instrument called the "definer" or "definator" was used by sculptors in Michelangelo's time to relate the drawing's proportions to the marble block. It consisted of a disk bearing metric marks, and a ruler that could be rotated once the disk had been placed on the block. Plumb lines were hung from the ruler.

OPPOSITE, RIGHT:
"The great artist has no concept . . ." Michelangelo saw his *David* imprisoned in the marble cage.

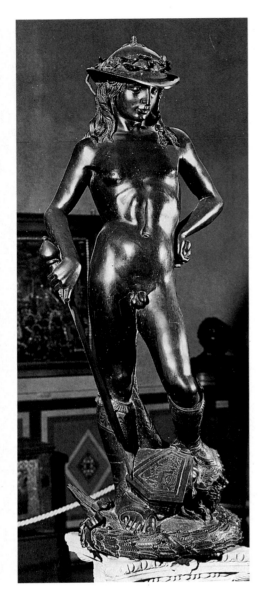

Donatello. *David*. Florence, Bargello National Museum.

OPPOSITE:
Michelangelo. Detail of *David*. Florence, Academy of Fine Arts.

state of mind. He stands forever ready to prove his *virtù*. In Alberti's words, 'to gain glory a man must have excellence. To gain excellence he need only will to be ... only a firm whole, and unfeigned will, will do.' David's monumentality (*il gigante*) transcends reality, and access to a symbolic frame of reference is crucial for understanding a sculpture which rests upon a pedestal of meanings. He is, and can only be, bigger than life."

Michelangelo worked unremittingly; he was seen heading to the cathedral's workyard "in the most unthinkable hours of night and day." He was engaged in the confrontation with his Giant, oblivious to all else, when Gonfalonier Soderini called on him early in 1504 to perform what he described as a "very important" service to the Florentine Republic. The powerful and influential Duke Pierre de Rohan, Seigneur de Gié, Marshal of France and a favorite of the king of France, had been seduced by Donatello's *David*, which he had admired during the 1494 French expedition to Florence. The marshal was a great collector of artworks, which he liked to acquire as gracious gifts from whoever was eager to obtain his special mediation at the French court. Florence had already been exceptionally generous to him; when he left the city, after his second visit in 1499, he took seven marble and two bronze statues that the Signory, sparing no effort to secure its territory, had garnered for him. Now the greedy marshal had been pressing for a bronze David, similar to the splendid one by Donatello, and Soderini found it difficult to deny his unrelenting requests.

Michelangelo tried to wave the new commission aside; his great *David*, although almost finished, still commanded his constant attention. Furthermore, he could not conceive of imitating, let alone copying anything by anyone. Soderini had to employ all his dialectical skills to persuade the sculptor that by pleasing the marshal he would help the greater cause of Florence. Besides, he explained, no one expected Michelangelo to do anything but prove, once again, in his inimitable style, the excellence of the Florentine genius. All that Soderini asked, on behalf of the marshal, was that there should be a head of Goliath at the winner's feet.

Michelangelo sketched this new David, complete with the macabre trophy. On the side of his drawing, he wrote the famous verse: "David with the sling, and I with the bow." Many have taken the "bow" in this proud sentence to mean the tool used by stonecutters even to this day. But Giovanni Papini in his *Life of Michelangelo* suggests another interpretation by comparing "his vocabulary to that of the poet whom he knew and loved: Dante." In the *Divine Comedy*, one finds the word *bow* used several times. Michelangelo may have thought of Canto XXVI of *Paradiso*, where Saint John questions Dante about love: "Who made you draw your bow at this exalted target?" Here *bow* is used as a metaphor for intelligence, mind, soul — surely closer to the meaning adopted by Michelangelo. The shepherd had won his fight with his sling; Michelangelo would conquer this new challenge, in which he was matched against a master like Donatello, by the power of his intelligence. One year later, the bronze *David* was cast with the help of Benedetto da Rovezzano. Documents in the Florentine archives show that the contract for the new *David* was perfected only after Michelangelo had begun to work on it. The later date of the contract itself, August 12, 1504, indicates the artist's reluctance.

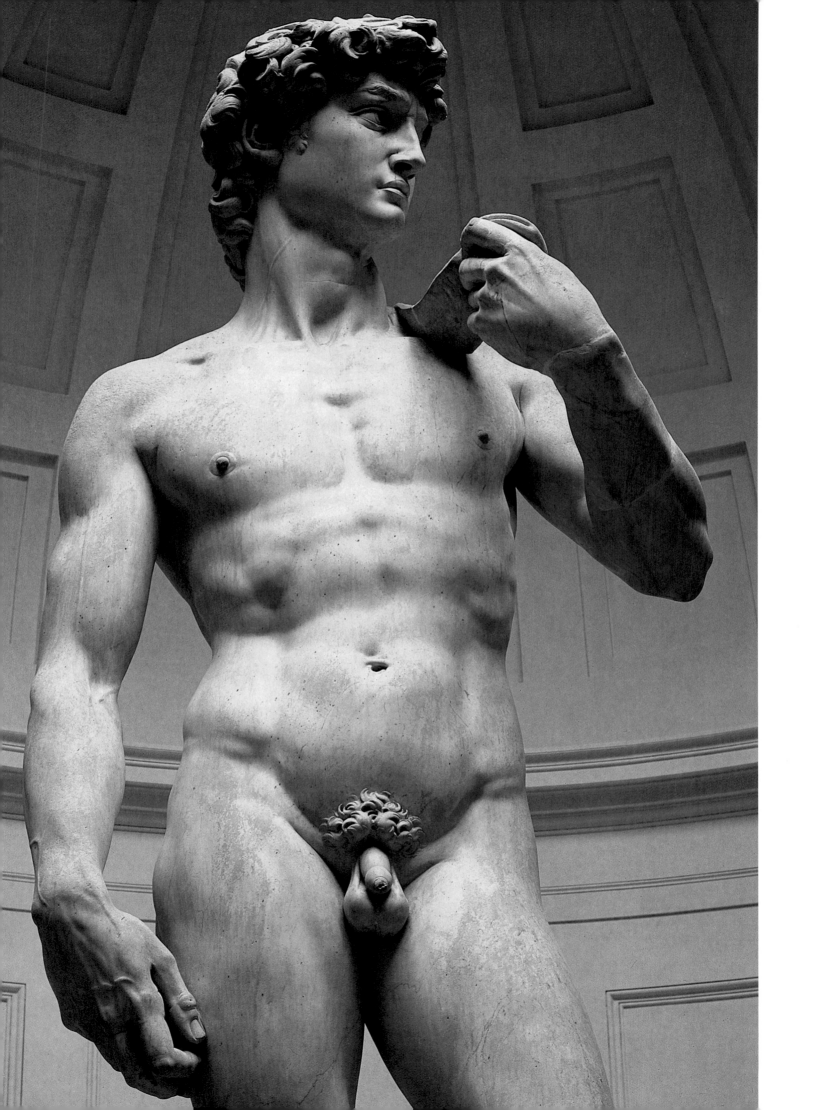

In the meantime, the duke de Rohan had gravely displeased King Louis XII and had fallen from royal grace. Florimond Robertet inherited both the status of the king's favorite and the prize of the Florentine munificence. In 1508, Robertet welcomed Michelangelo's bronze *David* in his castle at Bury, whence it was transferred to the castle of Villeroy, its last-known destination. From there it mysteriously disappeared. No trace was ever found of what was certainly another masterpiece. Only the ghost of it remains: the drawing of a youthful, slender David, a kerchief tied around his head, his foot resting on the gigantic head of Goliath. And the sentence, "David with the sling, and I with the bow."

At last Michelangelo was able to return to his Giant. It took him twenty-eight months, four more than the contract had set, to complete his marble *David*. Twenty-eight months of furious activity, driven by his desire to give Florence the very symbol of its own dignity and freedom. Nourished by a daily meditation on the biblical account and on the psalms that

Michelangelo. *David*. Florence, Academy of Fine Arts.

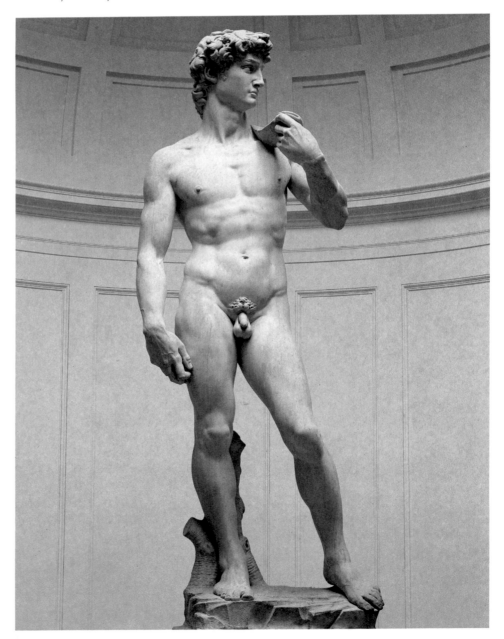

convey to us the voice of the shepherd king, Michelangelo delivered to his generation, and all generations to come, the calm, serene portrait of a human being who personifies the dominance of virtue over fortune. His nakedness, faithfully rendered according to the biblical tale of how David rejected the sword and armor that Saul had given him, reveals his condition as the "new Adam," champion of the Renaissance.

When the statue was finished, a specially appointed committee was entrusted with choosing its display site. The committee members, along with the two heralds and the trumpeter of the Signory, were the most honored Florentine artists of the time: Andrea della Robbia, Cosimo Rosselli, Francesco Granacci, Piero di Cosimo, Davide Ghirlandaio, Simone del Pollaiuolo, Sandro Botticelli, Antonio and Giuliano da Sangallo, Andrea Sansovino, Pietro Perugino, Lorenzo di Credi, Filippino Lippi and Leonardo da Vinci, as well as representatives of the guilds.

The discussion was opened by one of the heralds, who suggested

Michelangelo. Detail of *David*. Florence, Academy of Fine Arts.

that the *David* should take the place currently occupied by Donatello's *Judith*, which he felt was a bad omen for the city "as it is not good for a woman to kill a man." The herald's advice was not taken seriously; rivals and friends of Michelangelo went on to examine various proposals. Botticelli wavered between the balustrade in front of the Signory palace and the nearby Loggia dei Lanzi, insisting, however, that it should be in "full sight." Cosimo Rosselli, the painter, wanted it inside the palace courtyard, or in front of the Duomo. Giuliano da Sangallo, expressing his fear that the weather might harm the marble, opted for the loggia, where the David could be lodged in a niche, right in the central arch. Leonardo, the painter Piero di Cosimo and the architect Antonio da Sangallo seconded Giuliano's motion. Ghirlandaio would have liked it to stand on the balustrade, even if this meant that the *marzocco*, the lion symbolizing civic valor, would have to be removed. Fierce arguments ensued. Finally, Filippino Lippi proposed that Michelangelo himself should be consulted. At last, many months later the decision was reached to remove the *Judith* and to install the *David* in its place. Simone del Pollaiuolo and Antonio da Sangallo were commissioned to construct the pedestal for the statue.

To transport the monumental statue from Michelangelo's workshop to its elected destination, a carefully devised cage had to be constructed. Suspended with thick hemp ropes inside its strong wooden beams, the *David*, standing fifteen feet high and weighing several tons, was pulled out of the workyard; to let it pass through the gateway, the arch above it had to be broken. The statue was slowly hauled, with the help of winches and timbers, through the streets to Piazza della Signoria. It began its journey at midnight on May 14, 1504. The chronicler Landucci, who witnessed the event, offered this vivid description: "The Giant went very slowly so straight and firmly tied up that it dangled and didn't touch with its feet; with the strongest wooden beams and with great diligence it took four days to reach the Piazza. It arrived in the square on the eighteenth at noon; it took about forty men to move it, with fourteen beams underneath it to let it roll on, and the beams were moved with each step....It took until the eighth of June to set it up on the steps of the palace."

Jealousy and resentment, however, had not been stifled by the marvelous achievement; that first night, as the *David* emerged from the workshop, stones were hurled against it. Luckily, the statue suffered no harm. Many citizens stared in wonder as *David* went by their windows, his head proud and majestic. The chronicler goes on to tell us that "watch had to be kept at night to protect it."

The dawn that rose on that glorious June day started with a concert of bells; the citizens of Florence entered the square by groups of twos, tens, soon growing into hundreds, then thousands to view the boy who had emerged as the true giant from the colossal block of Carrara marble. The *David* had responded to their appeal, a monument to their own trials and greatness.

The pedestal was hit by lightning in a violent storm that raged over Florence in 1512. During the riots caused by the expulsion of the Medici from Florence in 1527, a bench thrown out of a window in the Signory

palace fell on the left arm of the statue, breaking it in three pieces. Francesco Salviati and Giorgio Vasari carefully restored it.

 David stood in its place until 1873, when it was transferred to the gallery of the Academy, where it can now be seen. In 1910 a modern copy replaced the original in front of the Signory palace.

POWERFUL, TOO POWERFUL TO BEHOLD

Several years ago, *Time* magazine reported several cases of emotional trauma caused by the encounter of some visitors with the Giant of Florence. Indeed, to meet the *David* is to experience a surging of inner feelings that range from immediate admiration to deeper emotions stirred by the eloquent silence and dynamic calm of the statue.

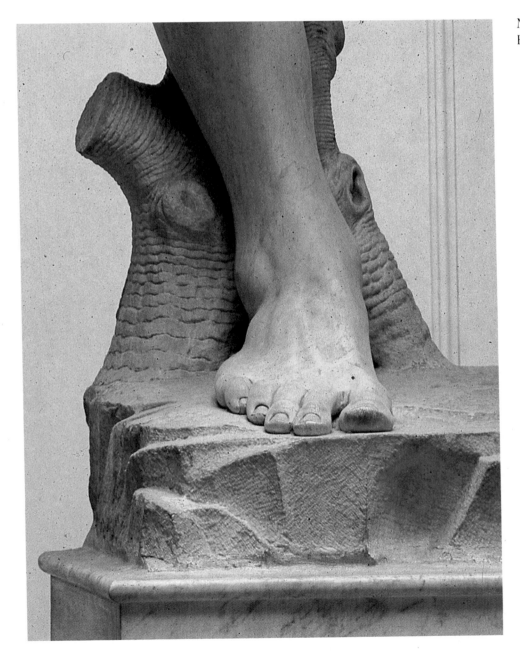

Michelangelo. Detail of *David*. Florence, Academy of Fine Arts.

The young man in his late twenties that stands in his glorious nudity is an athlete whose momentary stillness vibrates with the motion into which his body will soon spring; this is suggested by the left leg, with its supple bending of the thigh and calf, the foot barely touching the ground, and the left arm uplifted in a measured gesture. The right leg, firmly planted like a pillar of force on the ground, supports the weight of the torso and shoulder, stressing the energy charge condensed in the muscles of the right side, a charge to be released and transmitted to the left side as

Michelangelo. Detail of *David*.
Florence, Academy of Fine Arts.

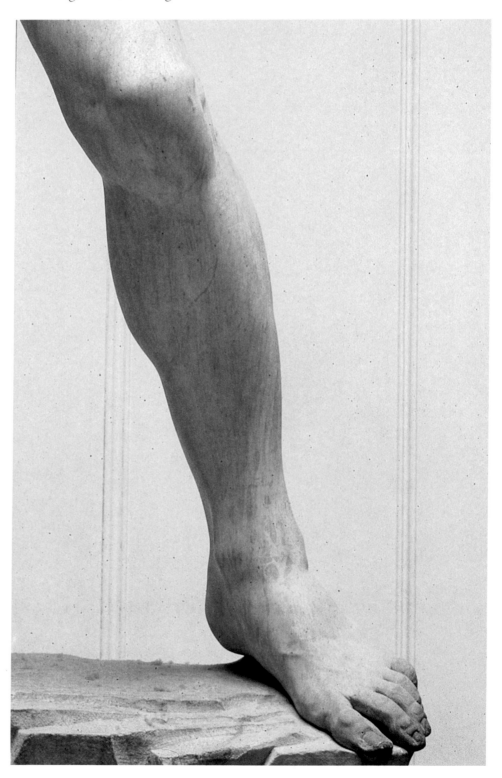

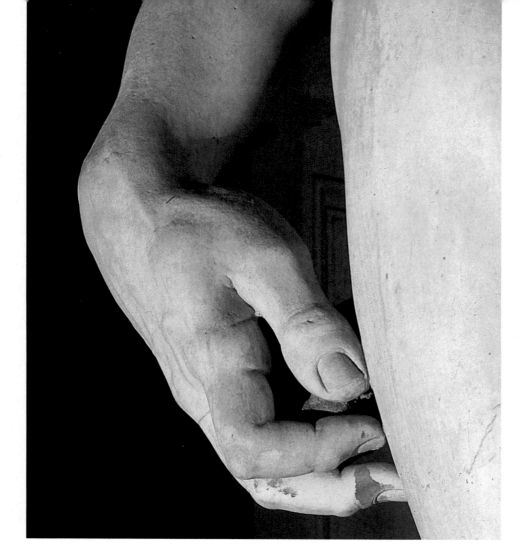

Michelangelo. Detail of *David*.
Florence, Academy of Fine Arts.

soon as the latter starts revolving, with the right leg as the pivot on which the whole body will turn in its increasingly whirling motion. "God is at my right hand," proclaims the Psalm.

The strong hand with its swollen veins that holds the slingshot shows the concentration of David's will. From the head held straight to the eyes deeply set under knit brows and fixed on the mighty opponent; from the nostrils slightly flared to every line around the mouth, each detail manifests David's inner resolution, his irrevocable decision to engage in the impossible duel. He is no more the boy shepherd. As he left Saul, having cast away his armor, David is the champion of an ideal freedom, whose stature can be measured only in the magnifying light of the spirit, rather than in accordance with the adolescent's physical size.

Linger awhile in front of the *David*, and let it conquer its space and manifest its shivering dynamic force before your eyes. There — he sees Goliath, a tower planted in the tender grass. His eyes are fixed on the Philistine. His hand closes on the stone he has picked up. It feels smooth to the touch, strangely light. His heart trembles, his throat tightens; his weapon is so inadequate. He clenches the stone tightly in his fist. He puts it in the sling. He feels it becoming heavier and heavier as he whirls it in the air, as if the stone were attracting to itself all the atoms of the universe. The sling slices the air with the exact precision of a blade.

Suddenly, David springs into action. With the acceleration of his whirling motion, he seems to grow taller against the green background of

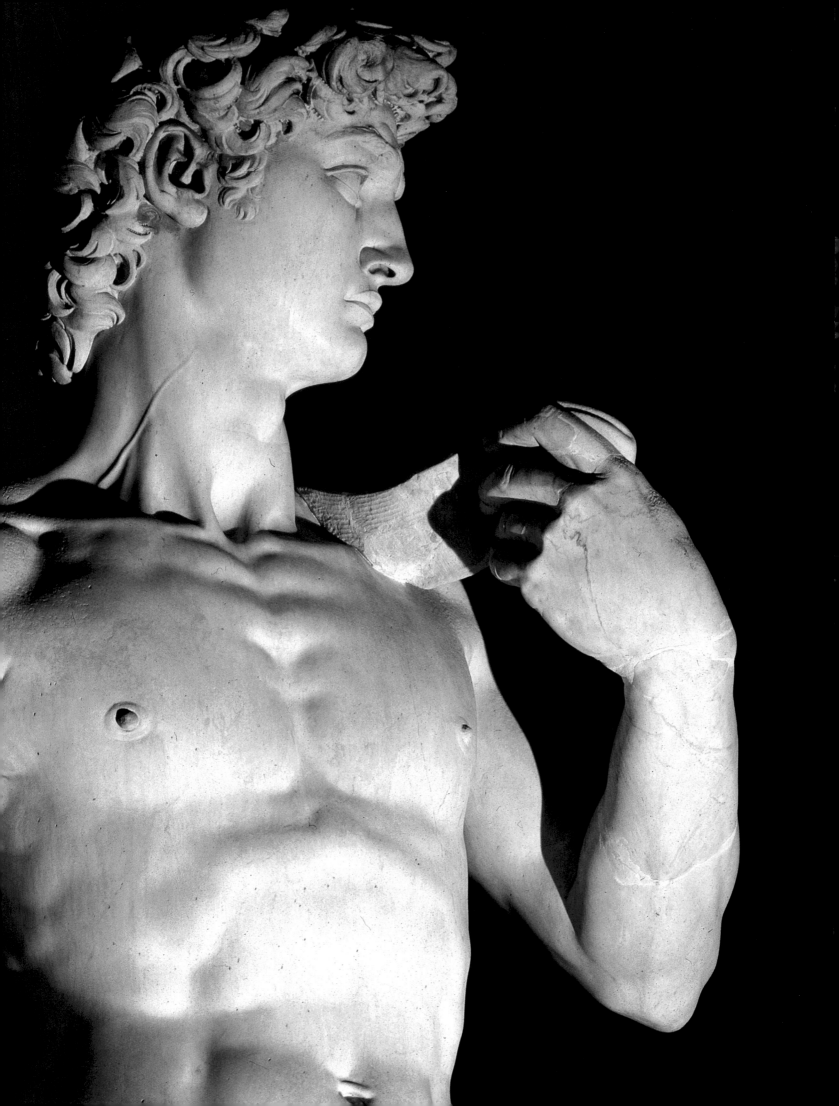

the valley, while the Philistine loses stature. The stone leaves the sling and flies with the fluttering of wings, the drone of angry bees. It hits the target, stamping death on the forehead of Goliath. Now David stands still, frozen in the finishing gesture, as though he never moved. What he has done is blocked in time; with no beginning and no end, his action is as eternal as his spirit.

MORE PRISONERS

"Only this burns me and makes me fall in love."
MICHELANGELO

In April 1503, Michelangelo took on the commission to sculpt the Twelve Apostles for the Duomo of Florence (his *Saint Matthew* is one of them). In addition, during the four-year period from 1501 to 1505, when he would go to Rome, he sculpted three Madonnas (the Pitti Tondo, the Taddei Tondo, the Bruges *Virgin and Child*) and did a painting in tempera (the Doni Tondo). Finally, he also drew the huge cartoon for *The Battle of Cascina*, his memorable statement of excellence in the forthcoming contest with Leonardo.

The Piccolomini contract remained as a thorn in his side throughout his life; he always felt remorseful for his failure to respect it. Nor did the Piccolomini family forget the engagement that bound Michelangelo. Many years later, in 1537, as the sculptor was facing the terrible *Last Judgment* fresco, he was reminded of it, and pressures were made in vain to force him to respect the contract. Three years before his death, in 1561, he was seized by a crisis of conscience and found no peace until he induced a descendant of the family, Francesco Bandini Piccolomini, archbishop of Siena, to grant him pardon and set him free from the prison of the contract.

The statues he did make for Siena are, in size as well as in artistic value, far from his other works of this period. The small figures, three feet high, show signs of the intervention of other hands besides Michelangelo's. Some other artist evidently translated his drawings into the sculptures. Particularly, the *Saint Gregory* and *Saint Pius* tend to give credit to the contribution by Baccio di Montelupo, whose name was mentioned in a letter of Ludovico Buonarroti to his son.

The reluctance that Michelangelo showed toward the execution of the contract probably indicated that he had entered it mainly as a source of income to assist his father and brothers, always in need of financial help. The clauses and conditions imposed by Cardinal Piccolomini, rather severe if one considers that Michelangelo had just offered such high proof of his talent with the *Pietà*, suggest that he must have felt a lack of enthusiasm for the commission right from the first. And there is the question of one peculiar clause requiring that he finish a statue of Saint Francis of Assisi that had been partially carved by the hand of Piero Torriggiani, the same hand that, in the days of his early youth, had crushed Michelangelo's nose, disfiguring him for life. Too much for Michelangelo to stand; enough to contribute to the waning of whatever eagerness he had felt at the moment he signed the often regretted document.

Exalted be the Lord of my salvation.
He rescued me from our enemies,
From the man of violence.
I will praise my Lord,
And glorify his name.
He displayed his love
For David, his anointed.

PSALM 18

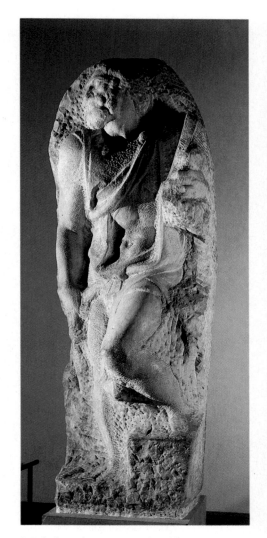

Michelangelo. *Saint Matthew.* Florence, Academy of Fine Arts.

OPPOSITE:
Michelangelo. Detail of *David.* Florence, Academy of Fine Arts.

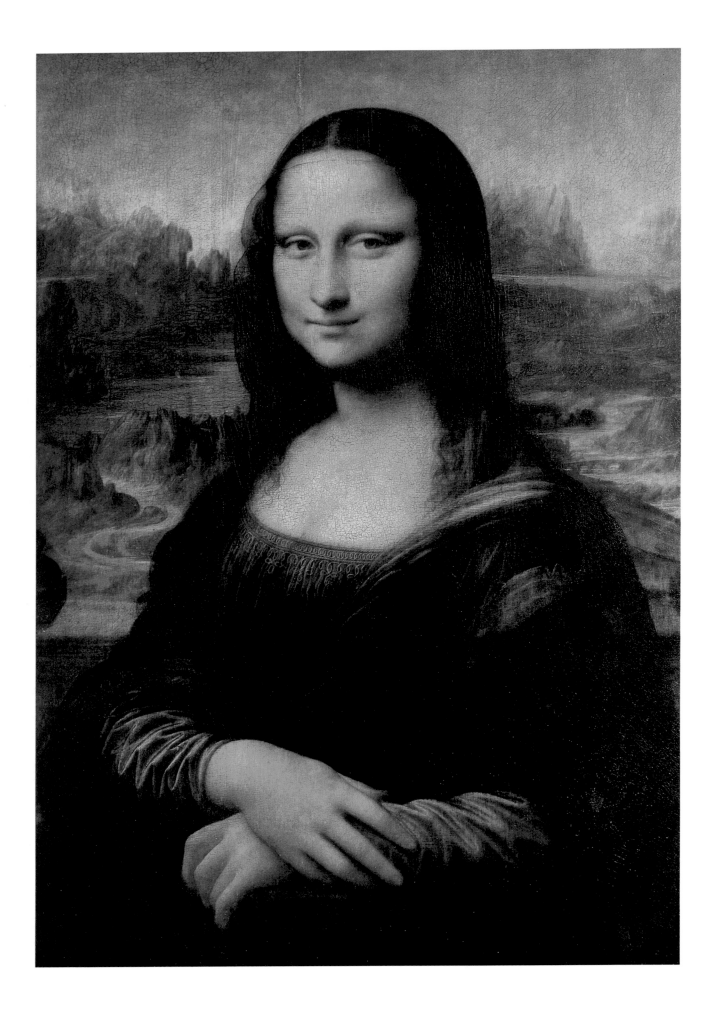

THE COVETED SMILE 14.

"The coveted smile was kissed by such a lover..."
DANTE

LEONARDO AND THE MONA LISA

No other work in the history of art is surrounded by the mystery and wonder that has accompanied the *Mona Lisa*. Who was the woman portrayed by Leonardo? Through the centuries, scholars have posed the question. Vasari identified the woman as Lisa di Antonio Maria Gherardini, born in 1479 to Anton Maria, son of Noldo Gherardini, a Florentine citizen from Borgo Santo Spirito. In a land registry dated 1480, Anton Maria recorded: "I have a daughter, Lisa, one year old, without any beginning of a dowry." In 1495, at the age of sixteen, Lisa became the third wife of Francesco del Giocondo, a merchant who was one of the twelve *Buonomini* of Florence, nineteen years older than his new bride. Another registry documents that in 1499 Lisa lost a daughter "who was buried in Santa Maria Novella." According to Vasari, Leonardo began working on the portrait in 1503, when Lisa was twenty-four years old and that by 1507 "it was not finished."

Another scholar, Benedetto Croce, suggested that the portrait was possibly painted in 1502 and that Leonardo's model was Costanza d'Avalos, duchess of Francavilla. But Costanza was born in 1460 and could hardly be the woman in her early twenties who sat for Leonardo. Adolfo Venturi, dating the picture at 1501, believed that the portrait was of the widow of Federico del Balzo, the strenuous defender of the Isle of Ischia. The art historian Lomazzo identified the woman as a "Neapolitan lady." To con-

OPPOSITE:
Leonardo da Vinci. *Mona Lisa*. Paris, Louvre.

Leonardo da Vinci. Detail of *Mona Lisa*. Paris, Louvre.

fuse the matter even further, in the Fontainebleau inventories the subject of the painting is described as *une courtesane au voile de gaze* ("a courtesan with a gauze veil").

The history of the painting is equally obscure. Antonio de Beatis, visiting Leonardo at Cloux in France on October 10, 1517, remembered seeing three paintings: "a young Saint John the Baptist, a Holy Virgin with child Jesus and Saint Anne," and a third one, a portrait of "a certain Florentine woman painted at the request of the Magnificent Giuliano de' Medici" (Lorenzo's son). De Beatis reported that the painting of the Florentine woman was given back to Leonardo to avoid the jealousy of Giuliano's bride, Filiberta of Savoy. De Beatis described the three paintings as "utterly perfect." Was the portrait seen by de Beatis the *Mona Lisa* of the Louvre?

Cassiano del Pozzo (1625) claimed that the *Mona Lisa* was bought for 4,000 gold ducats by Francis I of France and remained in the royal collection until 1805, when it entered the Louvre. It is a fact that Leonardo kept the painting in his possession until it was sold to Francis I. Scholars have wondered: if it had been commissioned by Francesco del Giocondo, why wasn't it given to him? Was Messer del Giocondo dissatisfied with the painting because he did not recognize his wife in it?

The speculation continues even today. Recently, a well-intentioned student of art made public the results of a computerized inspection of a photographic reproduction of the painting. The painstaking work led her to conclude that the woman in the painting was none other than Leonardo himself, that the painting was, in fact, a self-portrait, a theory befitting all the canons of psychoanalytical examination accumulated over the past four centuries.

Yet, as one gazes at the *Mona Lisa*, the erudite or fanciful labor of identifying its mysterious subject seems almost irrelevant. With its irresistible attraction, the small painting inspires a sense of growing wonder, as if the enigmatic smile erases the value of all mere physiognomy and becomes a beacon to invite the viewer behind the facade of that rotund face, those rather plump limbs, into a landscape of the mind where a *true portrait* exists.

Slowly, inexorably, the model, whoever she was, must have lost her importance, even her function, as Leonardo progressively discovered the real creature evoked by his brush, a creature that had very little to do with the woman posing for him. Not the portrait of Mona Lisa del Giocondo then, or a Neapolitan courtesan, but a woman born on the canvas as Leonardo evoked her from his own heart and mind, a projection of his inner self. The German scholar Marie Herzfeld, quoted by Freud in his essay on Leonardo, wrote that "in the *Mona Lisa* the artist dug inside himself to the point that he was able to introduce in his painting a great part of the *enigmatic sympathy* that was stored in his own soul."

In the end, as the scholar Muntz has noted: "No artist has ever expressed in this way the very essence of femininity; tenderness and coquetry, the whole mystery of a heart that guards its secret, of a brain that considers, of a personality that eludes and does not yield of herself but her splendor."

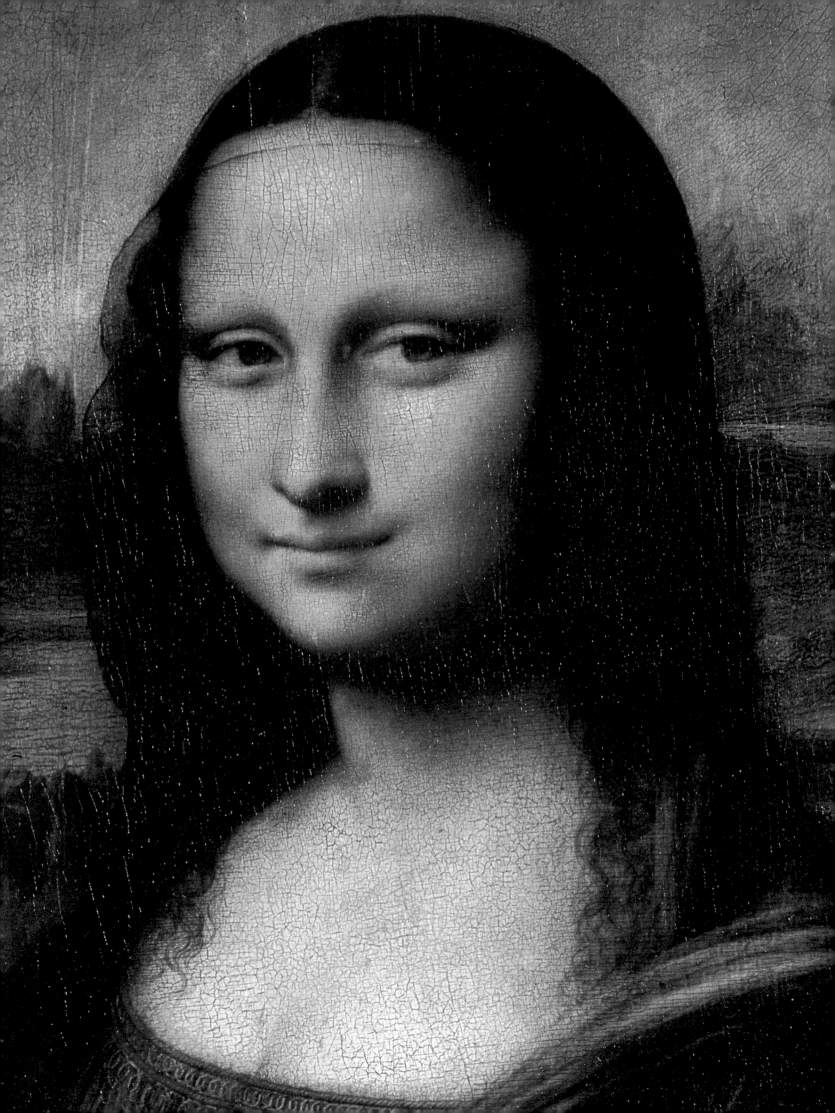

THE EXCELLENCE OF
PAINTING VERSUS SCULPTURE

*The sculptor as he creates his work employs the strength of his arm by which
he carves the marble or other hard material that encloses his subjects; and
this is done by most mechanical exercise, normally accompanied by copious
sweat that mixes with the marble dust and forms a mud smeared all over his
face. The marble dust flours him all over so that he looks like a miller; his
back is covered with a snowstorm of chips, and his house is filthy with the
flakes and dust of the marble. The exact contrary is true of the painter (taking
the best painters and sculptors as standards of comparison); for the painter
sits before his work, perfectly at ease and well dressed, and uses light brushes
dipped in fine colors; and his place is clean and filled with lovely objects; and
often he works to the accompaniment of music or of the reading of various
and beautiful literary works that, since they are not mixed with the clangor of
the hammer or other disturbing noises, provide great pleasure to the ear.*

LEONARDO DA VINCI

OPPOSITE:
Leonardo da Vinci. *Mona Lisa*
nude. Chantilly, Condé Museum.

In listing the ideal conditions for the execution of a painting, Leonardo indicated that the painter should wish for a wonderful storm, with lightning and thunder, and a gray light capable to exalt and, at the same time, soften surfaces. Faithful to his own precepts, when painting the *Mona Lisa* Leonardo possibly covered the room with black drapes so that the light would fall only from a window to the sky. He believed that an ambient light allowed the painter to register the interplay between the light itself and the model's figure. And certainly there must have been music in the studio; songs performed by his faithful Salaì on one of the admirable instruments designed and made by Leonardo himself, a lute, a flute, a clavichord, or a *lira da braccio*, the ancestor of the violin.

No matter what the circumstances of his studio, one cannot discuss the *Mona Lisa* without mentioning that smile. Vasari cites, among the first artistic essays of Leonardo, "some heads of females who smile." Were these early images already refractions from distant smiles? The ancient Etruscans, as they committed themselves to the river of time in their funerary portraits, displayed a similar undefinable smile on their lips. Or, as some scholars have suggested, did a secret nostalgia for a never-forgotten memory of Leonardo's natural mother find its echo on the lips of the woman we know as *Mona Lisa*?

Many writers have attempted to define the smile of the *Mona Lisa* but none have come as close as the art historian A. Conti in capturing its elusive quality. "The woman smiled in a royal calm: her instincts of conquest, ferociousness, all the hereditary qualities of her species, the will to seduce and ambush, the grace of deceit, the freedom that conceals a cruel intention, all this appeared alternatively and disappeared behind the smiling veil, and became fused in the poem of her smile.... Good and malicious, cruel and merciful, gracious and feline, she smiled."

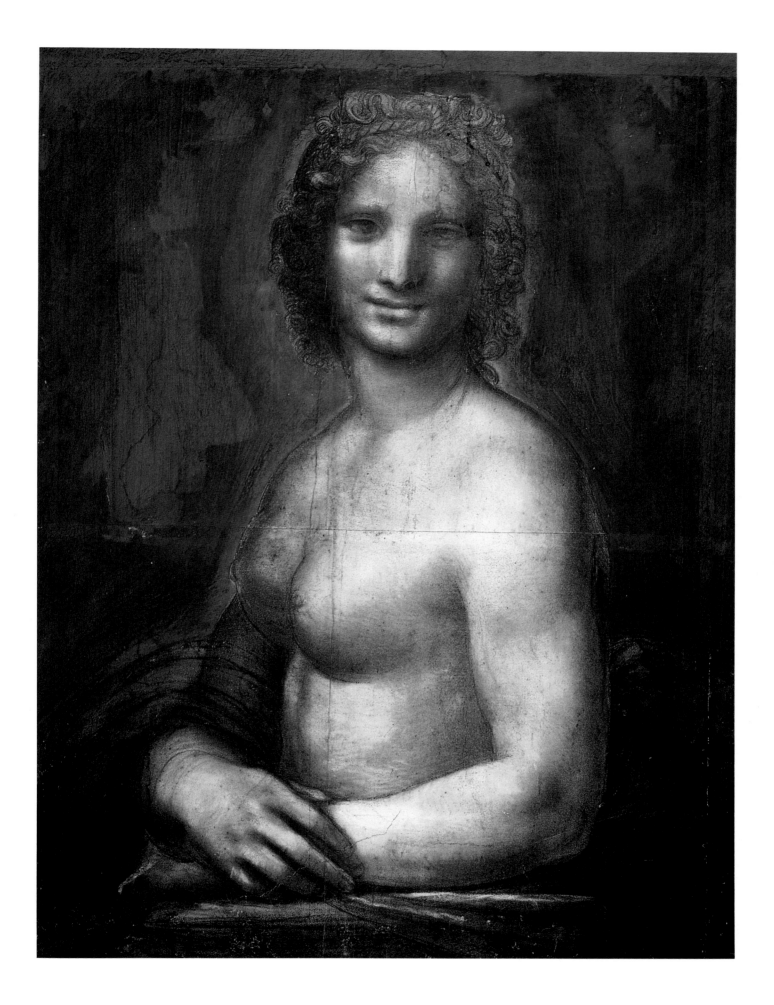

Surely the background landscape in the portrait is as mysteriously evocative as the woman's smile itself. Here trees, rocks, fields, waters appear to be vapors more than realistic shapes. Inconsistency and impermanence dominate the painting; only that smile, the quivering of a soul on barely rippled lips, in concert with the serene forehead and the intent eyes, holds the figure on the threshold of a dreamy unreality. As Leonardo once wrote: "The divinity that is within the painter's science so ordains it that his mind metamorphoses into a resemblance to the divine mind. Its powers unrestrained, it discourses of all the beauty of the world, animals, plants, fruits, towns, and the countryside; the ruins of mountains, horrifying places and pleasant ones; the sea and its rages contending with the winds and throwing up proud, passionate waves."

The portrait is as Leonardo left it to our wondering imagination. It has never suffered any restoration in the course of the centuries. No one has ever dared to remove the dirt that hardly affects its transparency and luminosity, these extreme Leonardesque qualities. As X-ray images taken in 1954 and 1983 reveal, nothing exists under the miraculous surface. A lambent clarity keeps the colors at a uniform level, allowing Leonardo to display the gamut and depth of his *sfumato* (soft shading), his technique of making tones, brushstrokes and lines tend toward the annihilation of limits and borders, in a sort of dreaminess that makes the portrait perpetuate and renew its magic at every encounter with it.

Today the portrait hangs in the Louvre, heavily guarded after it was stolen on August 21, 1911 (and then found two years later in Florence). The man who stole the *Mona Lisa* alleged that he was responding to a patriotic impulse, which he demonstrated by delivering it to the city of Florence.

With the *Mona Lisa*, a new moment in the spiraling ascent of man called the Renaissance was reached. The work does not have to relate to any identifiable model, to any ascertained data, nor does it belong to any one person. It is a legacy to all humankind, a witness to our individual claim to reach beyond the limits of what is tangible, controllable, ascribable. In this painting, Leonardo exercised the power that Aristotle aptly defined as "the energy of the soul toward excellence."

> *O researcher of things, do not praise yourself for knowing the things that nature ordinarily determines by itself, but rejoice in knowing the purpose of those things which are designed by your own mind.*
>
> LEONARDO

In these words is a key to unlock the mystery of his masterpiece.

15.
THE MOTHER

"Blessed is she who shaped you in her womb."
DANTE

It has been written that the first *Pietà* sculpted by Michelangelo in Rome is a tribute to the mother he had lost too soon in his infancy.

Indeed, in all his many works dedicated to the maternity of Mary of Nazareth that date from 1501 through 1506, the mother of Jesus is portrayed as a young woman; it was as if the artist were trying to express through his sculptures, and in one splendid painting, his tender nostalgia for the woman from whose embrace he had been torn away, and his constant desire to recover, through the magic of his own art, the warm comfort of her arms.

Later in his life, he would go back to the same theme: the tragic conclusion of Mary's mission as the mother of Jesus, the man who was given her to bring to life, nurse and raise, and the Redeemer who ceased to belong to her, until death granted her a terrible reappropriation. These other works differ greatly from his earlier ones: in them Mary is no more the young mother, serene even in the supreme moment of her son's sacrifice, her pure beauty unblemished by grief. The *Pietàs* in Palestrina, that in the Florentine Duomo, and finally, the Rondanini one on which he worked until the last day of his life, show Mary sharing the terrible burden of pain and human desolation that her son carried all the way to the Cross.

How different the mother in the Rondanini *Pietà* (which can now be seen in the Castello Sforzesco of Milan) is from the gentle, proud woman in the Bruges *Madonna*, which was commissioned in 1501 by the Flemish cloth merchants John and Alexander Mouscron for 4,000 gold florins, and destined for their family chapel in the cathedral of Bruges, where Dürer admired it in 1521. It is an all-round sculptural group, carefully finished, lovingly protected even after its completion by Michelangelo, who wrote to his father in a letter dated Rome, January 13, 1506: "that *Our Lady* in marble, I wish that you had it carried to our house and that you did not let anyone see it."

He represents Mary and Jesus with their figures so bound together as to be almost one single mass. The creative fantasy of the artist verges on a deep theological interpretation, as he shows the child in the act of stepping forward from the nest of her legs, as if to suggest the mission that he will have to perform independently and freely, beyond her desire to watch over him, a desire that is no less intensely expressed in her attempt to hold him back by clasping her hand on his.

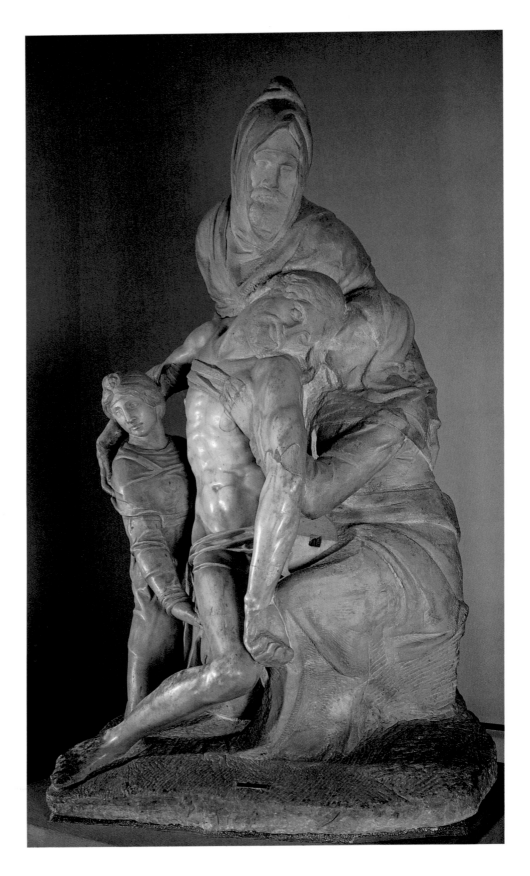

Michelangelo. *Pietà*. Florence,
Cathedral Museum.

OPPOSITE:
Michelangelo. *Pietà* (drawing).
Boston, Isabella Stewart Gard-
ner Museum.

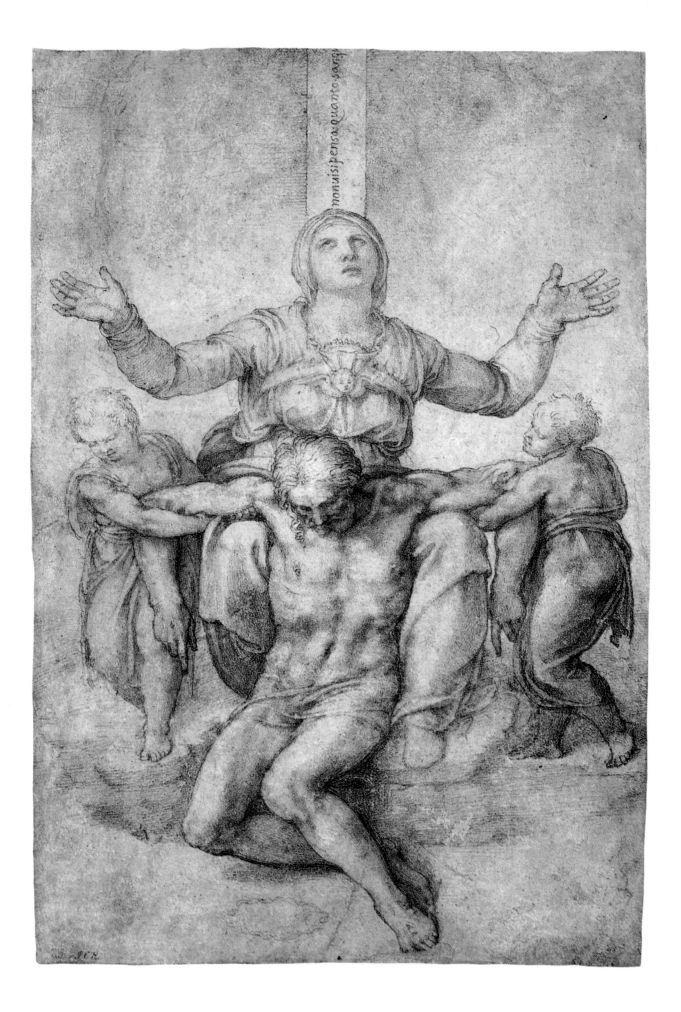

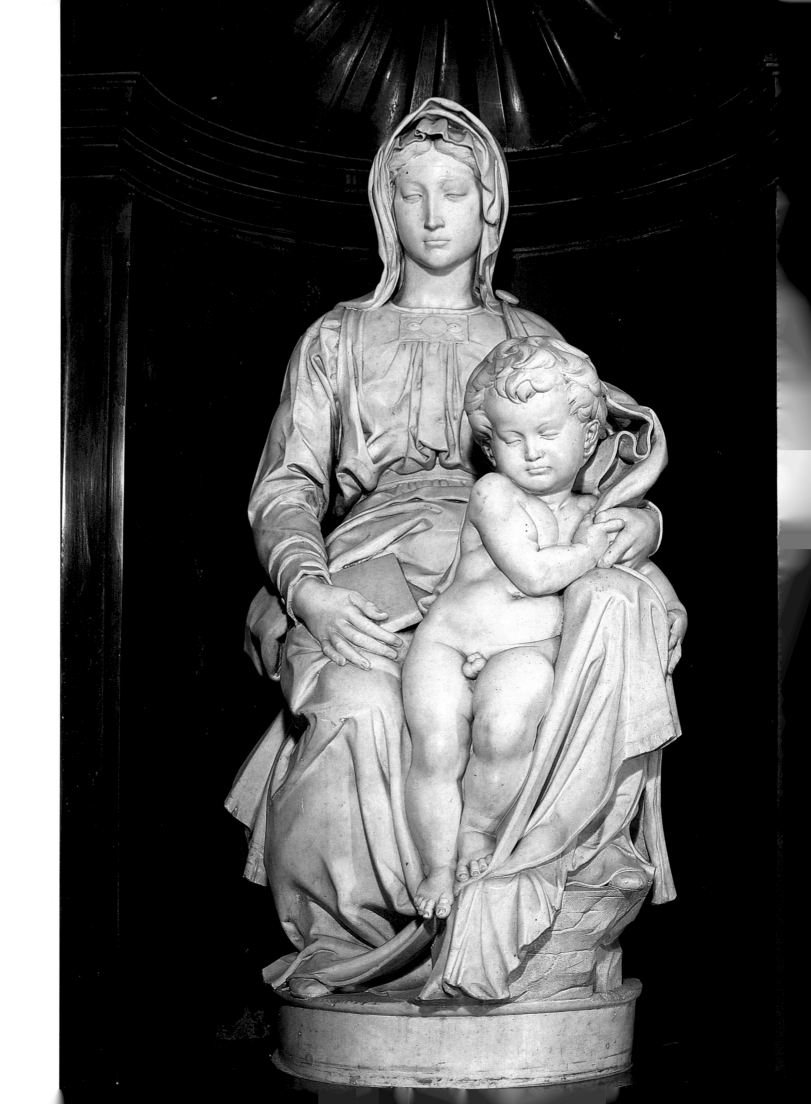

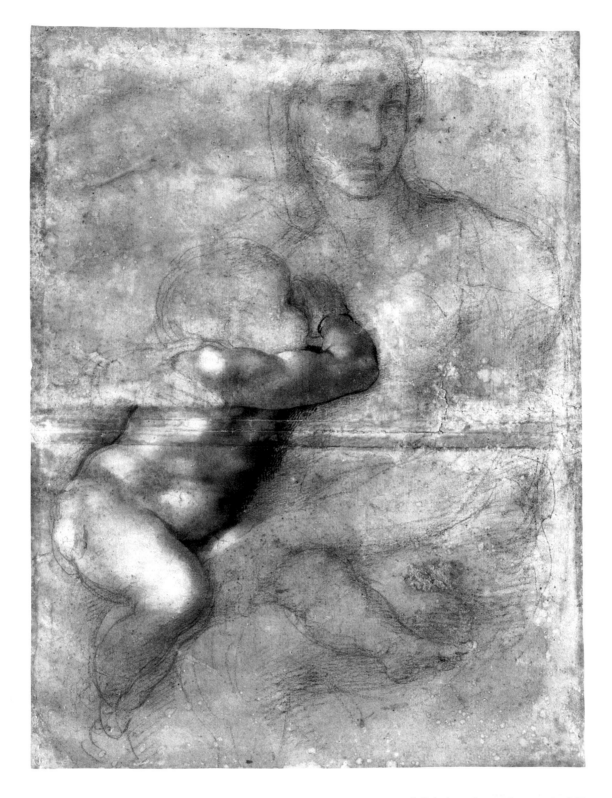

Michelangelo. *Madonna and Child*.
Florence, Casa Buonarroti.

OPPOSITE:
Michelangelo. *Madonna and Child*.
Bruges, Church of Notre Dame.

Michelangelo. *Madonna and Child and Saint John* (Pitti Tondo). Florence, Bargello National Museum.

In his first *Pietà*, Michelangelo had rendered Mary in the act of releasing the son whom she could not claim for herself: her left hand held up away from his body suggests this final severance. In the Bruges *Madonna*, the son appears to be close enough to the mother to evoke the wonder of his birth. The sinister shadow of the Cross is still far away. Her amply draped clothing provides a warm shelter for the child's naked body. The mystery of a life donated to one for all humankind to own is just unfolding.

In 1503, Bartolomeo Pitti, a member of the great family opposed to the Medici, offered a commission to Michelangelo for a sculpture in high relief, which he executed in a tondo, a circular piece of marble, possibly delivering it two years later. In it, the mother is seated on a square block of stone, holding on her knees a book on which her naked, nursing child is leaning. Mary's arm supports Jesus and her hand clutches him to her side, while she looks ahead, almost unaware of the other child (John the Baptist), who peers over her shoulder. The sculpture is finished only in the face of the mother; the other parts of the relief show the *non finito* technique that was to become Michelangelo's distinctive trademark in most of his later works.

The figures strain to fit within the round borders of this marble, just as they suggest the effort of emerging from its surface, living creatures caught in their dynamic impulse to respond to the artist's call. A distant,

dreaded future fills the eyeless gaze of the mother; once again the serenity of the moment is veined with sadness, as she contemplates the predestined ending already transcribed in God's book.

Similar to the Pitti, the tondo that Michelangelo made in Florence for Taddeo Taddei was larger in size and closer, in conception and sculptural style, to a medal. The group enclosed in the circle is more agitated than the one in the Pitti Tondo. The child John the Baptist is approaching, his arm outstretched, holding in his hand a small bird that seems to scare the little Jesus, who pulls away, trying to hold his mother's arm. Mary looks at the bird with a mixture of mild amusement and concern; her son is all too human, life yet to be discovered by him if a creature as frail as a sparrow could so frighten him.

Splendid in the treatment of the marble surface, which goes from polished areas (the mother's face and neck) to unfinished portions (the very fulcrum of the scene, the hand holding the little bird, is only roughly chiseled), the Taddei Tondo, now at the Royal Academy of Fine Arts in London, is another moving account of Michelangelo's revisitation of his personal memories and feelings; a colloquy between the artist and the woman who brought him into the world.

A gift meant for the wedding of the wool merchant Agnolo Doni and Maddalena Strozzi, from one of the great Florentine families, was the origin of another tondo, this one painted in tempera, a medium that

Michelangelo. Taddei Tondo. London, Royal Academy.

Michelangelo. Doni Tondo.
Florence, Uffizi Gallery.

OPPOSITE:
Michelangelo. Detail of the
Doni Tondo. Florence, Uffizi
Gallery.

Michelangelo used only in one other painting, the Manchester *Madonna*,
about whose paternity there is an unresolved conflict of opinions. The
daring setting of the scene makes the Doni Tondo one of the most strik-
ing works in the pictorial history of the Renaissance. Against a bare land-
scape, the mother is seated on a lawn, as Joseph hands her the beautiful,
naked child — who is thus held by them both. On a second level, a little
John the Baptist appears above a marble balustrade, with five nude male
figures either seated or leaning on a semicircular parapet in the back-
ground. Michelangelo painted this tondo at a time when Perugino, Ra-
phael, Botticelli and Leonardo were active; yet he seemed not to suffer

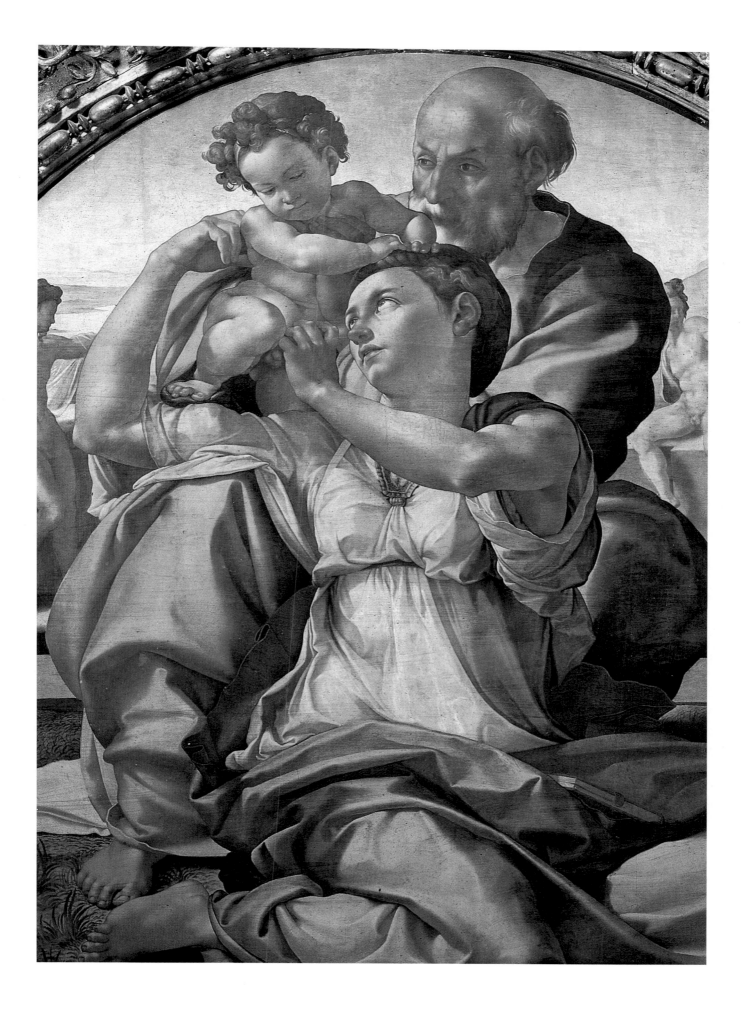

Michelangelo. Two details of the Doni Tondo. Florence, Uffizi Gallery.

their influence. In a powerful, unique way, he asserted his own creative style, his inimitable power in the drawing of figures, giving them the full relief of his sculptures and his ability to combine anatomical structure with keen psychological introspection.

With these perfect nudes, the pagan world of mythology recedes, giving place to the wonder of redemption, which has as its champions Mary, Joseph, Jesus and the Baptist. The various figures, staged against the blue feast of the sky, display similarly bright colors (a key to understanding the "revelations" from the restored frescoes in the Sistine Chapel), ranging from the bluish green and the burnt orange of Joseph's tunic to the green, azure and pale pink of the mother's robe. Michelangelo's colors are essential, full, crystal clear, without any trace of *sfumato* or chiaroscuro; they sing, or blare, inside the shell of the gilded, carved frame, like the echoes of a time gone by.

16.
A DUEL OF GIANTS

"The citizens of the divided city..."

DANTE

Two people could not have been more different than the tall, handsome, elegant Leonardo and the stocky Michelangelo, his nose flattened by Torriggiani's punch. Leonardo loved company, liked to hold court, to make an impression. If current fashion dictated long robes, he wore them to his knees. Michelangelo was oblivious to what he wore, and was frequently alone. He refrained from dragging "students" after himself, and did not teach, even though he was famous in Florence for his great knowledge of Dante and the *Divine Comedy*.

One can easily picture Leonardo strolling leisurely along the streets of his city, followed by his faithful Salaì carrying the latest pair of wings designed by his master and soon to be tested. One can see Leonardo, nobly attired, engaged in one of his extravagant gestures that have become legends, such as the time he bought cages of birds at the open market and set them free, quickly sketching their fluttering wings in one of his ever-handy copybooks.

Ironically, it was Dante who provided the spark for the first public encounter between Leonardo and the younger Michelangelo. An anonymous biographer of Leonardo reported this incident: "As Leonardo was passing by Santa Trinita in the company of Giovanni da Gavina, from the bench of the Spini, where a number of gentlemen had gathered to discuss some verses of Dante, someone called to ask him to explain them. At that time, Michelangelo happened to walk by, and Leonardo promptly said: 'Michel Agnolo will tell you.' Thinking that he was being involved so that he could be made fun of, Michelangelo retorted angrily: 'You tell them, you who have made a model of a horse in order to cast it in bronze, and you couldn't do it, and had to abandon it for your shame.' And having said this, Michelangelo turned his back to them, leaving Leonardo there, red in the face."

One wishes that the verses by Dante being discussed were those from Canto XI of the *Purgatorio* in which the poet imparts to artists a lesson in humility, as he recalls how the great Cimabue, who had taught the young shepherd Giotto, was surpassed by the latter in his own art.

O vain glory of all human powers
How briefly green endures upon the peak . . .
In painting Cimabue thought he excelled
And now it is Giotto that is celebrated
And the fame of the first is growing dark.
DANTE

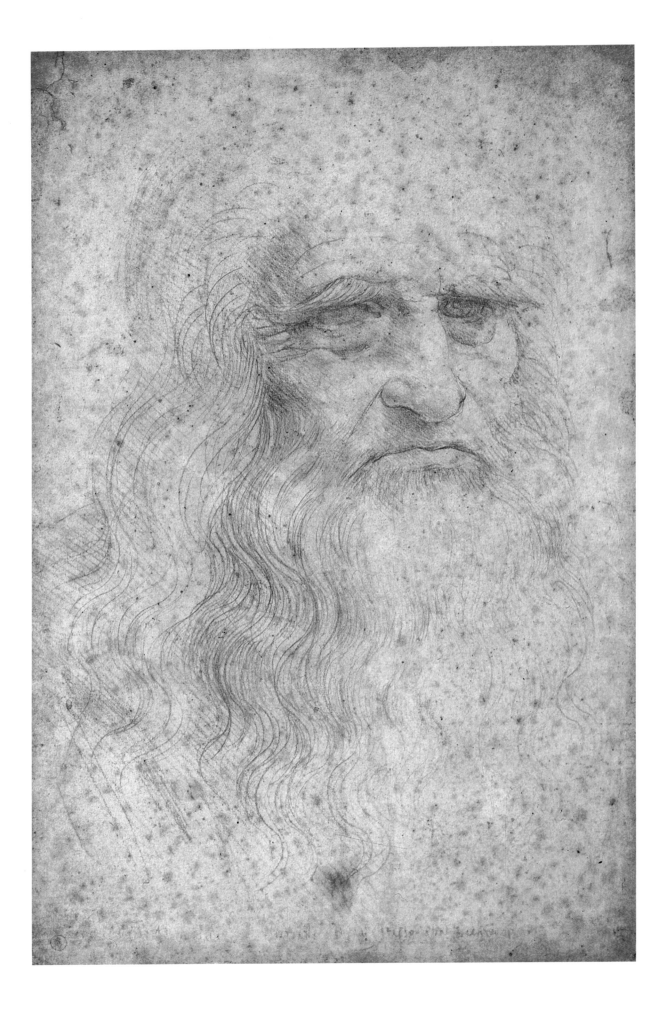

The incident verified the rivalry between the two great men. But, also, it revealed a trivial desire to humiliate, based on mutual failures (one with the horse, the other with the Piccolomini altarpiece). But the Florentines are like this: proud to the point of being abrasive, fond of a humor that bites more than it crackles, easily letting tempers erupt in brief squalls, after which peace is soon restored, friendship welded again.

It so happened that with both Leonardo and Michelangelo in Florence, and Raphael about to arrive from Perugia, the city was to become an arena for a contest of giants. The chosen place, the game master, the occasion for what could called be a glorious duel — all were being readied.

THE HOUSE OF FREEDOM

The Florentines called it Palazzo Vecchio, the "old palace." Of all the buildings in the city, this was the most cherished and famous, built by Arnolfo di Cambio, who was the overseer of other architects, technicians, masons, stonecutters and an array of other builders. Recently, it was discovered that special building criteria had been ingeniously applied to make the massive structure withstand earthquakes.

In the Palazzo Vecchio, the men who governed the city lived and convened. From its 308-foot tower, bells rang out that, according to the tone and rhythm of tolling, either summoned the people to gather unarmed in the square below or called the officials to their duties. On the walls, between the arches that supported the gallery under the crenellation, the Commune's coats of arms were painted: the lily, or iris, emblem of the city; the cross, emblem of the citizens; and the Latin word *Libertas*, emblem of the Priors, the members of the Signoria, or Signory, later called Signori,

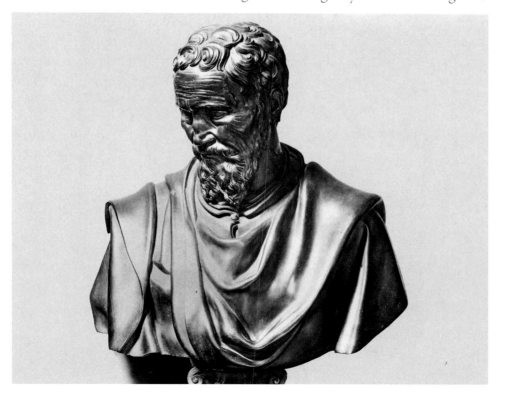

Attributed to Danielle da Volterra. Bronze bust of Michelangelo. Florence, Bargello National Museum.

Anonymous (Fourteenth century). *Expulsion of the Duke of Athens from the Prison of the Debtors*. Florence, Palazzo Vecchio.

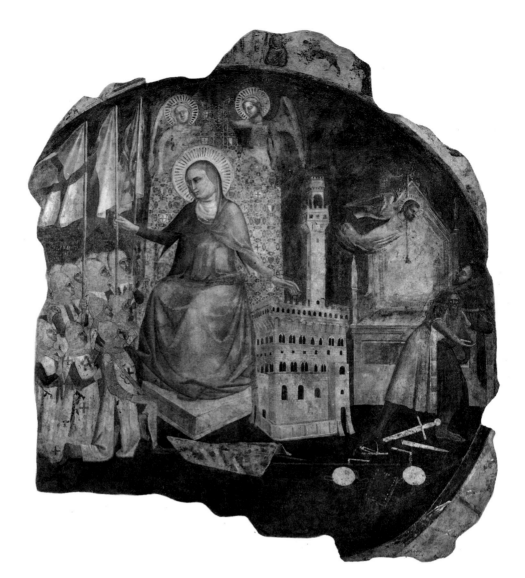

Giorgio Vasari. Drawing of the Salon of the 500s. Florence, Uffizi Gallery, Cabinet of Drawings.

lords. Other symbols were later added: an eagle trampling on a dragon, for the Guelph faction; two golden keys, for the Church; and the famous balls, or pills, for the Medici family.

THE HALL OF THE FIVE HUNDRED

The reform of the Florentine government advocated by Girolamo Savonarola led to the institution of a Grand Council, based on the Venetian model, that included all law-abiding male citizens over the age of twenty-nine, provided they or their ancestors had been entrusted with public offices. If their number exceeded fifteen hundred, the members of the Council would be divided into three groups, each of which would constitute a Major Council alternating with the others for a period of six months. With this reform, one third of the Florentine male population was entitled to enter the Council, posing the need for a hall large enough to house the Council of the Five Hundred.

On July 15, 1495, construction began for such a hall. The work, directed by Antonio da Sangallo, went rapidly, under the constant urging of Savonarola. According to Vasari, in order to speed up the work the Signory consulted with Leonardo, the young Michelangelo, Giuliano da Sangallo, Baccio d'Agnolo and Simone del Pollaiuolo. (This information is perhaps only partially accurate, as we know that Leonardo did not arrive in Florence before May 23, when the project for the hall had already been approved.)

Salon of the 500s in the Palazzo Vecchio, Florence.

Michelangelo. Study of a nude
for *The Battle of Cascina*. Flor-
ence, Casa Buonarroti.

"As long as they stood
They were the school of the World."

BENVENUTO CELLINI

Leonardo da Vinci. Study of
two heads (drawing dating from
the period of *The Battle of
Anghiari*). Budapest, Szep-
muveszeti Muzeum.

On February 25, 1496, the hall was completed, even though the floor
was not yet in place and the walls were not plastered. The first meeting of
the Major Council was held in the new hall on April 26, 1496. Brother
Domenico Buonvicini, one of the friars from Savonarola's convent, cele-
brated a mass and delivered an inaugural sermon.

Thus was the stage for the duel of the giants set.

On September 22, 1502, Piero Soderini, a meek, peace-loving man,
initially praised and later criticized by Machiavelli for the weakness of his
rule, was made Gonfalonier for life. Soderini arrived in Florence from
Arezzo, where he had been with the troops, shortly before dawn on No-
vember 1, 1502. "He was fifty years old, eloquent, married without chil-
dren, not too versed in literature, of rare courage and determination,
parsimonious, religious, charitable, and without vices," wrote Luca Landucci
in his diary. On February 19, 1503, after having resided in his house in
Borgo San Frediano, he and his wife, Madonna Argentina Malaspina,
moved into the palace, where an apartment was readied for them.

The master of the game was in charge.

THE SCHOOL OF THE WORLD

The gray, bare walls of the Hall of the Major Council, or of the Five
Hundred, did not seem appropriate for the place that now housed the
heart of the Florentine government. Piero Soderini decided to take advan-

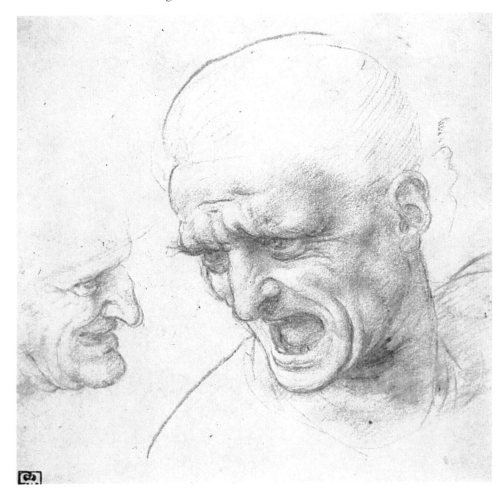

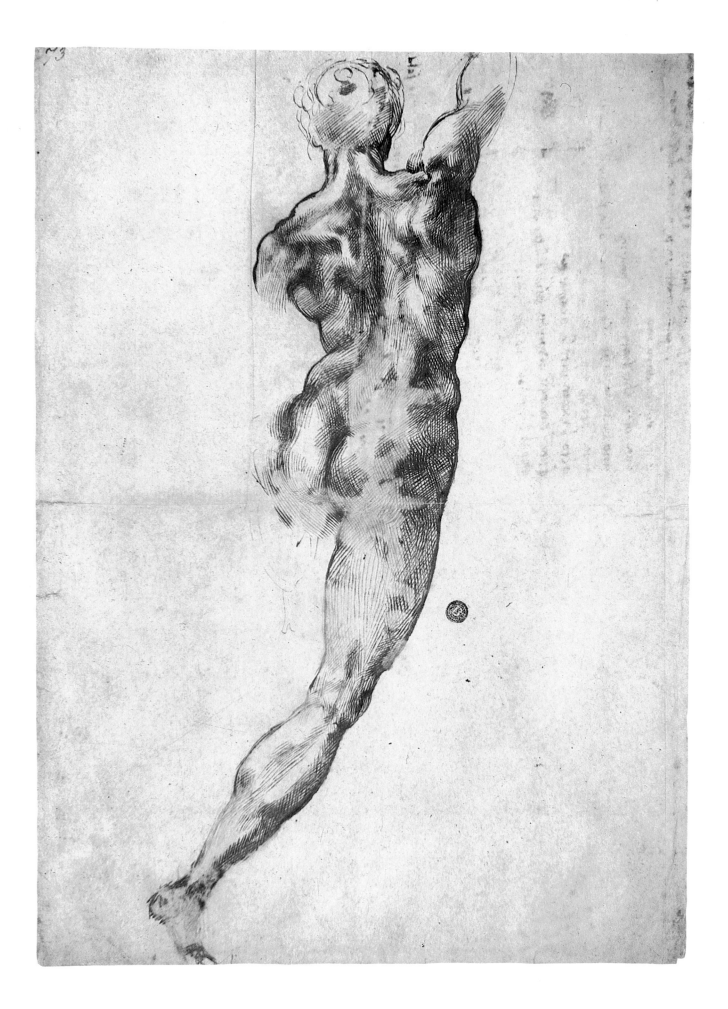

tage of having both Leonardo and Michelangelo in Florence. Deaf to all those who advised caution in creating a competition between these two, he summoned them to undertake the fresco decoration of the two sides of the same huge wall in the hall.

The theme assigned to each was an heroic episode from Florentine history. Leonardo, fifty-one years old, chose the battle fought at Anghiari on June 29, 1440, in which the troops of Florence, together with the papal army, routed the soldiers of the duke of Milan, Filippo Maria Visconti, under the command of Niccolò Piccinino. Michelangelo, twenty-nine, opted for the battle of Cascina, an event from 1364, that pitched the Florentine troops against the Pisans, who had launched a surprise attack.

The huge Hall of the Pope in the convent of Santa Maria Novella was put at the disposal of Leonardo. There he began to draw his cartoon in the last days of October 1503. For his preparatory work, Michelangelo was given the Hall of the Dyers in the hospital of Sant' Onofrio.

In February 1504, Leonardo received the supplies he had requested: "royal paper folios to make the cartoon and the linen to hem it." He constructed a "very ingenious scaffold that can be raised by pulling it together, and lowered by expanding it."

The term set for the completion of the cartoon was the end of February 1505. Leonardo was to receive a monthly payment of fifteen florins, beginning on April 20, 1504. The contract contained cautionary clauses compelling Leonardo to make prompt restitution of payments in case he failed to finish the fresco. In turn, the Signory engaged itself not to commission any other painter to complete the work without his consent, should he abandon it.

Giving wings to his impetuous fantasy, Leonardo turned the clash between the Florentines and the Milanese, which actually lasted only four hours, without any fatalities (except for one soldier who fell from horseback and broke his neck), into a desperate, frantic confrontation of men, horses and weapons, exemplifying the fierceness and cruelty of war that Leonardo had described as *pazzia bestialissima*. In the center of his painting Leonardo depicted the fight of cavalrymen for possession of a banner. With horses rearing, and their riders trying to wrest the coveted trophy from each other's hands, this collective frenzy is traversed as if by flashes of lightning by lances thrust across the scene, swords raised and about to crash on the splendidly chiseled helmets. Faces are distorted into horrible grimaces. The horses' hooves trample on the fallen bodies, and in the central foreground, a soldier is about to plunge a dagger into another man's throat.

Here was all of Leonardo, the painter of gentle beauties and the severe critic of war, being seduced by his subject into an exaggerated pictorial translation of a battle that was unworthy of its name. It was the same Leonardo who, when asked to design new destructive artillery weapons, invented the *fragilica*, "a bomb measuring ten spans, molded in bronze. Inside it are brass pipes filled with gunpowder and bullets. Through them, the fire flies out at the explosion, and the fragilica whirls and hops with incredible speed spitting out death in flaming sheaves within as short a space of time as it would take to say a Hail Mary." These are Leonardo's

own words; they attest to how he was carried away by his own enthusiasm. Strange words, indeed, for the man who otherwise condemned war.

Michelangelo, in his cartoon, focused instead on the moments preceding the battle of Cascina. His Florentine soldiers are bathing in a brook when their trumpeters sound the alarm. The enemy has been spotted: the men rush to prepare for a surprise attack. The blaring of the trumpets sets air itself into motion, unleashing a whirlpool of reactions. The men swim ashore, some hurrying to put on their armor, others busy dressing; an older man, possibly an officer, is pulling a stocking over his naked leg. The whole scene is immersed in confusion, a "forest of nudes" agitated as if by a sudden scourging wind. Each figure is a carefully rendered study in virile anatomy, with dashing movements suggested by muscular contractions. It is a most powerful exaltation of champions of youth, caught only moments before their bodies are defiled by wounds or death.

When the two cartoons were finished and exhibited to the public, initial curiosity gave way to wonder and admiration. Painters and scholars flocked to Florence from all over Europe to visit the Hall of the Pope and the Hall of the Dyers and study the gigantic drawings. The contest between the two major champions of the Renaissance had a witness in a third genius, younger than both, and currently rising to fame. Raphael was only a spectator of the greatest competition ever held in the history of art. Like so many others, but in a very special way for his own artistic development, Raphael learned a definite lesson from his visits to what Benvenuto Cellini enthusiastically called "the school of the world." The two greatest masters of his time had displayed for him their accomplished, diverse skills. Raphael would remember their lesson forever and make it a cornerstone of his own art.

LIKE A NIGHTMARE

In mid-February 1505, Leonardo raised his scaffolding in front of the wall in the Hall of the Five Hundred. The records of the palace workers' office listed the materials purchased for the fresco and their cost: wall plaster, Greek pitch, plaster of Paris, Alexandrine white lead, walnut oil and linseed oil. Also recorded were payments made to Leonardo's assistants, including Lorenzo del Faina and Tommaso Masino, called Zoroaster.

With the scaffolding in place, covered by canvas curtains to hide his work from view, Leonardo began to put on the wall his stormy vision of violence. In his never-ceasing quest for innovation, he had studied the ancient recipes recorded by Pliny for painting on a plaster surface. The mixture of colors with pitch and oil was supposed to give the fresco a shine similar to that of oil colors applied on board or canvas. The mixture required considerable heat in order to dry, and Leonardo supplied braziers that could be lifted to any desired height in front of the wall.

Leonardo painted the central part of his battle, depicting the fight for the banner. The colors were stunning, as brilliant as if they generated light from their own pigments. It is not difficult to imagine the elation of

the painter and his helpers when the scene was completed. Salaì must have played his lute, the vast hall resounding as if with a song of triumph.

Michelangelo was far from starting his portion of the wall. Leonardo was winning the first phase of the contest.

A mystery began from this moment in the history of the battle between Leonardo and Michelangelo. Of the latter's work, we know that the cartoon was seen in 1510 by Francesco Albertini, together with Leonardo's horses; but in what shape was the scene, the only part of the battle executed by Leonardo? Someone named Gaddiano reported in 1540: "Leonardo began to paint in the hall of the Major Council in the palace of Florence, the battle in which the Florentines routed Niccolò Piccinino, captain of Duke Filippo of Milan, at Anghiari; then he [Leonardo] went to Milan, and from there to France to serve King Francis. . . ."

The artist's departure from Florence to Milan was documented; a last purchase of colors for the fresco was made on December 31, 1505. Five months later, Leonardo asked for a three-month leave of absence to go to Milan, where the governor, Charles of Amboise, had summoned him on behalf of Louis XII of France. On August 18, Charles of Amboise asked the Signory to grant Leonardo another respite. The Florentine government tried to refuse, alleging that the painter had received his compensation and should honor his engagement with the Republic. In reality, Leonardo had completed the cartoon and had begun the fresco. Only the firm intervention of the king himself convinced the Signory to grant the request.

In September 1507, Leonardo returned to Florence, protected by a safe conduct by Louis XII, leaving again for France one year later. Apparently, during this time he did nothing with the *Battle*. A likely reason for his lack of interest in the work that had so deeply stirred his creative passion came from the behavior of the Signory, who had provoked his ire.

But there were perhaps other reasons why he abandoned the project. Gaddiano also reported: "Leonardo took from Pliny the method of applying colors on the plaster surface. But he misunderstood it . . . and as he

FRESCO

Fresco, meaning fresh, is a painting technique based on the application of colors on a wet plaster surface that absorbs the colors, so that once the surface dries the painting becomes integrated with the wall.

Before paint can be applied, the wall must be prepared by a ground consisting of coarse sand and white plaster on lime, troweled to even the surface. Over this rough coating (called *arriccio*) is then spread a thin finish coating, or wash, of lime and fine sand. While this is still damp, the drawing (cartoon) is transferred to the wall by pricking the outlines with small holes over which coal powder is dusted.

Then the painting proceeds with pigments mixed with lime water.

The painter does as much as he can in a day's time; the next day the unused finish coat is scraped away to make room for a fresh coat on which the painter continues to apply paint.

No revisions are possible once the painting is done, for the pigments become chemically bonded to the plaster in a very short time. The painter must plan and execute his composition with unfailing precision. If he needs to alter anything, he is compelled to erase what he has done and start anew on a freshly prepared portion of wet plaster.

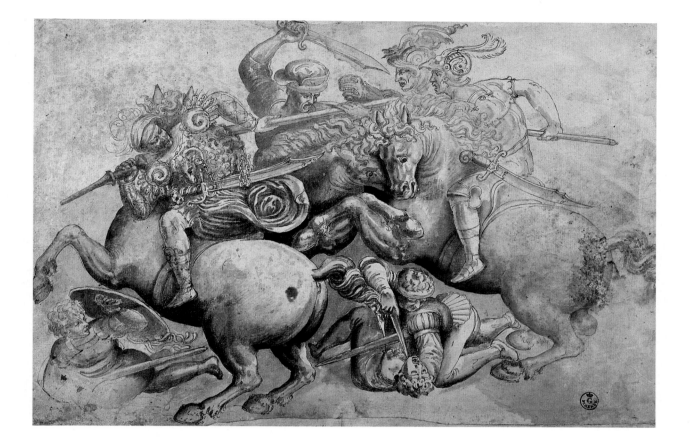

tried to apply it in the hall, the painting started to run...." His vision had turned into a nightmare. Possibly Leonardo tried to dry his colors by lighting his braziers; maybe the fault was in the linseed oil he used, or in some other ingredient he had used to prepare the wall, or his paint mixture. What is known is that the ruined scene with the cavalry brawl remained visible on the wall until Vasari covered it with the fresco that he himself painted on the same wall. Only some copies made in the course of the 1500s show a pale, partial documentation of Leonardo's work. The most reliable, and interesting, among these echoes of that celebrated scene are due to Peter Paul Rubens, and to the anonymous author of the *Tavola Doria* kept in Naples.

As to Michelangelo, he was prevented from translating his cartoon into a fresco because he was called to Rome by Pope Julius II on another gigantic commission. Both cartoons were first scattered, and then lost. Copies made by various painters, Aristotele da Sangallo among them, are all that remain of Michelangelo's *Battle of Cascina*.

Leonardo forgot the nightmare commission by climbing into the hills of Fiesole to test his winged contraption, in his absolute certainty that man, "the great bird," would fly.

As for Michelangelo, he returned to Rome where, prompted by the Pope, he started to dream of the multitude of heroes asleep in the womb of the Apuanian Alps, waiting for him to awaken them.

Leonardo da Vinci. Battle with horses (for *The Battle of Anghiari*). Florence, Uffizi Gallery, Cabinet of Drawings.

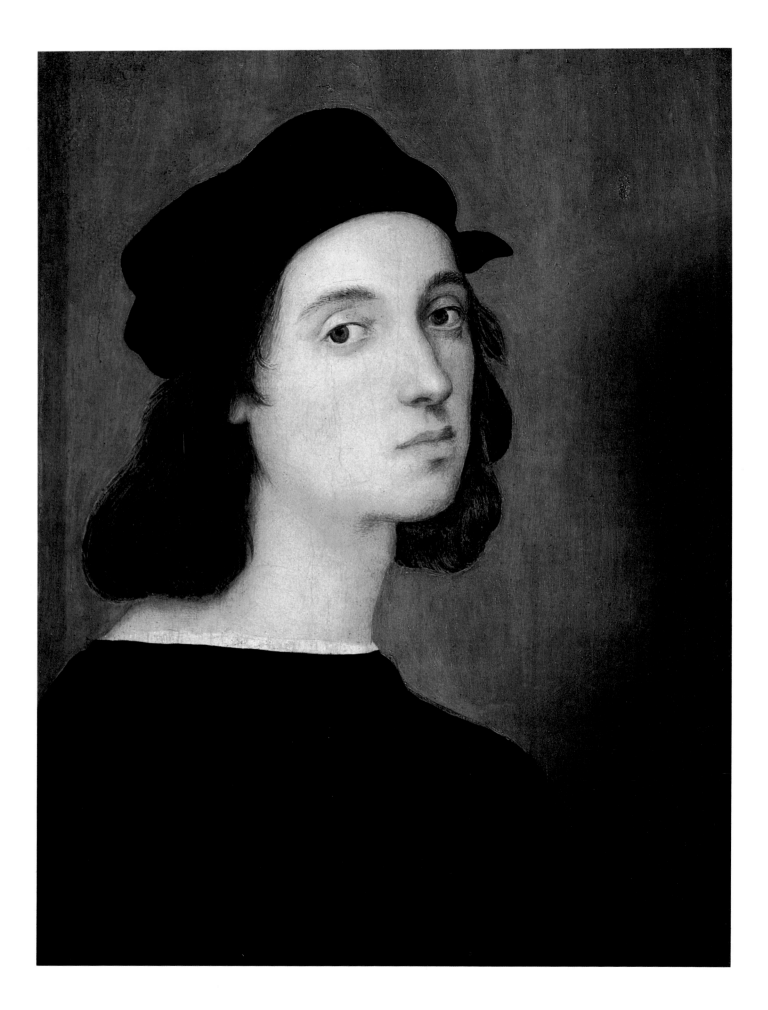

17.
RAPHAEL
THE ARCHANGEL
FROM URBINO

*"What had cost Perugino, Fra Bartolomeo,
Leonardo and Michelangelo more years to
develop than he lived, Raphael seized in a day."*

HOLMAN HUNT

OPPOSITE:
Raphael. Self-portrait. Florence,
Uffizi Gallery.

On a hill between the Appenines and the Adriatic, in the region called *le Marche*, lies Urbino, a town that retains much of its architectural grandeur from past centuries. In 1474, Federigo da Montefeltro was made duke of Urbino by Pope Sixtus IV and the following year Knight of the Garter by Edward IV of England. A celebrated general, Federigo tutored the sons of princes in the art of war. His court was regarded as a model of princely life, as Federigo was also an enlightened patron of arts. He made Urbino the center of a cultivated society which rivaled that of Lorenzo the Magnificent and his Florence in attracting and helping poets, scholars and artists.

Federigo employed the famous architect Luciano Laurana to build the ducal palace, a masterpiece that stands as one of the greatest edifices of the Renaissance, with its harmonious courtyard and its doorways, windows and fireplaces rich in sculptured ornaments. The ducal palace's library was enriched with copies of Greek and Latin books and came to be renowned all over Europe.

When Federigo died in 1482, he was succeeded by his young son, Guidobaldo. Later, assisted by his intelligent and amiable wife, Elisabetta Gonzaga, Guidobaldo followed his father's example of cultural splendor nurtured in Urbino. Baldassare Castiglione, in *Il cortegiano* (The Courtier), described the life and activities at the palace of Guidobaldo and Elisabetta as a most refined social school and the "resort of the best literary and political celebrities of the day."

In 1502, Cesare Borgia treacherously expelled Guidobaldo from Urbino. Only after the death of Cesare's father, Pope Alexander VI, was Guidobaldo able to return to his duchy, welcomed with outbursts of enthusiasm, acclamations and tears of joy by a population that regarded him more as a provident father than a ruler.

THE PAINTER'S SON

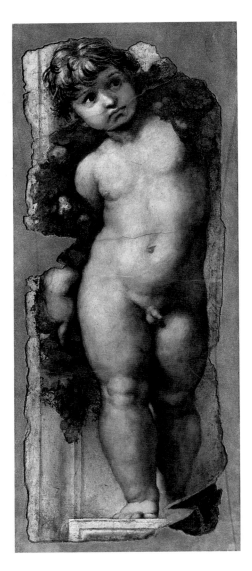

Raphael. *Cupid*. Rome, Academy of St. Luke.

OPPOSITE:
Raphael. *The Marriage of the Virgin*. Milan, Brera Picture Gallery.

At three o'clock in the morning of April 6, 1483, a male child was born in the house of Giovanni di Santi di Pietro, a painter of some distinction and a modest poet from the court of the Montefeltro. The mother was Magia di Battista di Nicola Ciarla, a quiet, self-sacrificing woman who guarded her child with infinite tenderness until her premature death, in 1491, when her son was eight years old.

The child was christened Raphael, *God has healed*, after the archangel who escorted Tobit in his travels. He was Raffaello, in Italian, and he often used the family name, Santi, in its Latinized version, Sanctius, or in its Italian version, Sanzio. He was always proud of his birthplace, Urbino, as evidenced by his works, *Wedding of the Holy Virgin* of Città di Castello and the so-called Borghese *Deposition from the Cross*. Both works are signed *RAPHAEL URBINAS*.

In his beloved hometown, Raphael learned the rudiments of the pictorial art from his father. And certainly the artworks that adorned Urbino were the first textbooks for Raphael's education. These included the churches of San Francesco and San Agostino, the monumental portal built by Tommaso Guidi, called Masaccio, for San Domenico, with the blue-white majolicas that Luca della Robbia added to the portal like precious gems.

How many times did the boy Raffaello, his fingers colored by the paints he mixed for his father's palette, stand looking at the ducal palace, massive and airy at the same time, proudly crowning the steep hill on which it rose? The entire building has a clear Tuscan structure, rational and musical, centered in a courtyard where light and shade are in continual concert. The builder Laurana solidly anchored the palace to the steep ground, without losing its lightness as it ascends. The crenellation atop its agile walls merely suggests a defensive purpose, as its decorative function appears to predominate. The main towers frame the amazing facade, while the smaller ones elevate the eagle, emblem of the Montefeltro. The alternate rhythms of its terse architectural lines generate musical effects, as the courtyard with its succession of arches dictates pauses of silence.

In the *Hostel of the Muses*, as the ducal palace was often called, the very young son of Giovanni Santi walked across the courts, climbed the marble stairways, ran through the corridors and hallways, warmed himself at any of its marvelous fireplaces, happy as a bird in a breezy sky. The rosy, bizarre frescoes that Ambrogio Barocci painted in the palace from 1479 and the no less fanciful ones completed between 1476 and 1480 by Domenico Rosselli and Francesco Ferrucci must have stimulated Raphael's imagination, setting examples he would eventually surpass.

Raphael heard the Muses sing for Piero della Francesca, the fabled painter from Arezzo, who arrived to claim artistic dominion over Urbino in the second half of the fifteenth century. He learned from Piero's *Scourging of Jesus*, as void of violent passions as a Greek scene, resplendent with light and sublime colors; and from the portraits of Duke Federigo and his wife, Battista Sforza, painted as figures in a dream against a sky receding to distant horizons.

Perugino. *The Deposition.*
Florence, Pitti Palace, Palatina
Gallery.

Others influenced the young boy. In the works of Melozzo da Forlì,
who in turn had been impressed by Piero, Raphael found the attainment
of perfection in perspective studies. He was inspired by Baccio Pontelli's
masterful wooden inlays. He held in his hands the medals chiseled by
Paolo da Ragusa and Clemente d'Urbino, for the duke. He studied the
tapestries made by the masters who had been called from Flanders to
weave the precious cloths used to decorate the walls in the palace. Other
touches of exoticism were lavished on the Montefeltro residence by the
Spanish painter Pedro Berruguete and by the Flemish Justus from Gand,

who excelled thanks to his brilliant and full-bodied oil painting technique.

In this wonderful dawn light, Raphael spent his early years. The free horizons that surrounded him, the guiding but not constrictive hand of his father, the numerous models of beauty represented by the striking achievements of true masters, helped to form his human and artistic style: gently and lively, suspended between earth and heaven. His father's teaching was soon supplanted by the more incisive influence of Timoteo della Vite, who arrived in Urbino sometime in 1495. His paintings are certainly akin to the early works by Raphael, with their certain suave softness, their twilight contemplation of nature.

Raphael was only ten years old when his father took him to Perugia to meet Pietro Vannucci, known as Perugino, the most eminent among the Umbrian painters. Giovanni Santi had an admiration very close to awe for Perugino, evident in one of his poems where he compares Perugino to Leonardo da Vinci:

> Two young men equal in age and love,
> Leonardo from Vinci and Perugino,
> Pietro Vannucci, who is divine in painting...

As he followed his father from Urbino to Perugia, Raphael crossed over from the Marche to Umbria, and from a court school to a wider arena. Spring, in his life as an artist, was beginning. The archangel from Urbino was preparing to take flight in the greater sky of Renaissance art.

AN ACCELERATED LIFE

Raphael's existence responded to a constant sense of urgency, as if he had a premonition from his early boyhood that his days were numbered. This was not a sad feeling of predestined doom, but a positive acknowledgment that he had been given a life to be savored, enjoyed and consumed in full within a designed term, brief by common standards yet sufficiently expanded to permit him to burn and shed light.

Perugino was a man possessed by a terror of poverty, and he sought to earn as much money as possible. He kept a large shop in order to be able to accept many commissions. After seeing a few samples of Raphael's talent, he readily granted hospitality, using the boy as an extra hand to help fill in the details of his canvases. Perugino had a very high opinion of himself. Under his self-portrait in the College of Exchange in Perugia, he inscribed this proud legend: "If the art of painting had disappeared, he would have re-created it. If it had not been invented, he would have created it."

Perugino's quite remarkable inclination to self-aggrandizement was matched by an undeniable geniality well supported by his own novitiate in the workshop of Piero della Francesca, from which he went on to study under Andrea del Verrocchio in Florence. By 1490, his personal style had been shaped, affirmed and established.

Perugino's recognized masterpieces won him commissions from the princely banker Agostino Chigi, who called him the best master in Italy,

*"When I shall have time,
and I fear this will not be soon . . ."*

RAPHAEL

Raphael. *Portrait of Pope Leo X with Cardinals Luigi de Rossi and Giulio de' Medici. Florence, Uffizi Gallery.*

and Cardinal Giuliano della Rovere (Pope Julius II). His fame and arrogant character surely enhanced the natural tendency of his new young apprentice to assimilate the mode of his acclaimed teacher. For a while, up to 1500, Raphael's works were hardly distinguishable from Perugino's. However, recent studies have confirmed that from the time the boy from Urbino arrived, Perugino's works show unmistakable signs of a somehow innovative influence, to which the master must have been subjected by the exceptional pupil he admitted into his workshop.

After the death of his father in 1494, Raphael lived alone in Perugia and found in that city the ideal follow-up to the cultural nobility of the Montefeltro court. In what was then considered an artistic province of Siena, Raphael experienced the flowing together of the Florentine School with the Umbrian School. The fresh, exciting coloring style that resulted from the combination of the two major schools left an imprint on Raphael that he forever kept in his mind as a source of evergreen inspiration in the development of his unique art.

Raphael's first ascertained painting was commissioned on December 10, 1500, for a chapel in the church of San Agostino in Città di Castello. The contract named Evangelista di Pian di Meleto as collaborator and called the seventeen-year-old Raphael "master." Only fragments of this altarpiece, *The Coronation of the Blessed Nicholas of Tolentino,* survive, together with a few preliminary sketches.

Raphael delivered the painting on September 13, 1501. In the fragment at the Museo Nazionale in Naples, the figure of the Eternal Father

A STORY OF LOVE AND HATRED FOR RAPHAEL TO REMEMBER

Gianpaolo Baglioni ferociously ruled Perugia, ever fearful of losing his possessions to Cesare Borgia. Suspicious of everyone, including his own family, Baglioni repressed any allegation of conspiracy with merciless atrocities.

In order to stir up enmity against him, some of his own relatives had persuaded his twenty-year-old cousin Grifonetto that Gianpaolo had seduced his very young wife. Mad with jealousy, Grifonetto led a nocturnal attack against the house of his rival cousin; the latter's father and many other members of his household were killed. Gianpaolo miraculously survived by jumping from a window.

To escape the violent revenge, Grifonetto had taken refuge, with his wife, Zenobia, in a farmhouse in the countryside owned by his mother, Atalanta Baglioni. Atalanta implored her son to return to Perugia to de-

fend his honor. He reluctantly agreed, but before leaving he cried out: "Mother, you will not see me again!"

Near the Hospital of Mercy he encountered Gianpaolo, who stabbed him in the throat, shouting: "Traitor Grifone, go with God!"

Atalanta, who had run in search of her son, found him lying on the ground. He died in her arms, covering her with his blood. His body, washed in wine, was exhibited in the cathedral where the other conspirators had been massacred.

Among the citizens who lined up in front of the dead Grifonetto was a weeping young boy, strikingly attractive. People noticed him; they turned to look at him. "He is a great painter," someone said.

"He studies with Perugino."

"His name is Raphael."

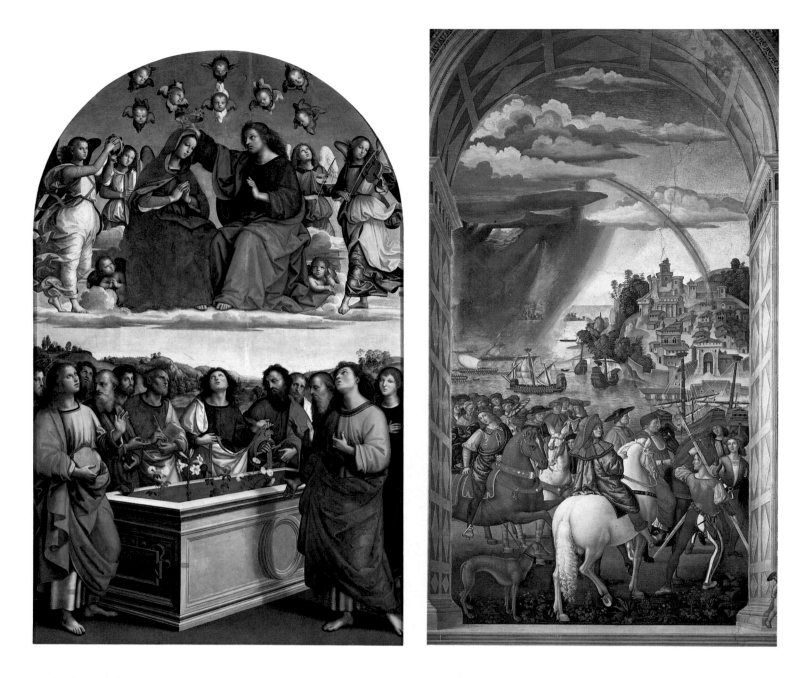

Raphael. Predella panels for *The Coronation of the Virgin* altarpiece. Rome, Vatican, Pinacoteca.
BELOW: *The Annunciation.* RIGHT: *The Adoration of the Magi.* FAR RIGHT: *The Presentation in the Temple.*

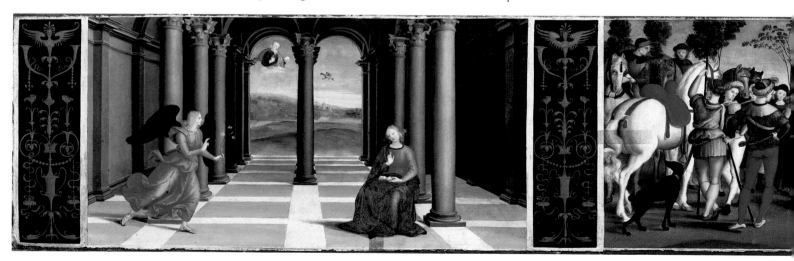

lifting the crown that he will place on the head of the Blessed Nicholas bears evidence of Perugino's lessons.

More personal and vigorous is the *Dream of the Knight*. An intriguing representation of a tale immersed in a light that vibrates with coloristic effects, the work marked a moment of definite independence reached by the teenaged artist.

In 1502, to honor the memory of Pope Pius II, Enea Silvio Piccolomini, his nephew Cardinal Francesco commissioned from Pinturicchio a series of frescoes for the library annexed to the cathedral of Siena, their native city.

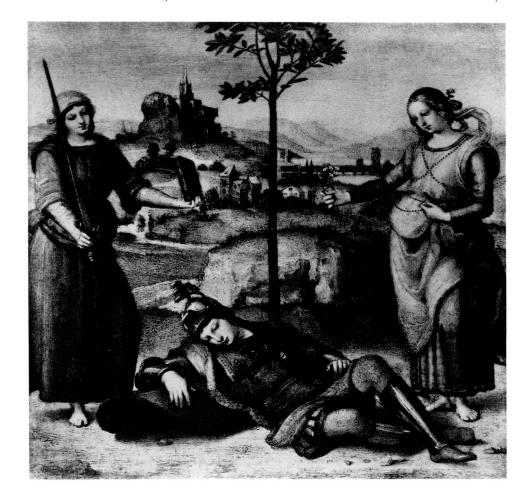

Raphael. *Dream of the Knight*. London, National Gallery.

OPPOSITE, TOP LEFT:
Raphael. *Coronation of the Virgin*. Rome, Vatican, Pinacoteca.

OPPOSITE, TOP RIGHT:
Pinturicchio. *Aeneus Silvius departs for Basel as secretary to Cardinal Domenico Capranica at Piombino*, for which a young Raphael had provided a drawing to the older master. Siena, Cathedral, Piccolomini Library.

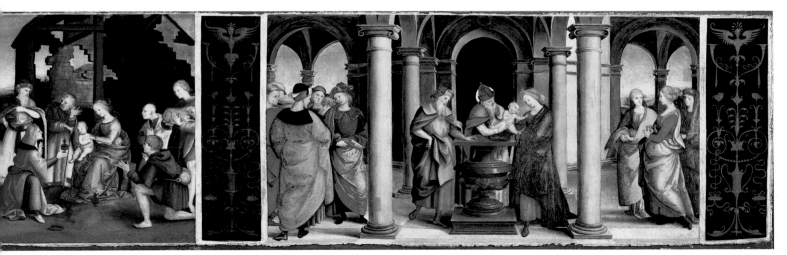

Raphael was asked by Pinturicchio to make some preparatory drawings for the frescoes. His sketches were clearly superior to the final work by his much older colleague. Now in the Pinacoteca Civica of Città di Castello, *The Banner with Saint Sebastian and Saint Rocco adoring the Holy Trinity* on one side and *The Creation of Eve* on the other, showed a return to the Perugino influence. In the *Coronation of the Holy Virgin* (painted in 1503 for the church of San Francesco in Perugia, exported to France and later recovered by the Vatican Pinacoteca), however, the mark of personal greatness emerged strongly as the young painter constructed the composition in space; he made the flowered sarcophagus with its rose blossoms the focal point, disposing the apostles all around it and placing in the upper part a semicircle of angels in which Jesus and the Virgin Mary are inscribed. A youthful spirit floods the painting, redeeming the mystical stereotypes of the time, by introducing a deep, delicate sensitivity that finds its moving interpreters in the angels to

Raphael. Portrait of Perugino. Florence, Uffizi Gallery.

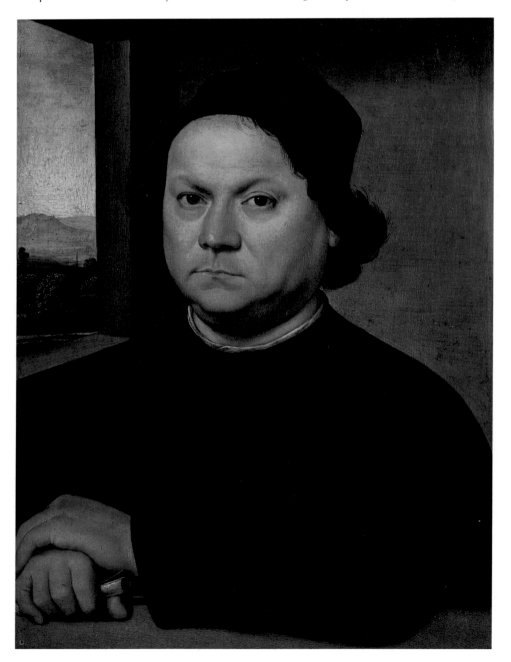

the right. The various scenes in the composition, although separated from one another, achieve a stylistic cohesion in a unity of feeling that permeates the painting in a new and eloquent manner.

In the three scenes in the predella — *The Annunciation, The Adoration of the Wise Men, The Presentation in the Temple* — the twenty-year-old Raphael revealed the secret of his now fully achieved emancipation. He still treasured the lessons of the Umbrian School but strengthened them, in a display of architectural monumentality, through his exuberant use of colors, ranging from luminous greens to lapis lazuli blues and flashing whites. The same year, 1503, he painted the *Crucifixion* for San Domenico in Città di Castello. The work, signed by him, is more of a glorification of Jesus' sacrifice than a depiction of a Roman torture. The crucified Christ and the saints who adore him are enclosed in an aura of quiet acceptance and resignation. The Raphaelesque genius clearly manifests itself in the treatment of the landscape, which seems to suggest a universal dimension.

Signed *RAPHAEL URBINAS* and dated MDIII, *The Marriage of the Virgin*, executed for San Francesco at Città di Castello and now in the Pinacoteca Brera, mirrored the setting of the *Christ Giving the Keys to Peter*, a fresco by Perugino in the Sistine Chapel at the Vatican. The long shadow of the teacher was still present, but in Raphael's work, the amplitude of the painted space overcomes the real confines. The composition is lightened by a more immediate sketching of lines and a fresher invention of tones. A cordial atmosphere envelopes the painting, in which human figures are in close colloquy with nature. The viewer is irresistibly fascinated by the delicate poetry that Raphael's brush summons.

Raphael's intense Umbrian season drew to a close as he began dreaming of Florence, the ideal destination for every artist at the time, the place for an appointment with history-in-the-making not to be missed. News had spread throughout Italy of the prodigious activity of Michelangelo and Leonardo in their city. The clouds that had darkened the sky over Florence, the smoke from the bonfires of Savonarola and the pyre that consumed him were being dispelled by a wind of renovation.

Raphael was ready to leave Umbria for Tuscany with his confidence, "his felicity and not mere facility," his genius. He secured warm letters of introduction to the new rulers of Florence from his early sponsors. On October 1, 1504, Duchess Giovanna Feltria della Rovere, sister of Guidobaldo, Duke of Urbino, and wife of Giovanni della Rovere, prefect of Rome and ruler of Senigallia, wrote to Piero Soderini, the Gonfalonier of Florence: "The bearer of this letter is Raphael, painter from Urbino, who having profited from his art has decided to spend some time in Florence in order to learn further. His father was a very virtuous artist and very close to me, and his son is a discreet and gentle young man. I am fond of him in every way and I wish him to reach perfection. For this I recommend him to your Lordship...."

As the sun set on his last day in Perugia, Raphael surely remembered one of his father's verses: "Beautiful is the day that has a happy evening." His time had been spent to fruition. The Umbrian city had accepted him and he had earned his citizenship.

RAPHAEL OF THE MADONNAS

Soft autumn breezes and purple skies greeted Raphael when he arrived in Florence in the fall of 1504, on the threshold of his twenty-second birthday. The city offered the young painter an extraordinary spectacle of beauty and a measure of excellence. Only two months earlier, the *David* of Michelangelo, symbol of the renewed commitment to freedom, had been installed in front of the Signory palace.

Raphael had the lucky chance to find Leonardo, the other star in the firmament of the Renaissance, in Florence. He met artists of outstanding value: the painters Andrea del Sarto, Ridolfo, son of Domenico Ghirlandaio, Aristotele da Sangallo, who copied Michelangelo's cartoon for the *Battle of Cascina*, and Brother Bartolomeo della Porta, in whose workshop he found hospitality; and Baccio d'Agnolo, a renowned architect, who gathered around him distinguished colleagues like Sansovino, Simone del Pollaiuolo (Il Cronaca), Antonio da Sangallo and Francesco Granacci.

It was Raphael's first winter in Florence. The city was swept by icy winds. It was heartwarming to gather around a good fire, to eat roasted chestnuts, savory cheese and olives, and toast the birth of the sun above the hills in a sky the color of new wine.

His encounters with Michelangelo were rare and the conversation sparse. The poet Francesco Berni said it well, referring to Michelangelo's restraint by comparison with many of his colleagues: "He tells things, you say only words." Indeed, his works were more eloquent than any ornate sentence; Raphael saw them all over the city, and the works enriched the young artist.

Leonardo's *Mona Lisa del Giocondo* left a deep and lasting impression on Raphael, with its undefinable *sfumato* and the mysteriously alluring smile that opened a door into the world of the psyche. Leonardo provided Raphael with a set of examples that led him to purify his native gentleness of design, adding to it Florentine imaginative rhythm of lines and fantastic tones, both simpler and richer. A number of drawings by the young painter from Urbino were inspired by the *Mona Lisa* and the cartoons for the *Battle of Anghiari* and the *Battle of Cascina*.

Because of Leonardo, Raphael went from the thickset, brilliant colors of the Umbrian school to the clear, smooth chromatics of the Florentines. His figures became more solid, and at the same time lighter and more musical by being placed in pyramidal groups. A new harmony dictated gestures, postures, with the echoes bouncing from one to another, as in the splendid *Madonna of the Goldfinch*.

Raphael learned and taught at the same time. He had a decisive influence over Brother Bartolomeo della Porta, as Vasari underlined in his *Life of Raphael*: "He had close interaction with Bartolomeo of San Marco, whose coloring talent he liked and tried to imitate; and in turn, he taught the good friar the laws of perspective, which the friar had not practiced until then."

Notwithstanding the superiority of his creative genius, Raphael's humility allowed him to profit from any and all influences that he filtered

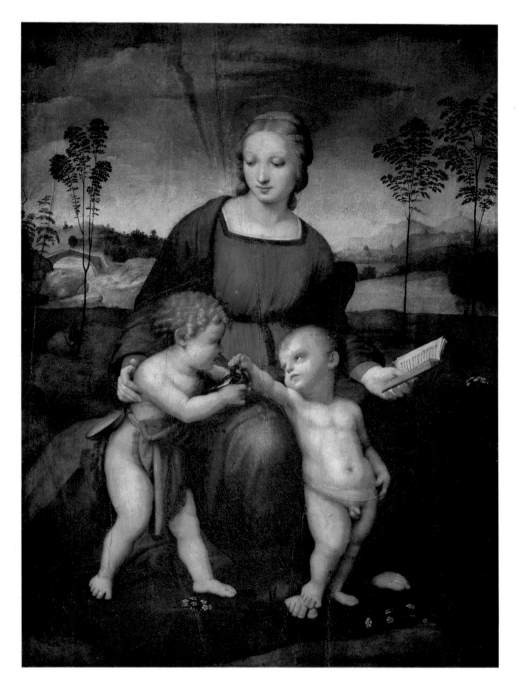

Raphael. *Madonna of the Gold-finch*. Florence, Uffizi Gallery.

through his unique sensitivity, a sensitivity supported by love. It was a love for nature, for the human being, and above all for woman, the miracle of creation that for Raphael was truly God's supreme masterpiece.

Della Porta, on his part, contributed to his friend from Urbino a sense of the grandeur of figures, the overall concept of vast compositions, something Raphael's apprenticeship with Perugino had not given him.

During his stay in Florence, through 1507, Raphael's most impressive quality emerged to dominate him — his ability to absorb lessons and then apply them with his strong originality, so as not to take anything away from his overpowering, inimitable style.

Florence displayed for him the living spectacle of its wonders: the dome by Brunelleschi, the Palazzo Vecchio of Arnolfo, the Baptistry. In Raphael's eager eyes, the Florentine Renaissance was not an abstract idea,

but an achieved reality — rationality, order and the harmonious correlation of the works of man in rapport with nature. All the values glorified by the great school of Florence came afloat for him in the pyramidal construction of his painting of the Virgin and Child known as *La Belle Jardinière*. The composition achieves a sense of depth, with the figures of Mary, Jesus and the little Baptist bathed in a green light that exudes from the atmosphere, the trees, the river, the quiet town, the hills drawing away toward the farthest horizon. There is a vibration in the air that reflects the movements of the characters, a connection that is transmitted from the mother's arm to the son, whose hand reaches for the book in her lap, while the cross held by the Baptist touches Mary's arm as he kneels close to her feet, gently pressing the grassy ground. This is Leonardo's air, his light; these are the volumes of Masaccio and Michelangelo; but the breath of love, this meditation in line and colors on the mystery of love, is Raphael's alone.

Madonna, in Tuscany, was an amorous appellation for woman: *mia donna*, my woman. It became the favorite title by which the mother of Jesus was called. She was the prevailing subject in religious art of this time. Raphael went beyond the stereotypical iconography, which tended to the hieratic or to the pious. He painted Mary as a real woman, interpreted with a passionate sentiment of humanity and a lyrical transport that was a love offering as well as an intense religious meditation.

The Umbrian influences, still so evident in the Northbrook *Madonna* of London or in the *Terranuova Madonna* of the Berlin Museum, were gone in the noble *Madonna del Granduca* in the Pitti Gallery. In the latter, the Tuscan spirit pervades the figures, evoking a subtle sense of melancholy, a poetic suggestion that places the mother and child between heaven and earth, creatures that belong to the sphere of mortal life and to the realm of the spirit where sentiments do not die. The tenderness with which the child presses his hand on his mother's breast as he holds himself by grasping her shoulder, the motion in Mary's body that suggests her stepping forward, her hand that supports Jesus as though he were weightless — every detail in the painting confirms a heaven on earth, and the purest of mirrors, the realm of the spirit.

The Esterhazy *Madonna*, the *Madonna del Belvedere* and the *Virgin and Child of Casa Canigiani* attest to Raphael's prolific inspiration. They form an ideal gallery that, with his profane pictures like the seductive *Lady with a Unicorn* in the Borghese Gallery, Rome, offers a series of tests of a rich talent that is constantly reendowed. Raphael did not tire of drawing, just as he continued painting without interruption. He studied the human figure, landscapes and nature in its varied aspects.

His portraits of Agnolo Doni and his wife, Maddalena, a commission Michelangelo had turned down, were Raphael's own meditation on the lesson of the *Mona Lisa*, as is documented by his sketches at the Louvre. A reflection of the magic that animated Leonardo's masterpiece is peculiarly evident in the *Portrait of the Pregnant Woman*, with the female figure coming to the fore, like an apparition, in a concert of golden tones for which the deep red of the velvet sash and the bright yellow of the vest are the grace notes.

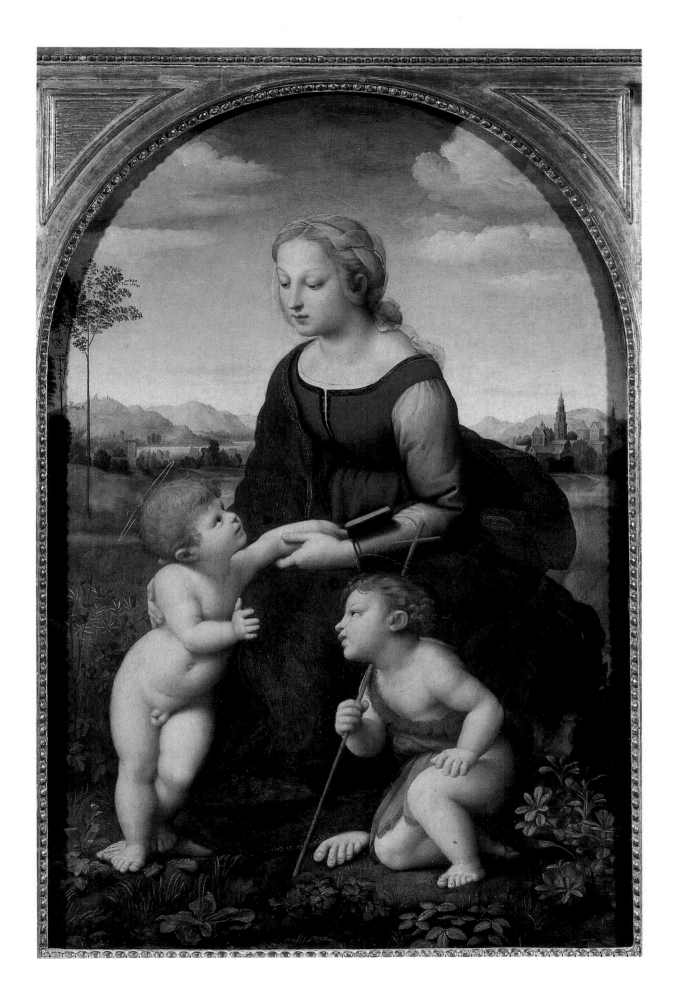

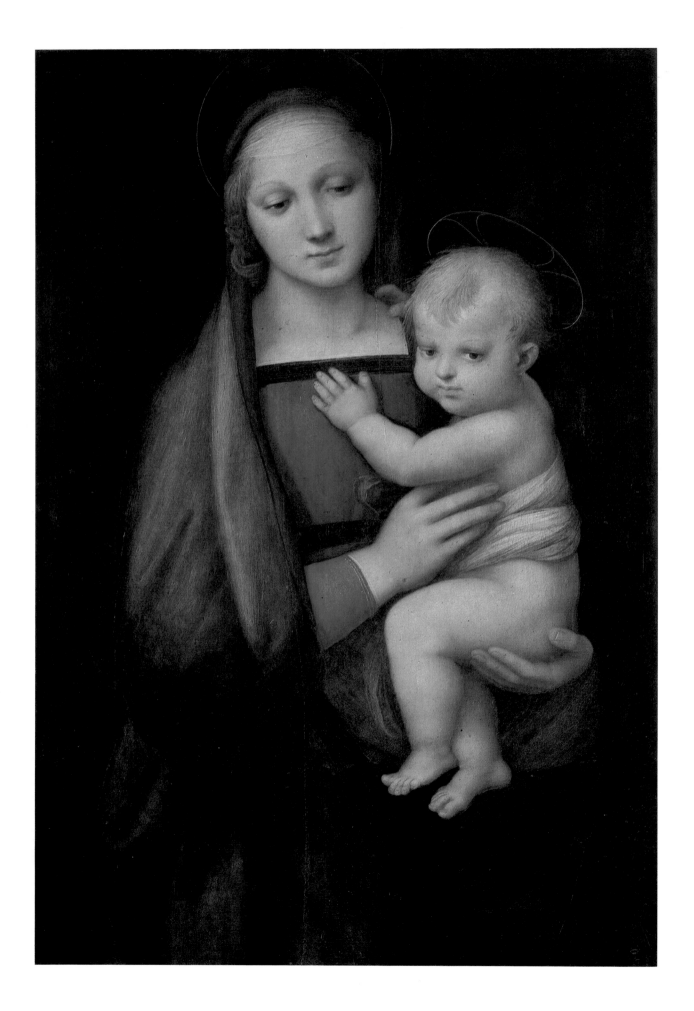

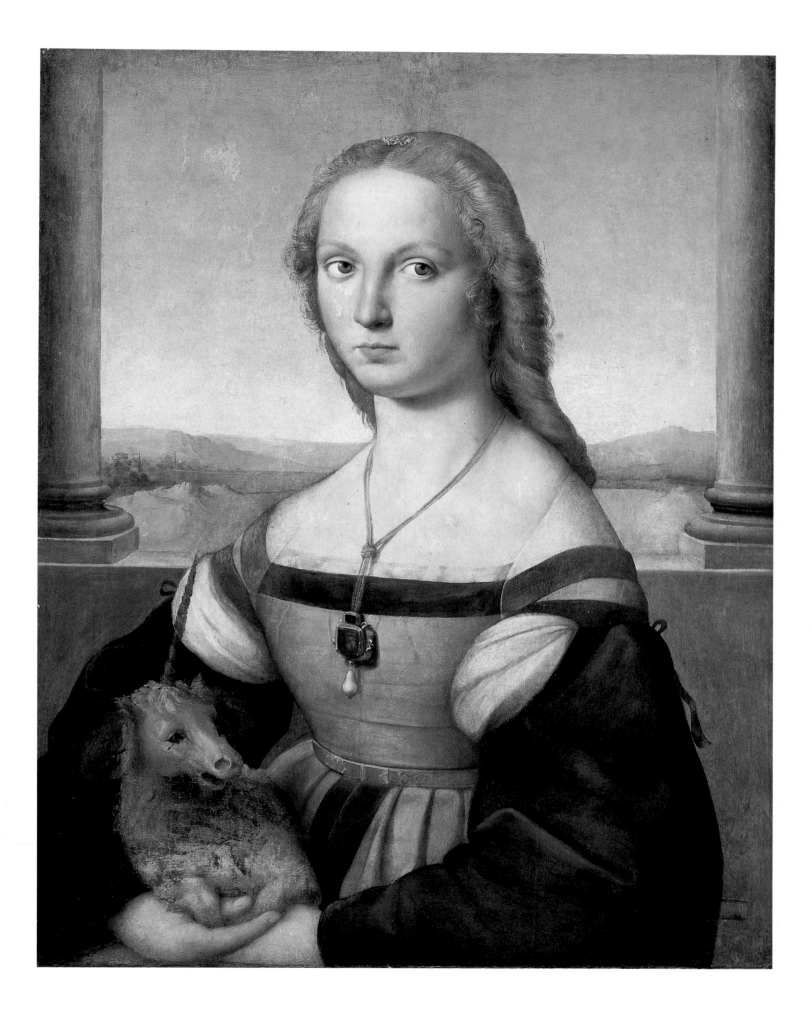

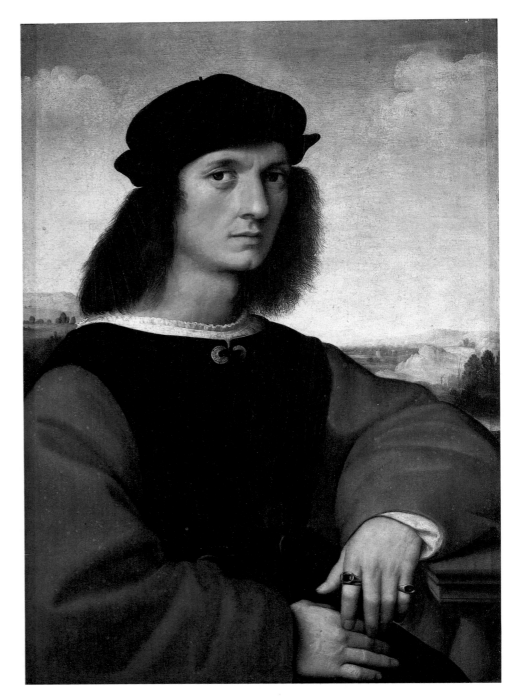

Raphael. Portrait of Agnolo Doni. Florence, Pitti Palace, Palatina Gallery.

OPPOSITE:
Raphael. Portrait of a Florentine Lady called "La Gravida." Florence, Pitti Palace, Palatina Gallery.

In Florence, Raphael met a generous patron, Taddeo Taddei, the same man who had commissioned Michelangelo's marble tondo. For him, Raphael executed a painting and made a generous gift of another. The *Madonna in the Meadow*, at the Kunsthistorische Museum, Vienna, was the first of these. A quiet, thoughtful Mary, with a faint smile quivering on her lips, sits watching the playful exchange between her son and John the Baptist, from whose hands Jesus is about to take a cross, made of twigs, that resembles a toy. Yet the gaze of the mother and her attempt to smile take on a deeper sense, as if, beyond the childish game, the slender cross projects a colder, longer shadow. The figures are in the familiar pyramidal structure, with Mary's and John's feet delineating the base. This perfect geometry, conveying a feeling of a supreme, preordained design, is echoed

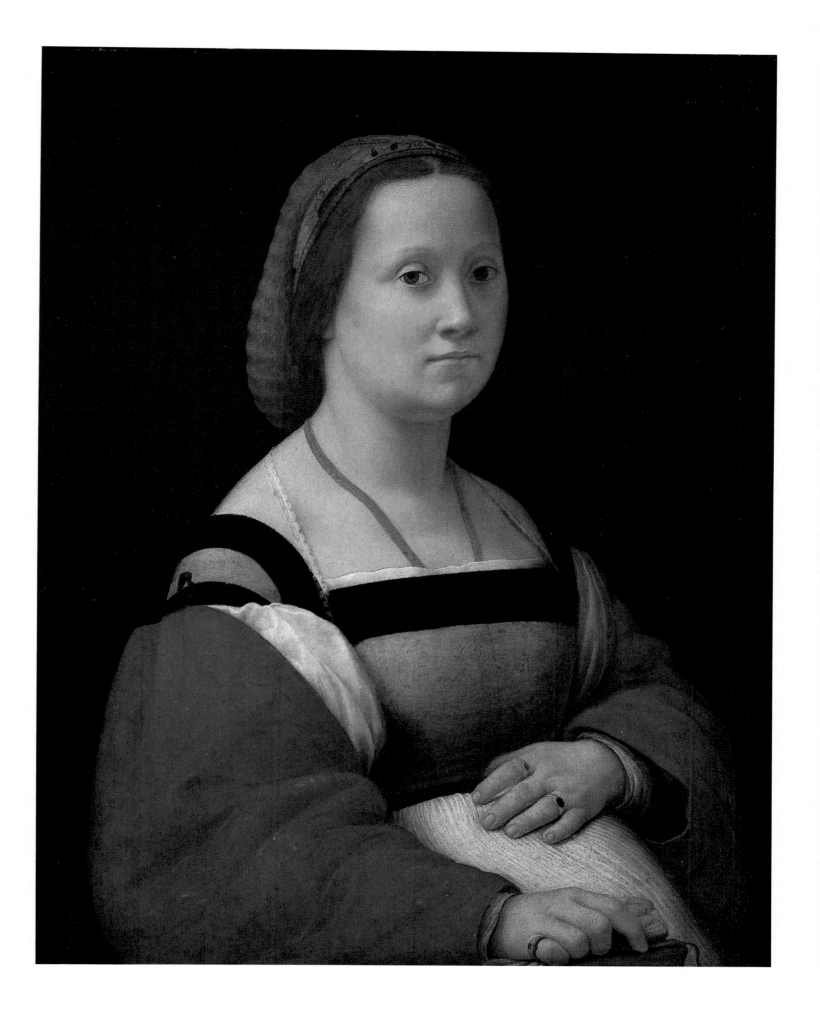

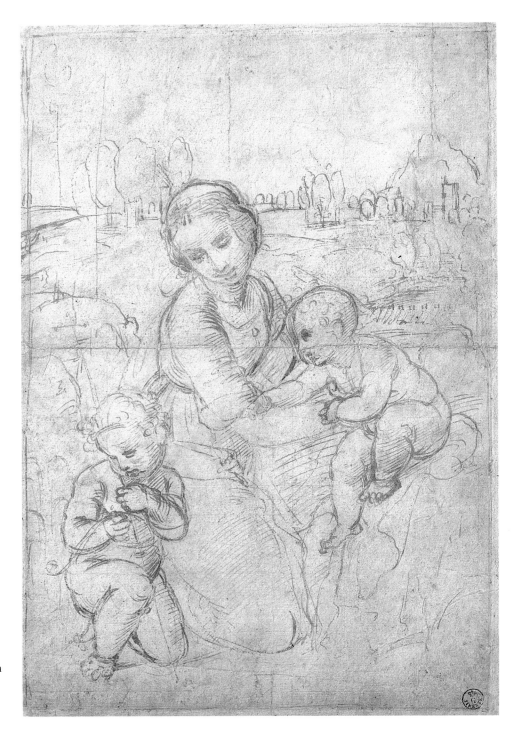

Raphael. Study for the Madonna of Prince Esterhazy. Florence, Uffizi Gallery, Cabinet of Drawings.

in the landscape of fields, water, human abodes and pale azure hills, under a sky where clouds are sailing.

Raphael's stay in Florence culminated with his initial work for the *Madonna of the Canopy*, presently in the Pitti Gallery. His desire to achieve more ample effects and larger spaces for his painting is manifested in the grandiose architecture of a niche flanked by Corinthian columns as a background for the scene. Mary, holding Jesus, is seated under a canopy between Saint Peter and Saint Bernard on the left, and Saint James and Saint Augustine on the right. (The painting was abandoned when Raphael left for Rome in 1508 and only later completed.)

An absolute symmetry commands the composition, yet the figures are far from rigid. A reverberating light endows every detail with a vitality that gives the scene a sense of a domestic play, with the child angels engaged in a charming conversation at the foot of the throne, while elevating it to the intensity of a *sacra rappresentazione* with the four saints solemnly attending the Madonna, who appears as a mother turned queen to grant audience.

The *Dumb Woman* of the National Gallery of the Marches was probably painted in the same period. It is another study of female psychology, a successful attempt to give the portrayed woman the eloquence that nature denied her.

Raphael, far from having "fluttered around" Florence as some biographers have suggested, was inspired and educated in the capital of the Renaissance. His activity was prodigious, his ascent without pause. He left the city to go to Rome, where new horizons opened up for him.

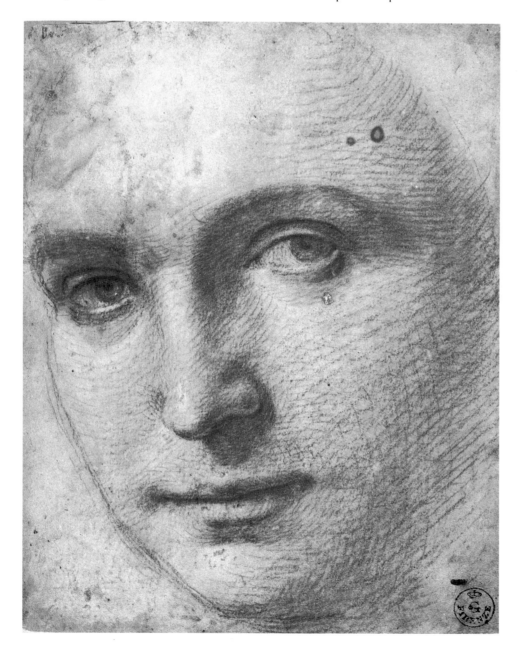

Raphael. Head. Florence, Uffizi Gallery, Cabinet of Drawings.

THE COLOR OF BLOOD

Four years before coming to Florence, Raphael had witnessed some of the most heinous crimes linked to family disputes that lacerated Perugia at this time. Caught in a tangle of power struggles and personal jealousies, the cousins Grifonetto and Gianpaolo Baglioni, ruler of the city, waged a bloody fight against each other. When Gianpaolo, whose father had been killed by Grifonetto, took revenge by stabbing his cousin to death, the whole of Perugia cried out with horror. Grifonetto's mother, Atalanta, who had tried to stifle the feud, asked Raphael to paint a picture evoking the crucifixion of Christ, to serve as a memento of the terrible episode and as an admonition about the horrors of hatred and the saving grace of mercy.

Raphael received this commission in 1503, and a sketch in pen and ink in the Oxford collection shows that he began researching the theme: the Deposition from the Cross. The drawing indicates the influence of Perugino. Many other studies of the same subject reveal the long and painstaking efforts on the part of the painter to define his idea and arrive at the conception that best expressed his feelings in relation to his artistic development. His moving from Perugia also meant moving from Perugino.

In Florence he did not forget Atalanta's commission, and he executed a painting that can justly be considered the summing up of his experiences both as a man and artist. In *The Deposition* of 1507, now at the Galleria Borghese in Rome, he put the scene in the foreground, with a sense of imminence that stresses the agony of pain and the sublime lesson to be learned from Christ's martyrdom. A wave of motion sweeps the

Raphael. *The Deposition* (drawing). Florence, Uffizi Gallery, Cabinet of Drawings.

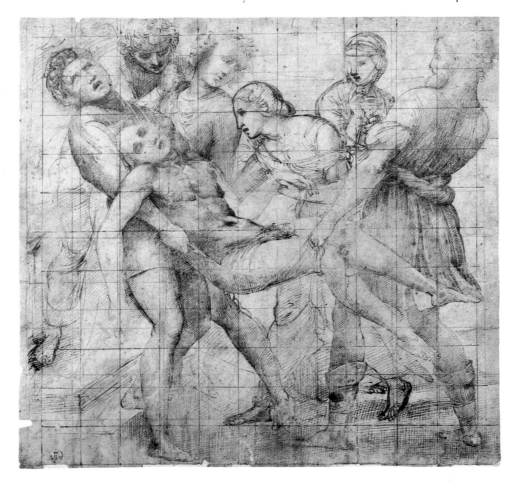

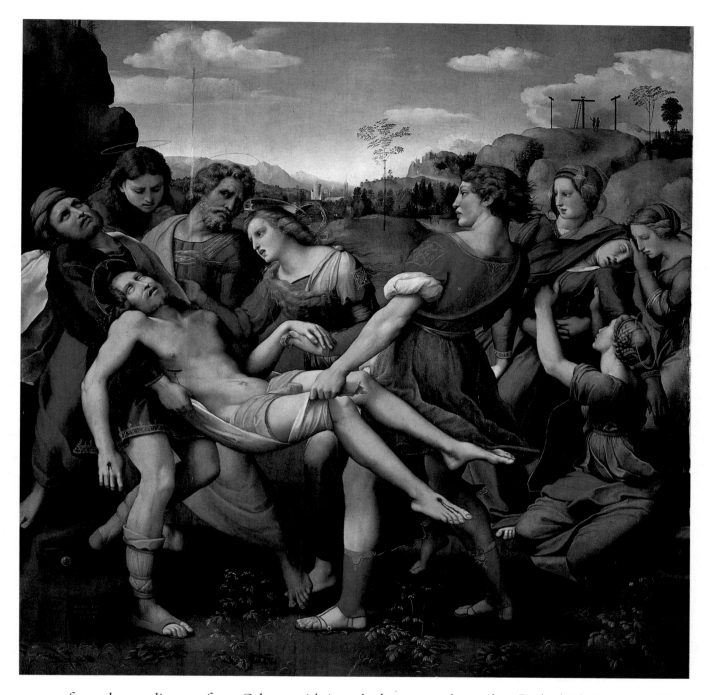

group of people at a distance from Calvary, with its naked crosses enhanced by a white-gray cloud against which they are etched. The desolation of the Roman instruments of death contrasts with a slender tree rich with foliage, which is close to Calvary. Influences, possibly recollections, are apparent in the picture: the body of Christ carried by the grieving disciples is connected to Michelangelo's *Pietà*; the background mirrors an Umbrian landscape; Mantegna comes to mind in the construction of the central group of figures. Raphael, in possession of all his technical gifts, displays them in the way he paints the silken hair of the Magdalen; in the interplay of hands, from the wounded limp hand of Christ to that of the Magdalen's gently holding his; in the juxtaposition of the group of the three Marys standing in their grief on one side of the scene and the implacable hardness of the rocky slope on the other.

Raphael. *The Deposition of Christ.* Rome, Borghese Gallery.

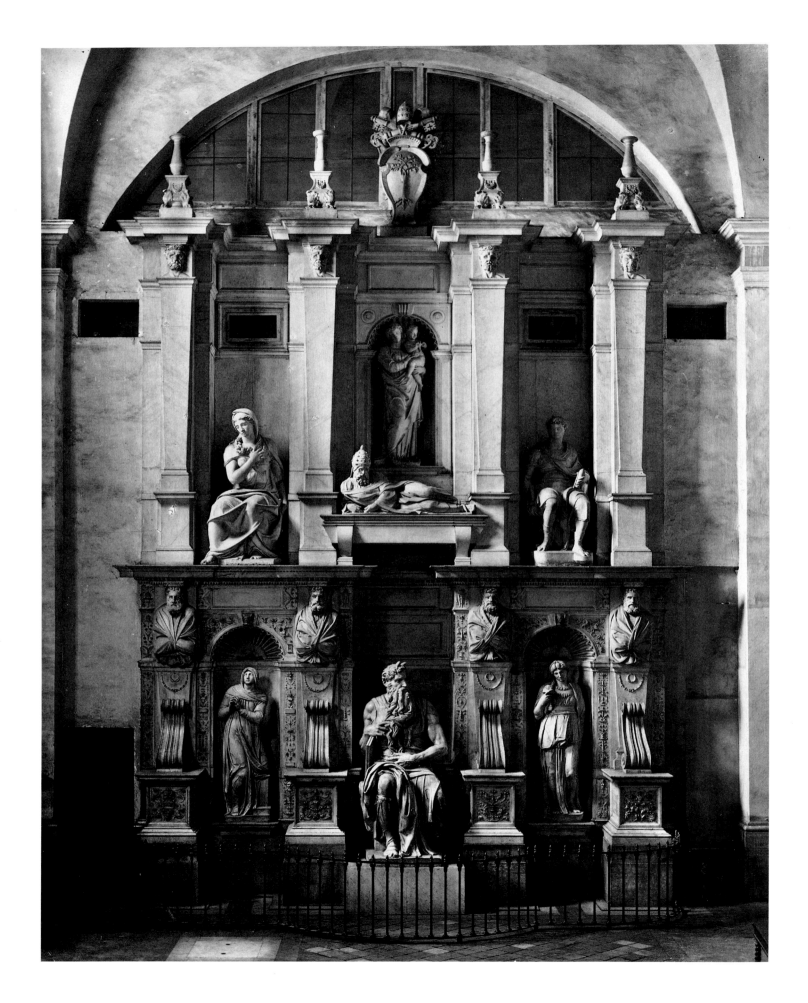

18.
A TOMB FOR THE LIVING POPE

"Melior Julius fuisset imperator quam papa romanus."

"Better for Julius to be an emperor than a Roman pope."

FRANCIS I

OPPOSITE:
Michelangelo. Tomb of Pope Julius II. Rome, Church of San Pietro in Vincoli.

As pope, he received the keys of the kingdom of heaven but he was better known for a staff that he brandished in the imperious way a *condottiere* held his sword or a king his scepter. Giuliano della Rovere, Pope Julius II, was a man of action, better suited to sit astride a horse than on the solemn pontifical throne. He was acquainted with war and military life; he planned to return soon to taste the dust of the long march, to smell the smoke of campfires and gunpowder. His armor, adorned with the oak tree from his family coat of arms, was polished by his private attendants with the same care they lavished on his ecclesiastical robes.

Although he was still just short of sixty, in the early autumn of his life, Julius soon became preoccupied with the idea of building a tomb for himself. Perhaps it was thinking of future campaigns, hence of being exposed to mortal dangers, that led the pope to wish for a tomb. Whatever his reason, when it came time to select an artist worthy of his vision, one name stood out: that of the sculptor of the *Pietà* and of the *David* that reigned over Florence. Michelangelo Buonarroti was being praised all over Europe; besieged by proposals of commissions from the king of France, as well as the lords of every court in Italy.

Julius envisaged an exceptional monument, one that would be remembered beyond the borders of time. No one was better suited for the job than the diminutive maker of giants, who dreamed on a great scale and brought his vision to fruition. Julius did not want a pharaoh's pyramid or a mausoleum; they were admirable constructions, but somehow dehumanized. He wanted the greatness of man to be reflected in human images; he expected the shoulders of God's harbingers, prophets and holy men and women, to support his own claim to immortality.

Julius visited the old basilica of Saint Peter to choose the best place for his future sepulcher. He was appalled by what he seemed to notice for

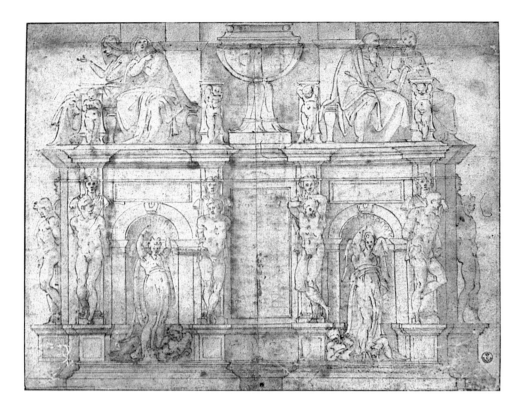

Michelangelo. Study for the
Tomb of Pope Julius II.
Florence, Uffizi Gallery.

the first time. Decrepit naves were filled with strange objects: marble pieces
from the early Constantinian building and thousands of ex-votos, or offer-
ings brought there by people in gratitude for some miraculous help granted
by Jesus, Peter, the Virgin or some other saint. There were sails and
anchors, for those who had survived a storm or a shipwreck; crutches and
silver casts of arms or legs; wheels from carts that had trampled someone
but left them unharmed; saving bells that had alerted a village of a fire, and
so on. The pope saw the decay, the clutter, and realized that no structure,
no matter how noble, would find a suitable home in such a place. Julius
decided that a new basilica must be constructed to house his tomb.

His head architect was Donato Bramante, from the Marches. He was
so talented that one day, notwithstanding the rivalry that divided them,
Michelangelo wrote of him: "Nobody can deny that he was as able in
architecture as any other from antiquity to our time."

The pope confided his intention to Bramante. The ancient, collaps-
ing Saint Peter's must be torn down and a cathedral worthy of the new
Julian era erected on its glorious site. Bramante received the idea enthusi-
astically and began planning the architectural wonder. His design was so
great that, again, Michelangelo reported: "Bramante designed Saint Peter's
as a clear, luminous, isolated building, a truly beautiful plan, and anyone
who has drawn away from it has departed from truth."

In the mind of Julius, the building of the new basilica marked not
only the inception of a colossal architectural work, destined to be one of
the wonders of the world, but also the beginning of a new, more glorious
era for the city that once was the see of the greatest empire in history.

Bramante could not proceed fast enough. The pope grew more im-
patient with every reason, even though legitimate, for postponing the

laying down of the cornerstone. It did not matter if the cost of the building materials rose horrendously, if stone and brick and lime could not be supplied on time and in the quantities required, or if as a consequence of all this, Vatican coffers were drained. A remedy was found: the Church began offering indulgences in exchange for contributions to help the majestic building progress. For a certain fee, anyone could purchase the redemption of a soul sentenced to purgatory. For so much money, so many years remission.

Under the pope's pressures, Bramante struggled to keep pace with repeated crises. When lime was badly needed, ancient marble was melted down. It was of little importance that the pieces sacrificed were irreplaceable reliefs, capitals of columns and the like. For this work, Bramante earned for himself the surname of *Ruinante*, and seemed not to care.

The building continued. Julius's dream was slowly becoming reality, amid the rubble of ruined walls and the incessant traffic of carts loading and unloading. The hammering, hoisting, sawing and bricklaying turned the Vatican into one huge work site.

As the building progressed, the pope imagined his own sepulcher resting in the very heart of the basilica, close to the remains of Saint Peter, which had been the true cornerstone of the ancient basilica and, with this new cathedral, would become a splendid beacon to the Christian world. Julius was not a champion of piety, although he was preoccupied with the restoration of higher moral standards in the Church. As a twenty-eight-year-old cardinal he had fathered two daughters, and there were rumors that he suffered a venereal infection during his youthful years. Rumors or truth, all this belonged to the past. The man who ruled the Church from the Vatican was taking his mission as a divine mandate and strove to lift himself above human weakness. To him, placing his tomb in the temple founded on the sepulcher of the first pope was a testament to a choice made by Christ and carried out once again with his own election: this absolved him from the sin of arrogance, if not from that of pride.

As soon as Michelangelo arrived in Rome, at the beginning of March 1505, he and Julius engaged in a series of meetings, discussions and exchanges that did not please Bramante. The head architect of the Vatican was worried about His Holiness's enthusiasm for the tomb; he feared his possible distraction from the building of the new Saint Peter's, as well as the avalanche of expenses the monument entailed.

Rome was already abuzz with malevolent stories about Bramante's alleged recourse to inferior materials and other less than honest practices. He had trouble defending himself in front of a less and less tractable pope. He did not need anything more to aggravate his position.

Michelangelo immediately began drawing plans for the tomb. He surprised even Julius when he showed him the great scope of his projections. The tomb he designed had nothing to do with the sepulchers traditionally installed in the churches of the 1400s, which usually leaned against a wall, offering only one front. Michelangelo conceived of an imposing rectangular structure with four visible sides. Its base would have niches disposed all around, or resting between pillars. In the niches, various stat-

ues, with slaves and prisoners among them, would symbolize humanity set free by the brave action of the pope. In the upper part of the tomb, at the four corners of the structure that crowned it, would stand four biblical giants: Moses, Abraham (or John the Evangelist), David and Saint Paul, the champions of human freedom.

Above this structure a beautifully carved ark would be carried by angels, helped by two statues representing Earth, weeping for the loss of a man as great as Julius, and Heaven, smiling with joy for his entrance into God's eternal kingdom. The ark would serve only as a symbol of the pope's burial. His body would be laid to rest in a marble coffin, contained in an oval room built deep inside the monument. A total of forty statues would be carved for the tomb.

The superb plan ignited Julius's passion for colossal achievements. When asked where the tomb would be raised, Michelangelo answered: "Right in the middle of the new basilica." To Julius, it seemed logical that the new pope should sleep his one long night without awakening on the heart of the first bishop of Rome.

To Bramante, though, it was the ultimate insult that such a monument should dwarf the basilica he labored to erect. Furthermore, he resented the rumors he heard of Michelangelo's criticizing his building methods and giving credence to the gossip about his alleged corruption. He tried to induce Julius to appraise more cautiously the magnitude of the tomb and its related expenses, but the pope was deaf to all advice. His heart was already with Michelangelo, on the peaks of the Apuanian Alps, at Serravezza and Carrara. Not a day must be lost, he thought, in securing the best marble blocks ever quarried there.

The whole concept was worthy of eagles, and Julius felt that he had entrusted it to wings powerful enough to lift it above doubts, hesitations and any other vice of the fainthearted.

THE TREASURE IN THE VINEYARD

Rome awoke on the cold morning of January 14, 1506, to a sweeping *tramontana* wind that carried the icy breath of snow across the mountains into the Tiberina valley. In the vineyard of Felice de Freddis on the Esquiline hill, amid the ruins of the baths of Emperor Titus, a farmer was digging holes in the frozen ground to bury seedlings.

Suddenly, he stopped, reeling back and crying in horror. A hand had emerged from the earth, the pale whiteness of skin visible beneath the dirt. The man ran to the house of his master. Soon a small crowd gathered around the spot; someone dared touch the hand, cold as marble. Indeed, marble it was: a mutilated arm, a head, then a tangle of arms and serpents and more heads emerged as the digging continued. Finally, a large statuary group, surprisingly well preserved, was unearthed.

The news of the accidental discovery quickly traveled throughout Rome, kindling the interest of Michelangelo. He soon visited the vineyard in the company of his compatriot Giuliano da Sangallo and his young son, Francesco. Sixty years later, Francesco da Sangallo remembered that day in

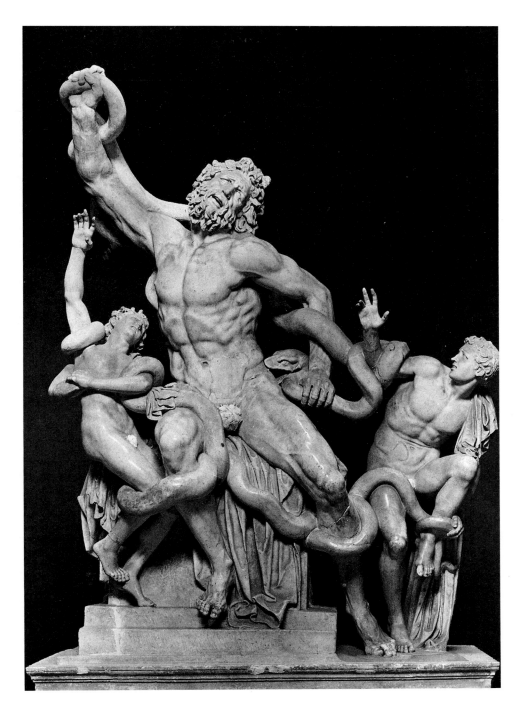

Laocoön. Roman copy, perhaps after Agesander, Athenodorus, and Polidorus of Rhodes. Rome, Vatican.

a letter to a friend: "I was only a child, and I happened to be in Rome when the pope was informed that a very beautiful statue had been found in a vineyard next to the basilica of Santa Maria Maggiore. The pope ordered a palfrey [meaning messenger]: Hurry and tell Giuliano da Sangallo to go and see it without delay.' And since Michelangelo Buonarroti was constantly in our house, because my father had summoned him and had gotten for him the commission for the tomb of the pope, he was asked to come along. And so my father took me up on his shoulders and we went. We went down to where the statue was, and my father at once said: 'This is the *Laocoön* mentioned by Pliny.' The hole was widened to pull it out; we saw it, then we went back home to have supper."

They soon confirmed that the statuary was the legendary *Laocoön,* the

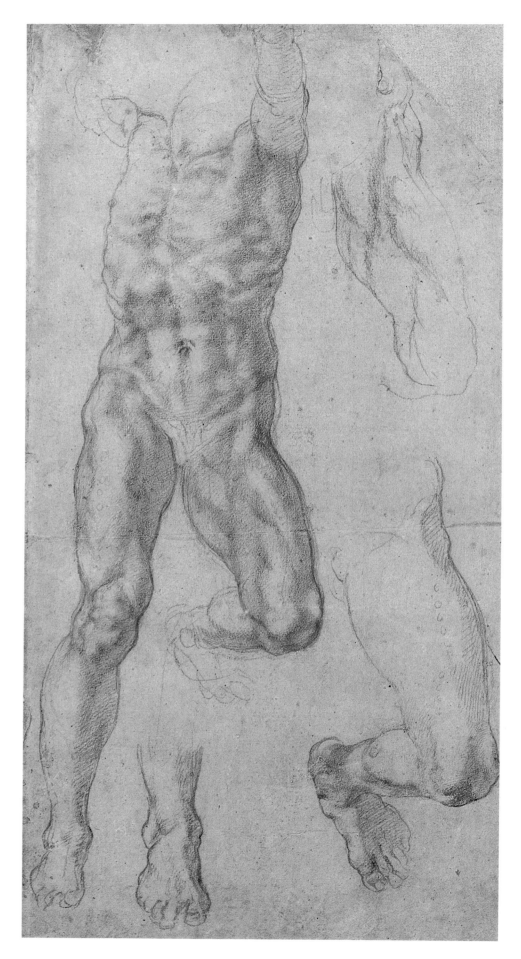

Michelangelo. Study for *The Death of Haman* (Sistine Chapel ceiling). London, British Museum. This study suggests the impact of the Laocoön on Michelangelo.

work of Greek artists identified by Pliny as the Rhodian sculptors Agesander, Polidorus and Athenodorus. The statues represented an episode in Homer's *Iliad*: a priest of Apollo at Troy hurled a spear against the horse treacherously introduced before the besieged city with a bellyful of Greek warriors led by Ulysses. When Laocoön prepared a sacrifice to Poseidon on the beach, two huge serpents summoned by the goddess Athena appeared from the depths of the sea. They ensnared the priest and his two sons, strangling them to death.

Once cleaned, the statuary revealed all the mastery of its authors. Michelangelo was transfixed by it. He never forgot the emotional impact caused by this unexpected encounter with the still-living spirits of his ancient colleagues.

The vineyard's owner was besieged with offers of large amounts of money for the sculpture; but Julius's authority prevailed. The group found its way to the Vatican, where it was installed in a niche designed for this special purpose in the belvedere courtyard under the Borgia tower, on the side of the first wing of the papal palace erected by Bramante.

Plinian tradition held that the statuary was carved from one solid block of Pentelic marble. Michelangelo wanted to study it, to ascertain whether it was truly made of one block, and to repair a broken arm without delay. Bramante suggested that his friend and favorite sculptor, Giovan Cristoforo Romano, work with the Florentine on the delicate task. Together, they discovered that, in fact, the group showed four extremely well-disguised junctions. The episode supplied a clear sign of the diffidence Bramante felt for Michelangelo. It would not be the last.

LOOKING FOR A SLUMBERING MOSES

"The voice of the true creator who spoke to Moses of Himself
by saying: 'I will let you see all that is worthy.'"

DANTE

In the month of April 1505, Michelangelo received 1,000 ducats from a fiduciary of Pope Julius in Florence to supervise the quarrying of the marble he needed for the tomb and the forty statues that he planned to carve.

Michelangelo was soon in heaven among the jagged ridges, the slopes that showed the whiteness of marble, the zigzagging paths that daring workers dug to reach the higher deposits. Because of his early days as a stonecutter, he was familiar with the work of testing the stone, choosing it according to purity and lack of veins, detaching it from the exposed quarry wall, squaring the blocks, preparing them to be secured with ropes, then ever so carefully letting them slide down the slopes by placing rolling timber under them, pulling the ropes, then gradually releasing them as the gigantic masses descended to the foot of the mountain where they were loaded onto carts and carried to the port of Carrara. There, ships waited to sail toward the ports near Rome.

Working free a marble block in a Carrara quarry.

OPPOSITE:
Michelangelo. *Moses* (Tomb of Pope Julius II). Rome, Church of San Pietro in Vincoli.

The dangers of the quarries did not frighten Michelangelo; he knew how to avoid the sudden slides of marble splinters, the untimely fall of a boulder, or the process that caused the walls of marble to separate from the mountain sides. He knew how to imitate the *tecchiaioli*, those alpine human goats who dangled from the peaks along the steep walls of the mountains to detect and dislodge the *tecchie*, or splinters of marble, that could kill or maim the workers. It was a labor worthy of eagles, with men suspended halfway between earth and the purest sky in all of Tuscany, with the sea down below smiling along the long, stretching beaches.

To tame the mountains was Michelangelo's true vocation. There the mind matched itself with the most majestic of all natural wonders, these Alps that erupted from the bottom of the sea millions of years ago to climb to the heavens, rich with their treasure of marble. There Michelangelo let his fancy wander from summit to summit, remembering the daring dream of Dinocrates, who proposed to Alexander the Great that he turn Mount Athos into a gigantic statue of Alexander himself. Like Alexander, Michelangelo dreamed of making a colossal statue out of a mountain. "And he would certainly have made the statue," his biographer Condivi wrote, "if he had had the time."

In all, Michelangelo spent eight months living with the quarriers, meeting dawns and sunsets, becoming acquainted with the sudden storms that played havoc in the *canali* of the Apuanian mountains, dislodging stones, creating torrents and unleashing fireworks of lightning that were both wonderful and terrorizing.

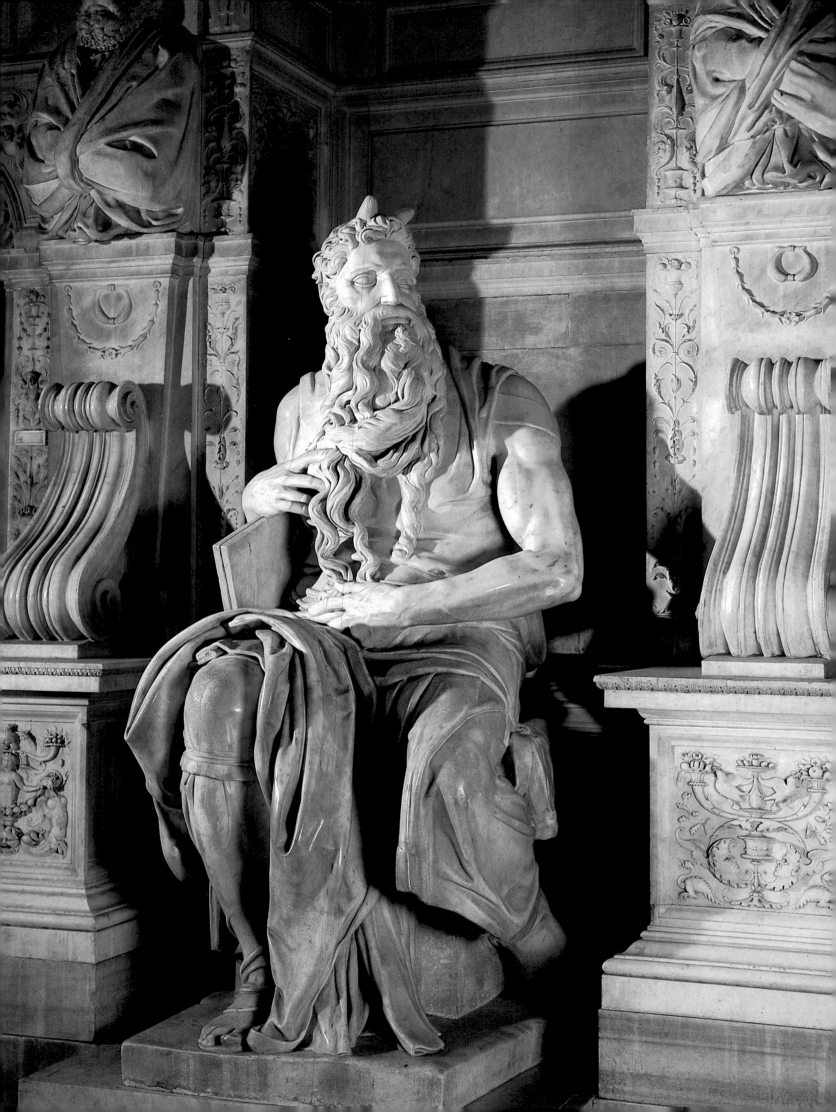

THE JEWISH PHYSICIAN OF JULIUS II

It is odd that biographies of Julius II and Michelangelo fail to mention the presence at the Vatican court of someone as important as the pope's personal physician, a man who took daily care of the pontiff, going so far as to "draw blood" from his most holy patient. The omission seems more deplorable when one considers that this physician was a Jew.

This was a time when accusations against Jewish physicians for causing harm to Christians were common, and they were forbidden to cure people who were not of their own faith. It is remarkable then that Samuel Zarfati, whose family had moved to Italy from Avignon in France, was chosen by Julius II as his trusted *medicus*. It is true that Christian as well as Moslem lords had bestowed favors and praises on the Jewish doctors who had cured them, the most famous being the great Moses Maimonides from Córdoba, who had been the "body physician" of the great Saladin; but in the case of the della Rovere pope, the appointment had a marked significance.

In 1504, a letter-patent addressed by the pope to Rabbi Samuel Zarfati disclosed the total confidence that Julius had in his physician: "We have heard that because you are unusually skilled in the art of medicine, our predecessor, Pope Alexander VI, granted to you full and free license to practice this art in accordance with its tradition even to the persons of Christians, and the privilege of prescribing medicines, and permitted the said Christians of whatever rank, position, order or condition, to receive medical cure from you and by your prescriptions ... and since however you were not a doctor of arts and of medicine at the time of the dates of previous documents nor are such at present, we, desiring to provide that both you who are in constant attendance upon us and Rabbi Joseph, your son, and your family, on account of your ability as a physician, should be the object of our gracious favor, of our own accord and not at your instance, not upon petition of your children or some other for you, but out of our pure generosity and of sure knowledge, we have decreed and declare by apostolic authority ... that the letters by which you and your son, said Joseph, as long as you live and he lives, are granted the permission and the privilege of practicing the said art of medicine upon the persons of Christians, be confirmed. Furthermore we have enjoined and commanded by this letter-patent that you, and whomever you please of yours, be elevated to the rank of master in the art of medicine, granting you the proper insignia...."

The letter went on to declare the title valid in whatever "university of learning," and to establish that the rabbi, his wife, his entire household were exempt from the jurisdiction of any power of court, temporal or ecclesiastic, and placed under the direct jurisdiction and protection of the Holy See. Samuel Zarfati and the members of his family were thereby spared the obligation of wearing the badge meant to distinguish the Jews, exempted from paying tributes and taxes, honored with any other immunity that doctors of arts and medicine received in the universities.

Upon Julius's election to the papacy, Rabbi Samuel Zarfati headed a Jewish deputation that presented to him the holy scrolls. The influence that he exercised on the pope was demonstrated on several occasions as, thanks to his intervention, a number of Jews from Naples and other regions were permitted to settle in Rome. Records show that whatever dissension arose between Christian physicians and Zarfati regarding the best way to cure the ailing pope, the rabbi's opinion always prevailed.

In the evenings he would meet with his humble, true friends speaking of marble, discussing this and that quarry, planning new tests to find the best quality, arguing with the transporters, with people like his intermediary Matteo Cucherello, whom he so often mentioned in his letters. For almost a year, he worked like any of his stonecutter friends, covered with marble dust, eating bread and cheese mixed with that all-invasive dust, but laughing, feeling totally alive, far from the jealousies of colleagues. He envisioned his Moses still slumbering in the large mass of marble, the buried prisoners agonizing to free themselves.

By the end of the year, he left the familiar mountains. It was hard to leave paradise and climb down to the plain, where the boats were being loaded to sail to Civitavecchia. The blocks looked so heavy that one wondered how the vessels could carry them without sinking.

Unknown. *Avicenna Visiting a
Hospital.* Florence, Laurentian
Library.

But he had to leave. The holder of the keys of the eternal paradise
was in Rome, waiting for the sculptor to return, growing impatient, like a
child who has been promised the most exciting of all adventures.

A SECRET CORRIDOR

*"Many times the pope went to visit Michelangelo in his house . . . and conversed with him
as with a brother."*

ASCANIO CONDIVI

Pope Julius made arrangements for Michelangelo to live and work in a
place adjacent to the Vatican citadel, and close to the church of Santa
Caterina, later destroyed, which rose near the Rusticucci Palace. Eager to
follow closely the progress of his tomb, Julius had the Vatican palace
masons build a secret passage that allowed him to visit the sculptor any
time he wished. A *ponte levatoio*, a drawbridge, on the side of the long wall
that connected the Vatican palace with Castel Sant'Angelo, ensured the
privacy that the pontiff required in dealing with Michelangelo, who was
already turning claustrophobic in his two rooms. To have descended from
the alpine heights of Carrara to the miasmic banks of the Tiber had been
hard enough; the damp walls of a decrepit Roman house were so depress-
ing that he lamented his living conditions in the letters he wrote to family
and friends in Florence. Little or no sympathy came from his father and
brothers, who were expecting financial help, even though Michelangelo
claimed that Julius was more generous with words than money.

The blocks of marble from Carrara that he carefully selected and
marked with his symbol (an *M* inscribed in one of three interlaced circles)
were being transferred from the boats in the harbor of Ripetta on the
Tiber to the ox-driven carts that carried them to Saint Peter's Square. The

Michelangelo. *Slave* (intended for the Tomb of Pope Julius II). Paris, Louvre.

pope was pleased by the sight of these white masses, shining like heaps of snow on the green grass.

But Bramante, worried about the mounting problems of controlling the expenses and materials for his basilica, was not as happy with the piles of precious, and costly marble on his work site. Also, he must have been jealous of the daily contact between Julius and Michelangelo, as well as the pope's relationship with Giuliano da Sangallo (Bramante's direct rival), who seemed, at least for the moment, to be winning the pope's favor.

Indeed, Julius was growing more and more fond of his meetings with the sculptor. Biographer Condivi heard from Michelangelo himself the tale of those daily visits during which His Holiness "spent time conversing with me about the tomb and other things, as he would do with a brother."

But Julius's attention was soon diverted from the sculptor. He stopped visiting Michelangelo and, even worse, seemed to have lost the keys to his coffer, refusing to pay the artist. Michelangelo was unable to pay the transportation costs to have his Carrara marble shipped to Rome. He hardly had enough money to buy food for himself and his servant. The cold winter months made his lodgings even more inhospitable, but, above all, his soul was in anguish. The lack of cordiality in his relationship with Bramante was turning into open enmity, and his efforts to break through the barrier raised between him and Pope Julius were to no avail. Bramante must be warning the pontiff of the dire necessity to choose between the new basilica and the tomb. Papal resources were being drained by these two projects at a time when Julius was planning a military campaign against Perugia and Bologna as part of a larger strategy directed against France and the Republic of Venice.

Perhaps someone else (for it would be out of character for Bramante to do so) warned that having a tomb built when one was still alive was tantamount to tempting providence. More likely, Bramante was genuinely concerned about the possibility of being left without funds as his construction grew in size and cost. Furthermore, the Vatican's chief architect must have been annoyed by the persistent rumors that he was lining his pockets with bribes from suppliers. Perhaps he suspected that Michelangelo was responsible for these rumors.

What is known is that Bramante, in his desire to counteract the Florentine influence on the pope, promoted a competitor of Michelangelo, the same Giovan Cristoforo Romano who had teamed with him for the restoration of the *Laocoön*. And Bramante was planning to open the doors of the papal court to a relative from his native Marches region named Raphael Santi of Urbino.

In a letter written in 1506 to Giuliano da Sangallo, Michelangelo reported a conversation he overheard at the pope's table while dining with a jeweler, one of Julius's favorite suppliers of precious stones. "It is the truth," wrote the sculptor, "that while having supper with the pope, I heard him say to a jeweler that he did not intend to spend any more money on stones, large or small as they may be. I admired his decision, and before leaving his table I asked him for the money I needed to carry forth my work. His Holiness replied that I should come back the next Monday; and

I went back Monday, and Tuesday, and Thursday. . . . And finally, on Friday morning, I was chased away from the palace." The table conversation was witnessed by the pope's master of ceremonies, Paride de Grassi.

But that was not all. The same letter contained a mysterious allusion to the mortal danger that Michelangelo felt at the time: "This was not the only cause of my departure; the reason was also another of which I do not wish to write; suffice it to say that it led me to think that if I remained in Rome, I would be in my own tomb before I could make that of the pope."

Who would threaten to kill Michelangelo? Most assuredly not Bramante, though in a letter that Michelangelo wrote thirty-six years later, he declared without hesitation: "All the quarrels that happened between Pope Julius and me were provoked by the envy of Bramante and Raphael from Urbino, and this was the cause of his not going ahead with the tomb during his lifetime, leading to my ruin."

Michelangelo was unceremoniously expelled from the pope's palace. "As the pope kept refusing the payments," he wrote, "one morning that I tried to talk to him on the subject, he had me expelled by a page. A bishop from Lucca who happened to be present, asked the page: 'Don't you know this man?' And the page said to me: 'Forgive me, sir, I have been ordered to do this.' " The almost brutal expulsion scorched Michelangelo's pride.

Michelangelo stormed home and wrote to Julius II a heartbroken denunciation of the affront he suffered: "Most Holy Father, this morning I have been thrown out of Your Holiness's palace: hence I want you to know that from now on, if you want me, you will have to look for me outside Rome." To make sure the letter would not be intercepted, Michelangelo asked his friend Agostino, a blacksmith, to deliver it personally to the Vatican.

It was April 17, 1506. Spring was about to revisit the seven hills. Penniless, Michelangelo borrowed 150 ducats from fellow Florentine Giovanni Balducci to pay for the transportation of his marble. A hood pulled over his head so not to be recognized, he left the eternal city, his dreams buried with the tomb that would never be.

19.
THE PAPAL CHASE

"We do not wish to wage war against the pope because of you."

PIERO SODERINI

"The pope," reported Michelangelo, "having received my letter, sent five riders after me. They overtook me at Poggibonsi, at three o'clock in the night, and they showed me a brief from the pope that said: 'At once, as soon as you have read this, under pain of our disgrace, come back to Rome.'"

At first, Michelangelo was furious. Then, when the pope's messengers threatened to kill him, he pleaded for mercy. His change of attitude appeased the chasers: they agreed to release him on condition that he write the holy father a letter stating that they had found him after he had already reached Florentine territory, thus making it impossible for them to take him against his will.

The letter sent to the pope amounted to a veritable challenge. Without any attempt to appeal for clemency or understanding, Michelangelo declared he would never return to Rome; his loyalty and good service did not warrant his being chased away like a criminal; and, since the pope did not intend to build the tomb, he considered himself free of any obligation. Swords back in their scabbards, the papal chasers galloped back to Rome.

There was an ominous silence in Rome. Michelangelo, back in Florence, kept a low profile; he looked to work for solace and reassurance. He began to carve his Saint Matthew, one of the twelve apostles for the Duomo, and alternated sculpting with drawing the cartoon of the *Battle of Cascina*. He prayed that the pope might forget him and his flight. After all, he was only a grain of sand in the eyes of the colossus Julius II.

Notwithstanding his activity, and the fact that Gonfalonier Soderini seemed glad for his unexpected return home, Michelangelo felt disquieted. He thought about leaving Florence, to put a safer distance between himself and the angry pope. He even considered an offer from the sultan of Turkey to design and build a bridge spanning the Bosphorus. A similar offer had been made to Leonardo, who had not gone beyond some preparatory studies.

Michelangelo kept hoping for papal oblivion; but Julius sent an apostolic brief, an official letter, to the Signory asking that the sculptor be

admonished to return to Rome, under pledge that he would suffer no punishment. Michelangelo did not trust the pontifical avowal and refused to heed the summon. The Signory was embarrassed; Soderini and the Republic's secretary, Niccolò Machiavelli, the prince of Renaissance diplomacy, were already ill at ease about the pope, who had demanded the help of Florence for his imminent military campaign.

A second and a third brief to the Signory conveyed the mounting fury of Julius at seeing his plea, and even his threats, ignored. The tone of the pope's words was so intimidating that the Gonfalonier felt bound to advise that "he, Michelangelo, has been dealing with the pontiff in a manner that not even the king of France would have dared to use." Soderini warned Michelangelo that "the time for further pleas to come from Rome is over. Florence does not wish to risk a war with the pope, and endanger the very existence of the Republic."

Raphael. *The Mass of Bolsena*, detail of Pope Julius II. Rome, Vatican.

227

"Get ready to go back" was the final advice to the artist.

On August 26, news came from Rome that the pope, after blessing the city, had started marching toward Perugia, escorted by five hundred horsemen in full armor. His campaign to reconquer Perugia and Bologna had been launched. Along the way, he had planned two meetings with Machiavelli, both pressing for an answer to his appeals.

On his march, he dragged with him the whole Roman Curia; only a few seriously ill cardinals were excused from joining the expedition. The pope imposed a severe regime on his retinue. Wherever he stopped, he made minimal use of the luxurious lodgings provided for him. On September 4, at Montefiascone, he spent the night in an old stronghold, in such disrepair that the wooden floor had to be reinforced to prevent it from collapsing. Torches were lit before dawn the next morning, to salute his departure for Orvieto. Only the faithful who had sacrificed a night's sleep were able to receive the papal blessing as they lined the country road on which Julius led his troops.

Literally out of breath, the cardinals and bishops, and the other members of his court trudged after him, in a desperate attempt to catch up with their leader, who seemed to have shaken at least twenty years off his shoulders. He appeared rejuvenated, bursting with energy as he spurred his army to make haste, while he dispatched letters to Milan, asking for reinforcements of auxiliary troops, which the king of France agreed to supply, and to Bologna, warning the city not to oppose his entry.

Machiavelli tried to find a solution by going to Orvieto, where Julius II arrived on September 5. He had two burning problems to solve: how to reject, in the most conciliatory terms, Julius's request for military assistance, and how to deal with Michelangelo's refusal to resume his place at the Vatican court.

Niccolò had left behind his wife, Marietta, who was in the last days of her pregnancy. Notified that he had become the father of a healthy son, he was eager to return to Florence.

Possibly, he used the sculptor as a pawn in the chess game he played with the warring pope. In his own astute way, Machiavelli claimed the inability of Florence to supply soldiers or arms and promised that he would persuade Michelangelo to come and meet the pope in Orvieto.

He asked the Signory for a sum of money and suggested it be entrusted to the sculptor, asking the latter to remit it to him at Orvieto. On September 5, Machiavelli was informed that Michelangelo was on his way with the money. But, once more, the sculptor eluded him and the pope. Another letter, a few days later, advised him that Michelangelo had sent the money back to the Signory office through a servant.

Machiavelli renewed his promise to bring Michelangelo to reason, appeasing Julius II, who delayed his threatened expedition against Florence. Armed only with his tremendous charisma both as a *condottiere* and as the supreme pontiff of the Roman Church, he led his army on, to Perugia, where Gianpaolo Baglioni surrendered to him.

His victorious banners had advanced from Umbria across the Marches to Romagna in less than two months. The papal army was growing in

soldiers and equipment, as reinforcements kept coming in answer to the pope's requests. He marched triumphantly into Perugia, with the eight Priori waiting at the gate of Saint Peter to offer him the keys of the city, his army advancing under arches erected all along the main street.

Machiavelli must have rejoiced over the stubbornness of his fellow Florentine. By standing his ground, Michelangelo had turned himself into a valuable tool in the secretary's hands. Julius would have to wait, while his keen wish to force the artist to bend his knee grew in intensity. What was harder to obtain became more valuable.

And, if forced to choose between Julius and Michelangelo, Machiavelli preferred the second. The secretary was critical of the fact that this truly gigantic pope caused the ruin of Cesare Borgia, the "Prince" of Machiavelli's political dreams. He had seen his hope that Perugia's walls would repulse the papal attack crumble because of the awe and fear in the heart of Gianpaolo Baglioni. At least Michelangelo Buonarroti had so far been able to keep his brave standard flying in the face of the pope's not so holy banners.

A SWORD, NOT A BOOK

". . . the keys that I was granted were not meant a symbol to become on any banner, for one Christian to fight against another."

DANTE

Julius II left Perugia on September 21. On the twenty-second he was in Gubbio; on the twenty-fifth, at Urbino. He was supposed to wait there for a reply to his letter of warning addressed to the Bentivoglio in Bologna. But the reply did not come, and the pope decided not to delay his departure for Romagna any longer.

On September 29, in a torrential rainstorm, the pope ordered his troops and shivering courtiers to move on to Cesena.

In the castle still resounding with the memories of its occupant and ruler Cesare Borgia, Julius II received a delegation of Bolognese citizens who begged for pontifical clemency for their city. Having warned that he "did not care about what other popes have done, by entering pacts or making promises," he reiterated his demands and his threats. He dismissed them and went to review his 2,200 men who formed the army of the Church, plus 300 Swiss and 100 Albanians, who were his mercenary contingent.

As the pope drew near Bologna, Giovanni Bentivoglio played his trump card by offering a rich ransom to the French troops sent by Louis XII to join the pontiff's forces if they agreed to defect. But Julius refused to be intimidated by the possible withdrawal of his ally and continued his march, fording rivers and streams that were swollen with falling rain. Not even a sudden recurrence of his gout deterred him. Thus, he gave the French king time to learn of the wily attempt of the Bentivoglio and to issue mandatory instructions to his soldiers to remain loyal to the pope.

Julius allowed time for a short rest at Imola. There, on November 2,

the news that Giovanni Bentivoglio had fled Bologna with his children, taking refuge in Milan, reached him.

On November 10, under triumphal arches that bore the legend "To Julius our Liberator, Bologna freed from tyranny," the pope rode into the city. The cortege filed in with the army players, fifty drummers, the banner holders who carried the Church standards and the flags of the twenty cities that had surrendered to the pontiff, ten white horses with gold caparisons destined for the pope himself to ride, and finally, at the head of his army, carried on the pontifical chair, Julius II in shining armor, his hand firm on the handle of his precious sword, and the whole exhausted court, finally able to look to a long-expected rest. They were escorted by fourteen mace holders, the ambassadors, the cardinals, his personal physicians, his secretary, the patriarches, the archbishops and bishops, and forty priests, plus a much larger number of monks and friars. The cortege was closed by servants who dispensed golden and silver medals, coined for the occasion to the acclaiming crowd.

Two famous men witnessed the papal triumph in Bologna, Desiderius Erasmus from Rotterdam and Albrecht Dürer — different men, diverging reactions. Erasmus was rather critical; Dürer was indifferent since, at the moment, he was totally immersed in his studies of "the divine proportion, and secret perspective," under the inspiration and with the providential help of Leonardo's friend Luca Pacioli.

Julius stayed in Bologna for one hundred and ten days. He knew the city well, having resided there for nineteen years as its archbishop. He immediately instigated the reform of the local government by issuing a new constitution that abolished the Council of Sixteen and empowered a senate made up of forty members, with a majority of patrician families over the representatives of the people, to rule in his name. It was in this "liberated" city, in this jubilant atmosphere, that Michelangelo arrived, finally conquering his reluctance and protected by letters of safe conduct, to answer the relentless bid of a pope who seemed to be made of the same hard substance as the giants he carved.

"We certify Your Lordship that he is an honest young man and unique in his trade, in Italy and perhaps also in the universe. We could not recommend him more fervidly: he is of such character that if he is treated with kind words and manners, he will do anything. It is necessary to show him love and he will make things that will amaze anyone who sees them." This was the text of a letter of safe conduct given Michelangelo by Gonfalonier Soderini to deliver to his brother Cardinal Francesco Soderini in Bologna.

On November 26, the sculptor climbed the steps of the palace of the Sixteen, the headquarters of the former Council abolished by Julius, where the pope was having lunch with a few of his cardinals, including Soderini's brother. This time there was no antechamber wait for Michelangelo; he was rushed in, all ceremonial rules neglected.

His "unbending knee" touched the floor; the artist yielded to the pope as every fortress had done all along his triumphant march from Rome. Before he opened his mouth, Julius exploded. "You were supposed

to come and see us, and you have waited for us to come and see you!"

Michelangelo asked for the papal pardon, explaining the reasons for his behavior, protesting his hurt, his good faith.

Cardinal Soderini deemed it opportune to intervene to appease the pope: "I beg Your Holiness not to regard his error, as he has acted from ignorance. All artists, outside their trade, are ignorant people." Contrary to what the good prelate intended, the pope vented his rage against him: "You insult him in a manner we ourselves would have never done. You are the one who is ignorant. Get away from my sight, in your disgrace."

The cardinal stood for a moment transfixed, unable to move. The pope's attendants had to push him out of the hall.

Julius II too did not wait to put his regained sculptor to a new test. He wanted a statue of himself to be placed on the facade of the basilica of San Petronio, the cathedral of Bologna. The monument was to be more than three times life-size (twenty-seven feet high) and show the victorious pope enthroned, dressed in his pontifical vestments.

Michelangelo responded with equal promptness. He drew furiously; in less than three months the clay model was ready. The pope paid him a visit on January 22, 1507, one month before leaving Bologna, and spent part of the afternoon watching him add the finishing touches to his work. The pope loved the statue; his only objection was about the book that Michelangelo had placed in one of the pontiff's hands.

"A sword," cried Julius. "I should hold a sword, not a book!"

In April, Michelangelo was ready to cast the wax model in bronze. Two casters had joined him from Florence. He rejected them after they demonstrated their ineptitude. A third expert, Master Bernardino, botched his first attempt at casting. Perhaps Michelangelo was humbled by the incident, remembering that day in Florence when he had had his first public encounter with Leonardo, and used the latter's failure to cast the Sforza horse in Milan to humiliate him.

At long last, almost one year after the commission, the statue was installed on the church facade. The comments of the population were enthusiastic. A letter of Giovanni Sabbatino to Isabella d'Este proclaimed: "This work is so excellent that people cannot tire of looking at it."

Glowing reports were sent to the pope: "Your Holiness is here, alas only in image."

But a sad destiny awaited the monument. Four years later, Giovanni Bentivoglio reconquered Bologna. In one of those turnabouts that history so frequently records, the same people who had acclaimed the pope as their deliverer now denounced him as a tyrant and declared their allegiance to the returning lord. The statue of Julius was pulled down, broken to pieces, and finally melted down to cast a gun for the artillery of Duke Alfonso of Ferrara, who, to spurn his papal foe, called it *Julia*.

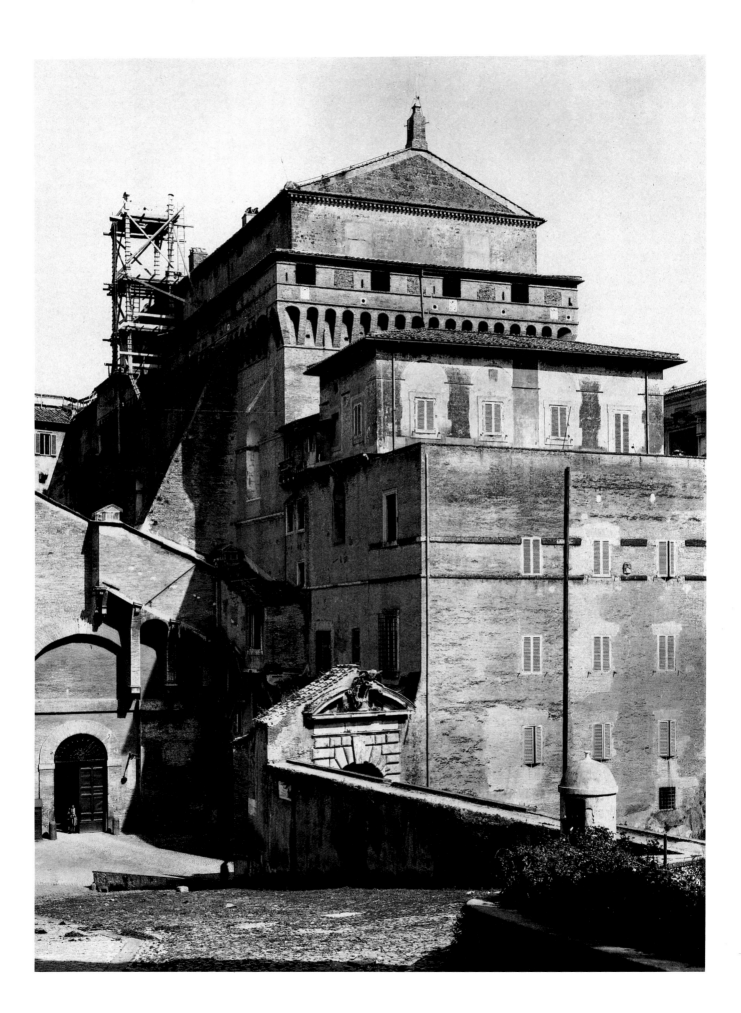

20.
THE BUILDERS
OF A NEW ROME

*"... the Vatican and of Rome the chosen parts
where Peter and the martyrs found their burial."*

DANTE

At peace with the pope, and promising to return to Rome as soon as he could settle some urgent family matters, Michelangelo went back to Florence. He had bought a good piece of farmland and planned to assist his younger brothers in finding some suitable source of income.

The news of the happy conclusion of the Bologna meeting pleased Piero Soderini; the dark cloud of the papal wrath had been dispelled, and now there was a chance that, before resuming his place in the Vatican, the sculptor might provide Florence with another statue like the *David*.

In March 1508, the Gonfalonier helped Michelangelo to rent a house for one year, and wrote letters to Carrara asking the local marquis, Malaspina, to endorse the sculptor's request for a particular block of marble from which he would like to carve a Hercules. But the new giant would have to remain in his prison of stone. Three weeks later, the pope called Michelangelo to Rome. This time it was not advisable to stall. His brothers would have to take care of themselves, although Michelangelo provided financial aid for them and their father.

In Rome, he expected to resume his project for the great tomb; the blocks he left behind were still there, near the basilica that had begun to rise on the foundations laid by Donato Bramante. The cost of the building proved to be even more exorbitant than the worst forecast. (More than a century, and the reigns of twenty popes, were to elapse before its facade was completed.)

At the first word of Michelangelo's impending return, Bramante's antagonistic feelings and fears were revived. There was a danger that the pontiff might resume the grand design for his tomb. Bramante had a plan of his own, to counteract the Florentine sculptor's undeniable influence on Julius II.

Now it was the new basilica that preoccupied the pope. He had repeatedly expressed his wish to commemorate his uncle and protector Sixtus IV. In 1475, Sixtus had commissioned the construction of the main chapel in the Vatican palace named after him: the Sistine. Designed by Giovanni de' Dolci, its uninspired architectural structure (Michelangelo called it "a barn") had been decorated by the greatest fifteenth-century

OPPOSITE:
Exterior of the Sistine Chapel, Rome.

233

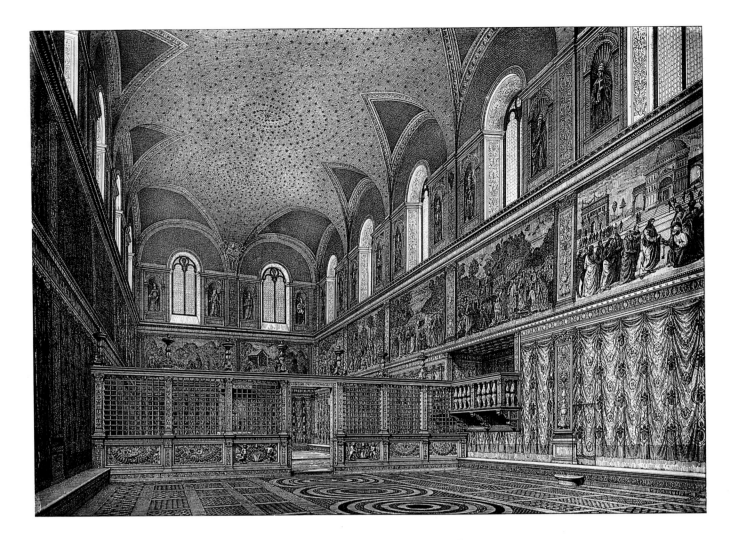

Drawing of the Sistine Chapel in Rome as it existed at the end of 1508.

painters of the Umbrian and Tuscan schools: Perugino, Pinturicchio, Ghirlandaio, Botticelli, Cosimo Rosselli, Piero di Cosimo, Luca Signorelli. Along the side walls, they had painted parallel stories from the Old Testament and Gospel: episodes from the lives of Moses and Jesus Christ. For example, the circumcision of Moses' son Gershom was mirrored by the baptism of Jesus in the Jordan.

The Cosmati, the celebrated mosaic-making Roman family, had created a wonderful marble carpet for the floor, and Andrea Bregno, Giovanni Dalmata and Mino da Fiesole had fashioned the marble screen meant to divide the faithful from the clergy officiating in the chapel. Mino da Fiesole had designed an elegant choir gallery.

The splendor of the fresco decorations, as well as these works by masters of great renown, elevated the aesthetic values of the Sistine. But one element offended Julius's eye: the ceiling. A rather obscure painter, Pier Matteo da Amelia, had covered it with a uniform blue tint dotted with golden stars, perhaps the easiest way to cope with the problem of painting such a vast surface, and at such a height from the ground.

Ever since his election, while expressing his thoughts about the inadequacy of the ceiling in comparison with the walls, the pope had declared his intention of entrusting the task of creating a more suitable decoration to a great artist.

However, Bramante knew that, more recently, the pontiff was greatly concerned about Vatican finances and the pressing necessity to support the building of the basilica. There was a good chance that, by Bramante's proposing the name of Michelangelo for the commission, the pope might feel relieved from the moral obligation of continuing with the tomb. On the other hand, as the sculptor had not practiced fresco since the years of his apprenticeship with Ghirlandaio, there was a definite possibility that he might fail, thus disappointing the pope, and falling from his grace. If this should happen, the Vatican chief architect had a substitute painter, ready and willing to take up the commission. That was his relative from Urbino, Raphael Santi, whom Bramante invited to the papal court in order to be part of Julius's peaceful campaign for the revival of the ancient magnificence of Rome.

To Michelangelo, who came back to Rome in April 1508, the proposal to paint the Sistine was unacceptable, even absurd. He proclaimed that he was a sculptor, that the Sistine ceiling was too large and odd in its shape to allow a pictorial design of any worth, that the work would be so arduous and long as to defy the efforts of the most daring among painters. Moreover, he had not practiced the fresco technique for a very long time, and the ceiling presented a major problem in the leaking of the roof; dampness was a sure hindrance to the successful outcome of fresco painting.

Bramante's scheme seemed to be working. Michelangelo's stern rejection of the pope's entreaties, pressures and imperatives made Julius ever more determined to compel the sculptor to carry out the commission.

, Michelangelo spent hours alone in the chapel. The ceiling opened over his raised eyes as vast as a desert. The challenge was tempting, but his natural reluctance was strong. Whatever his imagination suggested, the difficulties inherent were too great. The very shape of the vault, resting on pointed arches and lunettes, with the central part forming a flattened, narrow, oblong surface, required some sort of architectural invention to allow the unfolding of well-ordained scenes.

Irresistibly drawn against his better judgment, he began projecting on the dreaded blankness a vision of painted bronze and marble cornices, vertical pilasters adorned with bas-reliefs, and an entablature on which the central part of the ceiling would rest. He began to see animated figures on the lifeless surface, just as he did when considering what was imprisoned in a block of marble. The walls told the stories of humanity in progress, the mission of Moses and that of Christ. The wonder of the divine creation would unfold on the ceiling, the coming into being of the earth, God's gift to the first man and his companion, a conflict of divine love and human betrayal going from the bliss of the garden of Eden to the shame of the expulsion, from the salvation granted to Noah to the new shame of his lying drunk and naked in front of his children. Centered on the episode of the creation of man, Michelangelo's vision would rest on the powerful shoulders of prophets and sibyls, their pagan counterparts in divination. It was a daring vision.

Michelangelo was right. The ceiling demanded the combined effort of a painter, sculptor and architect. It was too much for one man, and too

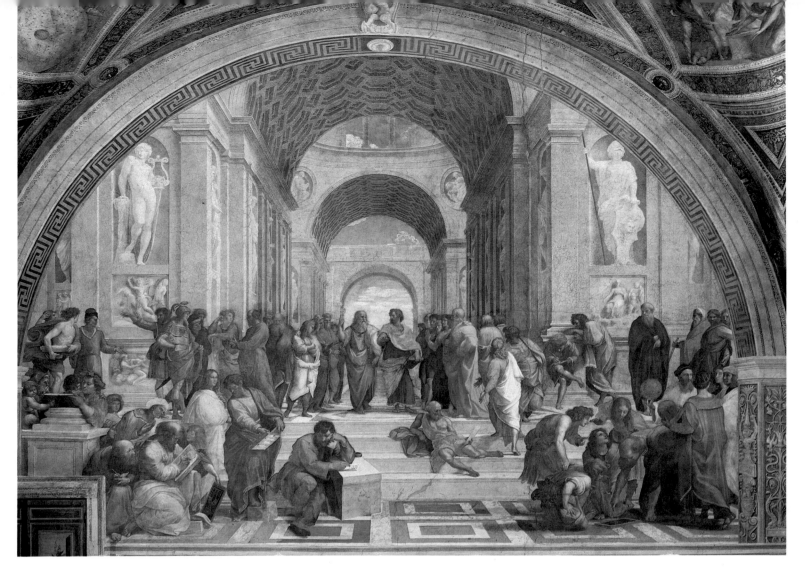

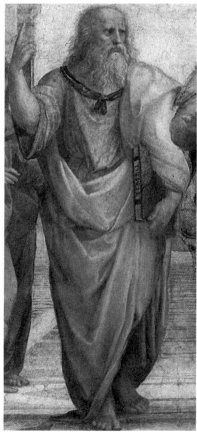

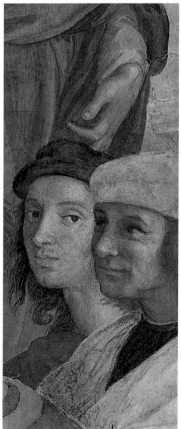

risky when this man had to face a patron as severe as Pope Julius. Besides, the scaffolding that had already been prepared for him was terribly faulty. The designers had not taken into account what to do about the holes opened in the ceiling to anchor the wooden beams once the scaffolding was removed.

No. The task was too formidable, failure more certain than achievement. Michelangelo renewed his refusal; he was a sculptor, he would not paint the ceiling of the "barn."

His refusal rammed against the granite will of the Pope. Julius insisted that if he wanted to call the Sistine a barn, he might well do so, but Michelangelo would make of his uncle Sixtus's chapel the most precious jewel of the Vatican.

Surrender was the only choice left to the sculptor. With the Sistine door slammed against his back, he was virtually a prisoner of the pope's coercion.

A new scaffolding was erected, according to his own instructions. Helpers were summoned from Florence, including his trusted friends Francesco Granacci, Antonio Michi, Giuliano Bugiardini, and Aristotele da Sangallo. Eventually, they would all be chased away from the chapel, their early contributions erased.

Michelangelo began his work alone on the towering scaffolding as on a peak of his Apuanian Alps, face to face with the implacable Love that "dictates inside man," as his Dante would say. He wrote: "Today, May 10, 1508, I Michelangelo, sculptor, begin to paint the Sistine vault."

THE SCHOOL OF ATHENS

Handsome, self-confident, preceded by the fame acquired in Florence, Raphael arrived at the Vatican. Bramante opened doors and hearts to make him welcome. There was even a commission waiting for him. The pope had long been wishing to have frescoes painted in his rooms. The archangel from Urbino was God-sent.

Once, not long ago, Michelangelo had been called to compete directly with Leonardo in their Florence. Now at the Vatican, he encountered confrontation with Raphael — torment against felicity, solitude opposed to conviviality.

One exchange between them was witnessed by many people. Raphael, surrounded by his own court of admirers, met Michelangelo one day as he crossed a hall in the pope's palace. Michelangelo quickly exercised his acerbic wit. "Where are you going in such company, as happy as a monsignor?" he asked. "And where are you going, all alone like a hangman?" retaliated Raphael. One can imagine Michelangelo, head lowered between his shoulders, mumbling to himself, "To my own torture," as he walked toward the Sistine Chapel.

Other tales of their clashes abound. According to some, Bramante went as far as to take his young relative surreptitiously into the chapel to show him the painting in progress. But, in truth, Raphael warmed himself at the great fire of genius that was burning inside the Sistine, and he paid

OPPOSITE, TOP:
Raphael. *The School of Athens.* Rome, Vatican, Stanza della Segnatura.

OPPOSITE, BOTTOM LEFT:
Raphael. *The School of Athens,* detail showing Michelangelo.

OPPOSITE, BOTTOM CENTER:
Raphael. *The School of Athens,* detail showing Leonardo.

OPPOSITE, BOTTOM RIGHT:
Raphael. *The School of Athens,* detail showing Raphael.

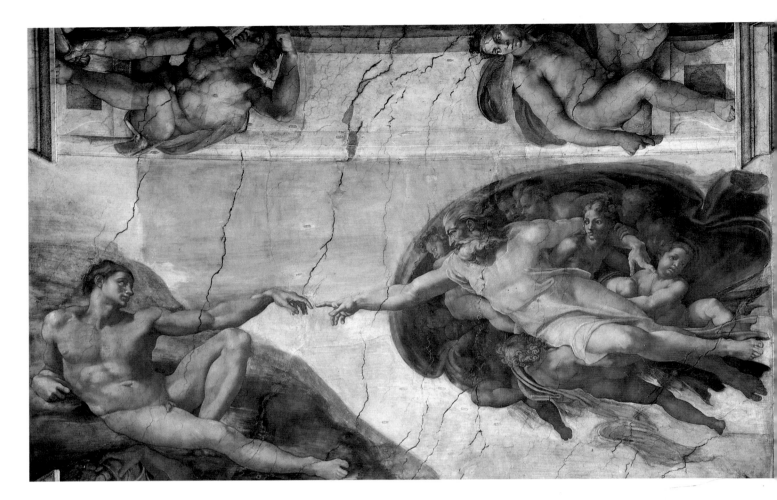

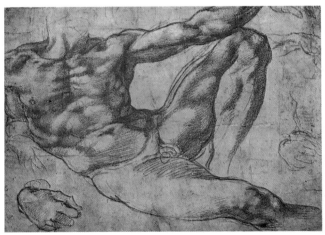

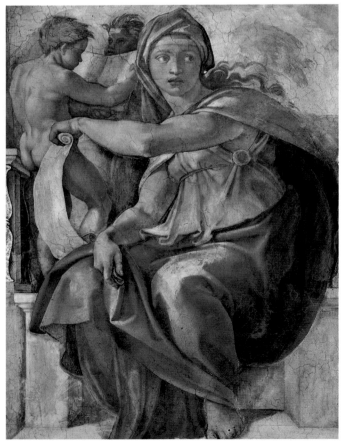

TOP:

Michelangelo. *The Creation of Adam*, detail of the Sistine ceiling. Rome, Vatican, Sistine Chapel.

ABOVE:

Michelangelo. Study for *The Creation of Adam*. London, British Museum.

RIGHT:

Michelangelo. *The Delphic Sybil*, detail of the Sistine ceiling. Rome, Vatican, Sistine Chapel.

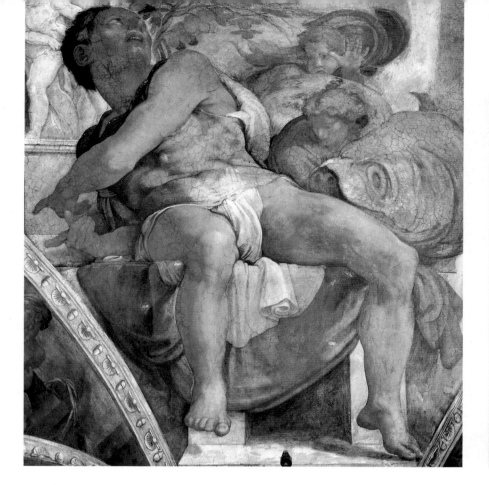

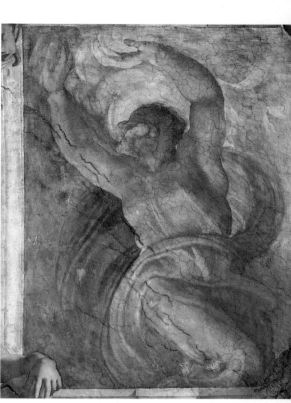

immortal tribute to his great brother, if not friend, in art, and to Leonardo, the other champion of their wonderful season. Ultimately, Raphael supplied the ideal conclusion to their common adventure of love and rivalry.

In drawing the cartoon for the *School of Athens*, he portrayed Michelangelo as Heraclitus, the philosopher of constant flux and unrepeatable experience ("no man enters the same river twice"), perhaps as recognition of the sculptor's merit in accepting the impossible task of the Sistine decoration; Leonardo as Plato, the supreme thinker. In a corner was Raphael himself, a participant in the assembly of the great contributors to human civilization. With his two colleagues in the exercise of art, he formed an ideal "triangle," the perfect figure of the Renaissance genius.

A CONCERT OF BELLS

In the hospitable house of the Martelli family in Florence, on March 22, 1508, Leonardo da Vinci began summing up his researches and discoveries in his small notebooks. The Arundel Codex, which still astounds us today, was being composed. Raphael and Michelangelo were immersed in their parallel yet different work, a few rooms away one from the other. Four years later, in 1512, the Sistine Ceiling and the *Stanze* were completed almost simultaneously.

With the ringing of the bells that saluted the new treasures acquired by Pope Julius for his resurrected Rome, the story of the Season of Giants was concluded. As witnessed by our never-ending sense of wonder at the masterpieces that were its harvest, it would have no equal in the flowing of history through the centuries, even unto our time.

LEFT:
Michelangelo. *The Prophet Jonah*, detail of the Sistine ceiling. Rome, Vatican, Sistine Chapel.

ABOVE:
Michelangelo. *The Division of Light and Dark*, detail of the Sistine ceiling. Rome, Vatican, Sistine Chapel.

PAGE 240, TOP:
Michelangelo. *The Expulsion from the Earthly Paradise*, detail of the Sistine ceiling. Rome, Vatican, Sistine Chapel.

PAGE 240, BOTTOM:
Michelangelo. *The Drunkenness of Noah*, detail of the Sistine ceiling. Rome, Vatican, Sistine Chapel.

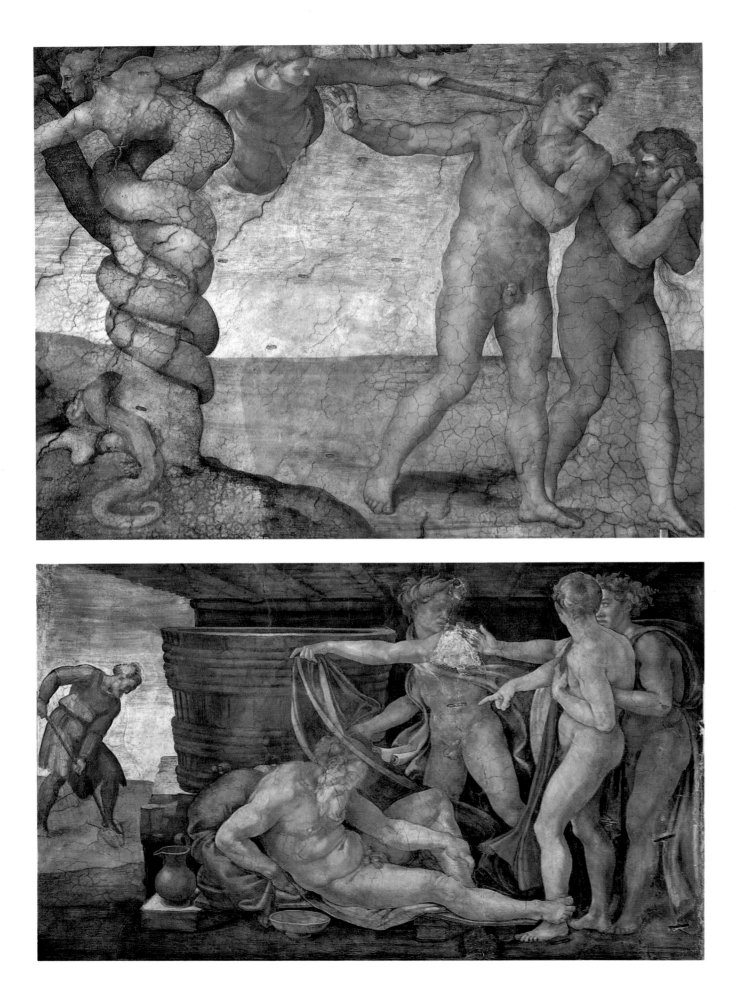

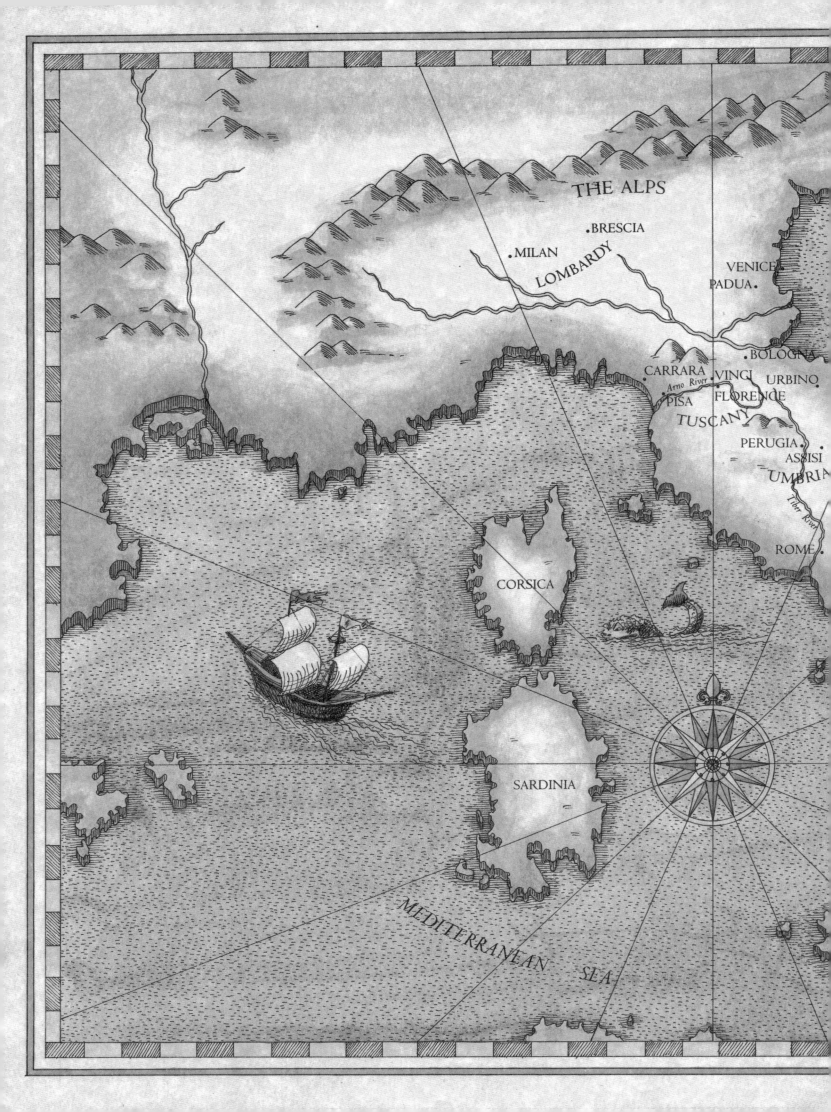

THE ALPS

•BRESCIA

•MILAN

LOMBARDY

VENICE
PADUA.

BOLOGNA

CARRARA VINCI URBINO
Arno River
PISA FLORENCE
TUSCANY

PERUGIA
ASSISI
UMBRIA

ROME.

CORSICA

SARDINIA

MEDITERRANEAN SEA